Where & How
to Sell Your
Photographs

Where & How to Sell Your Photographs

FORMERLY "WHERE AND HOW TO SELL YOUR PICTURES"

Seventh Revised Edition

by
Arvel W. Ahlers

AMPHOTO
American Photographic Book Publishing Co., Inc.
Garden City, New York

SEVENTH REVISED EDITION

Previous editions under the title *Where and How to Sell Your Pictures* were copyrighted © in 1952, 1954, 1956, 1959, 1962, 1966 by American Photographic Book Publishing Company, New York, New York.

First Edition	1952
Second Revised Edition	1954
Third Revised Edition	1956
Fourth Revised Edition	1959
Fifth Revised Edition	1962
Sixth Revised Edition	1966

Cover Photograph by Jack Lane

Library of Congress Catalog Card No. 74-83644
ISBN: 0-8174-0583-6

Manufactured in the United States of America

Foreword

OVER TWO DECADES LATER

It has been over two decades since I wrote the foreword to the first edition of this book—then the first thin paperback to come off the presses for a company destined to become the country's foremost producer of photographic books: AMPHOTO. In 1952, I welcomed the opportunity to introduce a book containing a wealth of information for free-lance photographers that had never before been compiled in detailed, comprehensive form. Today, in updating this introduction to an enormously enlarged edition, I am more enthusiastic than ever.

My dog-eared copies of the six previous editions of the book attest to the success of Arvel Ahler's technique in presenting factual information on the subject of photo markets, and the opportunities these markets extend to talented free-lance photographers. Dozens of pertinent subjects are handled with non-technical clarity: How to analyze a potential market; how to caption and submit your photographs; copyright requirements; model releases; the publishing rights you sell; the pros and cons of agency representation; pricing your photographs; publicizing your professional image; and handling the fine points of buyer-seller relationships.

Is there a full- or part-time career in photography for you? I can only answer that question in this way: Opportunities to sell pictures in the enormous world-wide markets are open to everyone without restrictions as to age, sex, locale, or background. All that any free-lance photographer needs is the ability to produce the kinds of pictures that buyers are looking for, *plus* the "know-how" of selling to the markets he is best qualified to supply.

After studying this book, you will feel as though you have been personally conducted through the offices of many types of picture buyers, have gained insight into their specialized needs, and have collected an address book filled with leads on buyers who welcome the kinds of pictures you can best produce. For thousands of people like myself, free-lance photography is rewarding as a means of self-expression as well as financially. I hope it will prove to be the same for you.

PETER GOWLAND
Santa Monica, California

Author's Note

When this book appeared in 1952, it was a 64-page, digest-size paperback. Although it then pioneered a little publicized field of photography, no one anticipated that it would undergo many revisions, constantly growing in size as its distribution climbed into hundreds-of-thousands of copies. This seventh revised edition is again greatly expanded over previous editions, and its format has been completely changed and enlarged.

When a book has undergone this many revisions, it is impossible to individually credit the legion of photographers, editors, authors, publishers, and photo-agency people who have so generously contributed their knowledge and talents to its existence. In token of appreciation, therefore, I dedicate the 7th revised edition to *all* the fine people in photography whom I have known and worked with for nearly four decades.

ARVEL W. AHLERS
Flushing, New York

CONTENTS

SECTION 3

SECTION 4

SECTION 5

SECTION 6

SECTION 9: BUSINESS POINTERS

SECTION 10

SECTION 11

SECTION 12

1. Genus: Free lance

A medieval knight who was his own boss—whose lance was for hire on a full- or part-time basis—came to be known as a "free lance." Today, one of his counterparts often has a camera and the many-faceted skills needed for offering his professional services for hire. His reward is an income commensurate with the time, skill, and marketing know-how that he (or she) puts into free-lance photography.

Many a successful free lance got his start in photography as an advanced amateur who took on an occasional pin-money job at a wedding or bar mitzvah to help pay for his photo equipment. Similarly, many photographic apprentices who originally trained for routine studio or lab jobs have since chosen to walk the more exciting, individual free-lance trail.

Why? Because free-lance photography offers unique satisfactions and side benefits that routine photography can rarely match. A free-lance photographer can live anywhere, choose his own working hours, and be sure of reaching, when he wishes, the outermost potential picture buyers in the world. Age, sex, creed, and locale are irrelevant. Many women raising children are also enjoying both prestige and income from free-lance photography. Similarly, hundreds of retired people are finding in photography an invigorating, challenging, and profitable occupation that they can pursue in as leisurely a manner as they choose. In short, photography today is offering people in all walks of life not only personal creative fulfillment, but prestige and income as well.

What is a free-lance photographer? As a rule, he is thought of as being any person who derives more than half his annual income from producing photographs for sale. By this loose definition, there are thousands of full-time free-lance pho-tographers in North America. Each is his own boss, usually working out of his own home or office, although he may also be associated with an organized "pool" of free lances who have formed a group in order to share expenses and attract a wider range of shooting assignments than they could land as individuals.

By a more practical definition, a free-lance photographer is any person who, working independently, makes a serious effort to produce a quantity of saleable photographs. Whether he free-lances on a full- or part-time basis, his main objective is to turn out photographs that can be sold *at a profit*.

To sell pictures profitably takes more than the mechanical ability to operate a camera. More, too, than the ability to "see" saleable pictures and interpret a subject in a fresh, interesting way. The free-lance photographers who have mastered the technique of selling *profitably* stand in a relatively small, select group. Take for example two free lances who have at their disposal essentially the same equipment and the same degree of creative talent. One man earns five, ten, perhaps even 50 times what the other photographer earns. What makes the difference? In most cases it can be pinpointed to marketing acumen—to individual differences in the ability to sell.

It is not within the scope of this book to go into the mechanics or esthetics of photography. Beginning, instead, with a glimpse of the free-lance opportunities that photography has to offer, we will concentrate on the fundamentals of selling pictures—the *know-how* of comparing different markets, analyzing those you want to probe, shooting the kinds of pictures *they buy*, and finally, delivering your finished work for a profit.

The number of different photographs that are annually bought in North America alone is so great that it boggles the imagination. In 1952, when the first edition of this book appeared, it was estimated by a group of librarians, editors, and photo-agency directors that about 15 million different pictures were being sold to prime buyers in the USA each year. Today, with the photographic industry expanding at a rate three times that of the U.S. economy as a whole, the early figure becomes meaningless. The only significant fact that emerges from conjecture is this: If a free-lance photographer's pictures express a point of view, tell a dramatic story, interpret a product or service, or evoke a responsive chord in the viewer, there is no lack of potential markets for the fruits of his camera work. Instead, his problem is that of choosing the markets he is the most content and best suited to shoot for.

2. Do You Need Formal Training For A Career In Photography?

A potential buyer to whom you submit a photograph is interested in one thing only: the end result. His interest is not in your professional stature or name, not in your background training, and definitely not in what kind of camera, film, or equipment you used. It is his job to select photographs to please, interest, inform, or stimulate a specific and vocal readership. Your photograph, judged by visual contents alone, will stand or fall by itself. That's the way the buy/sell game is played.

Do you need formal training in order to compete successfully in the free-lance field?

The answer would have been "no" only a few generations ago. Most of today's "old pros" achieved success with little or no formal training. But those days are gone forever. In this era of photographic exploration of everything from outer space to the components of a bacterial structure, the amateurism of "say cheese!" is as far removed from practical professionalism as is the earth from the sun. To cope successfully with the picture-taking problems he will encounter nowadays, the free-lance photographer who aspires to more than mediocrity needs a comprehensive knowledge of photography acquired through the help of experienced and professional teachers. Not that apprenticeship is totally passé, but in North America this approach is losing favor. The knowledge thus acquired is often too narrow to be practical, and the quality of learning depends too much upon the ability (and willingness) of the professional photographer to pass along what he knows.

Formal education, then, is becoming more and more a *must*. This raises such questions as: What kind of education? Where and how can it be acquired? How much is needed? How long will it take? Only partial answers can be given to these questions, because only *you* can decide which of the many facets of photography you want to consider as a career goal. The following paragraphs are intended only to give you a glimpse of some of the choices you have. This is by no means a definitive list, but for starters, here is food for thought.

POTENTIAL CAREERS IN PHOTOGRAPHY

Audio-visual materials: These are often produced as single-frame color transparencies in filmstrips or slides for projection, and are almost always synchronized with sound consisting of background music and voice-over narration. Educational, promotional, sales stimulating, in-factory safety, and so on, are among the innumerable subject categories included. Knowledge required by the photographer is more than he can acquire in any general course. Specialized training is therefore a must.

8mm and 16mm audio-visual movies: These are mostly produced on special assignment for companies, religious and fraternal organizations, foundations, state and federal agencies, and other groups. Video cassettes and cable TV materials also offer new and expanding opportunities for the future. All of these fields require formal training and are not recommended as an immediate goal for beginning free lances.

Advertising: This is the big-money field in which photographers earn up to hundreds-of-thousands of dollars a year. Naturally, the competition for plum accounts, the big national and international clients, is extremely stiff. The best route for the beginner is to work on a local basis providing photographs for newspaper and community or local-area ads. These will give him background experience and prove his ability. For local ads, check to see if an advertiser places material through an agency. If not, his own advertising manager is the person to contact.

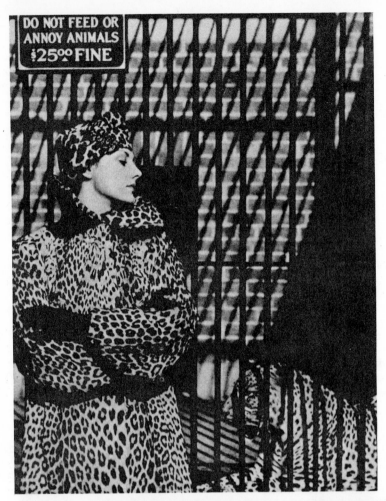

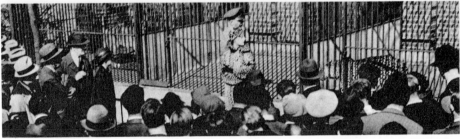

"Shooting a cover for the *New York Woman* on the theme of 'The Lady and the Leopard' was a case of suspense from the very start. The model was nervous, the leopard was annoyed, a huge crowd gathered, and the keeper—although helpful—announced loudly that the regular keeper was in the hospital as a result of having his hand playfully chewed by the big cat! We finally got the model next to the cage bars, but every time the leopard moved, she jumped about two feet. I thought she would faint when the cat stuck a paw through the bars. Finally the keeper and I had a chat. He tossed a piece of meat into the cage at the spot I wanted the leopard to be. The animal immediately ignored us as he ate, and the girl took her position and lifted her head cooly. At my signal, the keeper tapped a bar of the cage lightly and the leopard looked up at the girl. She looked back without flinching; I tripped the shutter. Oddly enough, we repeated this ploy 24 times. I was sure by then that we'd captured what we were after. Girl, leopard, keeper, and photographer all survived." Condensed by permission of Victor Keppler from his book *Man + Camera* (AMPHOTO).

Education: This often falls into the audio-visual field described above. However, another educational area often overlooked is that of supplying still photographs for publishers of encyclopedias, textbooks, and periodicals (magazines, brochures, etc.) in *any* specialized field, such as medicine, parenthood, ecology, and so on.

Publicity (PR) material: This exciting field offers innumerable opportunities for meeting celebrities, covering special events, and promoting everything from rural corn husking competitions to community-sponsored gala affairs. As the PR photographer for any local event, be it a testimonial dinner or a new shopping center, you will make contacts around town that can be invaluable to your professional career.

Photojournalism: Those who can master news photography for magazines as well as newspapers can demand good pay and build towards security in a field that carries the excitement of daily change and variety. Most schools that teach photography offer one or more courses in photojournalism. The best-paid photojournalist is often the person who can combine writing ability with his or her photography. The buyer can pay more for one person's complete package because he is usually saving money on what he would have to pay separately for a photographer *and* a writer.

Photojournalism—the funeral procession of President John F. Kennedy. This emotion-packed photograph appeared as a magazine cover and later was repeatedly reprinted around the world. Photo by Tony Calabro.

TV, motion picture, scientific, and police photography: These are expanding professional fields, but only certain schools and organizations are providing specialized instructions in them. As of this writing, one of the best sources of information on where to obtain specialized instruction is the Corporate Information Dept., Eastman Kodak Company, Rochester, N.Y. 14650.

Architecture and interiors: Although these are in a sense two separate fields, the professional who is good at one is usually capable in the other. The key is a perceptive eye in singling out the new, stimulating, daring, bold, or interpretative features in new or old architecture and interiors. Only those personally inspired by these ingredi-

ents can find the key. If you can prove your rapport through photography, the pay runs from good to excellent.

Travel: Here, too, is a growing field as jet liners shrink the globe in travel time so that people of all nations can afford to visit the dream-names of yesteryears.

Magazines and newspapers (travel sections) are heavy buyers of travel pictures, but there are also a number of totally different kinds of travel-photo markets. All types of public carriers— airlines, steamship lines, railroads, and bus lines —are potential buyers. State, county, city, and even community organizations that sponsor tour-

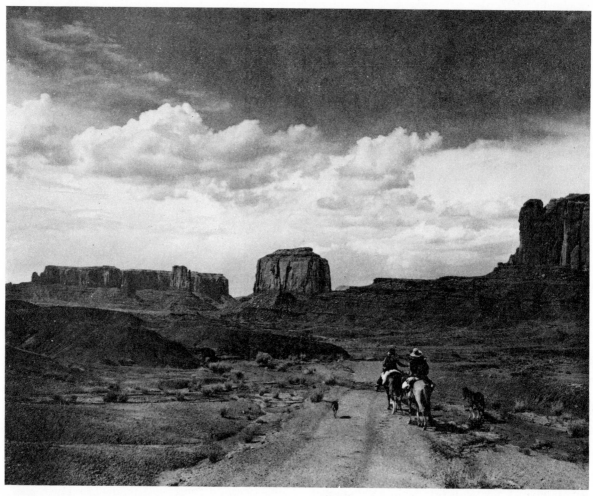

Navajos in Monument Valley. In color, its sales potential is infinite for magazines, calendars, regional publications sponsoring tourism, books, posters, and general stock-photo markets. The photographic team of Dorothy and Herb McLaughlin have over 150,000 stock photos in their files. (See Section 9, Part 3.)

ism drives also use travel photos in their publicity campaigns. Publishers of textbooks and encyclopedias are in some cases heavy users of photos that illustrate everything from agriculture to waterways, city skylines, ecology, wildlife, industries, and scenic terrains. Color transparencies, mounted as slides, are also used extensively as projected backgrounds for TV and motion-picture productions. (The majority of these slides are rented from stock photo agencies. After being paid for according to the use made of them, the slides are returned to the agency files to be rented or sold again.)

Fashion photography: This is a glamorous field in which the rewards can be great for a photographer who has fine taste and a flair for dramatizing it. Except for photographs taken on location, most fashion illustrations require studio equipment and props. Buyers are largely the manufacturers of wearing apparel, magazines that use fashion photographs editorially to support their fashion advertisers, and the producers of catalogs.

Nature photography: This specialized field is growing more popular in response to the world's

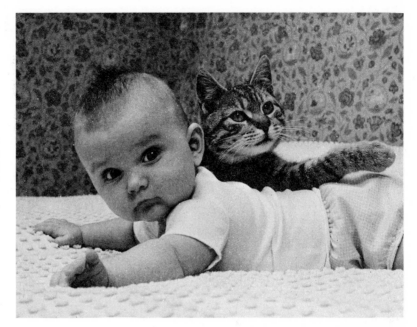

Babies and pets are highly saleable around the world. This is typical of the 50,000 stock photos of babies, pets, and nature subjects in the files of Walter Chandoha. (See Section 8, Part 4.)

increasing awareness of ecological problems. Many species of plants, insects, birds, and animals have become extinct since the turn of the century; many more may be extinct before the year 2000. Nature photography, as referred to here, includes oceanography and underwater photography. Markets for photographs in this broad classification range from all the print and motion picture media mentioned in preceding paragraphs to museum collections, research laboratories, and organizations that sponsor wildlife preservation.

Still-life photography: Here is a far better career field than many photographers realize. It requires imagination in the placement, color relationships, and lighting of inanimate objects. Food, household items, flower arrangements, art objects, jewelry—literally an endless list of subjects—are photographed for commercial use in advertisements, catalogs, editorial illustrations, greeting cards, calendars, candy/cookie box tops, textiles, ceramics, and so on.

Baby, child, and pet photography: This is a field in which many women excel, although some of the finest craftsmen, like French chefs, are men. If you love children, animals, and pets, this can

become a profitable field on either a full- or part-time basis. You have a choice between using a formal studio set-up, or a portable candid outfit that you can carry with you on assignments resulting from ads, telephone, or mail.

In the above summary we have described only a few of the many fields of photography you might care to consider. Schools that teach photography can give you insight into the potentials that exist in other specialized fields. Also, more detailed information on a variety of specialized fields is included in: *A Definitive Study Of Your Future In Photography* by Victor Keppler (Richards Rosen Press, Inc., New York 10010).

From time to time, various companies and organizations publish information on careers in photography. Among the former, Eastman Kodak Company is particularly career conscious. As of this writing, one of their excellent publications is *Careers in Motion Picture Production*, published by Eastman Kodak in behalf of the University Film Association and University Film Foundation. Copies of this and other career publications are available by writing the Corporate Information Department, Eastman Kodak Company, 343 State Street, Rochester, New York 14650.

3. Resident School vs. Home-Study Training

Those who recognize the need for at least some formal or specialized education in photography frequently ask: "Where can I study the kind of photography I want to work in?"

It is not an easy question to answer. If you are contemplating formal education, it will pay to look around before you commit yourself to *any* type of photographic course.

Generally speaking, you have a choice between special courses in: (1) colleges and universities; (2) resident photographic schools; and (3) home-study schools. In addition, there are specialized, but less comprehensive, courses available in seminars, night schools, and adult training courses. These should be considered supplementary rather than basic training.

Perhaps the first thing to bear in mind is this: Regardless of how an advertisement reads, or what a representative may tell you verbally, *no school or course can guarantee you a job* upon completion of their course. Under certain circumstances, they can offer useful counsel, or even direct you toward a job opening they have heard about. But that's the extent of the help you can expect.

Different schools vary greatly in the scope and quality of their courses. Some are "good" in the practical overall meaning of the word; others are quite superficial. Moreover, the degree of benefit that two students derive from a given course hinges not only upon the quality of instruction, but also upon the students themselves. It has been repeatedly noted that when two students enroll in a course for identical training, one may soar toward professionalism from the start while his colleague seems to tread water or simply washes out. In contemplating a course, then, the most important factor is *you*— your personal drive, ambitions, undeveloped talent, ability to learn, perseverance, and *determination* to succeed.

Once you have resolved to obtain formal training in photography, your next step should be to collect and analyze a wide variety of printed information *before* you sign up to take a specific course or enroll with a resident or home-study school. Once committed, there is danger of dissipating your original self-confidence if you later begin to entertain doubts about the wisdom of your choice. If, however, you do eventually decide to switch directions, let it be on a basis of experience acquired from having first made at least some progress up the ladder to professionalism.

COLLEGE/UNIVERSITY COURSES

Formal courses in photography are being added on an increasing scale to the curriculums of North American colleges and universities. In educational level, they range from the most basic general courses to the extremely specialized study required in medical and scientific photography. In addition to courses in still photography and laboratory work, some schools offer training in TV production, audio-visual work, motion pictures, police photography, advanced photojournalism, and so on.

It is estimated that there are 600 or more colleges, universities, technical institutions, and specialized schools in the United States that offer instruction in photography. Some grant degrees that range from certificates up to Ph.D. A comprehensive survey, prepared by Dr. C. William Horrell of Southern Illinois University, is available from Eastman Kodak Company. (For full index of Kodak publications, write Dept. 412-L, Eastman Kodak Co., Rochester, N.Y. 14650. There is no charge for the index.)

Several companies publish thorough compilations, in book form, of the photographic courses and degrees available from accredited four-year colleges and universities in the U.S.A. One such

volume, *Barron's Profiles of American Colleges* (Barron's Educational Series, Inc., 113 Crossways Drive, Woodbury, New York 11797) also includes such vital information as: tuition costs; financial aid; program of study; housing; educational philosophy; physical plant; library; extra-curricular activities; varsity and intramural activities; student travel programs; and accreditation. Other publications of this type feature more or less the same kind of definitive material.

RESIDENT NON-COLLEGE SCHOOLS

In addition to general courses, some resident schools offer training in both basic and specialized fields of photography. Many resident schools advertise regularly in the advanced amateur photographic publications. If you are looking for special training in medical, TV, motion pictures, science, etc., visit a reference library and check the photographic publications devoted to the specific fields that interest you. If the publications are not available, the reference librarian can help you locate their names and addresses.

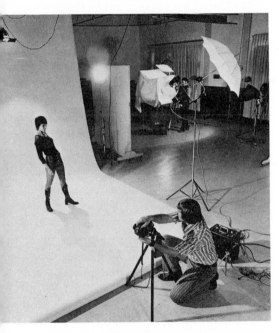

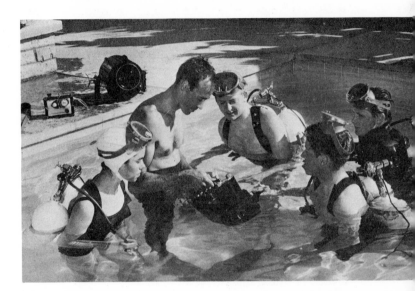

(Above) Students at work in the illustration department of a resident-study school of photography. The student in the foreground is working on a fashion set-up project.

(Above right) Underwater photography plays a vital role in recording man's efforts to explore the sea. Ernest H. Brooks II, second from the left, is explaining new tools and techniques to second-year students of the school.

(Right) Mr. Merl Dobry (in sunglasses), the motion picture instructor, is here checking over a student's script for an aircraft sequence. All photographs courtesy of Brooks Institute of Photography.

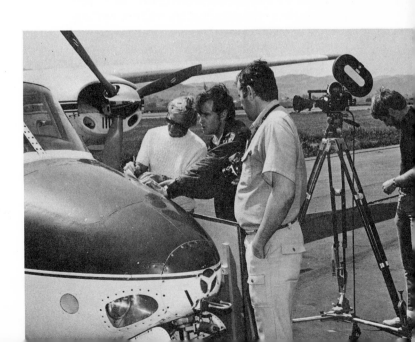

PHOTO SEMINARS AND WORKSHOPS

You'll find these being constantly announced in the photo magazines and on the pages of the photography sections of metropolitan newspapers. Some are perennials, sponsored by organizations and groups; others are announced by individual photographers. Most are held for a limited time and will involve tuition payments. In addition, you must consider such expenses as travel, board, lodgings, materials, and incidental costs.

In theory, a workshop or seminar consists of lectures, open discussions, the exchange of ideas, actual demonstrations of techniques and skills, and so on. In actual practice, the agenda varies widely. So, also, do the qualifications of the teachers, particularly those conducted by individual photographers. Even a "big name" photographer with proven competence in a given field may not have the ability to teach and inspire

his students. For this reason it often carries little weight for a free-lance photographer to state in letters to potential picture buyers, or in his press releases or exhibits, that he "studied under John Doe." The reason is simple. The potential buyer doesn't care *who* a photographer studied under. He is solely interested in the contents and quality of the photographs that land on his desk.

This does not imply that some seminars and workshop courses are not valuable. On the contrary, any special course that supplements your photographic education can be useful if qualified teachers set up a curriculum you can profit from. It is therefore imperative that before you sign up for a seminar or workshop, you check the curriculum, teaching staff, and other relevant factors. If the bulk of what is offered seems to fulfill your specific needs, you can feel reasonably sure of getting your money's worth.

HOME STUDY COURSES

According to the National Home Study Council, a trade association of correspondence schools, there are approximately 2 million Americans now participating in various home study courses. The trend toward seeking specialized training by correspondence is global, with Russia one of the leaders in this form of education.

In some foreign countries, satisfactory completion of home study courses in photography is accepted in lieu of apprenticeship, and thus provides the certificates that are mandatory for a photographer to operate as a professional.

In North America, some colleges offer extension courses in photography that can yield cred-

its toward a formal degree. It seems only a question of time until graduation diplomas from many photographic schools, both home study and resident, will be accepted by certain colleges for credit toward formal degrees.

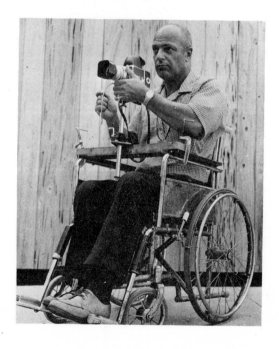

Jack Lane is a high-ranking graduate of an accredited home-study school of photography. Throughout his course of study he purposely refrained from mentioning to his instructors that he is a paraplegic, completely paralyzed from the ribs down. His home, car, and studio are built to facilitate wheelchair living. Animals, children, and nature studies are his favorite subjects, but he does take on industrial assignments, even though the situation may call for a crane to hoist his wheelchair to a point of vantage for an overhead shot. All the animal photos shown opposite are by Jack Lane.

22

What Home Study Accreditation Means

There are approximately 140 home study schools accredited by the *National Home Study Council* in Washington. The total student enrollment exceeds 1,500,000. Of these accredited schools, fewer than a dozen offer courses in photography.

The NHSC (National Home Study Council) serves as a type of clearing house for student complaints as well as liaison with the government. The qualifications a home study school must meet to become accredited (approved by) the NHSC are quite rigid. To begin with, the home study course material is carefully examined and evaluated. In addition, checks are made with Chambers of Commerce, Better Business Bureaus, and other watchdog organizations.

Non-Accredited Home Study Schools

Although NHSC schools are often considered the "elite" of the home study organizations, a number of other schools are not members of NHSC. Some are top-quality schools that do not feel the need of NHSC endorsement. Others, unfortunately, are simply "diploma mills" that could not qualify for NHSC membership. Their

Once accepted, a school is periodically revisited by the NHSC to make certain it continues to qualify for accreditation.

Bear in mind that accreditation by NHSC does not imply standardization of the scope of photographic subjects being offered, the individual teaching methods involved, or the tuition prices. You will need to query each school in order to get an up-to-date, comprehensive picture of the courses it offers and the costs involved. However, free information about accredited home study schools, the specific courses they offer, and their tuition rates, can be obtained by writing the National Home Study Council, 2000 K Street, Washington, D.C. 20006.

willingness to enroll anyone who can pay the tuition, regardless of an applicant's age or educational background, has for years contributed to the erroneous belief that home study schools enroll students indiscriminately. This is not true of any reputable school, whether or not it is a member of NHSC.

WHICH TYPE OF EDUCATION IS BEST?

Each type of training—college, resident school, or home study school—has its pros and cons. And each has champions who believe that their type of training is superior to all others. One of the best arguments for resident training is the easy availability of an instructor when a student encounters a problem that baffles him. Perhaps the greatest advantages a home study course has to offer (aside from living at home and being able to remain employed while being trained) lie in the fact that a student can study and work at his own pace and use his own equipment rather than types of equipment he might not care to use later on. (See Section 8, Part 1, for a definitive discussion of the educational advantages and disadvantages of different types of schools.)

How *effective* is home study training compared with resident school training? Research

suggests that independent study is just as effective as classroom instruction "when measured by examination performance," according to *The Chronicle Of Higher Education*. The basis of this statement is a monograph that re-analyzed data from over 90 separate studies conducted over a period of 40 years. Often stressed in educational journals is the fact that a key factor in any training program is the personality, perseverance, and emotional needs of the person being trained. Some students not only work well on their own, but at a faster pace than they would in a classroom. Other students work poorly without the competitive give-and-take and person-to-person stimulus of the classroom. Given a choice between resident or home study training, you alone can decide which type of education will benefit you the most.

Students enrolled in a home-study school are separated from their instructors only by the distance between their respective mailboxes. Each student's work receives an instructor's undivided attention and, in the better schools, a personalized letter of criticism, drawings that call attention to the good points about a picture, and suggestions for improving it. The work of individual instructors is frequently checked by supervisors and it is not uncommon for the director or dean of a home-study school to add his comments to work that is being prepared to be returned to a student. The following photographs appear through the courtesy of the School of Modern Photography.

(Right) Ed Hannigan, Dean and Instruction Supervisor of the School of Modern Photography (a home-study school accredited by the National Home Study Council, and approved by the N. J. Commission of Education) dictates his criticism and comments on the work of a student who has concentrated on flower subjects.

(Below left) Too many branches, not enough bird. Note the cropping "L's" that the instructor used before he began to get down to specifics on a tissue overlay of a student's photograph.

(Below right) Here, with drawings sketched on a letter already dictated and signed, Hannigan is adding an afterthought that will enable a student to make better use of the negative areas available to him with several different sizes and formats of film.

SUMMARY

1. In seeking formal training in photography, your choice will lie between resident schools (college or non-college based), or home study schools. Seminars, workshops, etc., may offer useful supplemental training.

2. No school or course can guarantee you a job upon completion of training. No reputable school ever implies that they will "place you."

3. There is a great variance in the scope and quality of training available from different schools. It will pay to investigate and compare the courses offered by several schools before you commit yourself to an enrollment. This may take time. A study by the aforementioned Dr. C. William Horrell has pinpointed approximately 100 different fields of specialization in photography, and an additional 40 to 50 categories in which photography is used to some extent.

4. The choice between resident and home study courses involves personal factors that you alone can weigh. Surveys indicate that when measured by "examination performance," the training from good resident and good home study schools is equally effective.

SECTION 2

1. The "Big 4" International Publication Markets

It has been estimated that well over fifteen million different photographs are annually purchased for printed-page reproduction in North America alone. How many additional millions are consumed by the picture-hungry presses of other continents is anybody's guess. With a webwork of satellite communications constantly expanding, we have embarked upon an era when even the daily global demand for photographs defies the imagination.

These are established facts:

1. The welcome mat is out *internationally* for the free-lance photographer whose pictures clearly express a pertinent point of view, evoke a responsive chord in viewers, stir an emotional response, tell a dramatic story, or interpret a product or truth.

2. The photographer who develops the skills needed for producing the kinds of pictures that buyers (and their audiences) want will never face a lack of markets. Instead, his problem will be that of choosing the markets he enjoys most and is best qualified to shoot for.

Practically speaking, the major international markets for free-lance photographs can be divided into five categories, which we will identify as A, B, C, D, and E markets. The first four of these markets (A, B, C, D) have "publication use" as their prime common denominator. An easy way to visualize their relationship to one another in size (and therefore as targets for the free lance) is by means of a pyramid like this:

A
BBB
CCCCC
DDDDDD

Each row of characters represents the relative size of a specific type of picture market:

Row A represents the "big-time" general-interest publications commonly seen on the newsstands. Each important picture-marketing country has leading publications that pay handsome prices for pictures but also attract the stiffest kind of competition.

Row B refers to newspapers, Sunday supplements, and special-interest newsstand publications devoted to gardening, hobbies, mechanics, electronics, do-it-yourself projects, travel, and the like. Segments of these special-interest publications are slanted primarily toward male, female, teen-age, or child readers.

Row C represents trade journals, company house organs, and direct-subscription publications that are not sold on the newsstands.

Row D symbolizes the diversified picture markets that buy thousands of pictures annually for use in advertising, travel brochures, box-top illustrations, greeting cards, calendars, jigsaw puzzles, and a host of other unrelated products ranging from record sleeves to photographic textile designs.

(The *E* or "off-trail" markets are for the most part quite different from the A, B, C, and D markets and will therefore be discussed separately in Section 3.)

The remainder of Part 1 of this Section will be devoted to the A, B, C, and D markets. Please note that for easy reference, paragraphs relating to foreign markets will be preceded by a dot (•) and begin with the italicized word •*Overseas.*

THE A MARKETS: TOUGHEST NUTS TO CRACK

Everyone is familiar with the huge-circulation publications such as *Playboy, Vogue, National Geographic,* etc. For the free-lance photographer, these are the glamour markets—the prestige builders in the big-pay circuit. Professionals and novices alike are attracted by the heady aroma of cash plus prestige.

Realistically, these are fine markets toward which to aspire. But they are poor targets to pin your bread-and-butter hopes on until you are a veteran photographer or have an unexpected windfall of photographic luck. Usually, the price a beginner pays for trying to crack the *A* markets is frustrating, talent-dulling discouragement.

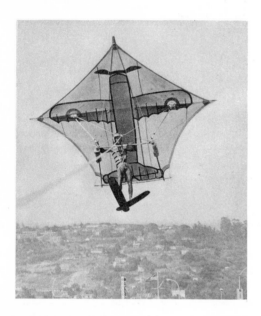

Gary Warren, enrolled in a photography school, is rated among the world's top ten water-ski showmen. One of his acts is to dog-fight with another kiteman; his hobby is to photograph some of the fights with a motorized camera attached to his ski. The weight of the camera gave him a bad dunking recently, so it's now attached to the kite wing. The photo at left below was taken in color as a colleague blasted through 20 gallons of blazing gasoline. *Life* magazine featured some of Warren's fire scenes in a double-page gallery spread. After that, *Stern, Paris Atlantic,* and others picked up the jump shots. The others have all been published several times. The photo opposite left recently appeared as a magazine cover. All photos except the kite shot by Gary Warren.

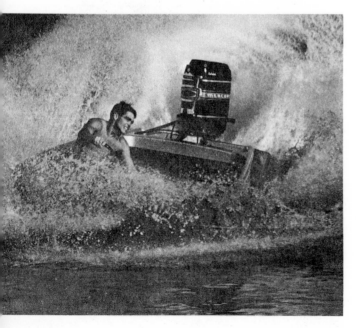

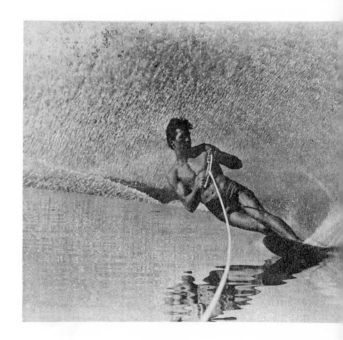

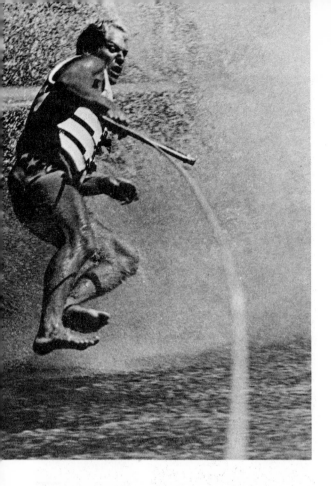

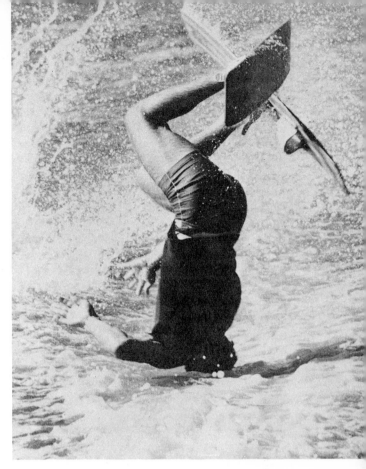

• *Overseas,* the glamour-prestige markets include such publications as *Paris-Match* and *Realites* (France), *She* (England), and *Tempo-Illustrato* (Italy). These, too, are difficult markets for the beginner to crack because they are specialized as well as competitive. For example, in England (and to a lesser degree in several Western European countries) the top-pay markets lean strongly towards feminine interests, i.e., fashions, beauty tips, home decorating, cooking, child care, and so on. Moreover, there is a tendency for a few major publishing houses to control large "stables" of periodicals. At last count, for example, approximately 80 British publications were being produced by fewer than a dozen concerns. For the free-lance photographer, this has both a pro and a con side.

On the pro side, a publisher often has a "clearing house" to which photographs and feature material are sent for distribution to the various editors under the publisher's control. Thus, even though a photographer misses selling his pictures to the magazine he aimed for, they might score a hit with an entirely different publication.

On the con side, the large publishing houses often maintain their own studios and roving staff photographers. This greatly reduces the amount of space available to free-lance offerings. Competing for this space, of course, are the world's top professional photographers, many of whom have the additional advantage of being represented on-the-spot by agents devoted exclusively to the circulation of their photos.

THE B MARKETS: NEWSPAPER AND SPECIAL-INTEREST PUBLICATIONS

No newspaper, large or small, has a photography staff large enough to cover all the important news events taking place, to say nothing of the dramatic "spot" news happenings that can't be foreseen by a picture editor. Metropolitan newspapers annually devour pictures by the ton and

their editors are usually receptive to top-quality free-lance offerings. The news editor, for example, needs pictures of important events that were missed by his staffers. Travel, science, and hobby editors are on the alert for pictures that will illustrate their text themes. The Sunday supplement editor needs eye-catching single pictures, storytelling series of pictures, and well-illustrated feature articles. Each season of the year, every holiday, raises a need for pictures of age-old subjects that have been given a fresh and imaginative twist. Most widely circulated newspapers pay fairly good rates for pictures they can use.

Small daily, weekly, or bi-monthly newspapers rarely pay much (if anything) for publishing rights in a picture, but they can be of immense value to a photographer as a showcase for his work. When in need of pictures, local business concerns, organizations, and individuals tend to call upon a photographer whose by-lined pictures they've seen in print. Moreover, the travel and contacts made while shooting pictures for a local paper often lead to producing picture stories or stock photos for better-paying markets.

Sharing the newsstands with the top-paying magazines are hundreds of sports, adventure, and special-interest publications, many of which pay substantial prices for pictures. Here, too, are a hoard of how-to-do-it publications devoted to electronics, gardening, shop, science, hobby, and recreational subjects of every description.

Generally speaking, the *B* markets offer good targets for the talented beginner. Frequently hard pressed for enough good illustrations to meet their publishing deadlines, many picture editors in this group lean over backwards to encourage new talent. This doesn't mean that they are pushovers for second-rate offerings. It means that an editor will often take time to counsel a photographer who shows a willingness to work and learn.

• *Overseas*, in addition to Sunday supplement (magazine section) material, newspapers tend to buy two types of picture from free lances. One is the news shot of international interest that the wire services or their own staffers failed to cover. The other type is the general-interest picture that has no immediate news value but is universal in its appeal. Favorites among the

JACK WAS HERE was the headline of a double-page spread of nine photos featured in the *St. Paul Pioneer Press.* A short block of text by Jeri Engh set the theme for the approach of winter. Jeri is the writer of a husband-wife team. The four photographs shown here were taken by husband Rohn Engh.

latter are pictures of young animals, seasonal material, and photographs involving children, pretty girls, or dramatic human situations.

Humor is at a premium in magazines as well as newspapers. The question of what constitutes acceptable taste, however, varies from one country to the next. Take, for example, a series of comic pictures of bassets produced by a California photographer. Her photos of bassets wearing hats, wigs, costumes, and props of all kinds appeared in *Life*, on greeting cards, in calendars, and in dozens of magazines and newspapers throughout North America. Americans enjoy the satire of a basset worrying over whether her outlandish hat is truly a Dior original. The French laugh equally hard over a cleverly captioned picture of a basset wearing a chef's hat. But given a costume of any sort, the same picture is often dead the instant it touches British soil.

It isn't that the English lack a sense of humor. The average Englishman can get a stitch in his side laughing over a basset in a funny situation, or over one whose expression reminds him of his in-law. But the humor must emanate from the animal and a seemingly happenstance situation, *not* from something that has been done to the animal such as dressing him up and forcing him to pose. The veneration with which the British masses regard the dignity of their pets is well known to picture buyers. Any published picture that could be interpreted as an affront to an animal's dignity will draw an avalanche of reader protests and subscription cancellations.

Overseas buyers often complain that American photographers include too much background in pictures of pretty girls and children. The demand for pictures of this type in which the subject's clothing, hairdo, automobiles, or buildings label them "American" is limited. In pin-up pictures, a plain, seamless background is your best bet for indoor pictures. Pictures with a homelike background (living room, patio, show-er, and the like) are difficult to sell as a general rule. Nudes or "figure studies" for many overseas magazines, calendars, and the like tend to be either artificially arty and devoid of personality or, at the other extreme, are in deliberately questionable taste.

Special-interest publications overseas run the gamut of sports and hobbies much the same as North American publications. In England alone there are approximately 2,000 magazines, most of which belong in this category rather than in the glamour price bracket described under *A*.

The do-it-yourself fervor is still popular on the Continent. Because of the high cost of labor and materials, people build everything from knick-knacks and furniture to greenhouses. Large weekly and monthly publications cater to these interests and their editors will pay well for original material that is presented effectively.

A word of caution should be given, however, in connection with do-it-yourself pictures for overseas publications: Be certain that the materials and/or parts required in the project are locally available. If electrical wiring is involved, remember that voltages, plugs, and outlet receptacles differ in Europe. Don't take it for granted that the veneer plywood or metal trimming you can buy here will be equally available in Scotland or Holland. If in doubt, check the advertisements in the publications to which you intend to submit pictures. If still in doubt, query the editor. Make certain, too, that the techniques you illustrate are correct and *fully* explained in your captions or supporting text material.

"Waste making" and "built-in obsolescence" are thoroughly international. For this reason, editors of do-it-yourself publications are partial to filler items consisting of one or two photographs with captions that thoroughly explain the conversion of a discarded item to a new and useful role. The simple art of bending old 78 r.p.m. records into flowerpots is an example (though 78's may be hard to come by).

THE C MARKETS: NON-NEWSSTAND TRADE PUBLICATIONS AND HOUSE ORGANS

Newsstands actually carry only a minority of the thousands of publications printed today. Among the true majority are dealer, trade, and professional publications sold by subscription only. Your photo dealer knows about one group. The engineer next door is familiar with a different

group. Your grocer, druggist, family doctor, or the man who services your car or TV set receives (or knows about) the trade journals and specialized publications devoted to his field.

These publications offer wide-open markets in which photo editors welcome pictures of interest and importance to their readers. The photographer on a speaking acquaintance with several trades or industries has an advantage over most competitors, particularly if he can provide factual text with his captioned pictures. Neither the text nor the captions need be polished prose. Given all the facts to work with, the editor can assign a rewrite man to hone the copy. Most trade-journal editors pay extra for text in hopes of developing a new and reliable source of future materials.

For all its size, the trade-journal picture market is dwarfed by the house-organ or company-magazine picture market, which is literally enormous.

Originally, a house organ was a minor publication devoted to shop talk and items of interest to a company's employees. Distributed only within the company itself, this type of publication came to be known as an internal house organ. In time, companies began to experiment with news items that would interest stockholders, customers, and outsiders, as well as company employees. The idea paid off in terms of public-relations benefits, and although thousands of house organs are still being printed solely for intra-company distribution, the dual purpose internal-external house organs are growing in popularity.

It is estimated that approximately 10,000 to 15,000 house organs in North America print about 225,000 different photographs each week. Some of the house organs sponsored by major companies average between 50 and 100 photos each issue.

The house organ field has provided full-time work for a number of photographers who provide pictures and text based upon a thorough knowledge of the products or services involved. An even greater number of free-lance photographers work both the trade-journal and house-organ markets, covering each subject from a variety of approaches in order to realize multiple sales (without conflict of interests) from a single shooting session.

• *Overseas,* virtually every trade and industry in each major country has its own official journal. An estimated 10,000 to 12,000 different trade journals are published in Britain and the Common Market countries each month. In essence, these publications share much in common with their counterparts in North America.

An estimated 30,000 to 50,000 non-newsstand trade magazines and house organs buy photographs believed to number well over 750,000 each month. Their rates of payment vary from poor to excellent, depending upon the company involved.

(Far left) Black-and-white from a full-color, large-size transparency produced for a leading company by Herb and Dorothy McLaughlin.

(Left) A typical industrial photograph of a foundry worker in a shipyard. Photo by Jack Urwiller.

It doesn't necessarily follow, however, that the editors of foreign trade journals will be interested in the same subject matter that finds a ready sale in the States. Pictures having a great deal of *local* trade appeal (personality profiles, district area conventions, and so on) are usually meaningless to the person who works in the same trade 3,000 miles away.

The following are among the best bets in subject matter directed toward European markets in the trade-journal field:

1. Pictures showing the utilization (in North America) of products manufactured in Europe.

2. Pictures of projects undertaken by European companies in the Western Hemisphere, particularly those showing European products being put to use in the projects.

3. New applications of time-tested products.

4. New installations and new experimental methods of production.

Pictures submitted to trade journals in Europe should have *longer and more detailed captions,* as a rule, than you might attach to similar pictures intended for North American journals. Special care should be taken in the spelling of names, companies, geographical locations, and products used. Avoid abbreviations that might confuse an overseas reader. Additional information supplied as supplementary text should provide interesting facts, brief anecdotes, and other grist, which the editor can weave into his article.

The house-organ picture markets in Europe are, at this point, fewer in number and less well defined than they are in the States. As a market for American free-lance photographers, they offer very few opportunities.

THE D MARKETS: ADVERTISING, CALENDARS, GREETING CARDS, BOX TOPS

Advertising pictures can bring big money, even though it is frequently a difficult market in which to get a foothold. Luck is sometimes a factor. For example, a young New York photographer inwardly had little hope of making a sale when he showed an advertising executive a selection of 35mm color transparencies that other agencies had already rejected. To his surprise, the executive bought a color slide that was later reproduced for one of his clients in black and white. The check they sent the photographer was for $2,500.

There, in a nutshell, is one of the reasons why so many free-lance photographers aspire to produce advertising pictures: money. A picture used as an ad in magazines, newspapers, car cards, brochures, or on billboards usually brings the photographer many times the amount he would normally receive on a single sale of the same picture used editorially. It is not uncommon for a single advertising picture to reward the photographer with a four-figure price. Many have sold for five figures.

Some free-lance photographers sell pictures directly to companies that sponsor large advertising campaigns. These pictures go into the company's files and are drawn upon for use in their booklets, direct mail pieces, and other

types of "collateral." Manufacturers of automobiles, agricultural implements, photographic products, and food specialties (baby food and pet food, for example) often maintain their own stock files of pictures. Travel lines (air, ship, train, bus) also accumulate their own files in many instances. A common practice is to pay a flat fee for full rights to the use of a photograph. If used in a booklet, or supplied free to a publisher for public-relations purposes, the original fee is usually all the photographer will receive. If used in an ad of importance, however, some companies pay the photographer a bonus on the file shot.

For each picture sold directly to a company for advertising use, hundreds are purchased by the agencies that handle a large company's advertising and public-relations accounts. In other words, many companies rely entirely upon their ad and public-relations agencies to dig up the pictures needed for various projects.

As a rule, it isn't easy for a free-lance photographer to sell to an advertising agency until he has acquired considerable experience in selling to less specialized (and lower paying) markets. Even the photographer with an established reputation in another field (editorial, for example) may find it hard to break into the advertising field on a profitable basis. Frequently, the difficulty stems from being unable to place his pictures on the desks of the proper agency people at the proper time.

Generally speaking, the picture-buying policies of advertising agencies are more loosely organized than are those of publishing concerns. Ad agencies, moreover, vary so much in size, personnel, client budgets, and policies that there is no well-defined port of entry for the free lance. Large agencies sometimes have a department headed by an Art Buyer or chief Art Director. This title may or may not mean that the person so titled actually *buys* photos. His main job may be to screen photographic offerings and filter the most promising talent to individual art directors and account representatives who handle the campaigns of various clients.

In a small agency, a single art director and an account team may be in charge of work produced for a whole stable of clients. Sometimes a telephone call to an agency will suffice to arrange for an interview in which the photographer can show a portfolio of his best work. A better approach, usually, is to find out which agency handles the account of a company you feel you could please, then to accumulate a portfolio of the type of pictures the company uses, and finally, to arrange for an appointment with the art director in charge of the company's account.

Note that we have not suggested you contact the company's advertising department to put you in touch with their advertising-agency people. Although the agency representatives will definitely see you if told to do so by their client, there's a chance they may be wearing painted smiles. You'll be flirting with a situation that tends to end on a note of "Don't call us—we'll call you." If and when this happens, don't hold your breath for the phone call.

Many photographers feel they haven't the time to cut through red tape that may never lead to a good ad-agency contact. Therefore, for a fee —usually a percentage of what is received for a picture sale or assignment—the photographer hires a photo agency or personal representative to do the legwork and selling for him. (This is explained in greater detail in Section 7.) Sometimes a photographer-agent combination pays off handsomely; sometimes it doesn't. Much depends upon the talent and effort each brings to his respective job, *plus* the current buying trends among ad-agency representatives and their clients.

2. A Closer Look At Specialized Publication Markets

The calendar, greeting card, and related industries' use of photography combine to present a huge international market for photographs. Yet there are so few free-lance photographers who produce suitable material that manufacturers and their photo agencies pursue a never-ending hunt for fresh, new talent.

Since this is a good money market, why do so few free-lance photographers make the grade? "It isn't that they are incompetent with a camera," explains one buyer for a leading greeting-card manufacturer. "It's simply the average free lance's lethargy when it comes to studying *our* needs. Rather than analyze our interests, he submits 'maybe' stuff in hopes of a windfall. At least 95 per cent of the unsolicited material we receive has photographic merit, but it's simply not up our alley."

The person who analyzes the calendar and greeting-card markets will soon begin to notice related markets of interest—record-sleeve manufacturers, photographic carton (box) tops, pastry tins, and in some cases the reproduction of photographs on wall paper, wrapping paper, plastics, ceramics, wood, treated metal, and glass.

The greeting card and calendar markets on both sides of the Atlantic make use of both black-and-white and color pictures by the thousands. In color, the greatest demand is for transparencies from 35mm size up. Larger transparencies are easier to sell; hence, those who concentrate upon these markets usually prefer 4″ × 5″ cameras. A few photographers have experimented successfully with 5″ × 7″ and 8″ × 10″ transparencies, but they know the ropes thoroughly. Very few picture buyers, incidentally, will consider color *prints.*

The greeting-card markets in North America are still dominated by paintings, drawings, and cartoons, but there is a rapidly growing consumer interest in various types of photographic subjects. Seasonal (mainly Christmas) motifs and scenes are in steady demand, as are floral arrangements of all types. Rural landscapes, marines, sunsets, animals, children and pets, and mountain vistas are in limited demand. Humorous shots of pets and babies, as well as simply "cute" shots of kittens and puppies, appear to be growing in popularity.

With a few exceptions, greeting-card manufacturers choose pictures that can be reproduced to their card-line sizes in *vertical format.* Study the photographic greeting cards on display in various stores. Note how they differ in size and subject matter. Bear in mind that if you photograph recognizable people, pets, or personal property, you must be able to provide the buyer with a properly signed model release.

• *Overseas,* photographic greeting cards are far more numerous and varied in subject matter. A stateside exhibit of the various uses of color photography in Europe was compiled by the author with the assistance of Barnaby's Picture Library of London. Wherever shown, audiences were impressed with both the quality of the reproductions and the variety of uses to which photographs were put.

Samuel A.C. Todd, Ltd., of Glasgow, for example, specializes in Christmas card designs, about one-quarter of which are photographic color reproductions. Subject matter ranges from autumn and winter landscapes through floral arrangements and tabletops to children costumed for Nativity scenes.

Nor are Christmas and Easter cards the only subjects that welcome photographic rendition overseas. Only birthday cards appeared in our display of Raphael Tuck & Sons, Ltd. (London). Approximately 30 per cent of the company's entire line of greeting cards were reproduced from color transparencies. A larger display, from Valentine & Sons, Ltd. (Dundee), contained photographic reproductions appropriate for general birthday greetings and specific greetings to "Dear Son," "Our Son," "Your Birthday," "Congratulations on your 21st Birthday," "To My Dear Husband," "Your Engagement,"

"Your Wedding Anniversary," "Just Married," "To Father," "To Dad," "Twenty One Today," "Silver Wedding Day," "Your Wedding Day," "To Brother," and so on. If you get the impression that greeting cards in England (and many other European countries as well) are a big business, you are right; far bigger from the standpoint of photographic reproductions than in the States.

A word of caution, however: See actual samples of each company's subject matter and reproduction quality *before* you submit material. Furthermore, under no circumstances consider overseas markets a dumping ground for your culls and seconds. They are as demanding, or more so, than North American card markets. Their competition is tougher.

The playing-card and party-novelty markets for color photography are about the same on both sides of the Atlantic. Subject matter ranges from nostalgic and picturesque scenics for the adult markets, to animals, pets, and games for children's playing cards. In the novelty markets, glamour, cheesecake, and "art" subjects predominate. Prices paid for the latter are seldom very high.

The jigsaw markets, like the markets for photographic stationery and note paper, are often overlooked by North American photographers. A number of manufacturers, however, are marketing these products, and there appears to be a trend toward making even greater use of color photographs.

• *Overseas,* both the jigsaw and stationery markets are quite well developed. For example, one of Europe's largest producers of jigsaw puzzles uses color photographs for about 75 per cent of their new designs each year. Some of their jigsaw puzzles range up to 20″ × 30″ in size. Another prominent jigsaw manufacturer (John Waddington, Ltd., of London) produces approximately 60 new jigsaw designs each year, 80 percent of which are from photographic originals. No accurate figures on the British-Continental sales of jigsaw puzzles are available, but they are estimated to total between seven and ten million puzzles a year.

Box-top (carton) covers produced in North America are fewer in number and, with a few exceptions, inferior in quality to overseas products. Many American candy and bakery products are packaged in cardboard cartons that have color photographs on the lids that were printed in Europe. Many of the photographic tins in which candy, cookies, and fruit are marketed in the States are also of European manufacture. With a few exceptions, this also holds true for metal serving trays, hot-dish pads, and various souvenir items bearing photographic images.

• *Overseas,* the commercial printing of magnificent color photographs on cardboard, ceramics, metal, and so on is indeed a big business. For example, Cadbury Brothers, Ltd. (London) produces about 100 new box-top designs each year for their Christmas and Easter programs alone. About 40 per cent of their designs are purchased from free-lance photographers. In addition, they produce a large number of floral designs in their own studio. In England, moreover, other producers of box tops such as Needler's Ltd. (Hull) and Metal Box Company, Ltd. (Mansfield), introduce hundreds of new designs annually, a large number of which are reproductions of color photographs purchased from free lances.

In metal trays, box tops, and items of other materials (glass, wood, paper, ceramics, plastics, textiles, and so on), the subjects selected for reproduction run the gamut from color transparencies of flowers and scenics to babies, pets, and sports. Many large chocolate manufacturers such as J.S. Fry & Sons, Ltd. (Bristol) publish annual catalogs of their box-top lines each year. A study of any of these full color, beautifully printed catalogs will tell a photographer more about a company's needs at a glance than would a volume of descriptive text.

The calendar markets for black-and-white and color photographs are much the same in tastes on both sides of the Atlantic. Simple composition and large masses of color tend to produce the most saleable calendar photos because they "read well" from a distance and draw attention to a sponsor's name or product. For the most part, calendar manufacturers choose pictures composed in a horizontal format.

Bear in mind that there are many ways in which a good calendar picture can actually lead the viewer's eye towards the printed copy. The

leading line of the famous "S" curve, for example, can be used in a garden path or winding country road. The downward lines of a waterfall or cascade can do the same trick. Even the eyes of a baby, pet, or adult can be effective when they seem to be directed toward the copy.

TIPS ON SPECIALIZED SUBJECT MATTER

Generally speaking, there are four broad categories of subject matter widely used on calendars and, in some instances, on greeting cards and box tops:

1. *Flowers, floral arrangements, and scenics.* If humans appear in pictures of this type, they should be secondary to the main subject.

2. *Human-interest pictures.* They may be slanted toward specific rural, industrial, and trade markets, or may be general human-interest pictures of babies, mothers and babies, situations involving children, and children and pets. Specialized markets exist for glamour pictures and nudes.

3. *Pets* (especially dogs). Cute or humorous subjects are the best. Kittens and cats rank second in popularity; ponies, horses, tropical fish, ducks, geese, and similar subjects are occasionally used.

4. *Sports pictures.* They may include cars, hunting, fishing, camping, sailing, and outdoor recreational activities.

One final tip on taking calendar pictures. It isn't enough to snap just a pretty picture. The subject you choose must convey an idea, call attention to a fact, draw a graphic analogy, invite pleasant reminiscences, amuse, or suggest an escape from humdrum reality.

Photo by Gary Warren.

Photo by Jack Urwiller.

Appealing shots of children and pets, pretty girls, nature subjects, and action sports—such as the four pictures shown here and the two that appear on the following page —are in global demand. Their uses run the gamut from magazines and annual reports to calendars, greeting cards, and posters. The simpler and more understandable the photograph, the better its chances for repeat sales to different types of buyers.

Photo by Rohn Engh.

Photo by Peter Gowland.

• *Overseas*, the calendar market for free-lance photographs is enormous. Instead of being largely a "give-away" item (as in the States), a calendar is largely a "sell" item. Stores are seasonally loaded with literally hundreds upon hundreds of calendars of every size and description, each carrying different price tags. Some have only one color picture on the cover, but contain dozens of black-and-white pictures inside. Others may have up to a dozen or more color pictures, as well as a different black-and-white photograph for each three-day period of the year.

Subject matter for calendars overseas is far more diversified than in the United States. In addition to the usual run of flower, scenic, baby, pet, and sport subjects, there are calendars specifically designed for use in a child's room—or to satisfy every kind of hobbyist from the butterfly collector to the bird-watcher and vintage-car buff. Typical of the British-Continental calendar publishers who make use of photography is Thomas Forman & Sons, Ltd. (Nottingham). Of approximately 140 different calendar designs produced by this company each year, about 120 will be oriented around photographs.

LOCATING THE A, B, C, AND D MARKETS

A great number of these markets are listed in the guides at the back of this book. Check them, bearing two things in mind:

1. Markets change constantly. New markets appear, old markets vanish, and existing markets change policies. Although carefully revised, the market listings in this book are intended as *general* guideposts, nothing more. Some will invariably have undergone changes between the time this material was gathered and the time it comes off the press.

2. Some picture buyers are unintentionally ambiguous in the way they describe their needs and requirements. Rather than submit pictures on the basis of a brief market listing, you would do well, whenever possible, to check samples of a buyer's publications. Better yet, make a personal analysis of them as described in Section 4.

For a variety of reasons, many greeting-card, calendar, box-top, and other buyers for specialized markets are not listed anywhere. In Europe, especially, those buyers who do not employ staff photographers tend to seek free-lance material from contributors they have developed or from photo agencies. If you choose to bypass a photo agency or personal representative, your best markets in the specialized fields are likely to be the ones you track down by yourself.

Photo by Rohn Engh.

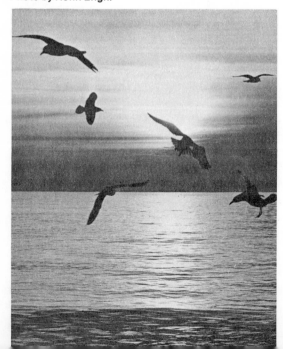

Photo by Gottlieb Hampfler.

SECTION 3

1. Local and Community E Markets

The *E* or off-trail photo markets include diversified subject matter ranging all the way from farm crops to funerary art. It is often a local market that a free-lance photographer has created for himself. For example, many of today's top professional photographers got their start by shooting pictures first as a hobby, then for extra cash. Doris Pinney, the well-known child photographer, began with snapshots of her son, then began taking pictures of other babies she saw in the park, and finally concentrated upon advertising photography. Joe Clark snapped pictures of his Tennessee kinfolk, was astonished when people offered to pay for his snapshots, and is now known internationally as the "Hillbilly Snapshooter."

Amateurs who sell occasional hobby or home-improvement pictures to their neighbors are probing the off-trail markets, as is the European factory worker who sells pictures of his countrymen at work. A university student who earned $900 selling his classmates pictures of their school activities was beginning to mine the off-trail market. Later he began to cover campus and varsity activities for the local newspapers. This laid the foundation for his becoming a full-time photojournalist.

It is a pleasant characteristic of the off-trail markets that one idea invariably leads to another. For example, a Philadelphia free-lance photographer approached a professional golf instructor with an offer to take a series of free pictures. As he hoped, the expert was so pleased with the way the photos documented the finesse of his swings, that he ordered duplicates for his advertising folders and personal portfolio. This gave the free lance another idea. As a result, the instructor now makes each client a "gift" of a complete photographic record of his or her progress, including enlargements of their "beginning" and "graduation" shots. The pictures, which the golf-pro now pays for, constitute blue-chip advertising. And since graduates usually want extra prints, the photographer makes a substantial profit on reprints.

E MARKETS OFFER EARNING POWER

Off-trail markets constitute the least competitive free-lance photo markets in existence. Hobbyists of all types are prospects for an alert free lance. So are craftsmen, contractors, athletes, amateur thespians, and civic and educational groups. Some free-lance photographers find their most rewarding customers among merchants, small manufacturers, companies that sell special services, real estate agents, land development companies, and recreational or summer resort owners. The common denominator in every off-trail market is a need, or latent desire, for interpretative pictures.

As you've already guessed, off-trail markets are where you find them. In the thumbnail sketches that follow, we have quoted from case histories collected in North America, Britain, and Europe. Their purpose is to trigger your imagination. Try picking out a few ideas that appeal to you. How could they be altered to fit your situation with *earning power* as your goal?

Architects. "I have found that they are often interested in buying 11″ × 14″ prints of buildings they have designed. These are shown to prospective customers, displayed at architectural con-

ventions as examples of current work, and can sometimes be sold to architectural trade journals.''

Army pay supplement. ''Soldier supplements government pay by taking both formal portraits and candid shots of his buddies to be sent to their sweethearts and parents. Offers a package deal for extra sales, i.e., one 8″ × 10″, two 5″ × 7″, and five wallet-size prints from same negative for a flat rate.''

Art student income. ''Student records work of other students at art school during the year. Sells prints to them. If art work shows special ability, he sometimes sells duplicate prints to college magazine and artist journals as samples of current schoolwork.''

Assignments from camera stores. ''Stores frequently receive requests for special photo copying and restoration. Amateurs who enjoy this work can often make an arrangement with management whereby they buy all their supplies from the store in return for job referrals.''

Athletics and sports. ''Athletes are usually proud of their prowess. By frequenting tennis courts, swimming pools, bowling alleys, local games, and sports affairs with a camera, you will find a ready market for prints of the participants in action, especially after your work becomes known.''

Automobile accidents. ''Garage owner keeps camera in cab of truck to use when called to the scene of an automobile crash. A series of shots of the wreckage and site of the accident often pays dividends when purchased by insurance agencies.''

Baby-sitting sideline. ''Teenager being interviewed for babysitting job shows parents a portfolio of candid pictures of children shot on previous jobs. Obtains advance deposit from parents interested in having their children photographed. Shoots title card of parents' names, address, date, for 35mm projector owners. Charges about 6 to 10 times actual cost of materials used for each set of pictures.''

Birthday and Christmas gifts. ''Photographer takes pictures of a child's favorite doll; enlarges, colors, and frames best photo, which is then set in plaster base with a pair of the youngster's shoes mounted in front of the print. Entire mount is given a coat of bronze varnish to simulate metal finish.''

Boats. ''Free lance contacts sales managers of popular boat-exhibit displays and top retail outlets for names of purchasers of new products. Offers to shoot launching, fitting-out, boat warming, shakedown cruise. Makes extra money by keeping in mind house organ of product being used, trade journals, boating and hobby publications.''

Building activities. ''Local town-planning authorities are first to have information of buildings scheduled for demolition and new ones to be erected on site. Before-and-after shots are saleable to building and architectural journals as well as local newspapers. Local museums and historical societies sometimes buy record shots of ancient buildings prior to improvement or demolition.''

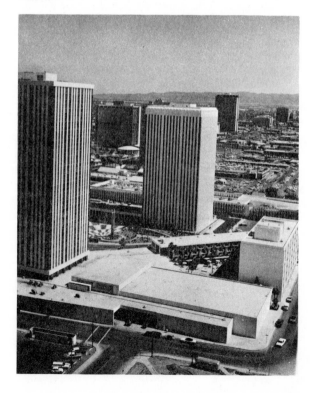

Aerial views of new or changing construction, city skylines, recreational areas, important natural resources, dams, superhighway cloverleafs, ecological situations, and the like can be an important source of revenue. Plan your subject matter with specific buyers in mind, as many as you can think of—from private individuals and corporations to trade and house magazines, to promotional pieces that will fit into your own advertising material. Although a blimp is your best bet for aerials, you'll probably have to settle for helicopters or high-wing monoplanes. The photo on the opposite page is a carrier terminal in Phoenix, Arizona. The photo at right is a busy highway cloverleaf of value to thruway planners and buyers of commercial building sites. The photo below shows the change of terrain that has taken place since the Arizona State University expanded to occupy an area once beautiful for its variety of trees. All photos by Dorothy and Herb McLaughlin.

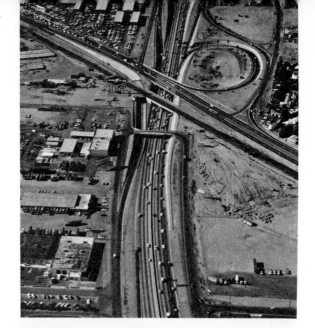

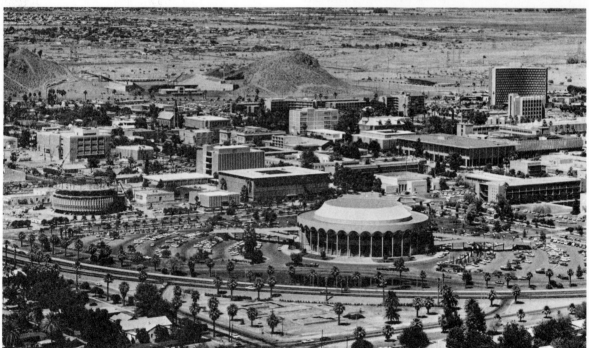

Buildings. "Pictures of gasoline stations, garages, and other small businesses can often be sold to owners. Pictures can be taken during spare time. 8" × 10" prints offered at reasonable prices often lead to further orders when building is remodeled or modernized."

Celebrity coverage. "Get pix of celebrities autographing fan albums for sale to fans themselves. Obtain model release from fan (not needed from celebrity) if submitting to fan magazines."

Children's events. "Children are participating in recitals and plays, parades and dances, in practically every community. Proud parents want pictures of their children in action, both as individuals and part of the group. There are good prospects here for the free lance who will provide customers with his choice of black-and-white or color prints."

Clubs and fraternal organizations. "Social organizations frequently need a photographer to

cover special functions, make portraits of officers, and document community service projects. Prepare portfolio of work to show president or publicity chairman of organization when soliciting jobs."

Construction work. "Free lance shoots buildings at various stages of completion. Shows sequence shots to owner and contractor. Sells to owner for company file, to builder for advertising and publicity."

Convention speakers. "Free lance obtains permission to shoot speakers at conventions. Sends sample contact prints by mail, along with order prices. Many will buy for personal albums, and for possible publicity or newspaper use later on. Also sale possibilities to trade publications, house organs."

Creative artists. "Many creative people working in ceramics, wood and stone sculpture, engraving, needlecraft, and so on, are good prospects for a free-lance photographer. They are often willing to pay for a complete photographic portfolio of items they have created, as well as for pictures of themselves at work."

Dance studio customers. "Photographer takes pictures of students during recitals. Sells enlargements to studio for advertising and publicity pictures; sells individual and group shots to members of the class."

Darkroom work. "With a well-equipped photo darkroom, you can develop, print, and enlarge pictures taken by friends and neighbors. Personal attention can result in better prints than commercial labs churn out, and if prices are reasonable, most people are glad to pay for better-quality prints as well as handy, fast service."

Exhibitions and fairs. "These are both naturals for the free lance. Most exhibitions and fairs have a wide variety of exhibits, from animals to zucchini. Animals and colorful displays make fine subjects and the hard-working owners are good prospects, particularly the prize-winners with their ribbons."

Farm crops. "Manufacturers of insecticides and farm fertilizers pay well for comparison shots of treated and untreated farmland and crops. It is important to use landmarks as reference points when doing a series over several months. Farming journals may buy pictures and captions if you include description of technical procedures and costs."

Fashion shows. "Free lance reads papers for news of fashion shows staged by women's organizations. Arranges with president or publicity chairman to take pictures. Organization frequently buys complete set. Individual models are prospects for extra prints."

Fishermen hobbyists. "A seaboard photographer shoots pictures of local and visiting fishermen (especially contest winners) who wish photographic proof of their catches."

Florist publicity. "Photographer contacts florists on regular basis to take color shots of wreaths and bouquets. Florist purchases pictures to record details of arrangements and to show to potential customers."

Funerary photography. "Some photographers specialize in taking photos of the deceased, cemetery architecture, pet cemeteries, and so on. This is a delicate subject, one in which the photographer must exercise great sensitivity and diplomacy. Yet it is a legitimate field that most photographers overlook. While some families may not want funerary pictures of a loved one, others want not only last record shots but also photographs of the banks of flowers, headstone, and marker or mausoleum. It is best to work with a funeral director, the man directly involved with a family during a period when people are in a highly emotional state. He will know if pictures are wanted and can give you guidance in the proper way of handling an assignment."

Gardener-photographer. "Member of local gardening society covers annual flower show early in morning when exhibits are fresh to record the best pieces. Sells prints or slides later to exhibitors—especially prize-winners."

High-school dances. "Prior to a dance, teen-ager announces picture-taking plans in school bulletin. Camera equipment is set up ahead of time and couples are approached as they enter. Business on cash basis: two mounted 8" × 10" prints, $3.95."

Home improvement. "Take pictures showing before and after views. Sell prints to home owners for photo albums and to firms doing work for salesmen's portfolios."

Houses for rent or sale. "A call on real estate offices in vicinity often brings orders for pictures of houses. Glossy 8" × 10" prints showing several angles of house will give agent a selection of views to show prospects."

Livestock. "If you live near a local market for livestock, prints of prize exhibits have a ready market: one to buyer, one to seller, and more to farming journals. Remember to note all names, dates, and facts for captions."

Little-League baseball pix. "Teenager takes pix of Little-League players, takes portraits and action shots during game. Sells prints to players, parents, and team sponsors."

Local flora and fauna. "Free lance researches natural history subjects native to vicinity. Sells prints to educational publications and museum curators for files."

Local industry. "Photographer arranges with local factories to take pix for layout and efficiency studies as well as public-relations use. Close-ups of employees at work find sales to trade and house magazines as well as to employees themselves. Model releases needed for photos submitted to publications."

Local products. "Free lance records products of local factories on display and in use, both in home vicinity and in the field. Sells to manufacturer for publicity."

Match covers. "Ideal personalized gift suggestion. Print portrait of subject on double-weight paper that does not break when folded. Cut off entire flap of match book and staple trimmed picture to stub end of match book. A box of 50 match books with mass-produced prints attached can sell for up to 10 times its cost."

Parades. "Thousands of parades are held each year. All participants—the majorettes, bandsmen, float owners, color guards, ordinary marchers—are a prospect for a picture, as are the members of organized groups. Try for unusual angles, humor, close-ups, and long range shots. Then arrange a display of your work, preferably in cooperation with a merchant who will give you window space. Publicize the display, and take orders."

Pedigree dog and cat breeder. "Breeder takes camera to all dog and cat shows, obtains close-ups of prize animals for sale to owners, calendar and greeting card companies. (Obtains signed model releases from owner for all pet pictures he intends to sell to publishers and advertisers.)"

Pets. "Free lance photographs pets in neighborhood, attends pet shows, and makes portraits of animals. Keeps records of owner's name and address and mails proofs with price list for prints."

School portraits. "Free lance in large town contacts principals of all local schools in area shortly after start of school year. Shots of scholars in classrooms sell to parents."

School stage productions. "High-school and college actors and musicians are excellent picture prospects for candids at work and backstage. Don't overlook possibilities of pictures in series as well. Also keep in mind the possibility of making duplicates for school publications."

Sculpture. "If you have knowledge of sculpture, contact local sculptors. Pictures from several angles are treasured by sculptors and also sell to dealers and art magazines."

Skating rinks. "Skaters love action shots of themselves in costume. Show portfolio to prospective customers at rink and take orders to be delivered at later date."

Store-window displays. "Photographer shoots displays in competitive store windows on regular monthly schedule. Builds up steady customer routes as pictures save store managers the time and trouble of checking the displays and prices of competitors. Also used in stimulating new ideas for effective display, advertising promotions, and sales campaigns."

Trade shows. "Photographer shoots display stands of exhibitors at trade shows. Writes beforehand for pass to enter before the public is admitted. Sells prints to exhibiting firms, trade journals, and house organs."

Used car dealer. "Dealer photographs cars and trucks he has just purchased. An amazing number of tires are switched before the seller makes delivery. Refurbishing with new tires lowers his profit margin. Thus, indirectly, a few pictures can save him money."

A TIP FROM THE PROS: USE NEGATIVE COLOR FILM

Most photographers who specialize in the off-trail markets rarely load their cameras with *color transparency* film. Instead, they choose either medium-speed black-and-white film or *negative color film.* Between the latter, the ultimate choice hinges upon the customer's needs. If the customer wants only black-and-white prints, there is no point in using the more expensive negative color film. If the customer wants only color prints, or a combination of color and black-and-white prints, negative color film is the answer. It's a good idea to remind a customer that if he ever wants color *transparencies* for projection or publication, you can have them made to order from your color negatives.

2. Specialized E Markets

THE KEYS TO DEVELOPING OFF-TRAIL MARKETS

Different types of specialized off-trail markets require different types of equipment, and the photographer's total competence in using that equipment. Moreover, in addition to having the right equipment and necessary skills, there are two *essential traits* that a photographer must develop in order to succeed:

1. He must be able to recognize a specific need for photography, oftentimes before an individual, group, or company is aware of what photography can do for them.

2. He must have the imagination, initiative, diplomacy, and patience that it takes to sell an idea to people who may never have thought of photography as an ideal medium for their use.

It is not within the scope of this book to catalog the various types of off-trail markets in detail. Nor can we put a price tag on your work. In the paragraphs that follow, we will focus attention upon some of the most promising off-trail potentialities. Pricing your work will largely depend upon the "going prices" in your community (see Section 9). By making discreet inquiries, it should be fairly easy to determine what the local traffic will bear in prices.

STEREO COLOR

Although there is no large, established market for stereo color, a number of free-lance photographers are capitalizing on stereo markets they themselves have developed. A Long Island photographer, for example, makes stereo slides of new homes from the time the construction crew begins work until the buyer moves in. At first he sold slides only to contractors interested in showing development companies samples of their workmanship; later the photographer found that real-estate agents and brokers could use stereo slides effectively in attracting new buyers. Finally he discovered that a buyer was a potential customer for stereo slides of the building and completion of his home.

Basically the same idea is being followed by a Los Angeles photographer who loans a stereo viewer to every real estate company that contracts to buy a stereo slide of each of its new property listings.

Most free-lance photographers who produce stereo slides do so as a sideline to their other photographic activities. Salesmen, educational groups, athletic instructors, repairmen, and those in the teaching, selling, or demonstration fields are potential customers *whenever* a three-dimensional picture will tell a more complete story than an ordinary two-dimensional picture in the same situation.

35MM SLIDES FOR DUPLICATE DISTRIBUTION

Many publication editors on both sides of the Atlantic do not accept 35mm color, though more and more of them are tempering former prejudices. Producers of really good slides who are serious about wanting to market their work usually manage to contact buyers on their own initiative.

If the buyer is not a publisher, he may want to duplicate the slide for distribution in camera stores, tourist areas, and so on. In this case, the buyer (not the photographer) takes care of having the slide duplicated and distributed. In most cases, the national distributor of color slides (in 35mm, 126, or 127 sizes as a rule) pays an outright sum for a slide, which then becomes *his property.*

Occasionally a photographer has duplicates of his slides made, which he sells through local outlets, by mail order, or both. There are instances in which these ventures have paid off

handsomely and others in which they have not. The two most important ingredients are subject matter, which must be interesting, and quality, which must be excellent.

• *Overseas*, a little known market for 35mm color slides exists in the shape of museums and art galleries. These institutions frequently buy Western Hemisphere color slides of pertinent interest to their own audiences. For example, the Geological Survey and Museum (London) says: "We would be interested in acquiring fine 35mm color slides of geological and geomorphological subjects of international interest. Pictures of this nature of the Grand Canyon, Niagara Falls, volcanoes, mining operations (metal ores, diamonds, etc.) would be most welcome."

FILM STRIPS

There is a steady, growing demand for film strips in educational, training, promotional, recreational, and selling work.

The 35mm-size film strip is still the most popular in industry and for audio-visual programming in schools, churches, fraternal groups, and business. However, half-frame film strips (color transparencies in a format half the size of a 35mm frame) have gained in popularity. This is particularly true where production costs are an important factor as, for example, amongst religious organizations, in schools, or in companies that produce a great many film strips in connection with safety-training lectures, sales training and public-relations work. The excellent quality of today's color films, together with the fine optical systems of modern projectors, make half-frame film strips a highly satisfactory approach to visual education.

Basically, a film strip is a series of pictures recorded on a continuous roll of film. It is usually in color and accompanied by synchronized sound. In addition to the full 35mm and half-frame ($18 \times 24mm$) sizes, some film strips are produced on 16mm and some even on 8mm film. Whatever size the film strip may be, it is projected frame-by-frame on a tabletop or room screen.

Producing a saleable film strip is by no means beyond the capability of an imaginative free lance. This is not, however, a field he should try to crack without training. Recognizing the markets is one thing; mining them is another. By the time a free lance has acquired the know-how of producing saleable film strips (either by taking special training courses in school or by working in a studio where film strips are made), he will be acquainted with the potential markets and the paths that lead to them.

16MM MOVIES: A GROWING MARKET

There is a continuing growth in the market for 16mm movies, an integral part of audio-visual education and communication. Thousands of 16mm films are already available on a free-loan basis from public libraries, private companies, state and federal bureaus, and social groups too numerous to mention. Millions of feet of 16mm film, moreover, have been shot to satisfy the needs of individuals and/or companies who do not distribute films to outsiders.

A competent movie photographer who has good equipment and who can interpret the needs of his clients will find more leads and prospects than he will know what to do with. The first thing he should decide is the type of pictures he wants to produce. The minor markets will often accept movies with or without sound accompaniment on tapes or discs. Others want their silent films sound-striped for dubbing in magnetic sound on film. Groups planning to distribute their films on a free-loan basis will probably insist upon optical sound. Until he learns the ropes, a beginner should start out by producing short feature films for the less demanding markets.

Minor Markets
People are willing to pay to have their weddings and other important events in their social and family lives filmed. Athletes and athletic instructors often have use for short films that can be

used for improving their form or teamwork. Hobbyists, particularly those who go in for sailboating, car racing, or "luxury" hobbies, are good film prospects. The movie photographer gets his leads the same way a free-lance still photographer gets them—by word of mouth, by advertising, or by watching the social, sports, and hobby columns in daily newspapers and using mail or telephone to contact the persons named. Newspaper leads also result in many filming assignments for lodges, social groups, amateur thespians, conventions, competitions, and similar projects.

Larger Markets

As he gains experience, a free-lance cinematographer will begin to look for assignments that offer more challenge to his skills and more money in his pocket. Here, again, his prospective clients are practically unlimited. For every company now listed in a handbook of free-film distributors, there are hundreds of companies that have not yet produced a film to help introduce *their* products: State and Federal Government bureaus will continue to sponsor films; on a smaller scale, city and county bureaus will also produce films to serve their specific purposes.

Research groups, medical, charitable, religious, educational, and political organizations are good film prospects. So is any industrial concern that sponsors employee-training or sales-training programs. Schools, museums, and some film libraries occasionally purchase shot-to-order films. Equally as important as the kind of films described above, but more specialized in their ultimate use, are court evidence films used by attorneys and insurance companies, and films made primarily for TV use. We'll return to the problems of TV shooting a little later.

The difference between an amateur moviemaker and a successful free-lance cinematographer is comparable with the difference between a box-camera snapshooter and a National Geographic photographer. The technical aspects of producing a professional-quality film are many and complex. Some of the more important things you should take into consideration before deciding whether or not you want to produce professional-type movies to sell are described below.

16MM FILMS: THE WORK INVOLVED

To actually record sound on film at the time a scene is being shot requires a great deal of special equipment and is as difficult as it is expensive. Rather than attempt it, most free-lance photographers simply shoot silent pictures at the speed of 24 frames-per-second. They record sound on-the-spot, or later, with tape recorders. On-the-spot sound may only be used for storing up handy reference material (names, addresses, and a description of what is taking place) or incidental background sound. This reference material is later used by the photographer, or by professional writers and sound men, in preparing the polished narration and sound effects to be dubbed into the film.

If a photographer has the time, facilities, and necessary skills, he may be able to shoot, edit, and add sound to a short film without calling upon outside aid. It's an awesome job, however, and on an important film most photographers rely heavily upon the trained technicians in a film servicing lab. If necessary, or desirable, the lab will take care of everything from editing the work print to making duplicates of the final release print. Special effects (fades, wipes, dissolves, and so on) will be added where they are needed; titles will be shot to order; color correction work will be performed if requested; sound will be added. Naturally all this *does* cost money.

Before you contemplate producing a film for one of the more important markets you should first familiarize yourself with what a professional film servicing lab can do for you and know what it will cost. Most labs have booklets available that describe their services. You'll find these labs listed in the classified sections of the metropolitan telephone directories. Your photo dealer can help you locate them in trade publications such as *Photo Dealer Directory* or *Photo Trade News Directory* (see Section 10).

The Kind of Film to Use

There are several different kinds of both black-and-white and color films to choose from. Your choice will depend upon several factors such as the type of client you are shooting for, the time element (whether it is a one-shot opportunity or a situation that will allow re-takes of spoiled footage), and the number of duplicate prints (if any) that will be needed. For example, reversal films produce positive, projection-ready images on the same film that was exposed in the camera. If you are filming a wedding, a local Chamber of Commerce event, or a documentary on safety practices for a local factory, reversal-type film will probably be your best choice economically. If you know in advance that your client will want a duplicate or two of a color movie shot on reversal type film, you may find it helpful to underexpose your original film by about 1/4 stop. Duplicate prints tend to be lighter in color than original prints, hence slight underexposure of an original print will produce more normal looking colors in the duplicate.

TV FILMS: SPOT COMMERCIALS

Every TV station in the country has facilities for televising 16mm film shot at 24 frames-per-second. This makes many small business firms first-rate prospects for the photographer who can produce good spot commercials.

Be prepared to show samples of your work when you call upon a prospect. Take along a projector and a reel of film that contains a *few* samples of the commercials you have done on other assignments, even if you weren't paid for these assignments. Don't haggle over the price; know ahead of time what your price is going to be. If you snare an assignment, set a deadline for delivering the finished film and *deliver* it, even if it costs you three times what you'll receive for it. Good work, fair prices, and a reputation for meeting your delivery date are your three strongest selling points in this game.

DON'T OVERLOOK PRIZE CONTESTS AND EXHIBITS
Dozens of contests for cash and valuable prizes are held every year. Some are international; all are worth your careful attention. Prize-winning photographs are almost always widely published and/or put on exhibition tour. Your credit line on a prize-winner is excellent publicity. This photograph by Harriet Hedgecoth first won $500 in a magazine cover contest. Thereafter it was reprinted and credited in a number of other magazines and newspapers. Placed with traveling exhibits, it drew the attention of several buyers. This, in turn, led to the purchasing of a wide variety of Mrs. Hedgecoth's vivacious photographs.

TV SPOT-NEWS COVERAGE

TV spot-news coverage is another specialized market that is expanding along with the nation's spreading network of TV stations. News stories choose their own time and place to break. Since it is impossible for TV staff photographers to be located in every section of the country, the 16mm cameraman who happens to be in the right place at the right time has a golden opportunity to cash in.

If you are photographing a potential news story for the first time, these are the things to bear in mind: Use *negative* stock in your camera and shoot at 24 frames-per-second. Get lots of variety in your shots—establish the over-all scene with a medium or long shot; cut in close for details; get close-ups of faces; switch from action shots to the reactions on the faces of spectators. In short, get a complete story down to accurate notes of the time, place, circum-stances, names, addresses, and anything else that will help the script writers prepare a sound commentary for the film.

Don't worry about processing or editing your film: Whoever buys it will take care of that. Concentrate upon getting in touch with a local TV station or newsreel service by telephone. Explain what news event you recorded, how much good footage you think you have, the type of film you used, and so on. Give them your name and address, but try to get a decision immediately so you can offer the film elsewhere if necessary. Rather than risk having a competi-tor get ahead of them, the people you contact first are likely to accept the film with the under-standing that it will be paid for at their regular rates only if it is usable. That's fair enough. Accept it.

HOW MUCH DO THEY PAY?

The rates of payment for movie film vary just as picture rates vary among magazines. A fairly standard rate of payment for a short silent film made to order for, say, an industrial concern, seems to average out about $1 to $1.25 per foot, plus expenses. For shooting a usable TV news story, a free-lance photographer can expect to receive something like $50 to $75, plus expenses, for his work. Let me repeat, *these rates vary* according to the importance and the quality of the film produced, the purchaser, and the status of the cameraman who produced it. At the start, a movie photographer is in no better a bargaining position than a still photographer who has yet to prove his mettle. This should not be of much concern to either type of photographer for a while. By the time a still man has sold a dozen picture stories and his movie-minded colleague has disposed of several films or newsreels, both know which side of their bread carries the financial butter.

SUPER 8MM MOVIES: THE MARKET

When the U.S. table tennis team went to China in 1971, the first Americans to visit there for nearly two decades, the first film of the visit was televised to millions on an ABC network sports program. The 8mm movie, taken by a senior official of the American team, was of high quality, in fact as good as many 16mm films. This was still another indication of the market that is now opening up for high quality 8mm movies.

Until recently there had been virtually no market for 8mm films except for family-type records of weddings, reunions, graduations, and other special shot-to-order assignments. The reels of 8mm movies one saw in a retail store were mostly copies of 16mm movies that had been mechanically reduced in size for 8mm projectors.

New developments in 8mm products are creating a brand new field of audio-visual oppor-tunities for free-lance photographers. Among the reasons for this are, first, the vast improvements made in 8mm cameras and sound projectors,

second, greatly improved 8mm color film, and third, the new format of Super 8mm films.

Although the optimum results in sound and color obtainable with certain combinations of 8mm cameras and projectors are in many ways comparable with 16mm results, it appears unlikely that 8mm sound films will ever totally replace 16mm productions. Instead, 8mm films will probably evolve a niche of their own in the audio-visual field and supplement rather than replace 16mm films.

The advantages 8mm has to offer are easily summarized: (1) lighter, less expensive equipment; (2) less bulk to contend with in transporting and storing both equipment and finished reels of film; (3) lower costs in producing and duplicating films.

At the present time, by using sound-in-camera equipment, it is possible to produce an 8mm color-sound film at a fraction of the cost of a 16mm production. It is the low cost factor that is attracting business and industry to the possibilities of using 8mm films for in-company purposes, such as sales training, safety programs, and documentary reports.

In time, mass sales of 8mm equipment may establish a lucrative free-lance market for original 8mm productions designed for school, church, civic, business, and home use. Meanwhile, most of the *major filming efforts* are still being produced with 16mm film as the minimum size. Reduction release prints in 8mm are made in the processing lab.

Where, then, does an 8mm market exist for the competent free-lance photographer? Like gold, it exists where you find it. It exists in the shot-to-order movies for individuals and organizations. These are, in a sense, "surface finds." Below the surface lie prospects among small manufacturers, co-op organizations (particularly farming and buying-marketing groups), person-nel-training offices, sales-training groups in small industries, and so on.

This is truly an uncharted sea. If it intrigues you, give it long, careful study before you set sail upon it. What will it cost you to produce a five- or ten-minute 8mm color-sound film? How much depreciation should be taken into account for your equipment? How much film, including spoilage, will be required? How much for processing, titling, the use of "canned" sound? How much for traveling and incidental expenses? The "little" expenses are the ones that build up like storm waves. Put down every expense you can think of, weigh it, and add to it the "profit" you expect to make on your time, equipment, and talent.

The end result is going to surprise you, especially if this is your first "movies-for-profit" venture. If you underestimate your costs, it will mean no profit whatsoever or even a loss. If you set the costs and profit too high, you will scare off the customer. What, then, is the happy medium? The market is too new and the costs are too variable at this point for a rule-of-thumb price scale to apply. The few free-lance photog-

"Double Trouble" was one of two photographs by Jack Lane for display and publicity in the 80th Annual Exhibition of Professional Photography, the world's largest and most comprehensive print show. Sponsored by the Professional Photographers of America (PP of A), the competition drew over 4,000 entries from its 13,500 professional members.

Eight youngsters, in silhouette, scrambling up a chain wire fence finally (after seven previous tries) won Gilbert Witten a first prize in the Kodak International Newspaper Snapshots Awards contest. The prize: a one-month trip for two people in 14 cities throughout the world, plus $1,000 in spending money.

While still attending a photography school, Ken Beckles was assigned to shoot a poster picture that would personify the dignity of young black people. He took several rolls of 35mm color and entered one photograph (a reject) in a *Life* magazine contest. This photograph won him $5,000 as the first prize in the portraiture category. Since then it has been widely exhibited and published with his credit line.

raphers in this field whose case histories have come to my attention have experimented with cost-plus scales with varying degrees of success. Most of the companies for whom they produced films were willing to go along with a contract that covered all the photographer's costs (itemized, of course) *plus* an additional percentage of profit based upon the total of those costs.

In some cases, the percentage of profit the photographers were to receive became the chief cause of argument. One company insisted it should be no greater than 25 per cent over and above the total of the itemized costs. Another company agreed to a 35 per cent profit; in an exceptional case, the photographer was allowed nearly 50 per cent profit based upon total costs.

There you have a glimpse of the 8mm color-sound movie market. It is promising, intriguing, but largely unexplored and in a state of flux. If you have the equipment, a liking for new fields, and the know-how to turn out a useful movie, this may be the opportunity you are looking for.

MARKET FOR COLOR PRINTS

Tremendous strides in the processing of color prints in the past few years have opened new markets for the photographer. It is now economically feasible to do color processing in your own darkroom; moreover, new methods and procedures have dropped the cost of color prints, thus expanding the market.

As you will note throughout this book, improvements in color-negative films such as Kodacolor, plus improvements in color print materials such as Kodak Ektacolor Paper, have slowly effected a breakthrough.

At the moment, these improved materials are of special interest to newspaper and industrial photographers. Over 900 newspapers in the United States and Canada are now using ROP (run of paper) color in both their editorial and advertising content. Color-negative film is designed for use outdoors or with flash. A single color nega-tive can be used to produce: (1) separation negatives for ROP color reproduction; (2) high-quality black-and-white prints (on Kodak Pana-lure or similar emulsions); (3) color transparencies for use in rotogravure, projection, backlighted TV or stage screens, window displays, and the like.

The three-way versatility of the film and its complement of printing materials is of special interest to the photographer who shoots a sequence of pictures. Any or all of the pictures can be reproduced in color or black-and-white to suit the needs of the picture buyer.

If you are interested in learning more about the specialized market for pictures taken on negative color materials, study the ROP newspaper, *Standard Rates and Data,* and publications such as *Photo Methods for Industry* and *Industrial Photography.*

COLOR LITHOGRAPHY PRODUCED "TO-ORDER"

Few off-trail markets have more to offer a free lance in variety or potential income than the enormous field of color lithography.

Some photographers specialize in certain areas of the field, such as producing advertising postcards for local motels, hotels, restaurants, nightclubs, marinas, housing developments, and the like. Others branch out into color shot-to-order for use on business cards, personalized Christmas cards, mailers that carry a picture of a product or interpret a service, menu covers, matchbook covers, or booklet covers. Closely related to these are "table tents" (the inverted "V" shaped advertising cards), which picture food and beverage specialties offered by hotels, restaurants, cocktail lounges, nightclubs, vacation spots, and similar prospects.

Calendars, advertising mailing pieces, annual reports, and seasonal "reminder" cards also offer endless selling opportunities for the free-lance photographer. His greatest profit, of course, will be derived from handling the whole job himself (or with assistants). By that, we mean that having sold an idea, he first arranges to obtain any mock-up art work that may be required in order to get the customer's final "go-ahead" in writing. Thereafter, he takes the color shots, arranges for color printing through quality engravers and printers, delivers, and collects.

There are a number of companies, such as Colourpicture Publishers, Inc. (Plastichrome®), Winthrop-Atkins Co., Drewry Photocolor Corp., and others listed in Section II, Parts 6A, 6B, in the marketing section of this book, that specialize in color engraving and/or stock card-and-envelope materials for use with color prints. The person interested in exploring this field would do well to contact some of these companies, not only for additional marketing ideas but also for price listings that will enable him to set a price scale on his work that will yield a profit.

1. How to Analyze Photo Markets

There is a right way and a wrong way to approach the problem of producing saleable photographs. The inexperienced photographer usually snaps pictures haphazardly with the newsstand magazines uppermost in his mind. Not until he has accumulated a stack of miscellaneous photos does he begin to consider specific markets that *might* buy his work. Then, guided mostly by the *names* of various publications, he begins to gather piles of rejection slips.

This procedure is the hallmark of the novice, and the world markets are saturated with his unloved offerings.

THE PROFESSIONAL APPROACH: FIVE STEPS

The professional photographer adopts an entirely different approach. Why look only to newsstand markets when the advertising field is so enticing? And why confine his goals to advertising when less competitive markets in the calendar, greeting-card, box-top, and photo jigsaw-puzzle fields offer potential gold mines? Why stop even with these markets if he has read authoritative statements made by such marketing experts as Mary Buckland, Director of Barnaby's Picture Library of London, who says:

"Having spent an entire career in the marketing field, I have discovered why it has never been boring. The world-wide demand is constantly changing, constantly growing. Where once we thought mainly of selling black-and-white and color photos to editorial, press, and advertising clients, we now sell (color especially) to the manufacturers of tin and cardboard containers, floor coverings, wall decorations, wallpaper, gift wrapping paper, plastic imprinters, and even those who manufacture silk head scarves and textiles. There's literally no end to the uses of photography in the years ahead."

Commenting along similar lines, Arthur Brackman of FPG, a leading New York stock photo agency, said: "More and more photographs are being used in North America as the realism of photography replaces drawings and art work formerly used in ads, display boards, product containers, and souvenirs of all types. Photos are now widely used, for instance, on postage stamps, ceramics, wood, plastics, leather, expensive china, and metal. This is largely due to improvements in films in combination with faster, more economical printing methods."

With total awareness of what Victor Keppler has summarized as being the "enormous—and still growing—money-making opportunities for free-lance photographers," the professional wastes no time in *guesswork*. He makes a careful study of markets that solicit the type of photographs he is best equipped to produce, then submits only the type of pictures each buyer *wants*. If interested in selling to calendar or greeting-card companies, for example, he would analyze samples of their current productions, making it his business to actually study a comprehensive cross-section of those samples.

To simplify matters, however, let us assume that as a professional you intend to stick to the magazine markets. The five steps that constitute the professional approach are discussed in detail below.

STEP 1: LEARN THE PROPER USE OF A MARKET GUIDE

The best way to profit by the market-guide listings in this book is to think of them as a collection of signposts. Their main purpose is to help you decide which markets appeal to you and to stimulate a chain reaction of *original* thinking on *your* part.

As you browse through the listings, note the range of subject matter in demand, the prices being paid for pictures, when pictures are paid for (on acceptance or publication), and whether or not color is being used. Make a list of possible markets for each of the several categories of subject matter you feel you could produce *profitably*. Stay away from vague generalities. "Pictures of people" has no place on your list unless you specify the *kind* of human-interest pictures the buyer uses. For example, "pictures of middle-income families at work and play" has some meaning. *If* you are in a position to produce pictures of this type, and *if* the market for these pictures is remunerative enough, by all means list this as one of your market possibilities.

STEP 2: DO YOUR HOMEWORK

It's not enough just to read about a picture buyer's requirements. You must do your homework. Make it a point to obtain several copies of each publication you have listed. Study these sample copies before you even touch your camera.

This is so important, it is worth repeating: *Get copies of the publication you hope to shoot for.* Study these copies from cover to cover before you attempt to produce saleable pictures.

If you can't find copies of the publications you want on the newsstands, try your local library. If you draw a blank there, send some money or postage stamps to the circulation manager (not the picture buyer or publisher) of the publication that interests you and ask for sample copies. The circulation manager may or may not refund your money, but you are certain to get faster service if you enclose the full retail price of the publication.

STEP 3: DO A BREAKDOWN

Having obtained sample copies to work with, you are ready to make an actual analysis of a photographic market.

Suppose, for example, that the publication you are interested in caters to male readers. An actual count of the photographs used in three issues might show that an average of 55 pictures are published in each issue. If 80 per cent of the pictures are sports shots and 15 per cent are general, storytelling pictures, your breakdown would thus far have established the *two kinds* of subject matter most likely to sell in this particular market.

Suppose further, that you decide to try selling the picture buyer some of your own sports shots. You discover by actual count that three out of every four sports pictures depict action—a fighter throwing a punch, a diver in midair, a canoe shooting the rapids. This breakdown gives you several additional clues to go by: (1) The picture buyer is choosing dramatic sports action rather than static shots or portraits of athletes; (2) his range of interest is by no means confined to major sports; and (3) the action itself is of more importance than the identity of the personalities involved. In other words, the picture buyer is more interested in what is going on than in the "who's that?" of the picture.

Now for the 15 per cent of the pictures devoted to the general-interest subjects. Do most of these pictures contain people in them? If so, the picture buyer leans toward human-interest shots. Do most of the pictures stick pretty close to specific themes, such as exploration and adventure, new discoveries in science, and the like? Do pets, babies, humor, or pretty girls occupy any of the picture space in the magazine? Are all the general-interest subjects covered by single pictures, or do several types of subject matter rate a series of sequence shots? Are any

of the pictures in color? If so, what is the ratio between black-and-white and color pictures in the magazine?

A breakdown of the general interest pictures in a magazine may give you several saleable ideas you would have missed entirely had you given up your research after analyzing only the sports pictures. But we aren't finished with the breakdown yet. There are still the potboilers to be considered.

A potboiler, in the writer's vernacular, is a short filler item consisting of a paragraph or two of copy that is used to fill out a column of text in the back pages of a magazine. A photographic potboiler serves the same purpose. The picture and its accompanying caption stand alone and are complete in themselves. Many publications pay a minimum of $20 or more for each photographic filler they accept. Since the need for these fillers is rarely mentioned in a market listing, most photographers completely overlook their possibilities.

STEP 4: KEEP A RECORD

Your memory alone serves as a poor filing system for a market analysis. Keep an accurate written record. Use plenty of paper for jotting down your original data, impressions, and picture-selling possibilities. Then condense your notes to the pertinent data you will actually be using. Use loose-leaf notebook pages or large file cards that can be indexed, whichever you find the more convenient. At the top of each page or card list the *name of the publication,* the *address of the editorial office that accepts free-lance contributions* (this information usually appears on the publication's contents page), and *the date of the issue or issues you have analyzed.* Of course, your analysis should be of current issues rather than copies six months or a year old.

Follow your lines of identification data pertaining to each market analysis with the facts and figures that will help you produce pictures exactly suited to that market.

STEP 5: KEEP ABREAST OF CURRENT NEEDS

Your files of market data that are allowed to grow out-of-date become almost useless. From time to time, analyze the same market again. Picture policies, editorial policies, staff personnel—even the name of a publication—can change overnight. Or a publication can cease to exist altogether. If you are quick to note a trend or change in the picture needs of a publication, you are in a position to climb on the selling bandwagon while your competitors are still wondering what happened. That is why an up-to-date analysis of a market as reflected in your own card file is worth a dozen formal listings in any market guide.

FINDING UNLISTED MARKETS

It is easy to find many picture buyers who are not listed in regular market guides, if you know where to look for them (see Section 10). The reference rooms in your local library will furnish some excellent leads. Here you will find trade journals, limited-circulation pamphlets, and dozens of other publications that make use of photographs yet are never seen by the average person.

Illustrated advertising folders can also be traced back to the agency or private company that produced them, thus yielding possible leads on future sales. Moreover, the classified section of every metropolitan telephone directory lists dozens of printers, many of whom turn out various types of illustrated pamphlets. Although the printers seldom have anything to do with buying the pictures that appear in these pamphlets, they can usually tell you who does the buying.

If you are traveling cross-country and chance to photograph a serious automobile accident or something of local news importance, make your next stop the nearest newspaper office. There are

literally thousands of local newspapers, dailies and weeklies, that buy an occasional picture yet are never listed in market directories.

Speaking of newspapers, the rotogravure section in most metropolitan newspapers offers a possible picture market. So, in effect, do photo prize contests sponsored by newspapers, magazines, product manufacturers, and advertising agencies.

Book publishers, real estate agencies, travel bureaus, summer camps, and vacation resorts are likewise prospective picture buyers.

As a final suggestion, have a look at the various publications that serve as trade journals for free-lance writers. Although photographs are not always mentioned in market lists compiled for writers, many of these markets do buy photos.

Most states and many cities, counties, development communities, and recreational areas publish pamphlets and brochures loaded with photographs intended to attract tourism and new industries. These, together with government-sponsored materials, are not to be found in any general market listing. Queries to the Chamber of Commerce, Public Relations Department, Business Men's Booster Clubs and so on of various cities, communities, and recreational areas will uncover market leads otherwise unavailable.

Photo by Jack Urwiller.

Photo by Herb and Dorothy McLaughlin.

Photo by Rohn Engh.

Photo by Rohn Engh.

Photo by Jack Urwiller.

Photo by Bill Montaigne.

Photo by Irving Desfor.

SUBMIT YOUR BEST, OR FORGET IT

When you submit a print it should represent absolutely the most professional quality you can produce. Anything less can be harmful to your image with a buyer, even if circumstances are such that he has to make use of what he considers inferior work. If you are not certain how to go about preparing and submitting a print or a set of prints to a buyer, study Section 5, Parts 1 and 2, before you drop a contribution into the mail.

Don't send a buyer imitations or near-duplicates of pictures he has already published. Once he has reproduced a picture he files it away in a "morgue." The last thing the buyer then wants to see is a ghostly reminder of a picture he has laid to rest within the last year or two.

If one picture buyer in an agency or one editor on a publication staff rejects your picture, don't try to go over his head and sell it to some other member of the same concern. Even if you are successful, you will have embarrassed and offended the person whose decision was over-ruled. A picture buyer, *any* picture buyer, has a memory for pictures that is fantastically long-lived and accurate. He not only knows what he has purchased and/or rejected, he also has a faculty for remembering the majority of pictures he has ever seen in or out of print. If you try to kid him about *anything* having to do with pictures, it will surely backfire to your disadvantage.

When you want to sell to one specific market, keep a weather eye on all the markets that compete with it. Avoid sending the publication you favor a set of pictures depicting the same subject matter that recently appeared in a rival publication. No picture buyer wants to be accused of walking in his competitor's shadow.

If you recognize a picture as being completely off-beat for a market, don't send it. A picture buyer hews very closely to a straight-line buying policy. A photographer who tries to sell him a piece of precious off-beat subject matter or a revolutionary new picture technique isn't being helpful. If not a minor annoyance, a photographer of this type can develop the reputation of being an outright pest.

THE BEST APPROACH TO OVERSEAS MARKETS

• *Overseas* markets will often purchase pictures having universal appeal. Many free-lance photographers, in fact, market duplicates of the same pictures simultaneously on both sides of the Atlantic.

Since foreign markets differ in many respects from North American markets, it is essential that free-lance contributors study these markets thoroughly before wasting time and money on fruitless submissions. This is not easy. Some of the major foreign publications are available on international newsstands, but the editorial markets reflect only one facet of the huge overall market-ing potential. For this reason, most American free-lance photographers prefer to sell overseas through an agency or personal representative. The commission they pay an agent is more than compensated for by repeat sales of the same pictures to markets the photographer would never have known about. Frequently, moreover, an agent is able to command far better prices for pictures than a buyer lists or would pay to an unknown and possibly one-shot contributor. (Photo agencies and personal representatives are discussed in Section 7.)

2. How to Submit Photographs by Mail or in Person

You may submit photographs by either first-class or fourth-class mail. In either case, *always* enclose return postage: the same amount you needed to send your contribution to market. For example, if it costs 75¢ to mail your submission, enclose 75¢ worth of stamps for its return.

SUBMITTING BY FOURTH-CLASS MAIL

You are *not* permitted to enclose a letter or note to the buyer when sending pictures by fourth-class mail. You may, however, caption your photographs. The mailing envelope or box should be sent unsealed and should bear a message reading: "CONTENTS—MERCHANDISE. *Postmaster: This parcel may be opened for postal inspection if necessary.''* Printed stickers are available in pads in any dime store.

If a letter is to accompany your fourth-class submission you can enclose it in a small envelope, which can be fastened to the outside of your package. The small envelope should be addressed and given a first-class postage stamp. If you prefer, you can send the letter inside the parcel, and on the outside, place a first-class postage stamp apart from the rest of the postage with a circle around it and a note reading, "First-class letter enclosed." Air parcel post usually travels faster and just as reliably as regular first-class mail.

Postage on an envelope or box of pictures sent by fourth-class is determined by weight and zone (distance to be traveled).

Never be tempted to take a chance on enclosing a note or letter to the picture buyer in a fourth-class package *without* the first-class postage on the outside to cover it. If the letter is detected by the Post Office Department—and it happens every day—the package may arrive as "Postage Due" in the buyer's office at the first-class rate for the entire parcel. The buyer must either shell out money to receive your contribution or go through the trouble of refusing it. Either way, your chances of selling *him* have probably vaporized.

SUBMITTING BY FIRST-CLASS MAIL

First-class mail is preferred by most photographers when mailing their contributions because they want fast service. A letter or manuscript can be sealed inside any envelope or box sent by first-class mail. If time is of great importance, as with news pictures or "seasonal" material, it may pay to send your submission "Airmail—Special Delivery." Very important contributions are often sent by registered mail and are insured for an estimated value of the picture contents.

ENCLOSING RETURN POSTAGE

Most professional photographers enclose a full-sized, self-addressed, stamped envelope with their submissions. This avoids the possibility of having loose return postage stamps overlooked when the package is opened. If you decide to dispense with a return envelope and send a self-addressed, gummed label instead, it is best to place the return postage in a small envelope (coin envelopes are excellent for this purpose), and clip it to your return label. *Do not:* (1) drop loose stamps into your original envelope; (2) attach them permanently to the gummed return label; or (3) fasten them to one of your prints with a staple or paper clip. Metal objects and photographs are enemies and when crowded together in an envelope, it is always the photographs that get hurt.

ADDRESSING YOUR SUBMISSION

Address your pictures to the attention of a specific editor or picture buyer *only* if you have had previous contact with him or if his or her name is specifically mentioned in a market listing. If you are aiming at a market you have never tried before, it is always safe to address your contribution to the "Picture Editor," even though such a title may not appear on a publication or agency masthead. The idea is to identify the nature of your contribution (photographs) so that it does not become buried by mistake in the office of someone who deals only with text, filing, production problems, or some other unrelated area.

In a *publishing house*, the Art Director, Publisher, Business Manager, and other departmental heads may or may not have anything tö do with the original selection of photographs that are purchased; therefore, it is often improper to address a contribution to them by name.

IS A LETTER NECESSARY?

Whether or not to include a letter with your submission of photographs depends on your answer to this question, "What do you intend to write about?"

If you have something of real importance to say, a picture editor will welcome a neatly typed letter with your contribution. Otherwise you are better off omitting the letter.

A letter accompanying a contribution should always deal specifically with the pictures being submitted. The "something of importance" may be a reference to the publication rights being offered, previous appearances of certain pictures, model releases, or information that may not already appear in the caption or text material. Such a letter should be brief and to the point.

A letter should *not* be twisted into a query concerning the sales possibilities of some other set of pictures. Neither should it request constructive criticism or fish for tips on what the buyer might like to see in future pictures. Moreover, this is definitely not the place to inquire about payment rates or to ask for technical information of any sort.

Under no circumstances should a letter go into detail about the technical difficulties and personal headaches involved in making a photograph. From a buyer's point of view, the only thing that matters is the picture itself, not the birth pangs of producing it. Irrelevant details, flattery, cajolery, or *verbal selling of any type* is an amateurish approach that should be avoided.

Children absorbed in their own world of play, curiosity, and spontaneous actions (unaware of or oblivious to the camera) are one of the world's best-selling photo subjects. If not too obviously North American children, the same photographs sell almost equally as well overseas. In addition to popular home-family type magazines, there is an enormous market for pictures of children in religious and non-newsstand publications. In color, some of the photographs shown here would be likely prospects for greeting card, calendar, advertising, box-top, jigsaw puzzle, and many other markets. All photos by Rohn Engh.

WHEN TO SEND A QUERY

There are times when you can save time, postage, and unnecessary work for everyone concerned if you query a picture buyer before mailing him a set of prints on speculation. This is especially true (1) if you have seasonal material (or other photographs of timely interest), which will lose their sales appeal in a matter of days or weeks; (2) if you plan to submit a large number of prints—say, 50 to 200 glossies—to any market as a single contribution; (3) when you would like to submit contact prints as well as, or instead of, enlarged prints; (4) when the subject matter is slightly off the beaten track.

Sample Query Letter

The first step is to make sure you have the general type of pictures the picture buyer is in the habit of using. (See Section 4, Part 1: "How to Analyze Photo Markets.") Then, if possible, use letterhead stationery in typing out a query, which might read something like the sample that follows.

Dear Mr. So-and-so (or *Picture Editor*, if you do not know a buyer's name):

I have a story-telling series of pictures of a two-year-old boy trying to button a sweater on his recalcitrant puppy. The series consists of nine 8″ ×10″ glossy photographs, and since neither the child nor the puppy was aware of the camera, the pictures have a candid naturalness about them that I think your readers might enjoy. Full caption data is attached to each picture, and any or all pictures are available on a one-time publication basis at your regular rates. If you would care to consider these photos on speculation, I will be happy to airmail them to you immediately.

Sincerely yours,
John B. Doe

In approximately 100 words, a letter of this type gives a potential buyer enough pertinent information for him to decide whether or not the material being offered is "down his alley." He knows that the subject matter is a boy and his dog, the pictures are on the candid side (rather than studio posed), there are nine standard-size glossy prints in the series, and the terms on which they are being offered are quite clear.

FIVE "DON'TS" TO REMEMBER

Keep in mind these five important *don'ts* when you frame a query letter to a picture buyer:

1. Avoid being long-winded or redundant.

2. Avoid confusing the potential buyer; don't discuss several different picture submissions you would like to make in the same letter.

3. Don't ask for tips on what a buyer is looking for in case he is not interested in the material you are offering.

4. Don't ask for a commitment or promise of any sort. In nine out of ten cases a picture buyer would rather pass up your offer, however enticing it may be, than go on record as saying he will pay a stipulated price sight unseen or promise that your prints will receive special handling over and above that received by other contributors.

5. A letter of query is not the place to air your ambitions, background, or personal history. If the buyer you are querying has purchased from you in the past but may have forgotten you, it would not hurt to include a casual reminder. If you are making a bid to crash his market for the first time, it will do no harm to mention one or two other important markets that have accepted your work. Other than this do not try to convey your professional talents by letter. Let the quality of your work come as a pleasant surprise when he sees your pictures.

THE PERSONAL APPROACH

Photographers who have proven their ability to produce the kind of pictures that are in editorial or advertising demand are welcomed by picture buyers. In fact, once a photographer has arrived, personal contacts with picture buyers often pay off in easier sales and special assignments.

What about the unknown photographer? Is he likely to benefit by presenting his pictures to a buyer in person rather than by mail? Generally speaking, no. While every buyer is eager to discover new talent, he is less than enthusiastic about hunting for it among photographers who have never sold pictures for publication purposes. The reason: Of the thousands of people who want to *sell* pictures, not one in a hundred has the slightest conception of what individual buyers want to *buy*. Rather than study the market a buyer represents, the average beginner seems to believe that once he has wangled a personal interview, the battle of selling his pictures will be half won.

Nothing could be further from the truth. A picture that is hopeless when submitted by mail is just as hopeless if presented in person. The main difference is that a picture that arrives by mail is easier to dispose of than the same picture in the hands of its maker.

In a sense, the unknown photographer who shows up with a portfolio of pictures is putting the buyer on the spot. No one likes to seem abrupt or unsympathetic, yet that is the role many picture buyers are forced to play. The photographer whose pictures are rejected naturally wants to know why they are unsuitable, but a buyer can rarely afford to take time to render a personalized criticism. His job is to buy pictures his market can use; if he undertook to offer criticism and marketing advice on all the pictures that miss the target, his time would be completely occupied with non-productive work; that is, non-productive from his employer's point of view.

This does not mean that a picture buyer never offers constructive criticism. Very often he does try to lend a promising new photographer a hand. But he is in no way obligated to do so, and the photographer who uses a personal appointment as an excuse to insist upon constructive criticism usually winds up with a polite brushoff.

Rather than take up a buyer's time at the start of his marketing career, an unknown photographer is usually better off if he makes use of the mails for his early submissions. If, after he has made several substantial picture sales, he feels that it would help to meet a certain buyer, his first step should be to make a careful study of the kind of pictures the buyer is currently using. Then, after printing up a few pictures he thinks may interest the buyer, he is ready to arrange an appointment.

Just a word about protocol. Never drop in on a buyer without having made an appointment ahead of time. If you are only going to be in the buyer's city a few days, write for an appointment at least two weeks in advance, offering the buyer a choice of several days in which to schedule an appointment. Whether you write or telephone for an appointment, be prepared to state *exactly* what kind of pictures you intend to show. Vagueness on this point has lost many a photographer an appointment on the grounds that the buyer is simply too busy at the moment. The fact is, he will always be too busy to see someone who does not know what kind of pictures he intends to bring along.

Be punctual to the dot. There is a bit of psychology involved in the business of being on time. Rightly or wrongly, a buyer is apt to wonder what a photographer who is thirty minutes late for his first appointment would be like if he were facing the pressure of an important deadline.

After you have presented your pictures and whatever information may be essential, let the buyer ask the questions. When you sense that the interview is nearly over, try to leave before he feels impelled to terminate the appointment. The impression you make on *this* appointment is likely to color the way you will be received *next* time.

AN EXCEPTION TO THE RULE

There is a time when the only rule you should observe is the one of common courtesy, in spite of what we have said about waiting until you have sold some pictures and know the ropes of marketing before seeking personal interviews. This happens whenever you are lucky enough to get an exclusive shot of a big news event.

Suppose, for example, that you happen to be photographing a skyscraper when an airplane crashes into it. If you have the presence of mind to click the shutter and record what takes place, you will probably own a photographic scoop.

Do not wait to make an appointment or even bother to develop your negatives. Head for the nearest newspaper office, ask for the picture editor, and tell him or his assistant what you have. He will make you an offer based upon the number of useable pictures he can get out of your roll of film. If you don't like his offer, try another newspaper office. Better yet, get bids from several picture editors over the phone, and accept the one that you like the best. If the pictures are of national and international interest, contact the picture editors at Associated Press, United Press International, and major picture magazines.

WHEN TO SUBMIT SEASONAL MATERIAL

The seasons of the year bear no relation to the seasons that picture buyers must observe in purchasing photographs. Most North American publishers work three to six months ahead of the calendar. This means that in July a picture buyer is up to his ears in photographs scheduled for December and January. By the time Christmas rolls around, he will be buying for late spring and early summer.

While it is important to plan your shooting so as to have black-and-white seasonal pictures in the hands of potential buyers at least three months ahead of time, it is doubly important to *get your color out early*. The reason: It requires a great deal more time to make color plates than is needed for black-and-white engravings. If your color lands on the buyer's desk barely three months ahead of the calendar for, say, his Christmas issue, the chances are he will already have made his purchases. Moreover, you won't get your color back in time to try a new market. Because of the time lead required for color, many photographers make it a practice to submit holiday subjects a year to eighteen months ahead of time.

Summer material should be mailed as early as February or March. Photo by Peter Gowland.

July is not too early to submit autumn photos by mail. In color, all seasonal photos should be submitted 6 months ahead of any special holiday. Photo by A. Ahlers.

Winter scenes should be mailed by August or early September if in black-and-white; three months or so earlier if in color. Photo by Rohn Engh.

SUBMITTING PHOTOS TO FOREIGN BUYERS

Sooner or later the photographer who chooses to send his material directly to overseas buyers becomes appalled by the amount of money he is spending on postage. If submitting pictures to American markets has seemed high to him, the cost of submitting the same material overseas will appear astronomical.

The first step in cutting down postage costs is to eliminate all but your best pictures. The second step is to make judicious use of the postal services.

If urgency requires the shipment of pictures by air, investigate the service known as Air Parcel Post. Experience indicates that it takes Air Parcel Post from 6 to 24 hours longer to span the Atlantic than it takes regular first-class airmail, but Air Parcel Post is cheaper.

International Reply Coupon

American postage will carry your prints by first-class mail to foreign lands. (Simply check with your postmaster for the current rates.) American postage, however, *cannot* be used by an overseas buyer for returning prints to you from his country. Rather than enclose American stamps as return postage, visit your local post office and ask for an *International Reply Coupon (Coupon-Réponse International)* in the amount of the return postage that will be required. This coupon can be exchanged by the buyer for the postage stamps that are used in his country. The fee charged for an International Reply Coupon is very small.

Customs

Another hurdle in the way of overseas picture submissions is getting through customs. Most customs officials are inclined to be lenient about photographs being submitted on speculation. However, each country has its own type of officials and regulations and oftentimes their notions are inexplicable to ordinary mortals. There seems to be no rhyme or reason why one parcel of pictures should cause argument when dozens of its fellows do not.

For some curious reason there seems to be a magic formula for avoiding arguments in Britain and most of the Western European countries. Picture parcels sent from the United States are rarely questioned if: (1) they weigh 8 ounces or less; (2) postage is relatively low; (3) insurance (if any) is nominal; (4) the packet or parcel is clearly stamped "Press Material."

In any case, always check with your local post office for the type of customs declaration label to be affixed to the parcel. For some countries these vary with the mailing rate.

1. How to Prepare and Submit Black-and-White Photographs

WHICH DO BUYERS WANT: NEGATIVES OR PRINTS?

When submitting black-and-white pictures on speculation, a buyer is initially interested *only* in what he sees in the form of final prints.

You should *never* submit negatives with your prints unless a buyer (or your agent) specifically asks for them. A photo agency or syndicate that plans to market your photos may request a negative in order to make multiple prints in their own lab. In this case, be sure to find out whether you will be charged for the printing, and if so, how much. Also be sure that you retain *ownership* of a negative unless you agree (in writing) to sell the negative outright. If a client is willing to pay for exclusive rights to a picture by purchasing a negative outright, all photographs thereafter made from the negative belong to him to use as he sees fit. (See "Exclusive Rights" in Section 6, Part 4.)

• *Overseas,* the requests for negatives on loan from your authorized representatives or agents may be more frequent than in the United States. Paul Popper, Ltd. (London), for example, normally requires six or more sets of prints for each photo-feature selected for simultaneous distribution around the world. During a recent political campaign, an overseas agency requested a set of 20 negatives of a presidential candidate taken by Herb and Dorothy McLaughlin of Phoenix, Arizona. The negatives were flown to England and printed as 40 complete sets of duplicates. These, in turn, were marketed simultaneously in the United Kingdom and Western European countries.

Agencies equipped to make prints from the negatives they request may or may not charge a nominal fee for this service. In any case, your negatives will be given careful treatment by a reputable agency and will be returned to you according to individual arrangement or held on file as long as potential demand for a print exists.

PRINTS: WHICH SIZE DO BUYERS PREFER?

The commonly accepted standard black-and-white print size in world-wide demand is 8″ × 10″. While smaller enlargements (4″ × 5″ to 5″ × 7″) are sometimes accepted by picture buyers, a professional photographer seldom cares to buck 8″ × 10″ competition with substandard sizes. Some professional photographers have printed their best offerings in sizes up to 11″ × 14″, or even larger. For now, you won't go wrong in limiting the bulk of your work to eight-by-tens. This size costs less to produce and mail than bigger prints, is ideal for filing in cabinets and drawers, and is the size that picture buyers are accustomed to dealing with in volume.

PRINTING PAPER: GLOSSY, SEMI-MATTE, OR UNFERROTYPED?

For years, glossy prints made by enlarging pictures on smooth-surfaced paper that could be rolled out on a ferrotype tin so as to provide a mirror-like glazed finish were considered the only type of picture acceptable for reproduction.

Glossy prints are still in greatest demand

because they emphasize fine detail and provide a maximum range of tone values. Semi-matte paper, by comparison, provides a relatively short range of tone values (gray tones between black and white). Moreover, it does not show up fine details as well.

If you find it too difficult or too time-consuming to turn out top-quality glossy enlargements, try using *lustre* paper or *unferrotyped* glossy paper. For the most part, picture buyers will accept prints made on the latter without question. The thing to avoid is paper that provides a built-in grain or texture. Papers of this type are not acceptable in the general market.

PRINTS: SHOULD THEY BE SINGLE- OR DOUBLE-WEIGHT?

Many photographers print 8″ × 10″ pictures on single-weight paper and go to double-weight paper for anything larger.

The advantage of using single-weight paper is that it is cheaper, and being lighter, requires less postage for mailing. The disadvantage of single-weight paper is its tendency to curl and the ease with which it is torn or damaged. Double-weight paper is more durable on every point of comparison.

In deciding which weight of paper you will use, bear in mind that picture buyers have no patience with photographs that curl in the hand and will not lie flat on a lay-out table without weights. Many a good picture-story has landed in a buyer's slush pile of material to be rejected simply because only an octopus could hold enough prints flat for someone to see what the story was about. If neither the anti-curl solutions (available from your photo dealer) nor the print-flattening techniques described in books on pictorial photography can make your single-weight pictures behave, your best bet is to switch to double-weight paper and be done with it.

PRINTS: SHOULD THEY BE TONED?

The average picture buyer is unimpressed by sepia or blue toned prints. Now and then he will accept a toned picture, but when he does it is for the sake of the picture itself, not the toning.

When it comes to fancy paper surfaces, decorative borders, hand-tinted photographs, and pictures printed through bizarre texture screens, buyers lose patience. These techniques may have a place somewhere, but it definitely is not in the general picture market.

Excessive retouching is likewise something to avoid. A picture buyer wants a high-quality photograph printed on plain-white enlarging paper. If dust spots leave tiny white blemishes on the face of a print, they should be spotted out with a sable brush charged with one of the several kinds of spotting colors on the market. Spotting is a simple job, and when carefully done, the original blemish disappears beneath a dot of color that blends with its surroundings.

Light pencil retouching on a negative is sometimes both necessary and desirable; however, everything possible should be done to avoid drawing attention to retouched areas in the final print. A print that has been heavily spotted with little concern for matching tone values, or a print made from an excessively retouched negative, stands a poor chance of acceptance.

PRINTS: DO BUYERS WANT THEM MOUNTED?

Prints mounted on large pieces of cardboard are generally intended for exhibition purposes. In a picture buyer's office they represent an odd size, which requires special handling. This does not enhance their welcome. If, as rarely happens, a professional photographer decides to use a backing on a photograph, he usually trims off the original white border of the print along with the surplus cardboard. This insures a flat print that will take a lot of rough treatment, but it does not otherwise enhance the picture's sales appeal.

Some photographers trim away the white borders of all their prints, mounted or otherwise. The feel that a white border distracts the eye,

whereas a borderless print places all possible emphasis upon the subject matter and presents a more professional appearance. Since there are good arguments both pro and con on this subject, the decision you make will be a matter of personal taste.

PRINTS: HOW MANY SHOULD YOU SUBMIT AT A TIME?

Having decided on a possible market for some of your photographs, a question arises: How many should you send? The answer is: *Don't* smother a prospective buyer with samples. A dozen or so of your best photographs will impress him more favorably than a hundred samples that have mediocre material larded in with the good.

Let's suppose you have a story-telling picture idea you would like him to consider in addition to the samples of work you have already done. If so, outline your suggestions *briefly* on paper and include them with your samples. Don't expect a firm assignment from this; buyers rarely give a firm assignment (a promise to pay a stipulated price) to newcomers. Your best bet may be to offer to produce, on your own, a picture (or picture series) that interests him, making it clear that this places him under no obligation to buy. The time to ask for a firm assignment is after a buyer has purchased enough free-lance material from you to know that you can consistently satisfy his needs.

A simple story-telling sequence that needs no text. The photographer, Doug Richmond, is himself an avid cyclist whose pictures of sports appear in many magazines. He also travels by cycle all over North and South America, photographing human interest, scenics, and the like for a number of books he has already been contracted to write and illustrate.

PRINTS: WILL ACCEPTED PHOTOS BE RETURNED AFTER PUBLICATION?

As a rule, ordinary black-and-white prints are seldom returned to a contributor after publication. By the time the art department, production department, and the engravers are through with them, ordinary prints are often in no condition to be of further use to their owner. In the case of a very rare print or one that cannot be replaced, most picture buyers will, upon request, take pains to see that the print is handled with special care and that it is eventually returned to its maker. Since a request of this sort upsets the buyer's normal routine, it should never be made lightly. (An original color transparency is a different matter. For details on how to submit color, see Part 2 of this Section.)

CONTACT SHEETS

Rather than submit a set of pictures consisting of 50 or 100 enlargements at a time, many freelance photographers submit sheets of contact prints on which a picture buyer can check in crayon the prints he would like to see enlarged. You can make twenty or thirty-six 35mm contact prints, twelve contact prints 2¼″ × 2¼″ in size, or four 4″ × 5″ contact prints simultaneously on a sheet of 8″ × 10″ enlarging paper.

For convenience in handling, contact printing is usually done on glossy paper to enhance small details. Special printing frames are available to hold paper and negatives together for easy contact printing, but you will get good results by simply placing a 9″ × 11″ sheet of scratch-free plate glass over the paper and negatives to provide the necessary close contact. This, of course, is done in darkness or under the recommended safelight for the type of paper you are using. Finally, turn on the white light (room lights or enlarger light) for a few seconds, switch it off, and develop the paper in the usual way.

• *Overseas.* In submitting enlargements, it often pays to include sheets of contact prints showing alternate pictures available in the same series. Buyers frequently prefer either the alternates or additional shots to those you selected for enlargement.

By submitting additional contact sheets, you spend less time in the darkroom trying to second-guess a buyer's needs. You also avoid the paper and postage costs of submitting a number of enlargements of no interest to the buyer.

INDEXING: A "MUST"

Few things are more confusing, or irritating, to a buyer than to receive dozens of pictures that have no numbers he can refer to in discussing them with the photographer. (For suggested filing system set-ups, see Section 6.)

Index numbers printed on the clear margins of negatives in India ink, *before* contact proofs are made, are an excellent means of identifying pictures. If you make duplicate sets of contact prints—sending one set to the buyer and retaining the other in your files—the buyer can order pictures by number without having to mail back the set of contact proofs. This can save a great deal of time and expense; moreover, it allows the buyer to use his set of contact prints for planning layouts while enlargements are being made from the numbers he has selected.

PRINTS: THE PERSONAL DATA ON THE BACK

In addition to the file number of the negative from which a print is made, the back of each print should contain your name and address in the upper left-hand corner. It saves time and looks more professional to use a rubber stamp for imprinting a name and address, but it is not too important how it is done so long as you do a neat job of it. The important thing is not to have

ink soak through the paper and mar the face of your photograph. If you print by hand, use a felt-tipped pen rather than a ballpoint that may show an impression on the face of the print; however, test the pen on some scrap enlarging paper first to ensure that there is no show through.

CAPTION COPY: HOW TO PREPARE IT

When you type out caption copy (or prepare typewritten copy for articles), be as professional about it as possible. Use a good grade of typing paper, a reasonably dark typewriter ribbon, and avoid smudges or excessive erasures that detract from the appearance of your copy.

Use elite or pica type, whichever you prefer. Double-space your copy (that is, leave a blank white space between the lines) so the person who edits it can insert changes of wording, corrections, or whatever else may be required to prepare the copy for the typesetters.

Some photographers include a carbon copy of the captions and text material (if any) that accompany their photographs. This is purely optional, but *do* keep a carbon copy of what you write, including correspondence, in your own files. Once in a great while, a set of captions or a manuscript is lost either in the mails or in the picture-buyer's office. If a photographer has no carbons on file, he will have to prepare the written material over again, and he will not be paid extra for it.

CAPTIONS—WHO? WHEN? WHERE? WHAT? WHY? HOW?

The most important thing about captioning a print is to provide *all* the pertinent data a picture buyer will need in the fewest words possible.

As a general rule, the answers to the six questions that appear in the above heading will supply this information. Supposing, for example, you shoot a human interest picture of a man and his dog being rescued from a tree during a flood. The essence of your basic caption might go something like this:

Bill Freeman, a 47-year-old Nebraska farmer, risked drowning in the rampaging Little Blue River last night to save the life of his dog, Terwilliker. Swept away by a flood, the dog was carried a quarter mile downstream before his leash snagged in the fork of a tree. Freeman reached the dog by following the sound of his barking, and when help arrived Freeman was seated in the tree fork, holding Terwilliker in his lap. The rescue of Terwilliker called for unusual courage on the part of Freeman, who is totally blind. Terwilliker, a 'Seeing Eye' dog, has been the farmer's constant companion for two years.

Don't worry too much if you commit a little grammatical mayhem in your caption. The only thing the picture buyer cares about is English that conveys *all* the facts.

• *Overseas.* For overseas marketing, captioning needs even more careful consideration than for the home market. Far more detail will have to be included, and facts should be explained in words having one-syllable clarity. Whereas a buyer in New York would understand the terse phrase, "Indians, Monument Valley," his counterpart overseas would probably be inclined to reject the shot for lack of supporting data. If necessary, the American buyer could obtain information from library reference books or national information services. The overseas buyer might spend weeks simply trying to locate the information.

A good criterion for judging your overseas captions can be the strength of your own knowledge of foreign countries. How much do you know about Albania? Twisting this around, how much does an Albanian know about America? To the average man-in-the-street abroad, America is still pretty much a composite of names and impressions consisting of the Statue of Liberty, skyscrapers, flashy cars, movies, cowboys, and Indians. For a caption to convey meaning to a European, it must be extended beyond normal length.

Take the "Indians, Monument Valley," for example. The caption should explain *what* Indians, *where* Monument Valley is located, *where*

the Indians come from, *what* they are doing there, *why* they have selected this spot, and so on. Not every caption will answer the six essentials either directly or in the order given, but it is a good idea to check your caption against these questions to make sure that nothing of importance has been overlooked.

The fact that expanded captions are a virtual necessity for pictures going overseas raises a still more unfamiliar necessity—that of submitting body text with certain single pictures or feature picture series. In addition to the standard captions, many photographs (including outstanding or unique stock shots) may require 100 to 250 words to supplement the information contained in the captions. It is a good idea to include cross references between the pictures and captions, because they are often separated for filing.

The Working Class. Each of the following photos has been selected from a series of story-telling photographs produced by globe-trotting photographers on assignment or for their own books or stock subjects.

The bass horn man, Mexico. Photo by Rohn Engh.

The sugar mill dross skimmer, San Salvador. Photo by Doug Richmond.

Eskimo blanket toss, Alaska. Photo by Dorothy and Herb McLaughlin.

Carrying water from Lake Atitlan, Guatemala. Photo by Doug Richmond.

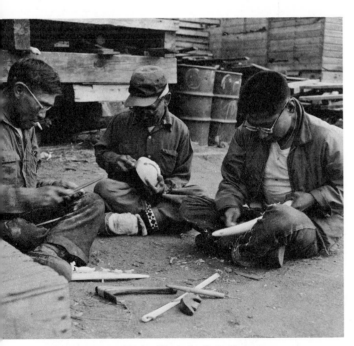

Ivory carvers, Alaska. Photo by S. Rothman.

African hunter. Photo by Rohn Engh.

CAPTIONS: TECHNICAL DATA

The majority of picture buyers seldom need the technical details involved in making a picture. For picture contests, photographic publications, and certain other specialized markets, however, technical data is of extreme importance. Since you never know when a picture may find a sale in one of these markets, it's a good idea to keep a data record on shots that have multiple sales potentials. The technical data on the Freeman picture might read: Rolleiflex camera, Plus-X Film. Shot at 9:30 a.m., June 3. Exposure: 1/200 sec. at f/11. K-2 filter.

If a special wide-angle or telephoto lens plays an important part in making a picture, mention of the lens and its focal length should be included in the technical data. Since almost any picture can be duplicated with a variety of lens opening and shutter-speed combinations, the actual value of this technical data is highly questionable. Useful or not, though, it *is* required by some buyers; hence the photographer has nothing to lose by including it.

CAPTIONS: ATTACHED TO PRINTS OR ON SEPARATE SHEETS?

In North America, there is no such thing as a "right way" that will please all buyers.

News and public-relations photos generally have a caption attached to the bottom of a print and folded up and over the face of the print. This enables the editor to look at the picture and read its caption without turning it over or consulting a separate sheet. Outside the news and public-relations fields, this method is rarely used. Captions thus attached rip off too easily and, in general, give prints an untidy appearance.

In reply to a survey of magazine editors, photo-agency representatives, and a cross-section of calendar and greeting-card picture buyers, the author found a wide difference of opinion as to the *best* way of captioning prints. Some magazine editors, for example, prefer captions on separate sheets of paper containing index numbers that correspond with numbers on the backs of the prints they refer to. Some photo agencies also approve this method. Other magazines, photo agencies, and genre picture buyers have no objection to separate caption sheets keyed to various prints, but would also like a *duplicate* copy of each caption attached to the back of each print, just in case the separate sheets become lost.

Captions typed on strips of thin paper are usually attached to the backs of prints with short pieces of acetate tape. Rubber cement is sometimes used, but never glue, paste, or any other adhesive that will cause the print to pucker, curl, or stain. Some photographers also use gummed labels for captioning. As a rule, such labels should be moistened only along the very edges in order to avoid having them cause prints to curl.

CAPTIONS: WHEN KEY SYMBOLS ARE REQUIRED

Sometimes the face of a photograph requires an "X marks the spot," alphabetical letter, dotted line, or the like, for the sake of clarity. Key symbols and legends should never be drawn on the print. The quickest and best way to key a photograph is to place a sheet of tracing paper over its face, secure the paper at the top of the print with tape, and do all your drawing and lettering at the appropriate spots on the tracing paper. Your symbols, dotted lines, and so on should be accurately located, but need not be polished art work. The buyer's art department will use your rough diagram as a guide in preparing the final material to be reproduced.

If it is necessary to do pen work on the face of a glossy print, there is an easy way to accomplish it. Dust the print lightly with French chalk or talc. Gently blow away the surplus. Do your lettering with a mapping pen and India ink; it will take easily. When the ink is thoroughly dry, remove the last traces of chalk with a soft handkerchief. You can also purchase sheets of letters and numbers, such as Press-Type, in many different sizes and type faces; these allow you to transfer pre-formed lettering directly onto the print. You simply position the sheet on the

print so that the letter or number you want to use is directly over the desired print area: With a blunt instrument, rub the plastic sheet over that letter or number, and it will be transferred to the print.

HOW TO PREPARE PHOTOGRAPHS FOR SAFETY IN THE MAILS

Prints that curl are not received with enthusiasm by busy picture editors! Double-weight glossies lie flat and reproduce well. Do not send negatives unless requested.

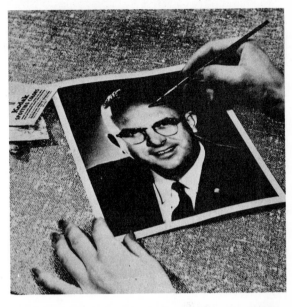

Careful spotting gives your print a professional finish—and the impression that you want every picture to look its best. Toning is unnecessary and excessive retouching taboo.

You do well to identify every print so that none will get lost in the shuffle. A rubber name-and-address stamp is impressive, but light printing (pen or pencil) is sufficient.

Many publications prefer captions on backs of prints. News shots often carry captions on bottom of prints. Some buyers prefer captions on separate sheets, keyed to photos.

Captions should clearly state who is in the picture, where and when it was taken, etc. Technical data can be sent if required. Attach with acetate tape; glue is unsatisfactory.

Captions for transparencies 2¼ x 2¼ or larger are best typed on strips of paper and inserted in the acetate sleeve that protects the transparency. 35mm slides require separate sheet.

Contact prints should be made of all prints sent to market. Each negative should be numbered, and the number transferred to each enlargement for future identification.

Mounts trimmed to print size serve to protect during handling. Salon-type mounts are not required; in fact, most editors prefer the convenient and standard 8 x 10.

The mails are hard on pictures. Be sure to pack prints between two pieces of stiff cardboard; secure with rubber bands to protect corners, yet provide for easy access.

Envelopes addressed to "Picture Editor" (even though organization is not large enough to have one) will reach correct person. Stamp or write on, "Photos—Do Not Bend."

Some photographers prefer a card file system for keeping track of exactly when and where a picture has been sent to market, sold, the price received, and all other data.

The looseleaf notebook is ideal if you don't send out too many pictures. Simply record the pictures you send by number or subject, to whom sent, and when returned.

Photographs should always be submitted perfectly flat. If you roll them in paper or send them in mailing tubes they will bounce back from the buyer as though printed on rubber.

When only a dozen or so pictures are to be submitted, a heavy manila mailing envelope will do. Special envelopes in standard sizes are available from your photo dealer. These bear the printed legend *Photographs—Do Not Bend* and contain two corrugated cardboard inserts designed to provide extra protection for prints sandwiched between them. If you want to save a little money, you can buy manila envelopes at the dime store and cut your own corrugated inserts from cardboard cartons.

When 25 to 50 or more prints are to be submitted at a time, it is best to mail them in a sturdy cardboard box. Save the boxes your 8″ × 10″ enlarging paper comes in; they're ideal for this purpose. If the box of prints you plan to submit has space at the top and bottom, put in some corrugated cardboard inserts to provide extra protection against having your prints damaged in the mail.

A "sandwich" made of prints placed between cardboard protectors is best held together with strong rubber bands. There is no need to secure such a sandwich as though it were a mummy. If you go on the premise that a picture buyer is never within reach of a pair of scissors or razor blade, you'll be doing him a favor. Adhesive tape (or tape of any sort) is a nuisance. So is tough cord that has to be cut away before the pictures can be separated from the cardboard inserts. Those who are used to receiving picture submissions by mail can often spot the contribu-

tion of an amateur by its appearance. Amateurs are likely to use any piece of cardboard they can lay hands on—even though it is the flimsy back of a pencil tablet, which creases under the slightest pressure. A greater give-away, however, is the manner in which a cardboard-and-picture sandwich is held together. Where the professional photographer uses rubber bands so that the cardboard inserts can be removed in a jiffy, the average amateur tapes his sandwich together as if to make it airtight. This is a tip worth remembering.

To speed the return of unaccepted material, so it can be sent to a new market without delay, many photographers enclose a self-addressed, stamped envelope with each submission. While picture buyers welcome the self-addressed envelope, it isn't always absolutely essential. The picture buyer will often supply the return envelope if the contributor provides a self-addressed, gummed label and adequate return postage. If the contributor does not supply a self-addressed, gummed label, there may be a delay between the time the buyer makes his decision and the time the unaccepted pictures actually go into the mail. The reason: Someone in the buyer's office has to type the contributor's name and address on a label or envelope for the return trip. How long it will take to get around to this special handling depends upon how many other contributors also failed to include return labels. Obviously it is smarter for the photographer to take two minutes to address a label to himself than to risk waiting several days for a stenographer in the buyer's office to do it for him.

2. How to Prepare and Submit Color Photographs

Since many of the procedures for submitting color to picture buyers are similar to those for marketing black-and-white pictures, they will not be repeated here. Instead, the paragraphs that follow will be confined to marketing problems peculiar to color only.

THE PRO SIDE OF COLOR FOR PUBLICATION MARKETS

Most photographers would rather sell one color shot than a dozen black-and-white pictures. The reason: A color photo nets the photographer five, ten, or umpteen times as much cash as the same picture would bring in black-and-white; moreover, selling a color shot for a cover or for use on the inside pages of a publication packs a lot more prestige in the credit line than the sale of a black-and-white.

But that's the bright side of the color ledger. Unfortunately, there is another side a newcomer should consider carefully.

THE CON SIDE

Color is expensive stuff to shoot for a number of reasons: (1) the initial cost of the film is many times that of black-and-white film; (2) the latitude, or leeway of exposure, of color transparency films (even the new super-speed films) is short compared with that of black-and-white film; (3) if a color shot has been over- or underexposed, there is no quick, sure-fire, inexpensive way to correct it, so if the exposure error is serious, the picture is invariably a dead loss; (4) for reproduction purposes, the *original* color transparency is often required; if the original transparency becomes lost or badly damaged, the photographer is out of business as far as that particular picture is concerned; and (5) although it is growing steadily, the market for color is still limited in comparison with the market for black-and-white pictures. Yet despite the comparatively few color transparencies actually purchased each month, picture buyers are flooded with color pictures of every size and description. It's a melancholy fact that color seems to dazzle a free-lance beginner the way a flame dazzles a moth. He shoots color where it isn't important to the subject—not important *enough*, anyhow, to impress the picture buyer. This fetish for color itself, plus the lure of extra rewards in cash and prestige, has led many a promising photographer to shoot away his bankroll when the same subject matter, if shot in black-and-white, would have resulted in enough sales to keep his self-confidence alive.

COLOR: WHICH TO SUBMIT, PRINTS OR TRANSPARENCIES

For a number of years now, most of the photographs that have been published in full color have been reproduced from color transparencies. The use of color *prints* for reproduction purposes has been small by comparison.

There are indications, however, that in some areas of specialized photography, the pendulum may be starting to swing the other way. Highly improved color printing materials have been growing in popularity among professional photographers, particularly among newspaper and industrial photographers. These are the main advantages that negative-positive (color negative) color films have to offer:

1. The photographer retains the original color negative in his files and submits only prints from it—as with black-and-white negatives. Any number of duplicate color prints can be made.

81

2. Enlargements from a color negative can be manipulated (dodged, burned in, and so on) during printing, just as prints are altered in black-and-white enlarging.

3. Through the use of special filters in the enlarger, the color tones in a print can be altered or otherwise controlled to produce a desired effect.

4. Excellent black-and-white prints can be made from color negatives on printing papers specially designed for this purpose. Thus, in shooting a picture story, the photographer who uses a negative-positive color film can submit pictures in either color or black-and-white, or in a combination of both—all from the same roll of film.

5. Excellent full-color transparencies for lectures, demonstrations, filmstrips, or color slides can be made from most color negative materials.

It is too early to tell how prevalent the use of negative-positive color will eventually become in free-lance photography. For the present, the person planning to submit color to the general picture market will probably fare best by sticking with transparencies.

A 4" × 5" transparency is the nearest thing to a standard size transparency that exists. Many photographers, however, produce 5" × 7" or even 8" × 10" transparencies. Although a buyer doesn't care how big they come, he is apt to draw a line on how small a transparency he will consider. Some buyers won't look at anything smaller than 4" × 5" in size; a great many more still place their minimum size limit on 2¹/₄" × 2¹/₄" transparencies.

35MM COLOR: THE OLD BAN AND NEW TREND

Some startling changes in the acceptance of 35mm color transparencies have taken place since the first edition of this book appeared in 1952. At that time, only nineteen of 800 picture buyers listed in the market section expressed a willingness to consider 35mm color. Today, many editorial buyers and photo agencies actually welcome 35mm color slides.

Major picture agencies are stressing the fact that the market for color pictures has undergone a tremendous change. "Ten years ago we avoided 35mm color because most buyers wouldn't consider it," says Peter Schults, President of Photo Researchers, Inc., Agency, in describing the about-face. "I credit the softening of prejudices in some markets, particularly editorial, to photographers whose terrific 35mm color shots are regularly reproduced in *Paris-Match*, *National Geographic*, and other prestige publica-

tions. Today, about 50 per cent of our stock-subject color is in this size. In specialized subject categories, the percentage is even higher. I'd say that at least 75 per cent of our nature and science color is in the 35mm format."

The Director of another prominent New York agency (who prefers to remain unnamed) says: "As of now, about 90 per cent of our color is 35mm size. Given a choice, we actually prefer 35mm color to 2¹/₄" × 2¹/₄" transparencies. 35mm film gives a photographer more exposures to a roll, a wider choice of film emulsions, and a better picture-framing format to work with. This gives us more pictures to work with in both variety and volume."

There is one important point to keep in mind: If a buyer or agent specifies 35mm color transparencies, *don't* send him color prints.

35MM BREAKTHROUGH IN EUROPEAN MARKETS

The market for 35mm slides overseas is not as bright as it is in the United States and Canada. There are exceptions, however, which we will discuss later in this section.

Generally speaking, most overseas buyers stipulate 2¹/₄" × 2¹/₄" as the smallest transparency size they will handle. Larger sizes are consid-

erably easier to sell to overseas clients. Buyers will rarely, if ever, consider color prints. Note that overseas buyers are sticklers for their standards of reproduction quality.

Many American photographers feel that overseas buyers lean toward color that, by North American standards, is considered ¹/₂ stop over-

exposed. Whether true or not, pictures with a slight degree of extra brightness seem to be more acceptable than those with saturated colors. It is a fallacy to think of overseas markets as an outlet for color that is slightly off-balance, or in any way less than top-notch quality. If anything, overseas buyers are more demanding than American buyers. Having transparency colors altered by professional lab techniques (as is common-place in the States) is virtually unheard of in some European countries.

Exceptions to the preference for large transparencies overseas are provided by the popularity of 35mm slides for use in television and on stage. Color television has recently opened new markets in England and Scotland.

Rear-projection techniques are responsible for many new overseas markets. The British Broadcasting Company, for example, often uses color slides to illustrate closed-circuit educational programs. Rear-projected color scenes also provide simple, realistic, and relatively inexpensive backgrounds for stage and TV actors, dancers, concert artists, and lecturers.

There are widespread advertising uses of color slides, too. As a man pours his chic friend a cup of tea, for example, color shots of half a dozen world capitals flash in sequence on the background to complement the theme: "Around the World, People Drink Glug Tea." Prices paid for slide uses depend upon the nature of use, frequency, and so on.

EUROPEAN MARKETS: ADVANTAGES OF COLOR PLUS BLACK-AND-WHITE

It is an excellent idea, in submitting pictures overseas, to combine black-and-white and color of the same subject. To quote the director of a prominent London picture library:

"One of the things a European photographer rarely does is 'cover' a subject in *both* black-and-white and color. If he shoots only in black-and-white and a buyer wants a color cover picture to go with an article, we are up a tree. If he has shot only color and the buyer wants black-and-white, we have to have monochromes made from the color transparencies, and the cost involved reduces the photographer's share of the receipts.

We particularly welcome American picture 'sets' of interesting subjects in which the 'key' or 'highlight' shots are in color, and the supporting pictures are in black-and-white. There is no set ratio between black-and-white and color we can suggest, because the importance of the subject is the deciding factor. But given an interesting subject likely to appeal to a substantial number of different types of buyers (editorial, advertising, box tops, greeting cards, calendars, and the like), one color shot to every six, twelve, or two dozen black-and-whites usually works out quite nicely."

COLOR FORMAT: VERTICAL OR HORIZONTAL?

Often a subject itself will dictate whether it can be effectively photographed in a vertical or a horizontal format. A seascape, for example, would probably suggest a horizontal format by its distribution of land, sky, and water. The Washington Monument, on the other hand, might call for a vertical format.

When a subject can be interpreted in color as effectively one way as the other, the photographer's choice of format should be governed by the publications he has in mind as possible buyers. Some publications (and this includes

advertising pamphlets and brochures as well as magazines) use only vertical transparencies on their covers; others make use of horizontal or even square transparencies. For interior use in the editorial or advertising portions of the publication, transparencies of several shapes may be used. The only way to discover the format preference of a specific publication is to analyze it carefully. The general procedures outlined in Section 4, "How To Analyze Photo Markets," can easily be applied to interpreting the color requirements of a publication.

Playing It Safe

Once in a while your knowledge of the potential markets for a particular picture may lead to a minor quandary. As an exaggerated example of what might occur, suppose you have a chance to shoot a subject that would have cover appeal for each of two competitive publications. Publication "A" uses vertical transparencies for its covers; publication "B" will consider only horizontal transparencies for cover use. How should you compose the picture in your viewfinder so as to make sure of at least two chances to market the final picture?

The easy way out, of course, would be to shoot two transparencies, one vertical and one horizontal. While the vertical transparency is away to market, the horizontal shot might remain home in a drawer. Or vice versa. Under no circumstances, of course, would basically simi-lar transparencies be offered to different competitive publications at the same time. (See "A Word About Ethics" at the end of Section 6, Part 4).

But suppose you had only one frame of color film left. How would you solve the vertical vs. horizontal format problem then?

One solution would be to imagine you were composing the picture for a square transparency, *regardless* of the actual physical shape of the film in your camera. The idea is to compose the picture in such a way that its main images can later be cropped (by the purchaser) to *either* a vertical or a horizontal format. Composing a picture in this manner may slow you down a bit until you get used to it, but it's a good trick to have in reserve against the day you have a one-shot-only chance to snap a saleable photograph.

COLOR: TIPS ON COVER SHOOTING

There is nothing haphazard about the way a buyer chooses a cover picture. The subject matter must, of course, be the kind that will appeal to his cash customers. But equally as important as the subject matter is the way the principle images are presented.

First of all, the main subject has to stand out in such a way as to attract attention. If the cover photograph is to go on a magazine, it has to have newsstand appeal; for an advertising booklet, it has to be able to compete for attention against other advertising booklets on a potential customer's desk. If the subject matter is to stand out clearly, the transparency should have a posterish quality about it, allowing the principal subject to be clearly delineated against a contrasting background. As a *general rule*, the safest background for a cover subject is a simple, solid-colored background that does not offer competition to the subject. A busy background full of blobs of color, blotchy highlights, patterns, or out-of-focus images tends to distract from the main subject, and hence is not a good cover bet.

Next in importance to the subject and background is the placement of the subject within the picture area. If you examine a number of magazine covers, you will note that the logotype (name of the magazine) almost invariably appears in either the upper left-hand corner or across the top of the magazine. Publishers know that these are the spots where a logotype has the best chance of being seen when the magazine is placed in a newsstand rack or on a counter.

Some magazines follow a policy of printing their logotype on a colored block or band that has no connection with the color transparency reproduced below it; other publications print their logotype *over* the background of the actual color picture they use. In either case, *nothing* will be allowed to seriously interfere with the legibility of the logotype. If a subject's head unavoidably threatens to impair the legibility of a logotype, for example, either the subject may be scalped, or the transparency may be rejected.

To be on the safe side, many photographers make certain that their main subject is placed well within the picture frame. This not only leaves room at the top for the logotype, but also provides space for blurbs (editorial or advertising copy) to be inserted alongside or below the subject if desired. If the extra copy space isn't needed, the buyer's art department can easily crop it away before the transparency goes to the engraver for enlargement and platemaking.

COLOR: SHOULD TRANSPARENCIES BE MOUNTED?

Transparencies represent a higher investment on the part of the photographer than a black-and-white print. They also require a great deal more protection than a photographic print.

Transparencies should *never* be submitted to buyers in glass mounts. The danger of damage by breakage is great. In addition, the buyer may want to perform a nose-to-emulsion examination of a transparency, and the glass imposes a nuisance.

As a general rule, transparencies up to $2^{1}/_{4}'' \times 2^{1}/_{4}''$ are best submitted in the slotted acetate sheets available from most photo supply houses. There are several different sheets to choose from: Two of the most practical designs accept twenty 35mm color slides or six $2^{1}/_{4}'' \times 2^{1}/_{4}''$ transparencies, respectively.

Most photographers use individual acetate sleeves to safeguard transparencies larger than $2^{1}/_{4}'' \times 2^{1}/_{4}''$.

COLOR: HOW TO CAPTION TRANSPARENCIES

Each slide should carry a file number keyed to your data-record system. This number, along with your name and address, is best printed on the cardboard mount of the slide itself. On each acetate sheet you should affix by sticker the index number and your name and address. Captions for small transparencies contained in cardboard mounts or acetate sleeves should be typed on a sheet of paper. (See previous section on captioning.) Each caption, of course, should be keyed to the transparency it describes, and the top of each caption page should carry your name and address.

In captioning a transparency larger than $2^{1}/_{4}'' \times 2^{1}/_{4}''$, the caption, together with the picture's identification number and your name, can often be typed on a narrow strip of paper and inserted in the individual acetate sleeve above or below the transparency.

COLOR: HOW TO MAIL TRANSPARENCIES

Protect transparencies to be submitted by mail with cardboard inserts, just as you protect black-and-white photographs. (See Part 1 of this Section for details.) Since your original transparencies can't be replaced in case something happens to them, we strongly recommend insuring them at the post office. Remember to enclose with the transparencies a check, money order, or sufficient postage to cover the costs of returning them the way you want them returned—i.e., first-class, registered, insured, and so on.

COLOR: WILL ACCEPTED TRANSPARENCIES BE RETURNED?

Unless a buyer purchases "all rights" (see "Publication Rights" in Section 6, Part 4) to a transparency, he should return it after his engravers are finished with it. A few buyers, unfortunately, are careless about this matter, even though they have purchased only "one time" rights to reproduce the transparency. As a rule, the buyer's intentions may be good, but by the time your transparency has cleared the engraver's he has already sent them a dozen new transparencies. Your transparency is no longer of critical interest to him and the truth is, he may have forgotten it.

Practically speaking, there is seldom much you can accomplish by force if you fail to get a transparency back after it has been reproduced. You can register protests with the publisher and various organizations if you like, but don't expect to gain much by it. The threat of being sued will rarely scare a buyer, because he knows that the value of the average transparency—now second-hand merchandise any way you look at it—generally isn't worth what the suit would cost you.

Persuasion will probably do more to help you

recover a missing transparency than any other tactic. If the buyer simply can't locate the transparency and you hound him enough, he may offer some sort of cash settlement to compensate for the loss. But think it over carefully before you press the matter that far; you may be jeopardizing your chances of selling him future work for the sake of a transparency you couldn't resell in a million years!

Remember also that many people handle a transparency after a buyer signs a check for its reproduction rights. Editors, artists, engravers, perhaps retouchers, production personnel—all have a hand in seeing the transparency through to final publication. If everything went well, your transparency should come home to roost in fairly good condition. If things went badly, it may look as if it came out second-best in a puma fight. The latter is a marketing risk you must be willing to accept.

SECTION 6

1. Why You Need Record Files

It is important that all professional photographers, full- or part-time, keep accurate data records. You want a system that can give instant answers, thus saving time and money—to say nothing of frustration.

A good set of record systems will enable you to find negatives and prints quickly and easily, locate model releases in a hurry, know where you sent a particular photograph or photographs, know the costs involved for any job or jobs, keep accurate track of your income, and keep comprehensive tax records.

The latter is of particular importance. You, as a free-lance photographer, full- or part-time, are entitled to deduct from your income tax returns all expenses directly incurred through your business activities. This includes supplies such as film and chemicals, depreciation of your equipment, entertainment that you can prove was a business necessity, and portions of the rental, light, and heat costs of your home if you operate an office, studio or darkroom there.

In order to benefit by income tax deductions, you *must* keep careful records. File all bills and record all losses, photographic donations to charitable organizations, and travel and messenger services incurred in business transactions.

Ideally, you should have several large file drawers, or better yet, two complete file cabinets: one for bookkeeping records, the other for filing negatives, contact proofs, model releases, and other data (such as source material to be used in text or captions) related to producing and selling your pictures.

NEGATIVES: RECORDING THE WHEN, WHO, AND WHERE

Strange as it may seem, a notebook and pencil are as important to the professional photographer as his camera. You should never rely on your memory for dates, the correct spelling of the names of people whom you photograph, or for the spelling of place names. Besides getting your subjects' names right, you should jot down all the relevant caption material you need.

It is during your shooting session, too, that you should get a model release signed, if one is needed. Thousands of photographers have lost sales because they failed to get model releases or the required caption material when they had the opportunity. Avoid this by making a notebook and pencil a part of your photographic equipment.

There is probably no "best" way to file negatives and prints. But below are two tried and true methods that have worked for many photographers.

THE KEY-NUMBER SYSTEM

The key to this system is a number written on the clear margin of each negative with India ink. Once this number has been assigned to a negative, everything pertaining to that negative is thereafter identified by the same serial number.

The *key-number* filing system is so flexible that each photographer can modify it to suit his particular needs. If a great number of negatives are to be classified and filed, it is a common practice to set aside two file drawers, one to

contain the actual negatives, the other to contain a record on each negative—a contact proof, caption data, sales and marketing notes, and other pertinent information. Data records, of course, are in each case keyed to the negatives they cover.

An accompanying subject-matter classification is also flexible. One popular method provides a three-way breakdown consisting of a major classification, a subdivision of the major classification, and the numerical notation of each negative appearing in the subdivision. This method is actually as simple as it is efficient. Here is how it works:

Each major classification is identified by a Roman numeral. Classification I, for example,

might be *Airplanes;* Classification II could be *Animals*; Classification III, *Babies*; and so on.

An *alphabetical* letter appearing after the Roman numeral usually stands for a subdivision of the main classification. Under Classification I *(Airplanes),* for example, the letter ''A'' might stand for *Commercial Planes,* the letter ''B'' might be used to identify negatives of *Sports Planes,* ''C'' could be assigned to *Jet Planes,* and so on. The number appearing after each subdivision letter would simply identify a negative's position in that subdivision. Hence a negative bearing the legend ''I-A-9'' on its clear margin would represent the ninth negative in the *Commercial Planes* subdivision of the general classification *Airplanes.*

Negatives and Prints: Wedded by the Numbers

The full negative number should be written in pencil in the upper left- or right-hand corner of each print made from a particular negative. If a buyer wants to purchase a print which arrived damaged, or wants a duplicate of a certain print, he can easily identify the print by number over the telephone or by wire.

In the *record file,* a notation of each time a

print from a certain negative has gone to market, and when and where it has been published, will complete its case history. If you think a case history isn't valuable, just let things get fouled up so that the same picture is used simultaneously by *competitive* buyers. The buyers involved will make you feel you haven't a leg to stand on, and they'll be right.

NEGATIVES AND PRINTS—THE BOOK SYSTEM

Whether you use the system just described or the book system, you should use a code for your negatives and contact sheets. The four-unit code is popular for the book method, but can be adapted to any system. A complete code number looks like this: 74-13-2-8.

This one is easy to remember and zeroes you in on any negative you may want. The figure ''74'' refers to the year; ''13'' signifies the shooting session, assignment, sitting, or job; ''2'' indicates this was the second roll of film used for that job; and the ''8''refers to the individual frame number.

As a rule, it is necessary to put only the first three numbers of the code on each strip of film. This is because 35mm and 120 roll film are numbered by frames. Use India ink and a fine-point pen to write the code on the film strip. If using a film that does not have numbered frames, you should use the full code number.

It follows that your contact sheet for a roll of

film should be coded too, with the same number as on the film. If the film has been properly coded with India ink, the number will print through when you make your contact proof.

If you shoot more than one roll of film on any job or sitting, each film and contact sheet should have its own job number. But, and this is important, the *job* number should be the same. Say you shot a fashion assignment and used several rolls of film. One film (and contact sheet) would be coded 74-13-1, the second 74-13-2, and so on. The year and job number are consistent; only the roll number changes. Your next job number would carry the code 74-14-1, and so on.

Now you have your negatives and contact sheets coded and it's time to file them in your book file. This is a ring binder. Put the negatives in their glassine envelope, fix them to the back of their contact sheet with transparent tape, and file. You may want to write the code on the glassine envelope in India ink for quick refer-

ence. The proof sheets can be punched with holes to fit the ring binder you have. Transparent acetate sheets, already punched, are available and give more protection to your negatives and proofs.

Some photographers use a piece of ruled, punched paper to type out an index to be included in each ring binder. Others prefer to have a separate ring binder for an index, one that catalogues all of the negatives and proofs in any number of other binders.

The method you choose to file your negatives is not as important as the fact that you do have a system, one that allows you to pull any negative you want quickly and without fuss.

FILING TRANSPARENCIES

There are numerous ways to file your transparencies, and they should be filed. First, you want to be able to get the ones you want in a hurry. Second, a good filing system protects your transparencies from dirt, dust, and rough handling.

The most common filing system, for those who don't have too many transparencies, is to keep them in the boxes in which they came back from the processor. Give each box a code number and keep an index.

On the other hand, the book or binder system is becoming increasingly popular. You can buy special plastic sheets that hold twenty 35mm transparencies and plenty of space to add your

(Left) A contact-print book carries the job negative numbers on the glassine negative sleeves. An index book carries the same code numbers of the negatives and provides a full description of the subjects involved. (Right) Several ways of filing small transparencies. However filed, each transparency should be numbered and index recorded. A separate file should record where the transparencies have been submitted, pertinent caption data, and sales that have been made. Photos by Al Maurizio.

code number. These sheets are hole-punched for a ring binder. You can get binders that will hold 400 transparencies or larger ones that will file 1,000 or more. Again, ordinary, hole-punched, ruled sheets can be used to make your index.

Still popular are the metal chests for storing transparencies, available in most photographic and department stores. They come in a variety of sizes, complete with index card, and offer safe storage.

Photographers who have a great number of transparencies and put on a lot of slide shows will often file their transparencies in the slide trays, whether box or rotary type. This makes good sense when you have gone to the trouble to edit a show and all of the slides are in proper sequence. The trays usually come with an index card. Identify each slide by number and each tray by subject.

WHO OWNS THE NEGATIVES—YOU OR YOUR CLIENT?

This problem frequently occurs: Someone hires and pays you for shooting some pictures. After you have delivered his photographs, who owns the negatives, duplicates, and surplus shots?

As a rule, the person who does the hiring owns the *photographs* and the right to do with them as he chooses. He does *not*, however, own the negatives, dupes, or extras *unless* ownership of them was stipulated in the hiring agreement.

On the other hand, even though the photographer owns the negatives, dupes, and extras, he may have no legal right to sell prints from them (or make use of them in any form of publication), without the consent of the person or company that hired him. For this reason, it is best to arrive at a written agreement *before* undertaking a job. If paragraphs of the agreement pertaining to possession and uses of negatives, dupes, and extra shots become complicated, consult a lawyer *before* you sign on the dotted line.

2. Model Releases

Why go to the trouble to get signed model releases when you take photographs? For your future protection, of course. And, strangely enough, model releases frequently have nothing to do with living models—people, that is. To put it simply: Your right to take a picture is one thing, but the right to make *commercial* use of a picture may be something else entirely.

Generally speaking (with certain exceptions to be discussed later), you may not sell or publish a picture without having first obtained the written consent of any person whose image figures predominantly and recognizably in that picture. Similarly, you may not use such a picture for advertising-display or promotional work without written consent. To do so—except in the special cases which will be discussed—is to risk legal trouble.

The typewritten or printed form that, after being signed by a subject, authorizes a photographer to sell or publish a picture in which that subject appears, is called a *Model Release*. It generally stipulates that in consideration of a certain fee (either cash, prints, or some other tangible value) mutually agreed upon, the subject grants the photographer permission to make use of the picture in any legal way he sees fit.

Some photographers use extremely short model releases; others go to the extreme of having a model and a witness sign up to a page and a half of finely printed ifs, buts, and wherefores. The accompanying sample release is average in length and contents.

Model Release *Date* *, 19*

In consideration for value received, receipt whereof is acknowledged, I hereby give (your name) the absolute right and permission to copyright and/or publish, or use photographic portraits or pictures of me, or in which I may be included in whole or in part, or composite or distorted in character or form, in conjunction with my own or a fictitious name, or reproductions thereof in color or otherwise, made through any media at his studios or elsewhere, for art, advertising, trade, or any other lawful purpose whatsoever.

I hereby waive any right that I may have to inspect and/or approve the finished product or the advertising copy that may be used in connection therewith, or the use to which it may be applied.

I hereby release, discharge, and agree to save (your name) from any liability by virtue of any blurring, distortion, alteration, optical illusion, or use in composite form, whether intentional or otherwise, that may occur or be produced in the taking of said pictures, or in any processing tending towards the completion of the finished product.

Model
Address
Parent or Guardian
 (Required only if model is a minor)
Witness

STAY ON THE SAFE SIDE

If you take a picture in the street to illustrate a news event or topic of current interest, you will be reasonably safe in selling that picture to a reputable publisher without having signed releases from the people who appear in the picture. Suppose, for example, you are in a crowd of people watching a fire, listening to a pitchman at a county fair, or berating a baseball umpire. If you make pictures of the crowd in general—the

reactions of people to what is taking place—you can usually sell those pictures for publication without signed releases. If you pick out one individual in the crowd and make a number of shots of him to illustrate a feature-type story, however, you should by all means obtain a signed release from him.

We have to use qualifying words like "reasonably safe" and "usually" in connection with

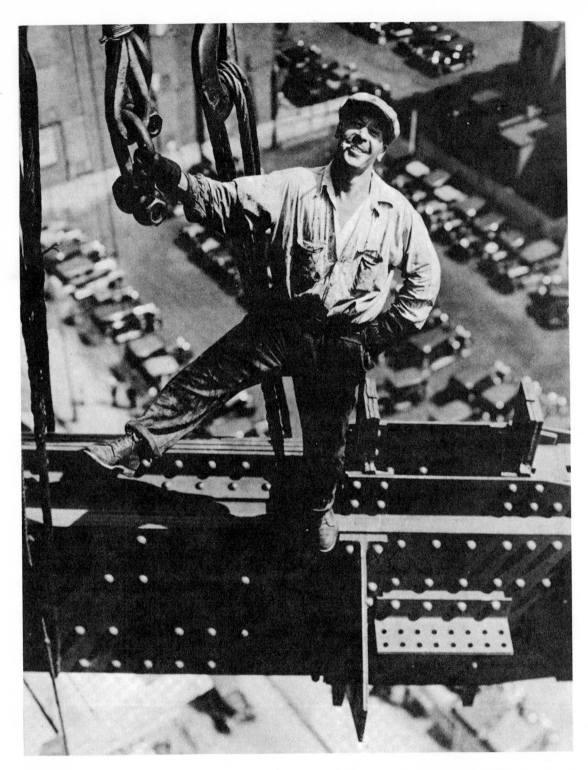

Is a signed model release needed for this photo? Emphatically "YES." Photographer Victor Keppler balanced nervously far out on a beam to get the exact photo requested by an advertising agency. An advertising client would not use the photo without a signed release. This photograph is reproduced by permission from the book *Victor Keppler, Man + Camera* (AMPHOTO).

Although the man in the foreground obviously doesn't want to be photographed, he is on a public street and a part of a series of scenes taken for editorial use. A signed release is not required in this case for he was not singled out for purpose of ridicule. Photo at right by Joe Palermo.

"Charged with Vagrancy" involves a stray dog placed behind bars for lack of better quarters for the night. This was originally a newspaper photo; but circumstances required no model release from the dog's owner—assuming he ever had one. Photo at left below by Jack Urwiller.

"Intruder" requires no release from the man on the horse because he is unidentifiable. A release from the model was of course a "must." Photo at right below by Peter Gowland.

model releases, because it would be misleading to make flat statements. There are exceptions to all cases. Much depends upon the photographer's sense of good taste in a picture. Much also depends upon how and where a picture is published. For example, suppose you photograph a famous actor walking into a hotel with his wife on one side and his leading lady on the other. This is an example of the kind of picture that you could ordinarily publish without having a signed release. But suppose that at the instant you snap the shutter the actor's wife turns aside in such a way that, from your camera angle, she is not visible at all. Innocent though the situation was, the resulting picture *could* be used by unscrupulous publishers in such a way as to damage reputations. Before you sell a picture you have doubts about, show it to the people involved and see if they will give you a signed release. If they won't sign a release, take it as an indication of the unpleasantness that *might* result if you published it anyhow.

The best rule in connection with model releases is to *play it safe.* If it is possible to obtain a release, get it, even though you don't think you will need it. There is always the possibility that the picture might interest an advertiser who would have to have a signed release before he would buy the picture.

With or without a signed release, there is an exception to your right to photograph certain people in the street, even though they are newsworthy. This exception occurs in connection with persons protected by state or city laws. Minors involved in juvenile delinquency, rape victims, and others protected by law cannot be photographed on the grounds that they are news-

worthy. If you expect to do much work with a news angle to it, *check* your state and city laws first. You will undoubtedly learn that while the people mentioned above are protected by law, an adult convicted of a crime has forfeited his right of privacy and can be photographed whether he likes it or not.

By the nature of their vocation, actors, politicians, athletes, business magnates, and movies stars sacrifice some of their private rights while they are in public places. You may usually publish a picture of a movie star, for example, without his written consent, *provided* no element of libel or breach of contract or confidence exists in the final result or in the method by which the picture was obtained.

The fact that people who live in the public limelight are more or less fair game does not give you the right to invade their privacy or photograph them haphazardly. If they say "No" to a photographer when they are in their own home or on their own property, then "No" it is. Moreover, a subject's permission to shoot and publish a picture is of no value to a photographer if the subject happens to be in a courtroom, theatre, or nightclub where the judge or manager says, "No pictures."

• *Overseas.* Distance and the fact that relatively few people in the States see foreign publications tend to offer a photographer more protection than he enjoys in the home markets. Rather than rely upon such uncertain protection, however, it is far wiser to consider the overseas markets the same as American markets in matters pertaining to model releases. This is particularly true when pictures taken in the States might be purchased overseas for advertising accounts.

ADVERTISING PICTURES: MODEL RELEASES A MUST

The need for a model release becomes a *must* when taking advertising pictures. In fact, it may include objects as well as people. If you plan to quote a person who appears in an advertising picture, get a signed statement to the effect that what you quote him as having said is accurate and acceptable. Keep in mind, too, that you may need a signed statement granting you the right to include his possessions and/or certain background objects in an advertising picture.

To clarify these points, imagine a situation in which a free-lance photographer, Joe, is picture-hunting on a private golf course. A young man has just sliced a drive into a sand trap. His girl friend (beautiful, of course!) watches him try to blast out of the trap and gives him the needle: "Been skipping your spinach lately?"

Joe snaps a picture at this point and manages to get a signed photo release from both the girl and her boy friend. Then he remembers the girl's

remark and wonders if a spinach canning company might be interested in the picture *and quote.* So Joe writes out the quotation and gets a signed statement from the girl to the effect that the quotation can be used verbatim or in a similar variant. At the same time he thoughtfully has the young man sign his name to a statement that it is okay by him to be the obvious recipient of the remark.

At this stage of the game, the girl's pedigree poodle rises from the grass and stretches. Since the dog was in the picture, Joe decides to play it safe by getting a release on it, too. Then he looks around and, sure enough, finds one more thing to be cleared—a sign in the background that identifies the private club. For this release he has to contact the club manager.

A lot of trouble? Yes, especially when Joe doesn't even know that the picture will find a buyer. But a picture used for advertising purposes commands many times the price the same picture would ordinarily bring for editorial use. And unless a picture is *completely* covered by signed releases, an advertising agency, and the agency's client, will have no part of it. In many instances both the agency's legal department and their client's legal department must approve all releases before a photograph can be used.

THE PHOTOGRAPHER'S MORAL OBLIGATION

Under no circumstances does a subject's signature release a photographer from certain moral obligations. If a picture is indecent to begin with, or if it is cropped, altered, or otherwise used in such a way as to bring disgrace or ridicule upon a subject, the photographer might just as well forget about his signed release. Similarly, if the caption material accompanying a picture is erroneous or misleading in such a way as to bring shame or derision upon a subject, the photographer is again in hot water. Written consent to use a picture has no bearing whatsoever upon laws governing obscenity or libel.

This doesn't mean that a photographer can't crop, montage, or otherwise perform darkroom magic on a print in order to increase its saleability. As long as he uses good taste in the photographic end and is accurate in his caption writing, he can do pretty much as he pleases with a picture without risking unpleasantness.

SHOULD YOU INCLUDE RELEASES WHEN YOU SUBMIT PICTURES TO BUYERS?

You need not submit your original, signed model release with a picture. A carbon copy, a photostatic copy, or a photographic copy will usually satisfy a picture buyer that you are authorized to sell a print.

A separate model release is not required for each of a number of pictures featuring the same subject, if all were made at the same time under the same remunerative agreement. To avoid any possibility of misunderstanding, it is a good idea to note on the back of a release (*before* it is signed and witnessed) that it covers all photographs made during a specific shooting session with a subject who has been paid accordingly. Subsequent shooting sessions with that particular subject will require a new release unless, of course, the photographer and model work out some sort of blanket agreement that covers all the photographic results they achieve.

If several models appear in a picture, a separate, signed release is required for each model. If a subject is a minor, the release must be signed by his parent or guardian.

Never submit a picture requiring a model release to a buyer unless you physically possess a release to show him. To submit a picture with a promise to send or obtain the necessary release later is as unbusinesslike as trying to sell an automobile with the promise that an engine can be supplied later if the prospective buyer is really interested.

• *Overseas.* When submitting pictures overseas, observe the same rules pertaining to model releases that apply in the United States. You should not include your original, signed releases with pictures, but you may, if you like, include photostatic copies. It will usually suffice merely to indicate in the caption of a picture that signed model releases are available.

3. Mind the Law: Rules and Regulations

Contrary to a widely held belief, professional photographers do not have the right to set up shop wherever they want to. Usually there are local or state laws, or both, to be considered. Nor can a photographer take a picture just anywhere he pleases. Here, too, there are rules, regulations, and restrictions that must be observed.

The problem is that laws vary from community to community and from state to state; therefore, as a professional photographer it is important that you know and abide by the laws of the areas in which you will be working.

For example, in many communities a photographer must purchase a permit or license in order to practice his profession. In some cases this would be a vendor's permit, since he is selling a product (a photograph). Some states also demand that he have a permit because he must collect a sales tax to be turned over to the state. In some areas you may need a permit for your studio and a different permit for doing photography outside your studio on location.

The laws vary so greatly, and change so frequently, that it would be impossible to list them all. As a photographer you must take steps to protect yourself by checking on local zoning regulations, types of licenses required, taxes to be charged, and whatever special permits may be necessary.

If moving into a new community to open a studio, you can check with the Chamber of Commerce to learn which laws on the books may affect your business. If the Chamber of Commerce doesn't have all the answers (though they usually do), play it safe and consult a lawyer.

Remember, too, that a permit to operate a studio does not necessarily mean that you can conduct other operations in the photographic field. If you plan to sell and/or repair cameras and photographic equipment, you may need additional permits and/or licenses. The same is true if you are going to do developing and printing for outsiders or plan to make or sell picture frames.

Also check into *state laws* before opening for business. It could save you a lot of headaches and not a few dollars.

WHEN DISCRETION PAYS

Photographers trying to take pictures of a news happening on a public street have often been told: "No pictures! Clear out!" This may happen at the scene of a fire, a crime, a riot or demonstration, or even during a peaceful parade. Are the photographers' rights being violated? Probably, but sometimes it doesn't pay to argue.

The photographer is walking on thin-shelled eggs when he tries to take pictures at a disaster scene. There may be no *formal* restrictions; usually there are none. However, he may run into mountains of resentment and opposition. Photographers are often considered ghoulish when taking pictures of death and tragedy. Spectators at such a scene are frequently more of a problem than the authorities. They are in no mood for cameras. Sensing the mood of the people, police officials will sometimes restrict the movements of photographers. That old standby, a disorderly conduct charge, can be instantly applied against a photographer who is too insistent. A disaster scene is not the place to argue about your rights. Try to get your pictures unobtrusively and without opposition.

It is understandable that a photographer may become aggressive when on the scene of a big action story. He wants to get his pictures. On the other hand, the firemen and policemen who are also trying to fulfill a job sometimes resent people getting in their way or otherwise hampering their work. In the heat of the moment they may order a photographer out of the way. Some officers seem to resent the presence of photographers at any time and need little excuse to get tough. A determined photographer may get his pictures in spite of opposition but he can also be

arrested. A good working relationship with the police and firemen as well as other officials is always your best bet. This is easy if you live in a small community; it may be tougher if you have come from the outside to cover a news event, but is still worth a try.

Theoretically, you have every right to take photographs on public streets and highways (with a few exceptions). However, under the pressures of a major news event, when police officers have trouble on their hands, you can rarely win an argument about rights. It is usually wise to find another location and try to continue your coverage. Later, if you wish, you can lodge an official protest and possibly get some satisfaction.

Many museums and art galleries prohibit the taking of pictures. Artists and museum officials are sensitive about their works of art and their collections; they want no copies made by and sold by unscrupulous photographers. Consider, too, that many museums operate at a loss or are heavily subsidized and earn income by selling reproductions of major works in their possession. Always ask permission.

The same is true when taking pictures at an art festival. You should obtain permission to take pictures from *both* the director and the individual artists. Most artists don't mind long shots, showing an entire exhibit or part of it. They may even permit a close-up of one painting, though they will often want to get into the shot themselves.

ZOOS CAN BE RESTRICTED, TOO

Strange as it may seem, many zoos prohibit the taking of pictures of animals, especially for commercial use. Still others will sell you the right to take pictures for a flat fee with the understanding that any picture used commercially will give a credit line to the zoo. For example, during a visit to the famous Frankfurt Zoo in Germany the author was charged $2.50 for such a permit. It was worth it!

There are so many rules and regulations restricting the photographer that you should make it a policy to ask about restrictions *before* you start shooting.

BEACHES, THEATERS, ICE SHOWS, HOUSE AND SENATE

Photography is prohibited at many privately owned and some public swimming beaches and pools. This is on the theory that the people there are entitled to privacy, regardless of how scantily clad they may be.

Some churches have a ban against photography within the church; others welcome photographers. Always ask first. When shooting a wedding, you actually need the cooperation of the person performing the ceremony, and by simply asking, you usually get it. Even then, however, you may be refused permission to take pictures inside the church.

It is against the law to take pictures from some bridges and around a number of military installations. Check and make sure. Some of the restrictions that date back to World War II have never been erased from the books.

You might as well forget taking pictures in a movie theater if you have selling them in mind. Though management may allow it, motion pictures are protected by copyright. There are copyrights covering TV programs as well.

It is often difficult to take pictures, especially with flash, during the performance of a stage play. Even if the management permitted it, the actors and actresses would probably howl. The glare of flash is distracting to both the cast and the audience. Since many shutters are noisy, you may not be permitted to take pictures even if you use natural light. However, both cast and management are often most cooperative when you seek permission to photograph them during a dress rehearsal. This is actually desirable because you can move around, change lenses, and come up with superior results.

Circuses and ice shows are often most cordial with photographers. At times they will hold

DO THESE PHOTOS REQUIRE RELEASES OR PERMITS TO BE PUBLISHED? The Weimaraner is the personal property of a proud owner. The owner's permission in writing (model release) is a "must" before the photo can be published. Photo by Walter Chandoha.

The buffalo are likely a private herd or on government property. In either case, written permission (a permit) may be required before the animals can be reproduced in any form of commercial use. Photo by Herb and Dorothy McLaughlin.

The same holds true for this photograph as described above. Always check about permits before you photograph wildlife on reservations or sanctuaries. Photo by Jack Urwiller.

If you photograph in a zoo, make sure any picture you intend to use commercially is covered by a permit. This holds true for shooting commercial photographs in parks, on city streets (if models are involved), and many places such as restaurants, beaches, and so on. Photo by Peter Gowland.

special photo nights so anyone in the audience has a chance to take pictures. Sometimes a few restrictions are applied, such as no flash during a dangerous moment—during trapeze and high-wire acts, for example—or when a flash could be distracting.

Taking pictures in the House and Senate generally rates a "No." There is also a ban on photos in the Congress, except when both houses meet in joint session. Better check even then. The same applies in taking pictures in state legislatures: Check before you attempt to shoot.

RESTRICTIONS IN COURTHOUSES, PRISONS, HOSPITALS, AND ON MILITARY PROPERTY

You may stir up a hornet's nest if you try to take pictures in a courthouse, whether federal, state, or local. Picture taking is banned in nearly all courthouses. In fact, you may even be restricted from taking photos on the property on which the building stands. In the United States, the decision is left to the presiding judge. In Canada, the restriction is general. By all means check before trying to take a camera into a courthouse.

Most prisons and jails have restrictions against the taking of pictures, particularly of inmates. This is true, too, of many hospitals and mental institutions; they don't want pictures taken of patients. It's another case of check and be sure.

Be careful of taking pictures of, or in, military installations. They are often restricted areas from ground or air. There are exceptions, such as at West Point in the areas seen by the average tourist. But elsewhere, don't even carry a camera without permission.

PERMITS

You might suppose that a professional photographer could shoot an ordinary parade from any vantage spot and move about freely to get the angles he wants. Such is not always the case. You may require special passes and be restricted to a certain area when shooting a parade. In Washington, D.C., for instance, you may have to get from six to a dozen special passes to cover a big parade. Always check with the local police department to see if passes are required or if certain areas are restricted. This is particularly important if a high official from any country is participating in the parade.

Sporting events are well covered by authorized or accredited photographers; in many instances a professional outsider can't simply take his camera and start shooting. There are restrictions, and it is wise to check with the proper authorities before you plan to cover any major sporting events, such as college and professional competitions. This stands to reason. If there were no restrictions you might have 10,000 "photographers" on free passes at an important event. Get accredited first, then shoot.

4. Copyrights and Publication Rights

Photographers seldom bother to copyright run-of-the-mill pictures because it is not worth the time, effort, or fee involved. Nor is the danger of theft that great. Should you happen to capture a valuable scoop on film, however, these are the basic facts you should know about securing protection under the copyright laws.

PURPOSE OF COPYRIGHTING

The Copyright Act is designed to protect a photographer against having his photographs copied, reproduced, distributed, or published in the USA or its territories without permission. Under the *common law* copyright, a photographer has a right to be the *first* to publish his pictures. The thing to remember is that merely exhibiting a photograph may be to "publish" it. Having thus been published, it becomes public domain if there is no copyright on it, in which case the photographer waives all future rights to it. To retain his rights, he needs a *statutory* copyright.

Most publications obtain a statutory copyright on the photographs they print in each issue. For years, many photographers have concluded that the publication's copyright protected their photographs printed therein from falling into public domain. Circular 42A of the Copyright Office of the Library of Congress reads: "Court decisions have indicated that an individual contribution [such as a photograph—Ed.] is not protected by a general notice unless the periodical publisher has first obtained ownership, or at least the right to secure copyright, in the contribution itself. In other words, copyright in a contribution may be lost altogether unless the contribution is published with its own notice, or unless an agreement concerning its copyright ownership has been worked out before publication."

This statement, as it became known, came as an unpleasant jolt to free-lance photographers. However, a new development, *not incorporated in Circular 42A at this writing,* has reversed the above statement. The Second Circuit Court, in Goddis v. United Artists Television, Inc. (March 9, 1970), said: "Although placing a special notice in the author's own name on each installment [or photograph—Ed.] appearing in the magazine would be a more careful practice than we find here, we do not think that failure to do so, by itself, should cause an author to suffer forfeiture." The publisher, in the above case, was therefore deemed the holder of the copyright for the benefit of the author.

HOW TO COPYRIGHT A PHOTOGRAPH OR CONTACT PROOF SHEET

As pointed out earlier, most photographers don't bother to copyright run-of-the-mill photographs. But let's suppose now that you someday come up with exclusive shots of four green Martians inside their flying saucer. Your first thought should definitely be to protect your pictures with a claim to copyright. Here is what to do:

Write or wire the Register of Copyrights, Copyright Office, Library of Congress, Washington, D.C. 20540. Ask for "Form J" for each picture you want to protect. (In the event that a "set" of related pictures is published as a single unit, it might be possible to apply for a single registration upon one application form and at a single fee.) Form J (see sample) is an "Application for Registration of a Claim to Copyright in a Photograph." Also ask for a copy of Circular 42A, which is a general copyright instruction sheet. A fee of six dollars per picture is payable at the time you return the Form J applications to the Copyright Office. In return for this fee you will be issued a certified "Certificate of Registration of a Claim to Copyright in a Photograph," or in some cases a "set" of pictures. This protects

Page 1

Application for Registration of a Claim to Copyright
in a photograph

FORM J

CLASS	REGISTRATION NO.
J	DO NOT WRITE HERE
	JFO JP JU

Instructions: Make sure that all applicable spaces have been completed before you submit the form. The application must be **SIGNED** at line 9. For published works the application should not be submitted until after the date of publication given in line 4 (a), and should state the facts which existed on that date. For further information, see page 4.

Pages 1 and 2 should be typewritten or printed with pen and ink. Pages 3 and 4 should contain exactly the same information as pages 1 and 2, but may be carbon copies.

Mail all pages of the application to the Register of Copyrights, Library of Congress, Washington, D.C. 20540, together with:

(a) If unpublished, one complete copy of the work and the registration fee of $6.

(b) If published, two copies of the best edition of the work and the registration fee of $6.

Make your remittance payable to the Register of Copyrights.

1. Copyright Claimant(s) and Address(es): Give the name(s) and address(es) of the copyright owner(s). For published works the name(s) should ordinarily be the same as in the notice of copyright on the copies deposited. If initials are used in the notice, the name should be the same as appears elsewhere on the copies.

Name ..

Address ..

Name ..

Address ..

2. Title of Photograph: ..
(Give the title as it appears on the copies; each copy deposited should bear an identifying title, which may be descriptive)

..

3. Author: Citizenship and domicile information must be given. Where a work was made for hire, the employer is the author. The citizenship of organizations formed under U.S. Federal or State law should be stated as U.S.A. If the copyright claim is based on new matter (see line 5) give information about the author of the new matter.

Name .. Citizenship ..
(Name of country)

Domiciled in U.S.A. Yes No Address ..

▶▶ NOTE: | Leave all spaces of line 5 blank unless your work has been PUBLISHED. | ◀◀

4. (a) Date of Publication: Give the complete date when copies of this particular photograph were first placed on sale, sold, or publicly distributed. The date when the photograph was made or the date when copies were reproduced should not be confused with the date of publication. NOTE: The full date (month, day, and year) must be given.

..
(Month) (Day) (Year)

(b) Place of Publication: Give the name of the country in which this particular photograph was first published.

..
(Name of country)

▶▶ NOTE: | Leave all spaces of line 5 blank unless the instructions below apply to your work. | ◀◀

5. Previous Registration or Publication: If a claim to copyright in any substantial part of this work was previously registered in the U.S. Copyright Office in unpublished form, or if a substantial part of the work was previously published anywhere, give requested information.

Was work previously registered? Yes No Date of registration Registration number

Was work previously published? Yes No Date of publication Registration number

Is there any substantial **NEW MATTER** in this version? Yes No If your answer is "Yes," give a brief general statement of the nature of the **NEW MATTER** in this version. (New matter may consist of compilation, abridgment, editorial revision, and the like, as well as additional pictorial material.)

EXAMINER

Complete all applicable spaces on next page

6. If registration fee is to be charged to a deposit account established in the Copyright Office, give name of account:

7. Name and address of person or organization to whom correspondence or refund, if any, should be sent:

Name .. Address ..

8. Send certificate to:

(Type or print name and address)

Name ..
Address
(Number and street)

(City) (State) (ZIP code)

9. Certification:

(Application not acceptable unless signed)

| I CERTIFY that the statements made by me in this application are correct to the best of my knowledge. |
| .. |
| (Signature of copyright claimant or duly authorized agent) |

Application Forms

Copies of the following forms will be supplied by the Copyright Office without charge upon request.

Class A — Form A—Published book manufactured in the United States of America.

Form A-B Foreign—Book or periodical manufactured outside the United States of America (except works subject to the ad interim provisions of the copyright law).

Class A or B — Form A-B Ad Interim—Book or periodical in the English language manufactured and first published outside the United States of America.

Class B — Form B—Periodical manufactured in the United States of America.

Form BB—Contribution to a periodical manufactured in the United States of America.

Class C — Form C—Lecture or similar production prepared for oral delivery.

Class D — Form D—Dramatic or dramatico-musical composition.

Class E — Form E—Musical composition the author of which is a citizen or domiciliary of the United States of America or which was first published in the United States of America.

Form E Foreign—Musical composition the author of which is not a citizen or domiciliary of the United States of America and which was not first published in the United States of America.

Class F — Form F—Map.

Class G — Form G—Work of art or a model or design for a work of art.

Class H — Form H—Reproduction of a work of art.

Class I — Form I—Drawing or plastic work of a scientific or technical character.

Class J — Form J—Photograph.

Class K — Form K—Print or pictorial illustration.

Form KK—Print or label used for an article of merchandise.

Class L or M — Form L-M—Motion picture.

Form R—Renewal copyright.

Form U—Notice of use of copyrighted music on mechanical instruments.

FOR COPYRIGHT OFFICE USE ONLY	
Application received	
One copy received	
Two copies received	
Fee received	
Renewal	

Page 2

Page 3

Certificate
Registration of a Claim to Copyright
in a photograph

FORM J

CLASS	REGISTRATION NO.
J	DO NOT WRITE HERE

This Is To Certify that the statements set forth on this certificate have been made a part of the records of the Copyright Office. In witness whereof the seal of the Copyright Office is hereto affixed.

Register of Copyrights
United States of America

1. Copyright Claimant(s) and Address(es):

Name ..

Address ..

Name ..

Address ..

2. Title of Photograph: ..
(Title of photograph as it appears on the copies)

..

3. Author:

Name .. Citizenship ..
(Name of country)

Domiciled in U.S.A. Yes No Address ..

4. (a) Date of Publication:

..
(Month) (Day) (Year)

(b) Place of Publication:

..
(Name of country)

5. Previous Registration or Publication:

Was work previously registered? Yes No Date of registration Registration number

Was work previously published? Yes No Date of publication Registration number

Is there any substantial **NEW MATTER** in this version? Yes No If your answer is "Yes," give a brief general statement of the nature of the **NEW MATTER** in this version.

EXAMINER

Complete all applicable spaces on next page

6. Deposit account:

7. Send correspondence to:

Name .. Address ..

8. Send certificate to:

(Type or print name and address)

Name ..
Address
(Number and street)

(City) (State) (ZIP code)

Information concerning copyright in photographs

When to Use Form J. Form J is appropriate for unpublished and published photographs.

What Is a "Photograph"? This category (Class J) includes photographic prints and filmstrips, slide films, and individual slides.

—Reproductions. Reproductions of photographs prepared by photolithography and other mechanical processes are generally regarded as "prints" rather than "photographs" and, when published, should be submitted for registration on Form K.

—Contributions to Periodicals. When a photograph is first published with a separate copyright notice in a magazine or newspaper, it is regarded as a "contribution to a periodical," registrable on Form BB.

Duration of Copyright. Statutory copyright begins on the date the work was first published, or, if the work was registered for copyright in unpublished form, copyright begins on the date of registration. In either case, copyright lasts for 28 years, and may be renewed for a second 28-year term.

Unpublished photographs

How to Register a Claim. To obtain copyright registration, mail to the Register of Copyrights, Library of Congress, Washington, D.C. 20540, one complete copy of the photograph, an application on Form J, properly completed and signed, and a fee of $6. Deposits are not returned, so do not send your only copy.

Procedure to Follow if Work Is Later Published. If the photograph is later reproduced in copies and published, it is necessary to make a second registration, following the procedure outlined below. To maintain copyright protection, all copies of the published edition must contain a copyright notice in the required form and position.

Published photographs

What Is "Publication"? Publication, generally, means the sale, placing on sale, or public distribution of copies. Unrestricted public exhibition of a photograph may also constitute publication.

How to Secure Copyright in a Published Photograph:
1. **Produce copies with copyright notice.**
2. **Publish the work.**
3. **Register the copyright claim,** following the instructions on page 1 of this form.

The Copyright Notice. In order to secure and maintain copyright protection in a published work, it is essential that all copies published in the United States contain the statutory copyright notice. The notice should appear on the photograph itself, or, if the work is a collection of photographs in book form, on the title page or verso thereof. It should ordinarily consist of the word "Copyright," the abbreviation "Copr.," or the symbol ©, accompanied by the name of the copyright owner. The year date of publication may be included in the notice, but normally it is not required unless the work could also be regarded as a "book."

—Alternative Form of Notice. As an alternative, the notice for photographs may consist of the symbol ©, accompanied by the initials, monogram, or mark of the copyright owner, provided the owner's name appears on some accessible part of the copies.

—Universal Copyright Convention Notice. Use of the symbol © with the name of the copyright owner and the year date of publication may result in securing copyright in countries which are parties to the Universal Copyright Convention which protection might not be obtained by use of either of the alternative forms of notice. Example: © John Doe 1970.

NOTE: If copies are published without the required notice, the right to secure copyright is lost and cannot be restored.

FOR COPYRIGHT OFFICE USE ONLY	
Application received	
One copy received	
Two copies received	
Fee received	

U.S. GOVERNMENT PRINTING OFFICE : 1970 O - 372-406 Feb. 1970—40,000

Page 4

you against use of your pictures without permission for a period of 28 years. At the end of that time, you may renew your copyright for another 28 years, for an additional fee. Should anything happen to you, the copyright on your photographs becomes the property of your legal heirs.

It is also possible to secure copyright for a contact proof sheet. A contact proof sheet usually contains 12, 20, or 36 contact proofs made from a single roll of film. Such a contact sheet may be copyrighted for a six dollar fee and each picture on the contact sheet will then be protected by copyright.

COPYRIGHTS: THE TIME ELEMENT

Getting back to your Martian shot, what about the time element? These are clearly exclusive shots, which you can't afford to sit on. Is there any way you can release them immediately, yet protect yourself against having them copied for commercial use before you receive official certificates of registration from the Copyright Office? The answer is, "Yes." You can protect yourself in such a way that, although you are not yet in actual possession of certificates of registration, you can publish the pictures, and anyone who makes commercial use of them without permission will be liable to a suit for damages. Here are the protective steps you should take:

1. In the lower margin of each *negative*, print the letter "C" and enclose it in a circle. (This can be done with India ink.) The symbol © stands for Copyright.

2. Write or print your name on the margin of the negative: © John Doe, 197-. Remember that what you print on the negative is going to appear later on the *face* of each enlargement made from that negative. So keep it neat.

3. As an added precaution, use a rubber stamp to repeat this information on the *back* of each print made from the negative.

The "notice of copyright" affixed to each negative and print is your protection against infringement. The law, however, provides for registration "promptly" after publication with notice.

• *Overseas.* Should you want to register a claim to copyright in a commercial print used in connection with an article of merchandise, or if you want to arrange for copyright protection with foreign countries, write the Register of Copyrights for specific information. You will find the Copyright Office glad to provide information on copyright laws and procedures.

DON'T INFRINGE YOURSELF!

A copyright protects you against having someone copy, exactly duplicate, reproduce, draw, or paint an exact likeness of your subject without permission. Conversely, you must take care not to market a photograph of any copyrighted painting, drawing, fabric design, trademark, and so on, without *written permission* from the copyright owner. In advertising pictures, particularly, it is often legally required to obtain permission from all the manufacturers of recognizable equipment or materials before a photograph can be put to commercial use.

THE PUBLICATION RIGHTS YOU SELL

When you submit a picture to a potential buyer it is important that you make it perfectly clear just what rights to reproduction you are offering for sale. The rights you offer will in some instances mean the difference between a large or small check, or even between acceptance and rejection. If you do not specify the rights you are offering, the picture buyer will assume certain rights and act accordingly. Should this lead to a misunderstanding later on, your chances of selling him another picture will be jeopardized.

Generally speaking, you have a choice of offering: (1) one-time publication rights for the use of a picture in a book, magazine, or for advertising purposes; (2) first publication rights; or (3) exclusive rights to reproduction.

ONE-TIME PUBLICATION RIGHTS

Most photographers offer one-time publication rights on their general run of pictures. When a sale is made, the buyer is entitled to make use of the picture only once in the publication for which it was purchased. If he wants to use the picture again at a later date, or in another of his publications, he makes an additional payment for it.

When a picture is submitted on one-time publication rights, it is assumed that the buyer will pay his standard rates for it. It is also assumed that the picture may have been published before and will certainly be offered for sale again. If the picture has previously appeared in a competitive publication, the photographer should mention when and where it appeared.

FIRST PUBLICATION RIGHTS

When a photographer indicates on the back of a picture that he is offering "first publication rights" on it, the purchaser usually expects to pay something above his normal price for the privilege of being first to make use of that picture. A sale of first publication rights does not, however, transfer permanent ownership of the picture to the purchaser. Once the original purchaser has exercised his right to be first to publish the picture, the photographer is free to offer one-time publication rights elsewhere. Further sales (one-time publication rights) can be made as long as the photographer can find new markets.

The chief drawback to offering first publica-tion rights on each new picture is the fact that a notice to this effect on the back of a print will scare off many potential buyers. Except for advertising and illustrating purposes in a relative-ly small group of publications, it is often not essential to a picture buyer that he be first to make use of a given picture. The buyer for a trade journal in the concrete construction field, for example, will not be interested in first publi-cation rights to a picture of a cement mixer when he can as easily use a stock photo for less money. In short, it rarely pays to offer first publication rights to other than top-notch mar-kets where a buyer feels that prestige is to be gained by being the first to use a picture.

EXCLUSIVE RIGHTS

When you sell exclusive rights to a picture, ownership of that photograph is permanently transferred to the purchaser. At no time in the future can you sell a duplicate of the picture or claim any of the revenue the purchaser realizes on it.

Some top-notch markets buy only exclusive reproduction rights to a photograph or color transparency. To obtain this right they pay considerably more than a normal rate for the picture. This is to compensate the photographer for the possible revenue he might have realized from multiple sales of the photograph.

Since the sale of "exclusive rights" may bring several hundred dollars for a picture that would otherwise earn only a fraction of that amount, why not offer these rights on every picture? The answer is that no one will buy exclusive rights to anything other than a very exceptional picture (or series of pictures). If, for example, you are lucky enough to be the only one to photograph a scene or event of tremen-dous importance, your pictures are the equiva-lent of a news reporter's scoop. This might be a perfect opportunity for you to hold out for a buyer of exclusive rights. If, on the other hand, several other photographers shot the same event that you recorded, holding out for a sale of exclusive rights would be a waste of time. The words *exclusive rights only* on the back of a photograph will mean instant rejection for a *routine* picture. No one will pay a premium for the same thing he can buy, figuratively speaking, for a dime a dozen.

Instead of buying permanent rights in a picture, many buyers purchase only the exclu-sive rights pertaining to a particular type of market, and only for a length of time that will

protect them from competitive duplication. A calendar company, for instance, might pay a premium for exclusive rights in a flower picture for a period of one year. At the end of the year, the photographer is free to resell the same picture wherever he can find a market.

CREDIT LINES

A credit line is something to think about *before* a picture is sold. In a sense, a credit line is a second payment to a photographer, particularly if he is just getting started on the road to building a reputation. The more pictures he has published under his credit line in quality publications, the more quickly his work becomes recognized among buyers.

The manner in which credit is given to photographers, or whether it is given at all, is a matter of policy with each individual publication. There is nothing a photographer can do to change that policy, especially after a picture has been accepted and paid for. The ideal credit-line practice, as far as a photographer is concerned, is that of placing his name somewhere near each picture he has published.

Instead of printing a credit for each picture, some publications include a credit line only in connection with pictures that are considered outstanding. Another prevalent practice is that of listing all picture credits together in a block of text appearing in the front or back of a publication. Although the latter method is better than having no credit at all, it is obviously less beneficial to a relatively unknown photographer than having his name appear alongside his picture.

Some stock-photo agencies include a photographer's name along with their agency's name in a credit line. Other agencies demand a credit line for themselves but *omit* the name of the photographer. Bear this in mind if and when you choose a stock-photo agency to do your selling.

INSURANCE: A CAMERA FLOATER POLICY

It doesn't take long for a free-lance photographer's cameras, accessories, and darkroom equipment to accumulate to the point of representing a sizable investment.

What happens when his equipment is stolen, lost, damaged, or destroyed? If he is uninsured, he will have to make up his losses as best he can. If he carries what is generally referred to as a *camera floater policy,* he will be partly, if not completely, reimbursed in one form or another.

Many of the larger insurance companies offer these special policies to cover photographic equipment, and the premium rate is extremely reasonable. Almost any good insurance broker can get a policy for you, or you can arrange for a policy yourself by simply calling up a few of the insurance companies listed in the classified telephone directory.

INSURANCE: LIABILITY

Suppose someone trips over your tripod and breaks his leg or a spotlight falls on your subject's head. There are hundreds of ways in which a photographer's equipment can contribute directly or indirectly to personal or property damage. If a lawsuit follows and the judgment is against him, the photographer may be financially crippled for years to come.

Liability insurance offers protection (in most cases) against this eventuality. Like automobile insurance, however, the degrees of coverage, cost, and actual pay-off reliability in case of serious personal or property damage varies from company to company. By all means look into it if you expect to do much free-lance work.

TAXES

As a professional photographer, you will need books that accurately reflect your income for Federal and, in some cases, State and City obligations. But in many areas, this is only the beginning. There may be a state income tax to be collected and remitted, a small business or corporate tax, annual permits or licenses to be renewed, and still other taxed or untaxed situations to contend with. State and local laws are inconsistent. It is literally a tax jungle nowadays, and the best advice you can be given is this: Don't guess. Pay an expert tax consultant a reasonable fee to make sure you are fulfilling everything demanded of you. And finally, keep these taxes in mind when you tackle the problem of pricing your work. If photography today no longer comes cheap, it is because costs of all types, including taxes, must be realistically figured into the price of your end product.

A WORD ABOUT ETHICS

Picture buyers and professional photographers may not be angels but they rarely short-change one another intentionally. Regardless of how they grouse about each other, they share a mutual respect and trust; without good faith they couldn't do business together. It's essential.

To preserve his end of the good faith, a photographer must live up to a largely unwritten code of ethics. These are some of the things expected of him:

1. When a photographer submits duplicate prints to several picture buyers at the same time, as in the case of stock shots, he should *not* submit them to direct competitors. Photojournalists who duplicate text and picture-sets for simultaneous circulation should also avoid submitting identical material to buyers who are direct competitors. Always let one buyer reach his decision before submitting duplicate material to his direct competitor.

2. A photographer should never submit pictures for which he lacks necessary model releases, or which contain caption he suspects of being inaccurate or untrue in any detail.

3. When a photographer is represented by a photo agency or personal representative, it is unethical for him to quietly deal with competitive agencies or to market duplicate shots directly to buyers without *first* making his position and intentions clear to *all* agents concerned.

4. If a photographer is assigned to do a job and is furnished film and supplies, he cannot ethically use his own film and time to photograph the *same* subject matter with the intention of selling his pictures to other markets, *unless* he has the permission of his employers to do so.

5. A photographer should not offer a buyer or agency a picture containing subject matter that violates federal or state laws. During national emergencies, ships, harbors, bridges, highways, and certain industrial plants are out-of-bounds to photographers. Juvenile delinquents and those unconvicted of an alleged crime are frequently protected by law. The responsibility for censoring questionable material *invariably rests first of all with the photographer*.

Most of the stock photos on these pages have been sold and re-sold (always on a "one-time publication rights basis") many times—a few have sold to as many as 30 to 50 different purchasers. These samples are but a fraction of the different types of subject matter sold through both "general" and "specialized" photo agencies around the world. A number of photo agencies are listed in Section 11, Part 22.

At the Beach. Photo by Gary Warren.

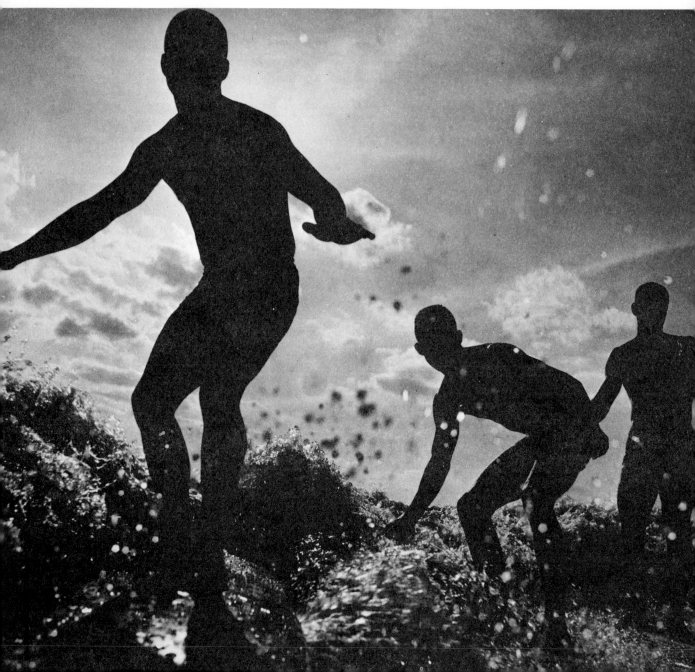

SECTION 7

Stock Photos—A Prime Source of Income

As a full- or part-time professional photographer, you will someday find that you have accumulated hundreds of striking photographs for which you have no specific market in mind. Some may consist of leftovers from a series of pictures that sold. Others may have been shot for markets that sputtered out, or that you reached too late, or that you anticipated (ecology, for example) long before actual markets began to boom. Still others, perhaps the bulk of your material, were shot spontaneously because the subject matter intrigued you, or because you had a few frames of film left on an otherwise exposed roll.

Any picture for which you have not sold exclusive rights is a potential stock photo. It can be sold again and again under one-time publication rights wherever you can find a buyer. For example, Walter Chandoha (see Section 8, Part 4), who specializes in animals, horticulture, agriculture, and nature photography, has stock photos that have been published in scores of magazines, books, and calendars. One shot of a goggle-eyed Weimaraner has sold 25 times.

Arthur d'Arazien, a well-known industrial photographer, has sold the same color transparencies again and again; one shot of an isolated, snowbound mountain cabin has thus far sold 18 times and earned over $5,000. Samuel Chamberland has supplied over 4,400 stock photos for calendars with subjects ranging from New England villages to European landmarks and French-Italian cooking. In recognition of his talents, Italy has awarded him the Stella della Solidatita, and France bestowed upon him the Legion of Honor.

Peter Gowland, Joe Clark, Herb McLaughlin, and countless other photographers have built stock-photo files that add substantially to their yearly income—and which will continue to do so for years to come with minimal effort on their part. Some free-lance photographers, having accumulated stock file photographs running into the thousands (or tens of thousands), advertise their wares to potential buyers by mail and sell to clients directly, thus realizing 100 per cent of the billing price. In many instances, they also provide stock-photo agencies with duplicates to be sold here and abroad. Although an agency charges a commission on each sale, it exposes a photographer's work to far more potential buyers than he (the photographer) could hope to reach. Moreover, the agency takes care of all the details of getting the photographs circulated, billing, collecting, and so on. More than a few photographers consider agency sales pure gravy income. For this reason, a number of photographers who once operated studios or had jobs as staff photographers have made a full-time career of concentrating on the production of stock pictures only.

WHY MORE BUYERS ARE TURNING TO AGENCIES

A survey of several hundred buyers for carrier lines (air, sea, and land transportation), travel organizations, advertising agencies, and publishers of every conceivable type, clearly indicates

that they all are relying more and more heavily upon picture agencies to fulfill their specialized needs.

While the buyers' reasons for this vary in details, the advantages they most consistently mention are easily understandable. From the buyers' point of view, stock agencies offer:

1. Immediately available selections of pictures to choose from. This eliminates searching for a competent photographer, making a firm assignment, and waiting for the results.

2. A far greater variety of material to choose from because an agency will submit, in quantity, the work of a number of photographers for the potential buyer's consideration.

3. Fairly standardized pricing and billing procedures.

4. Minimal contact and data-obtaining pressures. If the selected photographs are lacking in captioning details, the agency is responsible for obtaining whatever additional information the client needs.

5. No emotional reactions to total rejection. This factor is more important than it may appear. If the work submitted by an agency is rejected, nobody becomes incensed. Far too many individual photographers, on the other hand, including a number of long-time pros who should know better, react childishly to rejection. They demand an explanation by phone or letter, either of which imposes upon the client's time. Some go so far as to vent their disappointment by becoming accusative or even abusive. The worst offenders soon become known throughout the photographic field of buyers, agencies, art directors, and editors. Inevitably their sales suffer.

Total Loss. Photo by Irving Desfor.

Glacier Trails, Mt. McKinley Nat. Park. Photo by Dorothy and Herb McLaughlin.

AGENCIES: THE DIFFERENT KINDS

The basic function of any stock-photo agency (whether it calls itself a "library," "guild," "league," "service," or whatever), is to bridge the gap between those who produce pictures and those who put them to commercial use. Beyond this, individual agencies tend to be as dissimilar as the planets.

In size, agencies vary from a one- or two-man operation whose files contain photographs numbering in the thousands up to the big-leaguers who employ dozens of evaluators, filers, mailers, secretaries, administrators, and field salesmen. The heart of any agency is its picture archives, and the number of photographs held in stock by the giant agencies may total five million or more. A number of large agencies based in major cities have branch outlets in both North America and foreign countries. An even greater number of USA and Canadian agencies have no actual branches of their own overseas, but are affiliated with foreign agencies on an exchange-of-material basis.

Experienced buyers know that certain agencies specialize in specific subject categories. To illustrate this point—*and with no partiality or recommendation intended or implied*—let's say that a buyer is in need of pictures of a vintage horseless carriage, a girl in an ankle-length striped bathing suit, or other items of the mustache-cup era. His first (but not necessarily only) contact might be the *Bettman Archive*. This elegant emporium of not-always-ancient photographic nostalgia houses well over one million pictures, including reproductions of woodcuts, etchings, ads, and signs of all types.

For wildlife pictures, the buyer might think of the *Outdoor Photographers League*, the *Animals, Animals Agency,* or *Photo Researchers;* for church subjects, the *Religious News Service;* for Hollywood celebrities, *Globe Photos* would be a good bet; and so on through a long list of agencies that deal all or in part with specialized subject matter.

For general stock-photo subjects, any number of agencies can fill the average buyer's need. Some, however, lean more heavily to color than black-and-white or vice versa. Others specialize *within* their general area of operation. *Black Star* and *Magnum*, for example, are often thought of primarily as being picture-assignment agencies.

Cardinal Cushing at Funeral of Robert F. Kennedy. Photo by Tony Calabro.

categories of ecology, environment, youth, conservation, and winter sports; however, new special subjects are constantly cropping up. At least one agency that specializes in the combination of text with photos to produce complete-package offerings is working diligently on oceanography, medical research, and the foreign revival of interest in building large, safe, lighter-than-air dirigibles for intercontinental passenger service.

Some free-lance photographers file their stock photos with agencies that specialize in marketing specific types of subject matter—travel, sports, animals, girls, agriculture, and so on—reserving only their miscellaneous material for a general agency that covers all types of markets. The practice of splitting one's output of stock photos offers certain advantages so long as all agencies involved know about it and extreme care is taken to see that no two agencies *ever* have duplicates of the same pictures in their files.

Even so, there is a growing hazard in having too many agency fingers in the marketing pie. This is an era in which more and more special-interest magazines are being produced by individual publishing houses. Frequently the same art director or picture editor does the buying for several dissimilar special-interest magazines. Let's say that a picture editor orders photos on approval from three different agencies for three different special-interest publications. When they arrive, he discovers pictures produced by the same photographer in each of the approval consignments. Since agency prices are not standardized, one agency has offered its selection of the photographer's work at substantially lower rates than the other two agencies. Noticing the discrepancy, the art director is apt to decide that the lowest price is the *only* price he will pay for the work of that particular photographer. This being the case, the two higher-priced specialty agencies must either lower their prices or lose their sales. The situation just described actually happened a few years ago; with more and more art directors and picture editors doing the buying for whole stables of specialized magazines produced by the same publisher, some agencies currently insist upon being the *only* North American agency outlet for each photographer they represent.

In other areas, general stock-photo agencies have developed such specialized categories as fashion, sports, human interest, home-life, travel, documentaries, still life, and so on. Perhaps the favorite current specializations are in the

Man of Hong Kong. Photo by John Faber.

Serenity. Photo by Peter Gowland.

AGENCIES: HOW THEY OPERATE MECHANICALLY

By necessity, the following paragraphs describe the mechanical operations of stock-photo agencies as a whole. As mentioned previously, individual agencies may vary a great deal from the general pattern of operations.

When an agency agrees to market a photographer's pictures, it is with certain understandings, which may or may not be formalized with signed contracts. Whether or not contract-signing is involved, nearly every agency will gladly provide a printed list of the types of subject-matter they market, the sizes of black-and-white prints and color transparencies they prefer, the commissions they charge on each sale, and other pertinent data. A number of agencies also send periodic newsletters to their active photographers, telling them in advance which kinds of subject matter they are in particular need of. The first step a free-lance photographer should take when he becomes interestsd in selling through an agency is simple. He should query a number of agencies about their range of subject interests and procedures. (See Section 11, Part 22, for agency listings.)

In so doing, bear in mind that a constant influx of fresh material and new talent is the lifeblood of both general and specialized agencies. By contrast, assignment agencies are geared to handle the work of relatively few photographers effectively. It is therefore normally quite difficult for the average free lance to launch his career by obtaining the services of highly specialized assignment agencies.

Having selected an agency, the photographer's next step is to submit his "credentials" in the form of a few dozen of his best prints and/or color transparencies. If he likes, he can include a few contact sheets that will indicate the range of subject matter he can produce. In a brief accompanying note, he should give the agency an idea of *how many* stock photos he plans to submit immediately and how many and how frequently he expects to add to his collection. This is important, for it is costly to an agent in terms of paperwork and manpower to open a new account. The photographer who has only a few stock photos to start out with, and who expects to add to his collection in driblets, may be asked by a responsible agency to wait until he has more material on hand and can see his way to a more prolific output before joining the agency. This is sound advice.

With regard to size, most agencies prefer 8″ × 10″ black-and-white glossy prints, single or double weight, for filing convenience. This doesn't mean, of course, that 11″ × 14″ or unferrotyped prints are ruled out, but the agencies that actually prefer the latter are in a minority. 35mm color transparencies are becoming increasingly acceptable because a wider range of subject matter can be found in this format than in 2¼″ × 2¼″, 4″ × 5″, or larger transparencies. Pressured by the need for variety, agencies that wouldn't touch 35mm transparencies a few years ago are now including them in their file offerings. However, as Arthur Brackman of Freelance Photographers Guild said, "We still find the adage 'the larger the transparency format, the better the sales' still applies in the 70's the same as in the past." That this is true has been proven by several photographers who have shot the same picture in both 35mm and 4″ × 5″ format. Given his choice, a buyer has invariably purchased the larger transparency, even though he could sometimes have had the smaller one at a savings.

Let's suppose that arrangements have been made for you to begin building a file of stock photos with an agency of your choice. What happens when your pictures arrive at the agency?

First, they are gone over by a person trained to spot unsuitable material at a glance. What makes a picture unsuitable for your agency (though it might be accepted by a different type of agency)? Dated subject matter ranks high on the list: a scene in which a distant flag shows 48 stars; a city skyline that has changed radically since a picture was made; a street scene that includes outmoded cars, clothing, or hairstyles; and so on. Pictures with limited appeal are also born losers with most agencies—gory shots of accidents and crime, animals dressed up in supposedly cute costumes or obviously posed for strained-humor situations shots. Out, too, go the dull, cliché pictures that have been overdone or that have no center of interest or discernible reason for being. If a photograph is of a type that

Dandelion Seed. Photo by Harry Garfield.

The Morning Paper. Photo by Rohn Engh.

requires a model release, a copy of the dated and signed release should accompany the picture; otherwise, most agencies will return the picture with a note suggesting that it be resubmitted with a copy of the release. This is a far safer practice than accepting the picture immediately and then requesting a release, which may or may not be forthcoming later.

HOW TO SUBMIT PHOTOGRAPHS TO AGENCIES

In anticipation of some material being rejected, the photographer should, at least with his first few submissions, enclose a self-addressed mailing sticker and an envelope containing return postage. Some agencies refund all or part of the postage when they return reject material, but this should be their option.

As discussed in previous Sections each picture you submit should be easily identifiable with your name and index file number, and should be accompanied by a caption. Most agencies prefer that you *do not include your address* on stock photo material. If you do include your address, it will likely be obliterated before the picture goes to market. You can probably guess the reason. With the agency doing the selling job, it would be unethical for a buyer to pick up your address and contact you directly. After a sale has been made, it is equally unethical for a photographer to contact the buyer and attempt to promote further sales by sidestepping the agency.

Once an agency has accepted your photographs for marketing, they are carefully recorded and stamped or labeled with the agency's

113

Profile. Photo by Peter Gowland.

Closeup. Photo by Jack Lane.

name. Then they are usually filed by subject matter (*not by your name*) so they will be easily available for sending out, on approval, to potential customers. Thus, a batch of 100 of your pictures may wind up in 10, 30, 50, or even 100 separate files under different subject and sub-subject classifications.

HOW AGENCIES SELL

Each day the agent's mail brings letters and often long lists of pictures from clients requesting consignments of pictures on approval. More urgent needs arrive by telephone, telegraph, or cable. Thoroughly trained researchers immediately go to work, collecting the pictures that most nearly fulfill the client's specifications. The results of their efforts may contain anywhere from a dozen pictures to a hundred or more. These are recorded and delivered to the prospective client by the fastest means possible; on local requests they are often sent by messenger.

Some agencies also have field representatives who make appointments to call upon prospective buyers with parcels of photographs of the type they know the client regularly buys. Others daily solicit a list of selected clients by telephone or mail. However they go about it, the agency's sole function is to sell. It is not unusual for a picture to go to dozens of different prospects before it finds a buyer. Neither is it unusual for the same picture to sell dozens of times to different, noncompetitive buyers.

AGENCIES: OTHER SERVICES AND COMMISSION CHARGES

A few agencies buy negatives and color transparencies outright from a photographer; others insist upon having a professional custom lab make prints from the photographer's negatives; some keep the photographer's negatives on file so that fresh prints can be made as soon as a print is sold or becomes travel-worn. These agencies, however, are in the minority, and the commissions they charge on a sale vary according to their individual policies.

114

Togetherness. Photo by Rohn Engh.

Lobster Critic. Photo by Doug Richmond.

Sunset, Acapulco, Mexico. Photo by John Faber.

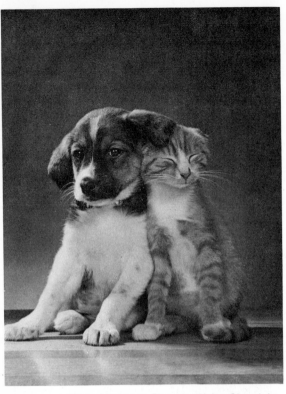

One-sided Love. Photo by Walter Chandoha.

The Grin. Photo by Rohn Engh.

Morning Haze. Photo by Rohn Engh.

Cover Girl. Photo by Peter Gowland.

The majority of stock-photo agencies pay the tab for recording and filing a photographer's work, sending it to markets, billing, collecting, remitting, and so on. In return for their services, they usually retain 40 to 50 per cent of the total price they receive for selling one-time publication rights in a photograph. As a rule, an agency can and does obtain more for the use of a picture than a photographer could obtain by himself. But the biggest advantage an agency has to offer is the *range* of prospective clients it has access to—literally dozens of potential markets the photographer never hears of, or couldn't reach if he did—and the persistency with which an agency continues to try to sell a picture long after the average photographer would have given up.

It is important to bear in mind that, aside from quality and variety, your income from stock photos will hinge upon how many good photographs you have working for you. By far the best income-producing policy is this: Start out with as many photos (literally hundreds, *not driblets*) as your agency will accept. Then budget yourself to as to how many additional new photos you will produce each month. Discipline yourself to meet this quota regularly; if you fall a little short one month, try to make up the shortage in the next period.

AGENCIES: THE TIME ELEMENT

The magnitude of labor and paper work involved in operating an agency is often underestimated by those who, having joined an agency, expect frequent reports, suggestions, and personal letters. They fail to realize that *selling*, not individual attention (except in rare cases), is the agency's *only* reason for being. Some agencies themselves are at fault for giving free-lance photographers the impression that they will receive frequent reports: Actually, no sizable agency has the time or manpower to do more than issue newsletters and related materials, remit checks after a sale has been made, or contact a photographer when a special request from a client calls for pictures in the photographer's specialty or locale. Beyond this, a free-lance photographer with a relatively small collection of photographs on file should not expect much person-to-person contact. Weeks, even months, may go by with the agency having no check to remit or any other reason to send a personal communication.

CONTRACTS AND RESPONSIBILITIES

Upon agreeing to try to market a photographer's material, some agencies insist that a formal contract be mutually signed; other agencies bypass formal signatures but do spell out their policies and operational methods in full. In perhaps a majority of agencies, a photographer must agree to leave his material on file for a minimum of one, two, or three years. This gives an agency time in which to try to make enough sales to at least break-even on the sizable expenditure involved in recording and circulating the photographer's work. Before the minimum file period became a common policy, many agencies took a heavy loss on "jumpers" (those photographers who frequently jumped from one agency to another over a short period of time).

Generally speaking, stock-photo agencies maintain their files under the most hazard-proof conditions they can contrive. It is to their own advantage to locate in buildings having fire-walls and to install sprinkler systems, so-called "fireproof" file cabinets, and the like. It is also in their best interests to have picture consignments delivered locally by messenger service or to make use of certified or insured mail. There is a limit however, particularly in the USA, to which an agency can assume responsibility for a photographer's material. This limit is usually expressed in terms similar to those you have read on the copyright pages of various magazines. In essence, a publication or photo agency promises to exercise "all reasonable care" in handling the material it receives, but can assume no responsibility beyond that point. This leads to the question of insurance.

Tired Huskies. Photo by S. Rothman.

The Sphinx. Photo by John Faber.

Coffee Bean Driers, El Salvador. Photo by Doug Richmond.

Pacific Breaker. Photo by Peter Gowland.

Connecticut Sunset. Photo by Jack Urwiller.

119

PHOTO INSURANCE

In itself, a photograph normally has no intrinsic value. That is why a manufacturer will reimburse a photographer for the cost of a roll of defective film, but rarely for what the photographer may feel his lost pictures were worth.

Normally, a stock-photo agency carries little or no insurance on the many thousands of pictures it carries on file. It can't afford to because the annual insurance premiums would be prohibitive.

This leaves the problem of insurance strictly up to the photographer. A few photographers carry insurance on their negatives—particularly those of subjects that have provided repeat sales. Prints are less frequently insured, because they can be replaced from the negatives. Top-quality color transparencies that can't be replaced are sometimes insured but more often are duplicated by professional custom labs. The majority of photographers, therefore, find the insurance premiums too steep to warrant protective coverage on their run-of-the-mill stock photos.

PERSONAL PHOTO AGENTS

At the beginning, a free-lance photographer will probably have to do his own selling in person, by mail, or both. It is only by *studying the needs* of various types of picture buyers that he learns when to snap a shutter and when to save his film. Until he knows this, the output of his camera is likely to consist of so little saleable grist that no stock-photo agency, much less a personal agent, will be interested in representing him.

A personal photo agent rarely represents more than a few noncompetitive, carefully selected free-lance photographers. Since his living depends upon selling their work and obtaining specific assignments for them, he chooses photographers who are (1) prolific producers of the *kinds of pictures* that well-paying clients want to buy, and (2) capable of handling special assignments with imaginative finesse. The personal agent maintains a constant study of specialized and unpublicized photo markets as well as TV, publishing, calendar, and other better-known, commercial picture outlets. If known to be a reputable agent, he has ready access to many buyers the average photographer never hears of, much less has a chance to meet.

Ideally, a personal photo agent puts all his time and energy into selling what a photographer has produced or can produce on assignment; meanwhile, the photographer is free to concentrate all his energies upon picture taking. With this kind of a working arrangement, a personal agent is often able to render the photographer specific picture-producing advice as well as marketing representation. In return for his services, the personal agent receives a commission. This varies up to about 25 or 30 per cent of the gross return on each picture, but it is a matter subject to arbitration under different circumstances. Whatever the commission agreement may be, it should be spelled out in contract form and be signed by all parties concerned.

SUMMARY WITH ADDENDA

1. Any photograph you take, except those to which you may have sold exclusive rights, is a potential stock photo. Many photographers have sold one-time publication rights in the same picture dozens of times, both here and abroad. The repeaters are the real money-makers.

2. Some photographers build up files of thousands of stock photos, which they advertise (usually by means of illustrated mailers or catalogs) and sell directly to clients. Others place their material in the hands of stock-photo agencies for marketing. The agency handles all the details and expenses connected with circulating the photographer's photographs. On each sale, the agency retains a commission of about 40 to 50 per cent of the price it receives. (Reference above pertains to the average agency and its operational policies. A few agencies have different procedures.)

3. General stock-photo agencies handle all

Collecting Grand Canyon stock-photo scenics. Dorothy and Herb McLaughlin.

Young Tama Indians, Iowa. Photo by John Zielinski.

types of subject matter in both black-and-white and color; specialized agencies limit the types of material they market; still others concentrate upon photo-plus-text feature materials, or assignments only. Some photographers divide their output by sending all their specialized subject matter, such as animals, and so on, to agencies that deal exclusively in one or two types of subject matter; their miscellaneous material then goes to a general stock-photo agency. It is poor policy to have duplicates of pictures in the hands of competitive agencies.

4. Most agencies have a subject-interest and policy sheet available upon request. These sheets warrant careful study and comparison before you submit a consignment of sample work. Note that many agencies require one to three years in which to try to market a photographer's work before they will attempt to recall his material from circulation.

5. A stock photo has no intrinsic value. To the best of the author's knowledge, stock-photo agencies in the USA rarely, if ever, insure the contents of their files. Even on a cost-of-materials basis alone, the premiums that would be charged on many thousands of pictures would be prohibitive. A few photographers take out insurance on their own work; the majority feel they can't afford it.

6. A personal agent devotes all his time to representing one—or at most just a few—noncompetitive photographers. He does most of his selling or assignment seeking by arranging personal appointments with prospective clients. The commissions charged by personal agents vary, but in metropolitan areas an average is 25 to 30 per cent (plus expenses) of the *gross* amount received on a sale of a picture already in his portfolio, or the same percentage on the *net* amount (which allows for the photographer's investment in props, models, and the like) that is received when he obtains a firm assignment.

A well-established personal agent can afford to be choosy about whom he represents and is therefore not only hard to locate, but also hard to entice. This has led to the development of a number of variations aimed to free a photographer from the time-consuming and often frustrating problems of marketing his own material. In some cases, photographers have found that a personal agent for artists will also present portfolios of photographs to prospective clients. In other cases, small groups of highly talented but noncompetitive photographers have been able to interest a personal agent in representing them collectively.

Surprising as it may be, the most effective personal agents in the field are often women. The dozen or more that immediately come to mind are not only charming and persuasive, but also have an above-average knowledge of photography itself. Each knows the exact capabilities of the photographer she represents, for as you have probably guessed, she is his wife.

Underwater Creature. Photo by Peter Gowland.

Jacob Deschin. Photo by Boris Goldenberg.

SECTION 8: TIPS FROM THE PROS

1. Education: The Classroom or the Mailman?

BY JACOB DESCHIN

Adapted by permission from *Invitation to Photography* © by Ziff-Davis Publishing Company.

Editor's note: Author Jacob (Jack) Deschin has few peers in the field of photographic reportage. For years the regular columnist on photography for the New York Times, *he has also authored many books, lectured, and produced countless articles for magazines in the photographic field. Currently editing a newsletter called "The Photo Reporter," he also manages three photo galleries featuring the work of little-known photographers, and remains a constant contributor to all types of photographic publications.*

There are two good ways to study photography. Which is for you? Line up the pros and cons of classroom versus home study of photography and, in some respects, it seems there is almost as much to say for the one as for the other. The quality of teaching in both camps has improved so vastly in the past decade or so that the comparison, once odious, now begins to make sense. As Victor Keppler (founder of the Famous Photographers School) points out, home-study schools in the past few years have considerably upgraded their entire training program. "All are approaching a point where they know that it isn't just a matter of textbooks alone (this is not home study)"—that it also takes better instructors and a closer relationship with the student through the mails on a "one-to-one" basis rather than, as Sol Mednick (head of photographic instruction of the Philadelphia Museum College of Art) observes, a case of "wholesale teaching and ready-made ideas."

Describing the advantages of the school classroom, Mednick comments: "The student has continuous involvement with what he is doing. You are in an environment where there are other people whose immediate involvement is the same as yours. Your presence in class permits exploration of ideas beyond the school curriculum, plus the daily environment of learning. There is possibility of dialogue."

Harry Callahan (head of photographic instruction at the Rhode Island School of Design in Providence) comments this way on the question of correspondence versus classroom instruction:

"The difference is that a college gives a broad education—in our school we have architecture, fine arts, liberal arts, design, and teacher education. This naturally covers many fields besides photography. I find this a rich environment to work in. In school the student is in constant association with his classmates and faculty. On the other hand, I certainly feel a good correspondence course serves a very real need. I believe this especially for people who are in no position to go to college."

Which kind of instruction for what kind of goal? Is the prospective student planning on a career in photography and in a specific area—commercial, photojournalism, medical, teaching? Or does he want training in the techniques

123

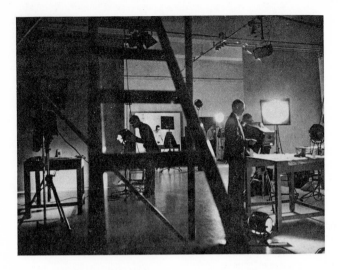

There is no single "best way" to obtain formal training in photography. Some students learn best in a classroom under the direct supervision of instructors and where there is an air of competitiveness with fellow students. The better resident schools of photography offer wider ranges of technical subjects because they have equipment and facilities not available to students pursuing a home-study course. In the long run, however, everything hinges upon the individual student—his personal drives, financial situation, locale, objectives and, above all, his will to learn and succeed. Photos by courtesy of Brooks Institute of Photography.

solely as an adjunct to a scientific, technological, or research career? Or is he an ambitious amateur who wants to stay that way and whose goal is only to perfect himself in the medium so as to express himself esthetically, for his personal satisfaction and artistic fulfillment?

One can, as many have, "pick up" self-training as one goes along, although admittedly this has two important drawbacks: The learning process takes much longer and is at best erratic; it is wasteful because it lacks organization, and mistakes are constantly being made that could have been avoided in a relatively formal course of training—classroom or correspondence. In self-training one can keep going over the same ground needlessly.

Because of the individual problems that keep coming up in the course of instruction, the classroom relationship is superior to that of the home-study method, says Walter Civardi (of the Pratt Institute in Brooklyn, N.Y.), since the student can discuss it with someone on the spot, with the teacher, with fellow students, in an atmosphere of learning and teaching.

"It is almost a trading back and forth between two minds in an attempt to explore the picture, the technical, the interpretive aspects," he says. "There is a satisfaction in working with one's peers, exploring each other's knowledge and ideas; it is a kind of cross-fertilization, and it works in a school between individual, instructor, and classmates in a way that it cannot work in a correspondence school."

But it does work in a home-study school, insists Ed Hannigan (Dean of the School of Modern Photography, Little Falls, N.J.). The instruction is "on an individualized, personalized basis."

John Zielinski, originally a writer, took several courses in photography at different universities. "I simply wasn't satisfied with the end results," he says. "While I could look at a subject and sense its potential, I lacked the solid know-how of producing an end result having visual impact." Shortly after enrolling in an accredited home-study course, Zielinski's photography began to match his writing skills. "Amish boys running," (below) was published in a photo magazine. *Life* editors saw it and featured it as a double-page spread. Note that not a single boy has both feet on the ground—a sheer lucky coincidence. Over 30 publications have purchased the same photograph, and postcards, posters, and booklet reproductions run into the thousands. In addition to being exhibited in galleries both here and in Germany, the picture helped Zielinski obtain two outright grants from the Iowa Arts Council to produce documentary exhibits of "The Amish" and "Iowa's Indian Heritage." All of the photographs shown here are from Zielinski's book entitled: *THE AMISH—People of the Soil.*

"The Patriarch." Zielinski lived near the Amish people in a community 17 miles from Iowa City. He visited them often but never took his cameras onto their land. The Amish religion forbids "graven images" and they would not, therefore, "pose" for a photograph. This was a telephoto shot taken from the highway. Although fully aware of the camera, the Amish trusted Zielinski as a neighbor and friend. He has never shown them his pictures; the subject of photography has never been mentioned.

"On the Way to Kalona to Shop." The black buggies with iron-rimmed wheels are traditional. The Amish do not condone rubber tires on vehicles.

For Civardi, the correspondence school even at its best cannot match the advantages of the classroom.

"The correspondence method is to be taken only in the absence of other means," he says. "For certain persons, it is the only and perhaps the best way. He is apt to get a higher level of text from a good correspondence school than from local people. But anyone who has access to creative, top-notch photographic teaching would be foolish not to take advantage of it."

"If a man can go to a good school," says Keppler, "classroom training is great. If not, I would much prefer home study plus partial seminar training in the field you want, if it is available."

Dr. Milton Willenson (Director of the Germain School of Photography in New York City) finds classroom training preferable because the student can work under the instructor's critical gaze, in company with other students, and learn in association with his peers. However, for persons living in places not easily accessible, the correspondence course may be the answer.

"Those who want to make photography a profession generally come to the residence school," says Andrew Marino (head of resident instruction at the New York Institute of Photography). "For those who are unable to attend school, because of the demands of a job or because individual temperament forbids operating in the contained, regimented atmosphere of a school, the correspondence course is the answer."

Lawrence Boccioletti (head of correspondence instruction at the New York Institute of Photography) sees "two different sets of values. If you live out of town and it's not physically

"On the Streets of Kalona." This is the most widely published Amish photograph Zielinski has thus far produced. It was also reproduced on large buttons bearing the legend: "Fight Pollution—Buy a Horse!"

"Going Home." There are an estimated 25,000 Old Order Amish in America (the horse and buggy ones whose ancestors fled from persecution in Europe about 200 years ago). About that many more in 50 settlements in the U.S. and Canada are somewhat more liberal in customs.

"The Funeral." Amish ministers in each district are selected by placing a straw in just one of a stack of Bibles. The person who draws the Bible containing the straw is the minister who, without salary, thereafter adds church duties to his regular farm work. All Amish photos reproduced by permission of John Zielinski.

possible to attend classes, take the correspondence course. However, if it meant making a sacrifice to take the residence course, I would do it. One advantage of residence is the presence of the instructor, who can quickly solve a problem that can bug a guy for weeks, like trying to pinpoint exactly what he is doing wrong."

Lawrence Esmond (Director of the New York Institute of Photography) sees the correspondence student as a "classroom of one, studying in the quiet of his own home, away from crowded classrooms, and without losing his immediate income while being trained for a new profession."

Keppler and Hannigan agree that "in the home study area, the one big advantage is that you study and work at your own pace," and in the "comfort of your own home and according to your own time schedule."

Moreover, says Hannigan, in home study "you can work with your own equipment and become familiar with it rather than with strange equipment of types the student rarely ends up having himself."

Keppler and Hannigan also point out that the working student can study by mail without giving up any sort of job he might have.

In this connection, Dr. Willenson notes the usefulness of the correspondence school for the working photographer who wants to upgrade himself but has no time or cannot get away. For example, should the photographer wish to study

some specialty, such as color principles, and there is no place nearby to study locally, correspondence is an alternative.

Bringing up the question of relative cost, Hannigan says: "Training by correspondence is less expensive because no laboratory fees are involved for the use of studios, darkrooms, and materials. Also, the student does not have to pay expenses for out-of-town travel to the school," where this is a factor.

The disadvantage in home study, he says, is the "lag in time between mailing work and receiving graded lessons back. However, once the student establishes a fairly regular schedule, the work is maintained in a continuous flow without interruption."

As to the quality and authoritativeness of the instruction, Keppler says: "You can get training from some of the top photographers in the field"; and Hannigan says: "Correspondence courses have the advantage of having been planned, written, and counseled by successful professional photographers and their total amount of experience, skill, reputation, and talent far exceeds that available through classroom courses."

"Much depends upon the individual and his purpose," writes Bernard Freemesser (Associate Professor of Photography at the School of Journalism, University of Oregon in Eugene). "For one interested in commercial employment, responding to the desires of others rather than a concern of his own, the correspondence idea may be adequate. For the involved and concerned student desirous of making a meaningful statement of his own, it is not."

Apparently with classroom instruction in mind, he writes: "One thing that we tend to overlook is the contact with other students of varying levels of competence in photography. Much is learned in this cross-fertilization. They help one another more than they realize, and it is accomplished in subtle ways, in a language they understand. Acceptance by his peer group may be the strongest motivation he has to improve the quality of his work. Many times the more mature student acts as an amplifier of the instructor's ideas, and in explaining it, clarifies it in his own mind.

"The immediacy of the classroom situation, with its almost instant rewards and rebukes, does, certainly, have an advantage. Perhaps the situation could be summarized this way: Where the student is young, timid, and uncertain, moved as much by a desire for credits as self-expression, seeking more to find himself than to say something, the warmer, more intimate atmosphere of the classroom is probably desirable. But the mature person can accept the detachment of home study—less personal, perhaps, but . . . more productive."

The following is a partial list of books authored by Jacob Deschin: Photography in your Future, *Macmillan, 835 Broadway, New York, and* The New York Times Guide to Picture Making With a Camera, *Western Publishing Company, New York.*

Available from Amphoto Publishing Company, East Gate and Zeckendorf Blvds., Garden City, N.Y. 11530: Say It With Your Camera; Exakta Photography; 35mm Photography; Canon Photography; Picture Making With the Argus.

Out of print but possibly available in used-book stores and libraries: Rollei Photography, *Amphoto Publishing Company, New York. From McGraw-Hill Publications, 330 West 42nd Street, New York:* New Ways In Photography; Lighting Ideas In Photography; Finding New Subjects For Your Camera; Fun With Your Camera; Making Pictures With The Miniature Camera; The Alpha Camera. *Published by Ziff-Davis Company, 1 Park Avenue, New York: Little Technical Library Series including:* Photo Tricks and Effects; Tabletop Photography.

Peter Gowland

2. Does It Pay To Specialize?

BY PETER GOWLAND

Portions of text adapted by permission of *Infinity*, © by ASMP, The Society of Photographers in Communications, Inc.

Editor's note: Established professional photographers and instructors in photography schools are often asked, "Should I specialize—and if so, how do I get started?"

Peter Gowland purposely built an image as a photographer of beautiful girls, pinups, glamour, and nudes. Some of the glamour stock shots shown here have sold to 20 or 30 different buyers. While building the specialty, Gowland shot everything from animals and children to still life and hobby-craft pictures. But with the revenues from an enormous file of stock photos, books, and inventions, the G.I. of World War II who built his own studio on a government loan can now afford to specialize in a new direction. For Gowland now, it's mostly assignment movies.

Here are some of the pros and cons of specialization as he sees them.

There are several reasons why I feel that it pays to specialize if you want to earn the kind of money that goes with being a "name photographer." Buyers seek out the photographic specialist the way people who are ill turn with greater confidence to medical specialists. They hope to get a better job done—and whether they actually get it or not, they are willing to pay the specialist more for his effort.

Again on the pro side of the ledger, specialization automatically reduces competition for paying clients. This is because there are literally thousands of "photographers" whose work has no particular direction. The specialist, being known in a given field, not only gains preferential standing but can charge more for his work. Not that he can't take on other assignments having no relation to his specialty. He can—and should—so long as he feels he can turn out a top-quality job. But when he does, his hourly price should be higher than average; good clients expect to pay it.

Now let's look at the other side of the coin. Becoming a "name specialist" isn't as easy as making an eenie-meenie-minee-moe decision. I consider it almost impossible to begin a photographic career as a specialist—and immediately make money at it. Here's why:

To gain recognition takes time, and unless you have unlimited capital to tide you over, it will be necessary to take on other photographic assignments. It may also take time to really know what your specialty is, or what you prefer it to be. In my case, I always liked photographing pretty girls, but until I could build up a file of markets to buy my pictures, I took shots of children, cats, people at parties, little-theater stills, homes, gadgets, flower arrangements, and assorted subjects a mile long!

130

Although expert in photographing children, pets, portraiture, still-life, and other subjects, Peter Gowland created an "image" of being a photographer of beautiful girls via pinups, glamor, nudes, and the like. An inventor also, he sells a complete line of Gowlandflex cameras and accessories. These are typical Gowland-girl photos, many of which have sold dozens of times to different clients. In both black-and-white and color, he supplements direct sales from his own studio-home with sales of the same photos through American and European photo agencies. While he still adds to his stock files of his original "speciality," Gowland, once an actor himself, now concentrates most of his energy upon producing documentary movies.

Once my name became exposed to the public on photographs of girls in bikinis, or artistic nude studies in the photographic magazines, on calendars, and in the men's magazines, I was able to promote it even more by writing books on the subject. From then on the other work was gradually dropped and my wife Alice and I found ourselves building up a file of photographs that featured a girl, or a girl and boy, but always a pretty girl involved in some way or another.

I never did seek assignments. The few times that I took our material around to potential buyers left me so depressed that I decided there had to be another way. With the publicity gained from books and magazine layouts, clients now sought me out. I like it that way. In fact most of our jobs are through the mail and we rarely ever meet the people who hire us. When we do, it is always in an informal way, because our home and studio are together. That is another way in which we specialized—informality. There is no ostentatious office and studio. Instead there is a quiet wooded area where one can be barefooted if one chooses, and yet the work turned out is equal to that of any large commercial studio.

There you have some of the advantages of specializing. But what about disadvantages?

One disadvantage of specializing is that it is hard to make anyone believe you can do anything else. Philippe Halsman once told me that he ought never take a picture of a nude, because if he did he could never photograph the Pope! In my own case, there are other types of photography I'd like to get paid for, but still do just for the pleasure and at my own expense—traveling, for one. Unless I take pictures of glamour girls in foreign countries, I can't get an assignment. Sometimes I'd like to get an assignment for a fashion layout, but here again, my "image" is basically that of a pin-up, glamour photographer. Fortunately, fashion has had a trend to the more glamorous side lately and even nudes are being used in the better women's magazines to illustrate feminine trends and hygiene. That should make it easier for me to sell in these areas.

Another disadvantage of specializing is that one may get stale and bored with shooting the same subject matter over and over. (Yes, even beautiful girls can become boring—photographically!)

132

Gowland, center, at work in filming a movie of "The Hambletonian." Photo by George Smallsreed, Jr., of the United States Trotting Association.

In the back of my mind always has been a desire to do movies. Alice and I have had a 16mm movie camera since our children were babies, and we have shot thousands of feet of movies that we personally enjoy. But it wasn't until I made the big step and purchased a 16mm Eclair sound camera that we really felt we were entering a new field of creativity. Since then, we have made dozens of professional films in which I was the main cameraman and director of photography while Alice worked as the unit manager and assistant producer. We have worked together and separately.

Two of the films we made were on saving our beaches and streams. Alice wrote the script and directed one of them. She also did all the post-production supervision. I did the photography. The others were three films on educationally handicapped children done for the Santa Monica Unified School District. On these, Alice was unit manager and I the cameraman. We both like

children and gained a tremendous satisfaction from working with the people associated with the project. I have hired myself out as cameraman to several different companies including ABC's "Wide World of Sports," which took me to Hawaii for surfing films, to Aspen for the Olympic games, to Val d'Isere, France, for skiing. At other times I was the director of photography and first cameraman for an Arnold Palmer golf special for TV, an auto racing film done by James Garner, an airline promotional film for American Airlines, a jogging film with Jonathan Winters and Rocky Marciano, and a boxing film where I had the privilege and pleasure of photographing Muhammad Ali. One of my best films was on the "vanishing eagle" for ABC-TV entitled "The Eagle and the Hawk," with Joanne Woodward and her 12-year-old daughter Nell Newman.

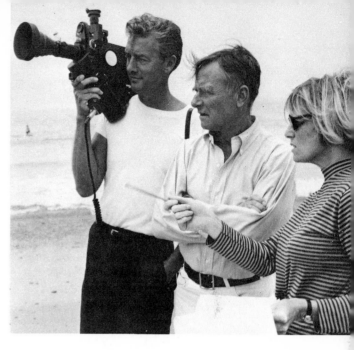

Gowland, left, discusses a forthcoming scene with writer Christopher Isherwood and Alice Gowland. The "Save Will Rogers Beach" documentary has thus far accomplished its purpose. Photo by Dale Laster.

For many shots, Gowland uses a tripod. For Take 1 of Scene 22, he handheld the camera to follow the action.

Still camera photos for publicity and stock-file use. An all-volunteer, nonpaid, staff worked on this civic effort to save the Will Rogers State Beach. Photos by Peter Gowland.

Most of these films have been a great physical effort for me. They have included climbing mountains, flying in a helicopter and hanging out the cockpit, dangling from ropes over rocky ledges, carrying heavy equipment all day and then dropping exhausted into bed at night. But motion pictures have broadened our scope of creativity because there are so many new creative elements to contend with.

We still enjoy glamour work which now seems easy in comparison to the film world. Our latest project is a book that we hope to have printed in grand style as a combination of photography and art. Here again, we find that by broadening into the movie world, we have also broadened our original specialty, that of glamour. Eventually, I think movies will also prove my contention that, when the time is right, specialization pays off.

In the last few years Alice and Peter Gowland have written photography books on Europe, Hawaii, and Japan. They now have a camera manufacturing company which makes the 4″ × 5″ twin-lens Gowlandflex, are busy with advertising layouts, and have a stock-photo business. Books written by Peter and Alice Gowland include: How to Photograph Women, *Crown Publishers:* Stereo Photography, *Crown Publishers;* Figure Photography, *Fawcett Book 250;* How to Take Glamour Photos, *Fawcett Book 285;* How to Take Better Home Movies, *Fawcett Book 325;* Glamour Techniques, *Fawcett Book 363;* Face and Figure, *Fawcett Book 400;* Glamour Camera, *Fawcett Book 430;* Photo Secrets, *Whitestone;* Electronic Flash Guide, *American Photo;* Photo Ideas, *Whitestone 33;* The Figure, *Whitestone 39;* Camera in Hawaii, *Whitestone 42;* Camera in Japan, *Whitestone 48.*

3A. The Shifting Magazine/ Newspaper Markets

BY RUS ARNOLD

© *Writer's Digest*, Adapted by permission

Editor's note: For over three decades, the credit-line of Rus Arnold has been attached to innumerable articles, books, teaching courses, and lectures on varied professional aspects of picture taking and picture marketing. In recent years he specialized in producing illustrated articles, especially columns for magazines and newspapers in North America and abroad.

Shortly after Rus Arnold granted permission for Parts 3A and 3B to be reprinted in this book, the photographic world was saddened to learn that he suffered a fatal heart attack while fulfilling a photo assignment in Hawaii. He is greatly missed by those whose privilege it was to have worked with a truly talented instructor and photojournalist.

A photographer today has to be quick on his feet, anticipating changes, learning new methods, finding new markets. There was a time when the magazine photographer specialized in children and pets, or pretty girls in bathing suits. That's been, with a few exceptions, a waste of time and materials in recent years. For many photographers, the sales have not been big enough to pay the bills.

In pictures as in text, magazines have moved on to new subjects. The emphasis is now on a searching analysis of *reality* rather than a glossy fictionalized dream. But in photography as in text, the major magazines are no longer the prime market; there are other, more lucrative, more challenging markets.

And some favorite old markets are coming back. There was a time when the photojournalist depended a great deal on the sale of stock pictures out of his files. That was in the kids-dogs-girls days. Today many photographers are back in the stock-picture market, calling on textbook and encyclopedia publishers, whose standard $35 for a black-and-white and $125–$150 minimum for color is now suddenly very tempting. Magnum, the photo-collaborative agency that used to concentrate on getting assignments for its members, is now doing a large percentage of its volume in stock sales from its huge files.

But don't write the magazine market off. I recently talked with Ruth Lester, who spent many years as a kind of Vice-President in Charge of Over-the-Transom Photo Submissions at *Life*. She has probably talked to more beginning photojournalists than any other editor in the business. So what does she tell the young hopefuls? She tells them it's nice to hitch your wagon to a star, but you have to keep both feet on the ground. Go after the less competitive markets, she advises. Seek out the special-interest publications, the smaller magazines that may not even be featured on the newsstand. They aren't getting as much fresh material as they would like to buy. Check the current market notes in publications such as *Writer's Digest* and *Writer's Market*. Keep on the lookout for magazines you've never seen before: the airline in-flight magazines, the hobby magazines, the professional publications, the house magazines, and so on.

Meanwhile, what are the pros doing about the situation? Some are bemoaning the loss of markets such as *Life* and *Look*, but the real pros are finding new outlets. For some years now there has been a trend from stills into filming. I visited the New York midtown studio of Arnold Eagle, once a top-ranking industrial and magazine still photographer, part of Roy Stryker's famous string at Standard Oil. Arnold was one of the first to switch to films; now he is kept busy teaching techniques of film-making. In New York, as in universities around the country, the youth are

showing a greater interest than ever in learning photography, but in more and more cases it's movies rather than stills.

TV has been a particularly tempting market. While some magazine photographers have traded in their Hasselblads, Rolleis, Leicas, and Nikons for Bolexes and Arriflexes to shoot film footage for broadcasts, a handful of dedicated still photographers have been experimenting with the sale of still pictures for telecast. An obvious market has been the TV commercial; there has always been a need for still pictures for these, especially on local stations. And recently there has been great interest in the use of stills for animation; we've all seen the commercials that feature special effects achieved by quick glimpses of a series of stills.

Now there are experiments in the use of stills as a medium for television documentaries. One of the first great successes in this area was David Douglas Duncan's coverage of the 1968 political conventions for a series of NBC telecasts. That was probably the first time a magazine photographer was assigned to do stills especially for a telecast feature series. Later an expanded selection of the pictures appeared in book form.

Shooting stills for television requires little change in your working procedures. For normal telecasting you must remember to shoot everything in horizontal format, fitting the shape of the TV screen. You must also remember that the TV screen crops your pictures. About $1/4''$ on each edge of a 35mm color transparency never gets onto the home screen. So you must shoot in such a way that the 25 per cent of your picture that is along the four sides can be cropped with no loss to the meaning of your picture. And while studios use prints for some purposes, your best bet may be 35mm color slides.

If you deliver prints, check on whether the individual broadcaster prefers $8'' \times 10''$ or $11'' \times 14''$. In either size, prints must *not* be high-gloss, lest the studio lights cause reflections, and *must* be cardboard mounted. TV directors, like movie directors, like to pan around still pictures, or dolly in and out. They like to start with an extreme close-up, then move back gradually to show the entire scene, or move gradually across the picture from one detail to another. That is why, when using prints, they like the larger size.

Camera movement over a still is usually called *Oxberrying*, after the brand name of one of the animating stands most used for that kind of filming. It may be done live in the studio or prebroadcast and then taped.

Television is just one of the new markets opening up for the photojournalist. There is the related field of slide-film productions, particularly for the educational field. And as soon as the industry decides which of the various proposed forms the new videocassettes will take, for playback on home TV, a big market will open for the photojournalist who has had editorial experience.

The big lesson from my last trip to New York is that you can sit down and bewail the loss of old picture magazine markets—or you can go out and fine new ones. The real pros are looking—and finding!

3B. Travel Tips For Lensmen

BY RUS ARNOLD

Reprinted by special permission of *The New York Times* © 1971

There is a story going the rounds about the weary tourists who sit down at a sidewalk cafe somewhere in Europe, Asia, or Africa and are approached by a smiling stranger who greets them with, "Hello, Americans, yes? You want I take picture of you together in our beautiful city, yes?" He picks up the traveler's camera from the table, begins to focus it, then moves back for a better angle—and back and back and suddenly he's off at a run, taking the camera with him.

A made-up story, you say? I know three travelers to whom it actually happened—in Turkey, in Hong Kong, and in Paris. Taking a camera abroad on a vacation sounds like one of the most innocent things a person could possibly do, but unless the traveler exercises certain precautions, he can wind up literally holding only the bag.

Keeping a tight grip on all your photographic equipment at one time can be a drag, even with a roomy shoulder bag. But you should guard your cameras as you would your wallet or your purse, and never let them out of your sight. Even leaving them in the hotel room can be risky. A safer procedure would be to tote one camera with you and check the excess equipment in the hotel manager's lock boxes.

"Hong Kong Harbor." Photo by John Faber.

"Christ Statue." Photo by John Faber.

"Red Square, Moscow." Photo by John Faber.

"Russian Children, Kiev, U.S.S.R." Photo by John Faber.

"Peruvian Llama Herdsmen." Photo by John Faber.

SAFARI JACKET

The camera itself should be on a secure strap, around the neck and in front, where you can get at it quickly for picture taking, rather than slung over the shoulder where it can be banged or snatched. Spare film, extra lenses, and similar gadgets can be carried in a woman's purse or a man's pockets. My own choice is a safari or bush jacket, which looks good, is comfortable, and provides four roomy button-down pockets for stowing things.

"Arc de Triomphe, Paris." Photo by John Faber.

"The Wall, West Berlin, Germany." Photo by John Faber.

PURCHASING EQUIPMENT OVERSEAS

You may decide to buy some of your camera accessories abroad. This works fine, and can save you money, if you can be sure that what you want will be available where you plan to buy it. In some European countries equipment costs more than it does here—even in duty-free shops. But other duty-free shops and free ports, and some cities in the Orient (Tokyo and especially Hong Kong), are a bargain hunter's paradise. If you know equipment, come prepared with a list of Stateside prices for comparison and stick to established dealers and standard brands. You may, however, run into restrictions on what you can bring back to the States, even though you are prepared to pay the import duty. If you plan to buy cameras, lenses, or similar items abroad, send for the free pamphlet, "U.S. Customs Trade Mark Information," issued by the Bureau of Customs, Washington, D.C.

IN CASE OF TROUBLE

Should you have camera trouble, don't trust it to a fellow tourist. Take it to an established dealer; if there is a language problem, ask the hotel manager to put you in touch with a reliable dealer or repair man. Notice, I said *manager*. A neighbor of mine, traveling in the Far East, had some problems with his Nikon. Frustrated, he asked a hotel bellhop to get it repaired overnight because he was leaving the next day. The next morning the bellhop returned the camera with apologies. "So sorry, no can fix." Another city, another country, this time English-speaking: The dealer looks at the camera, listens to the story, and shakes his head in dismay. The camera's entire viewfinder optical system had been replaced by an earlier, cheaper model—and a defective one, at that.

With the security problem taken care of, it might be wise at this point to look into the question of ethics, specifically in regard to photography. A compulsive picture-taker sometimes forgets that travel is supposed to be fun and not hard work. He may also overlook the fact that his companions are not as interested in picture taking as he is—forever getting in the way, forever holding up tour buses, forever inconveniencing his fellow tourists just so he can get "one more shot."

A good rule of thumb to follow in this regard: Be as considerate of people's feelings as you are of your photographic equipment and you will return home with good pictures—and good friends.

"Tibetan Monks Making Sand Paintings." Photo by John Faber.

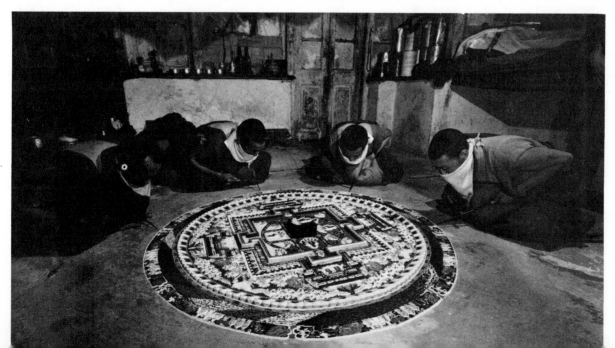

4. How Walter Chandoha Produces Animal Pictures that Sell

BY ARVEL AHLERS

Adapted by permission © *Famous Photographers Magazine*

In animal and pet photography, no name shines with greater brightness than that of Walter Chandoha. For nearly two decades, editors and advertisers have banked upon the surefire visual impact of his animal pictures to snare attention for the messages they wanted to communicate in print.

With his wife and six children—stair-stepped in ages from kindergarten to college—Chandoha lives and works on a picturesque farm nestling against the Appalachian foothills of New Jersey. His spacious living room, which served as a studio for many years, was built in 1800. Adjoining it, the polished soundness of the puncheon floor of his library testifies to the craftsmanship with which it was laid in 1732—the year George Washington was born.

A winding lane flanked by wild growth leads from the house to the old barn, which Chandoha has now converted into a completely equipped studio. It is here that he shoots about 80 per cent of his pictures. Although most of this work is on assignment, only his most venturesome clients brave a twisting complex of country roads to confer with him in person. The more timid wisely rely upon the telephone and mails.

Chandoha's present setup is a far cry from the makeshift cellar "studio" in which his photographic career was born in 1947. Living in a New York City apartment at that time, he was taking various commercial college courses while trying to decide whether to become an art director or an advertising copywriter. A quirk of fate ruled out both careers. As a hobby, he had begun snapping pictures with a 4″ × 5″ press camera. One day he found a homeless cat, took some pictures of it, and won a prize in a photo contest. The subject

matter instantly caught the eye of a New York columnist, Mabel Scacheri, a devout cat fancier. She encouraged him to take pictures of cats with the idea of selling them. He did, and they sold. Speaking of one of the first pictures he sold, Chandoha says:

"I photographed the kitten with my 4″ × 5″ press outfit—definitely the wrong camera for the job—but I didn't know any better. And even if I had known, I couldn't have afforded another camera. As I recall, *Parade* magazine bought this shot along with about six other photos. The pro-rata price was probably ten to fifteen dollars per photo, and it was a tremendous thrill to be 'published.' Equally important from the financial point of view is the fact that not only this shot, but literally dozens of my later photos have sold again and again to different buyers—and after twenty years they still sell!"

The heady combination of money and recognition, plus the enjoyment he got from working with animals, solidified Chandoha's plans for a career. And as his interests expanded to include other animals in his repertoire, he became aware of three solid reasons why his choice of subject matter had been a good one.

First, the range of totally different markets for animal pictures is enormous. These include editorial publications of all types—newspapers, magazines, books, brochures, greeting cards, and calendars to name a few. Moreover, special-purpose printed items range all the way from candy-box tops and jigsaw puzzles to the ornate menus created for swank restaurants, airlines, and luxury cruise ships.

Second, animal pictures are universal in their appeal. They are instinctively understood and

"Would *I* mind having a cat in *this* house?"

dress styles, automobiles, and background objects, an eye-stopper shot of a yawning alley cat or bug-eyed spaniel offers no clue as to when it was taken. Instead of becoming obsolete, an animal picture remains mint-fresh to each new audience, even though it may have been sold to dozens of different buyers over the years.

Let's assume that a beginner interested in animal and pet photography has mastered the art of producing needle-sharp, technically acceptable prints. He knows that the major portion of the work he sends to market will be in 8″ × 10″ format (either glossy or blotter-dried). But how does he locate potential subjects for his lens?

"He must dig for them," says Chandoha. "Once he's attuned to looking for photogenic animals, they'll turn up everywhere. Friends, neighbors, even total strangers have pets they're willing to have photographed in return for a free enlargement. The local veterinarian, pet shops, and animal shelters are also good bets. A word of reminder, though. Whether you rent an animal for cash or give its owner a photo as payment, be sure to get a signed model release that allows you to use the picture any way you choose."

If locating a subject is the first step, it follows that the next step is to take the kind of pictures that somebody will buy. What, then, is the most important ingredient in a saleable animal picture?

"Expression," Chandoha says emphatically. "The picture that sells is the one in which the animal's expression is appealing or humorous, or in some way suggests recognizable human moods or personality traits. Sometimes a fast shutter finger will capture a spontaneous expression that strikes a chord with the viewer. At other times you have to induce an expression with an unexpected noise or movement. It may be that the animal's facial expression alone will do the trick; again, it may be a bizarre or humorous posture or a bit of frozen action. Any way you slice it, the picture has to catch the viewer's eye and stir a responsive emotion."

Although the bulk of Chandoha's work nowadays is advertising and editorial material "shot to order," he hasn't forgotten the route he followed *before* clients began to beat a path to his studio.

"In my opinion," he says, "the best way for a beginner to get started is in his local community. Daily and weekly newspapers, county and

enjoyed by people of all ages, all nationalities. An animal picture that sells in North America, for example, is often just as saleable in Europe, Australia, or the Orient. It is *universal* appeal that places it among the ten most saleable types of photographs handled by stock-picture agencies around the world.

Third, a good animal picture is *ageless*. Where human subjects become dated by hair and

state publications, camera clubs, libraries, banks and merchants who will display his work are a starting point. The prices that local publications can pay may be as small as five or ten dollars per picture—or they may not be able to pay at all—but they do provide 'exposure' to bigger-paying clients.''

Does this mean that a beginner should, if necessary, be willing to let some of his pictures be published for free?

''Absolutely. Not to advertisers or private customers, of course, but to those who can give publicity in return. Giveaways pay when you place them with the right people. If it hadn't been for newspaper photo columnists who published my free photos with favorable write-ups, I might still be struggling for enough 'exposure' to attract the high-paying clients.''

In between assignments shot to order, Chandoha continues to enlarge his personal stock-photo file. In addition to tailoring sets of pictures to publishers whose names and addresses appear in conventional market listings, he continually probes for new and unlisted markets. The latter numerically exceed the listed markets by the thousands.

If he has no personal contact in a new potential market, Chandoha first studies the type of work currently being published by that market. Next he looks for a theme that might interest, say, a publisher of calendars, greeting cards, or books. Finally, he selects a set of pictures that illustrate the theme and writes a few lines of captions to go with the pictures.

The captions aren't meant as finished prose; their sole purpose is to give the picture buyer an idea of what Chandoha is suggesting as a theme or, as he calls it, ''a peg to hang the pictures on.''

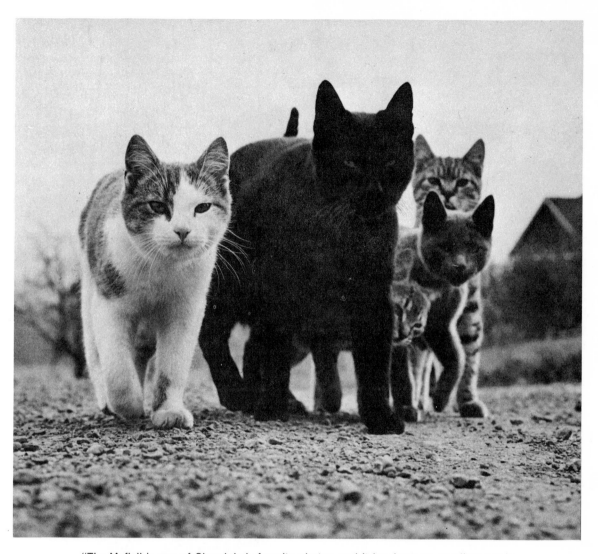

"The Mafia" is one of Chandoha's favorite photos, and it has been an excellent resale money-maker. To get five cats to walk straight toward the lens as a group and in this formation is like experiencing a blizzard in Florida. Chandoha calls it sheer luck, but how often would a photographer trusting to luck alone be prepared to catch a "grab shot" in focus from what appears to be practically ground level?

Typical themes for some of his successful series have been: "The Animals I Have Known;" "Cats in Hollywood;" and currently a calendar series entitled "Laughing Manners."

It's a simple matter to locate publication markets interested in animal/pet pictures. Many of them are listed among the publications included in Sections 10 and 11. These are well-established markets—but not necessarily the best-paying ones. Many of the finest markets for animal/pet pictures—from the standpoints of money and prestige—are not listed as such in any market directory. They are advertisers who occasionally use pictures of this type for special campaigns, or greeting-card, box-top, or jigsaw and novelty manufacturers who use a limited number of animal/pet pictures.

How can you locate the specialized and high-paying markets?

"You have two avenues of approach," says

Chandoha. "You can place your pictures with a photo agency that will charge a commission of up to one-half of the gross amount they can get a buyer to pay for publication rights in your picture. Photo agencies know how to reach many different kinds of potential buyers who never publicize their picture needs." Chandoha, however, prefers not to work through a photo agency.

"An alternate approach will save the agency commission, but require legwork and research on your part. When you see a wall calendar with photo reproductions that suggest a possible market for animal pictures, look for the name and address of the company that sponsored the calendar. If the address isn't printed on the calendar, note the name and location of the firm that did the printing. Do the same thing when you see photographic greeting cards, candy- or cookie-box tops, puzzles, games, TV serving trays, or other novelties that feature photo reproductions. Then visit your local reference library and, via industry directories, metropolitan phone books, or whatever other sources you can find, trace down the manufacturer and/or his advertising agency.

"In some instances, the person to address is the publisher, editor, or public-relations director. Since you can't know the correct title of the person to contact at the beginning, you can always play it safe by addressing your contributions to the 'Picture Editor.' Once you have pinpointed the person or department that buys pictures for a company, the next step is relatively easy."

Instead of making an appointment with a picture buyer and presenting his portfolio of pictures in person, Chandoha usually prefers to let the mail do the initial legwork. "It saves us both time and effort," he explains. "If the buyer is interested in this theme—or in a different one that my pictures trigger him to visualize—all he has to do is contact me by telephone or mail. It's easy to switch our working relationship from 'on speculation' to 'on assignment.' And because there is seemingly no end to the demand for good animal/pet pictures, I have only this to say to those who are thinking of entering this specialized field: Success won't come overnight. In order to succeed you must (1) know and enjoy working with animals; (2) believe in your own ability; (3) set a definite goal; (4) be *determined* to succeed. The last is extremely important. It's another way of saying that you have to want something very intensely before you'll get it!"

Books by Walter Chandoha include: Borland County, *Lippincott Publishing Company, $7.95;* Walter Chandoha's Book of Foals and Horses, *Crown Pub. Co., $6.95;* Walter Chandoha's Book of Puppies and Dogs, *Crown Pub. Co., $6.95;* Walter Chandoha's Book of Kittens and Cats, *Crown Pub. Co., $6.95;* All Kinds of Cats, *Knopf Publishing Company, $3.95; and* All Kinds of Dogs, *Knopf Publishing Company, $3.95.*

5. Tips on Producing Children's Books

By Lou Jacobs, Jr.

Editor's note: Lou Jacobs, Jr., is a rare type of photojournalist. Rare on three counts. His pictures are excellent; his writing is excellent; and the range of subject matter he covers is enormous. Lou's work has appeared in everything from national newsstand publications to house magazines (house organs), and government publications.

His five adult books on photography qualify as being among the best of their kind. At present, Lou is turning out a whole flotilla of illustrated children's books, 21 of which are listed at the end of this article. Here are tips on how he works.

There are two basic types of children's books: story-fiction that is generally illustrated by drawings or paintings, and factual non-fiction, which may include hand-drawn pictures or photographs, or both. Fiction rarely lends itself to photography, since fantasy is hard to capture on film. However, there is a steady demand for factual books illustrated photographically, and I've been active in this field for eight years.

Around 85 per cent of all children's books are sold to schools and libraries. The rest sell through bookstores where the personal taste of buyers is rather erratic. Though it's pleasant to tell friends and relatives you have a book published, don't count on seeing it on too many retail book shelves unless it's unusual. Publishers seem to plug popular authors and old standards, but it is encouraging that schools and libraries provide a wide market for factual children's books with photographs. A good review in *Library Journal* is worth six autograph parties at least.

Books that sell best are usually related to "now" subjects, such as race relations or curriculum studies in public schools. Subjects such as airports, harbors, natural history, biographies, geography, and so on, handled to fit the age levels of the kids most interested, with good photographs (color or black-and-white) and clean layout, are popular with librarians and teachers.

Keep this in mind: Children's books are selected first on the basis of writing and topic.

Quality and appropriateness of the text are the criteria by which most editors judge a potential book, because they are word-people. Top-notch photographs may impress an editor as well, but most publishing houses ignore the impact of pictures if a book is not suitably written. Therefore, you must learn to write for various age levels, ally yourself with a writer who knows the score, or make yourself known to editors and publishers on the basis of your photographic ability in general, or in specific areas.

In order to sell a children's book, you need not complete the photographs, nor have a finished text—but these help if the book is your first. A well-done set of pictures that synchronizes neatly with well-written words will obviously impress an editor more quickly than a proposal, but the latter can be adequate.

To make a proposal, you need a title, an outline that includes chapter headings plus 50-100 words about each chapter, a sample chapter and some sample photographs. Size 8″ × 10″ black-and-white prints or preferably duplicate color transparencies are fine. I usually write an introduction as well, which is really a sales pitch for the book and may be revised if and when the book sells.

Before you do a book or make a proposal, it is wise to research the library for titles similar to the one you have in mind. Check the *Guide to Books in Print* so you won't needlessly work on a subject that is already adequately covered on

library shelves. However, librarians tell me that a new approach or an updated subject is usually worth a try.

For instance, I was asked by Elk Grove Press to do a book for third- and fourth-grade readers called *Airports, U.S.A.* There were other books on the subject, but mine had the latest material in words and pictures, plus a modern layout which have helped it sell fairly well (about 15,000 copies to date). I followed this with *Aircraft, U.S.A.*, because previous books on airplanes were too complicated for young kids, or were illustrated with outdated photos or drawings that did not have the appeal of more literal photographs.

You should also research the library for books you like on any subject that include photographs, and list the publishers of same. Send your book or proposal to those publishers whose books you most admire or who seem to have a feeling for photographic books. There are at least 40 first-rate book publishers of this type in the U.S.A., and probably as many more smaller houses worth knowing. Simply pack your book or proposal carefully and mail it 4th class manuscript rate, *insured* for the maximum $200. I also add special handling, which supposedly puts my book in with 1st class mail. Enclosing return postage is a standard policy unless you've previously worked with an editor or publisher. I send a check for postage, insurance, and special handling, and my books usually come back insured and well-packed. Occasionally, a first-rate publisher sends my check back and pays the postage for me. If a letter accompanies your parcel, add a first-class stamp to the parcel with a notation "First-class letter enclosed."

Keep a file-card list of your submissions with dates sent and returned. Send a short covering letter with your book as a courtesy as well as added sales talk. If you do not get a response in about six weeks, write a note asking for a reply. Book editors are notoriously slow, and I try to speed the process when necessary.

When you sell a book, you'll find that publishing contracts have both similarities and differences. Most offer 5 per cent of the retail price of the book as royalty to the writer and 5 per cent to the illustrator. If you ask, you may get escalation, which means an additional $1/3$ per cent royalty after 10,000 copies are sold. The main terms to be wary about are residual rights. Reprint rights should pay at least 50 per cent to the author-illustrator. Foreign rights should pay 50–75 per cent, and all other rights, such as filmstrips, should pay 50 per cent or more. Royalties are usually paid twice a year, and if you get an advance, which averages $500–1,500 for a children's book, you won't collect royalties until that advance has been earned.

Try to include a clause in the contract that the publisher must bring your book out within a specified time, such as one year. Remember, once you get an advance, work three to six months to complete a book, and wait six months or more until it's published, it will be another year or two before you'll see another check. Books are rewarding to the ego, and some may pay $3,000 and up (10,000 copies is the usual goal) but it takes a long time to start collecting.

At this point you may wonder about finding a literary agent to handle contract negotiations. An agent is easily worth the 10 per cent commission, but it may be difficult to find worthwhile representation until you have sold at least one book. In any case, ask your writer or photographer friends for recommendations, or check a list of agents in *Writer's Market*, and send query letters to a few agents describing your work. Careful inquiry could result in your finding an agent who feels your potential is worth developing.

All kinds of photographs are used in books. I included a lot of scenic pictures from my files for *The Shapes of Our Land*, about geology, shot some of my own for *Shamu the Killer Whale*, and shot all the pictures from scratch for *Two Is A Line*. Each book may be different, but once you become familiar with the markets, you'll find new ways to use your pictures and new subjects to tackle.

Don't get discouraged by rejections. One editor's meat is another's poison. *Four Walruses* was once turned down with an editor's comment, "it is not publishable in its present form," only to sell the next time out. I've circulated proposals and manuscripts to 25 publishers before I found the right one.

One last note: If you are asked to sell pictures for someone else's book, the standard minimum prices are $35 and up for black-and-white and

$125 and up for color. You can negotiate these rates if a large number of pictures are bought, and you might ask for royalties instead, according to the number of pictures and the work involved.

In any case, photography and children's books are going steady, and you may well get involved if you play your pictures right.

Books by Lou Jacobs, Jr.:

For adults (all published by AMPHOTO): How To Use Variable Contrast Papers, Free-Lance Magazine Photography, Electronic Flash, The ABC's of Lighting, *and* Konica Autoreflex Manual.

For children: Duncan the Dolphin *(Follett),* Wonders of an Oceanarium *(Golden Gate Junior Books),* SST—Plane of Tomorrow *(Golden Gate Junior Books),* Four Walruses *(William R. Scott),* Beautiful Junk, *by Jon Madian, photographs by Barbara and Lou Jacobs, Jr. (Little, Brown & Co.),* Shamu the Killer Whale *(Bobbs-Merrill),* The Jumbo Jets *(Bobbs-Merrill),* The Shapes of Our Land *(Putnam's),* You and Your Camera *(Lothrop, Lee & Shepard), and* Two is a Line *by Jon Madian (Platt & Munk),* Airports, U.S.A. *by June Behrens (Elk Grove Press),* Aircraft, U.S.A. *by June Behrens (Elk Grove Press),* Oil, U.S.A. *by June Behrens (Elk Grove Press),* Air Cargo *by June Behrens (Elk Grove Press),* Truck Cargo *by June Behrens (Elk Grove Press),* Ship Cargo *by June Behrens (Elk Grove Press),* Train Cargo *by June Behrens (Elk Grove Press),* Space Station '78 *(Macmillan),* Cyra-Nose the Sea Elephant *(Elk Grove Press), and* Sand and Man *by Willma Gore (Elk Grove Press).*

6. A Selling "Must"—Update Your Markets

BY KIRK POLKING

Editor's note: Kirk Polking has had nearly three decades of experience as an editor, author, and lecturer on marketing free-lance text and photographs. Formerly the editor of Writer's Digest, Writer's Yearbook, *and related publications (all of which include information pertaining to free-lance photographic markets), she has also authored a number of books and by-lined over 100 published magazine articles.*

The free-lance photography market is changing constantly as new publications are born; others merge, alter policies, or simply die. This means that if you want to sell pictures and picture stories today, you *must* keep abreast of what today's editors want to buy.

How do you find out? By studying comprehensive books such as this, as a starter. Then by adding information to your store of knowledge from all the supplementary sources you can find. These might include the *Writer's Market,* an annual that lists the text and photographic interests of over 4,000 publications of all types, over 70 per cent of which require changes in each new edition. Another annual is *Gebbie's House Magazine Directory,* which specializes in the types of photographs needed by the editors who produce magazines and other printed materials for manufacturing companies, service organizations, and many nonnewsstand publications. Still other supplementary sources of information include various newsletters, photographic publications, and monthly publications listed in Section 10 of this book.

Always bear in mind that a printed market listing is intended to serve as a guideline *only.* It is up to you to study actual samples of the publications that interest you. There is no substitute for analyzing a current issue of a publication to see for yourself what an editor means by "human interest" or other nonspecific needs that may appear in a printed listing.

Remember, too, that only a fraction of the

TEST YOUR MARKETING ACUMEN

Study the photographs on these pages and jot down as many *different* categories of listed and unlisted potential markets for each picture as you can think of. If you are a beginner in marketing, three or four different categories should be encouraging. An experienced photographer should be able to rattle off at least 10 good prospective categories, and anywhere between 10 to 75 or more different potential buyers in *each* different category for *each* photograph.

"Indiana Farmer." Photo by Herb and Dorothy McLaughlin.

magazines that buy photographs are available on your local newsstand. Wherever you go, look for publications that are *not* distributed by newsstand vendors. Are you, for example, an Elk, a Moose, a Rotarian, a Legionnaire, a Jaycee, a Junior Leaguer, an M.D., or a Girl Scout Leader? There are magazines published for just about every association, club, and fraternal organization you can think of. Nearly every major manufacturer, profession, college, hospital, retail store, or service organization has publications available only by subscription. Hundreds of religious publications are also buyers of photographs. Most local firms and professional people will give or loan you copies of their publications. If you can't borrow copies of publications that you feel you'd like to study as potential picture markets, jot down their addresses and write for sample copies. Some will provide samples at no cost. Others will charge the single copy price, or ask you to pay the postage for sending it to you.

A technique used by professional article writers to save time and unnecessary effort can also be useful to a free-lance photographer. When a writer, for example, gets an idea he thinks would interest a magazine he first writes a query letter to the editor. In no more than a page, single spaced, he highlights what his article will contain. With his query, he encloses a self-addressed stamped envelope for the editor's reply. If the editor isn't interested, the writer then queries the next market on his list. When he does get a go-ahead from an editor, he can then write it *specifically* to suit that particular editor's requirements.

Similarly, if a photographer thinks he has a saleable photo feature, let's say, about the successful merchandising techniques of a local retail store, he can describe the basic facts and photos he can provide in a letter to the editor of a specific trade magazine. Enclosed with his self-addressed stamped envelope should be a few samples of his best photographic work. If the

151

"Tibetan Refugee Children." Photo by John Faber.

"Newcomer." Photo by Jack Lane.

"Minnesota Dusk." Photo by Rohn Eng

editor is interested, the photographer can then phone the manager of the retail store and say "*ABC Magazine* is interested in a photo feature about your successful 'Garden Shop' merchandising; I wonder if I could set up a time with you when I could take some photographs for a story for them?"

Some free lances (especially those with confidence born of selling experience) do it the other way round. They go ahead and shoot the pictures and then present the completed package. You will soon discover which way seems to work best for you.

The more you study marketing directories, the individual magazines themselves, and the updating monthly market lists, the better able you'll be to spot saleable picture and story ideas as you go to and from work, or take a trip, or

"Total Loss." Photo by Jack Urwiller.

"Summer Beach." Photo by Gary Warren.

"Amish Winter Travel." Photo by John Zielinski.

skim a newspaper over your morning coffee. It may not be easy to sense saleable picture opportunities at first, but it can be profitable if you work at it. This is the key with which thousands of free-lance writers, photographers, and photojournalists have opened the doors to personal success.

Books by Kirk Polking:

How to Make Money In Your Spare Time by Writing, *Cornerstone Library, 630 Fifth Ave.,* *New York, N.Y. 10020;* The Beginning Writer's Answer Book—*a selected compilation from Writer's Digest, Writer's Digest Pub. Co., 9933 Alliance Rd., Cincinnati, Ohio, 45242.*

For juveniles: Let's Go To An Atomic Energy Town, Let's Go With Lewis and Clark, Let's Go With Henry Hudson on the Half Moon, Let's Go See Congress at Work. *All published by G. P. Putnam's Sons, 200 Madison Ave., New York, N.Y. 10016*

James Morrison

7. What Today's Newspapers Need the Most—Better Photographers, Better Editors

By James Morrison

Editor's note: Thoroughly educated in both photography and journalism, Jim Morrison quickly rose from the role of a newspaper staff photographer-reporter to that of "wire-editor" for CP (Canada's national news agency). In both Canada and the United States, he has combined professional photography with lecturing, teaching, and the writing of articles and books. In 1971, he became managing editor of a leading Canadian newspaper, The Fredericton Daily Gleaner. *Not content to simply supervise the work of staff photographers and reporters, however, he often takes to the field with his own cameras with the goal of making the photographic-reportage of his paper superior to that of all other newspapers in the area.*

Photography is more important in the field of journalism today than at any time in history. The future of this craft is most promising, but there are certain obstacles in the path. Chief among them are photographers who can't take top-quality pictures and editors who can't recognize a good picture when they see one.

These are not insurmountable obstacles, but if journalism is to take full advantage of the potentials of photography, a change in attitude has to take place on the part of some photographers and, most certainly, on the part of many editors.

The swing to photo-offset printing by newspapers, magazines, and book publishers has opened the field to more capable photographers. The operational word here is *capable.* But capable of what?

It isn't enough today to merely record an image of a person, a place, a happening. Today's photographer has to be *creative.* If he lacks the spark of creativity, he is a liability to his newspaper. Similarly, an editor who is blind to a good picture is a liability to the paper. But, on far too many newspapers, mediocrity is an acceptable standard. With some it is the only standard.

So what should an editor be looking for? What type of picture should the photographer go after?

First, the photographer should avoid the static shot. If he turns one in, the editor should reject it.

For example, how many newspapers are still carrying "line 'em up, mow 'em down" pictures of athletes, wedding groups, or the officers of a club or organization? Far too many. These are what I term "crows on a picket fence" shots. Everyone has seen them. Usually the figures are stiff, rigid, with phoney facial expressions. No doubt the photographer has coaxed a "smile" by asking the subjects to say "cheese." Lord love us, it still happens.

Photographers would do better just to take a head-and-shoulder shot of the club president, *if* his editor insists on getting a shot of the occasion.

Here is where the photographer is often handicapped by lack of specifics and stimulating direction from the editor. The assignment sheet may say cryptically: "Cover the Conservation Council meeting at 7:30 p.m. Get a shot." Now that's begging for a "crows on the picket fence"

In both b&w and color, this picture ranks among the top ten fire pictures ever taken in the annual News Picture Competition of *Editor and Publisher*. Photo by Herb McLaughlin.

Hot weather produces a tongue-in-cheek problem of topless apparel in Pembroke, Ontario, news photo. Photo by Bill Montaigne.

"Wichita Rhubarb"—a sports news shot that speaks for itself. Photo by Jack Urwiller.

type of shot—unless the photographer uses more imagination than did his editor.

In the photographer's shoes, the way I'd handle such an assignment would be to try for action shots. Controversy nearly always accompanies any meeting on the environment. Speakers get angry, shout, gesticulate, stalk out. This is where close-up shots of animated faces can do more to convey the tone of the meeting than a thousand words. Never settle for the obvious. Action is the secret of giving visual impact to most spot news photography. I don't mean corny, contrived action. I mean the *real thing.*

As another example, what news photographer hasn't been asked by an editor to "get me a shot of spring" or "a winter shot," or so on. In so doing, he is leaving the outcome—the "success" of the assignment—up to the imagination of the photographer.

If you were the photographer, what does spring mean to you? A babbling brook? A crocus pushing through snow? A new-born lamb? Fine. Take any one of these and you could have a spring shot. A pretty girl with her skirt blown high by a March wind has also done the trick for many editors and photographers.

But while any of the above could be a legitimate spring shot, the creative photographer also needs to know his readers. Knowing them he should try to relate to their needs. Spring may very well mean something entirely different to a reader in Pennsylvania than it does to one in Iowa, or to another reader in Vancouver. The ideal spring shot should be authentic for the area in which it will be printed. Let the *reader* relate to it and feel a part of it.

Every newspaper should either have a picture editor or at very least an editor who knows photography and can guide his photography staff. With more and more reporter-photographers on papers today, journalism has an increasing number of editors who are knowledgeable about photography. These are the papers that excel in their photo-reportage.

Ideally, an editor should be able to explain to the photographer what he wants the story to convey and be able to suggest the type of picture he thinks will do the job. At the same time, he should give the photographer enough creative freedom to do what he thinks best once he is at the scene. A smart photographer will sense what the editor wants, but if, on the scene, he sees what he feels is a better shot, he will take it too. When actual photographer-editor rapport exists, it's not unusual for a good editor to agree with the photographer's choice. After all, he must have some savvy or he wouldn't be an editor. (I can hear some derisive comments in newsrooms all over the United States and Canada. Unfortunately it is true that too many newspapers tolerate editors who know nothing about a good picture. But on the brighter side, newspapers as a whole are making headway all the time.)

The news-photo routine is much the same in Canada as it is in the United States. In other words, there is no standardization. When the chips are down, everything is geared to the individual papers.

The routine on a metropolitan paper, moreover, is much different than on a small daily. Some papers have darkroom crews and the photographer never actually processes his films or prints a picture. Once he leaves his exposed film with the technician, that's it. In other operations the reporter-photographer system is used, with no full-time photographer. A technician soups the film and makes prints while the reporter-photographer writes the story. In still other cases, the paper may have a one-man photography staff, and this individual has to do everything from taking the picture to making the print. Indeed, he may even have to write the story.

Now let's suppose you are a free-lance photographer instead of a staff photographer. What are your chances of selling free-lance photos to a newspaper? How should you go about it?

First, you should make a solid contact at a local newspaper. Make up a portfolio of your work, and arrange a meeting with the picture editor, the city editor, or the managing editor. All three if you can. Tell them you are available on a free-lance basis.

You'll probably be told: "That's good work. . . but we don't need another photographer now. Don't call us. . . ."

So be it, but you have made an important contact. Whenever you shoot a picture you think

an editor might like, get it to him *fast*. If he does like it and has space, he'll probably buy. He knows you and knows your work.

As you build up a good file of published photographs, you can start spreading your wings. From a regional paper you can start offering your pictures to larger papers and magazines. Remember, a picture that would interest an editor of a small daily wouldn't necessarily interest the editor of a bigger paper, or one some distance away. On the other hand, it might. *Study your markets. Know them.*

If you're lucky, you may get a "scoop" type of shot, one that the paper's regular staff photographer has missed. Usually these will pay you no more than your ordinary contribution. However, there are exceptions—spectacular shots of a one-of-a-kind nature. With these you can dicker for a bigger slice of the pie. Or you may want to offer it to a regional or national magazine, where the payment is usually appreciably higher.

National news agencies don't, as a rule, purchase photographs from free lances. There are exceptions, and you may be lucky enough to get a shot that would interest such an agency. However, remember that newspapers affiliated with such an agency usually provide them with pictures as well as stories. Since the agency has its own photography staff, it usually covers major events of national interest. Still, it's a good idea to get to know the local agency man, whether he be a staffer or a contributor.

How much will you be paid for free-lance shots? There's no definitive answer. It depends on where you live, the demand for photos, and the size of the paper.

I know photographers in small towns who will accept $3.00 for a picture, at the same time demanding a photo credit line. They claim it's good business. I question that personally, but every man to his own bag. I also have friends who refuse to take pictures for any newspaper, claiming they lose money even if they are paid $50.00 a shot. That's the other extreme.

I'd say the majority of small papers will pay anywhere from $3.00 to $7.50 for a picture. Larger papers may or may not pay more. Even in some small towns I've known photographers who demanded $30.00 for one shot taken on a weekend and got their price.

What it boils down to is that you must be a businessman as well as a photographer. If you have a darkroom in your own home, do your own developing, and have a low overhead, you might be able to accept less for a picture than the man who has a studio to keep up. But why should you if your work is the equal of his or better?

The best idea is to establish the going rate for news photos in your state, province, city, and town, and then set your price somewhere in the same vicinity. But don't sell yourself short.

News photos can be sold to other markets, too. Local television stations are often interested in good spot news pictures for their telecasts. If you build a reputation on quality, television can be rewarding.

If the news shot has people in it, those very same people may be customers. It happens all the time.

Accident scenes and fire shots are often purchased by insurance agencies. Sometimes they are for the files; sometimes they are used as evidence in a case.

News photography can be exciting and profitable. You must take it seriously, though. Get good equipment, and maintain it well. Never be satisfied with a so-so shot. Strive constantly to improve the quality of your work, both from the technical and the creative viewpoint.

By all means be creative. It's your best bet to edge out the opposition. A good quality photograph that shows imagination in execution will win every time over a picture that is technically good but inspirationally bad.

It's up to you. You're the photographer!

8. The Videocassette Dream

By John Trevor

Editor's note: Formerly the Managing Editor of Infinity magazine, John Trevor has also been highly active in the fields of film production and videocassettes for over a decade.

Don't let that dream of a lucrative videocassette market fool you into thinking it's here. It isn't. And it may not be for several years to come.

According to one company that has been storing and distributing films for the past 40 years, tape will eventually be the standard medium for videocassettes. This company is therefore installing tape duplication facilities for future program producers and distributors, and at the same time going mainly after technical servicing of TV commercials, 75 per cent of which are on tape.

But no one yet knows *which* medium will be adopted for software in the projected multibillion-dollar videocassette industry. Another question is, how soon will hardware manufacturers like Ampex, CBS, Sony, Teldec, and so on be ready to talk seriously to software producers about programming? And last, but not least, where will the money (estimated at $100,000,000) come from to finance the large-scale programming, the quantity of software, that will induce consumers to buy playbacks?

Thus far most of the pitch has been toward industrial and commercial users, to groups rather than to individuals, because the existing hardware and limited amount of software are more expensive than the average individual can afford.

Undoubtedly 16mm films can and are being used to meet the demand from videocassette hardware manufacturers pushing their products, but conversion is costly. Besides, producing programs for videocassettes will probably become as specialized as film and TV program production have become over the years.

The consensus of opinion in the videocassette software industry is that the real market is at least five or ten years away. And there are some who believe, like Gordon Stulberg, head of 20th Century-Fox, that CATV (cable television) is the big outlet for feature movies and similar major programming and that videocassettes are just not that important—yet.

Apparently the major problem facing software producers is the lack of hardware standardization. Today there are four basic prepack materials for videocassettes: tape, vinyl, film, and disc. Until the shakeout comes, any real investment in videocassette programming will be delayed by a certain amount of skepticism about what the right material is to put it on. Even within the area of tape, for example, several different systems, each incompatible with the others, make it difficult to play safe.

If hardware manufacturers finally achieve something of the standardization that the audio industry managed to achieve with record players and tape decks, the first real chunk of investment in videocassette software may be forthcoming. Even then, however, the new industry will be challenged by a burgeoning CATV market. For obvious reasons CATV is cheaper for the consumer than buying a library of videocassettes. But in time we may have the same kind of split and overlap among CATV devotees and videocassette aficionados as among FM listeners and LP or prerecorded tape consumers today.

On the bright side, both CATV and the videocassette market will mean a tremendous demand for programming of all kinds. And this time, as contrasted to during the LP boom era when the magazine photographer was in his heyday but unaffected by the wholly aural medium, the photographer has an advantage: CATV and videocassettes are audio-*visual*. Then too, there is a commercial TV market, which will no doubt present a growing market for the uses of imaginative still photography.

CURRENT APPROACHES TO VIDEOCASSETTES

1. Miniaturized Film—The leading film-cassette system for playback on TV screens is the C.B.S. electronic video recording system, called EVR, employing a special fine-grain, miniaturized film. The recording process begins with the conversion of standard movie films or video-taped programs to video signals, which go on to actuate the EVR electron-beam master recorder. Using a fine electron beam instead of light to expose the master film, the system creates images reduced to a double channel of movie frames on film only about a quarter-inch wide. In color programs, one channel encodes color. Copies of the master film can be produced by high-speed contact-printing methods at the rate of a half-hour program every eighteen seconds, and the copies are wound in a seven-inch-diameter sealed cassette. When a cassette is placed in the playback unit, it automatically runs through an electro-optical assembly that translates the film to color images on the TV tube.

2. Magnetic Tape—Widely used in TV broadcasting, magnetic video tape is being adapted to the home playback market in many competitive systems. Three of them, Sony's Videocassette, Cartridge Television Inc.'s Cartrivision, and N.V. Philips' VCR, are promised for next year. The systems differ in detail, but are basically similar and simple in principle. Working from a program on standard video tape or film, images and sound are converted to video signals and sent to a master video-tape recorder. The master tape thus produced is used to guide multiple duplicating recorders in turning out copies, which are then packaged in cartridges or cassettes. Slipping a cartridge or cassette into the playback unit readies the tape to run over a pickup head, sending the program's signals to the TV screen. Magnetic tape, alone among all the TV playback media, also permits home recording on blank tape of family movies or televised programs, for instant or later replay.

3. Plastic Disc—The newest entry in the field is this improbable-looking adaptation of the old disc record. Developed jointly by A.E.T.-Telefunken and Decca, Ltd., and demonstrated in 1970, it is promised for delivery in black-and-white and color in early 1973. In the disc system a video-taped program transmits frequency-modulated signals to a master recorder's cutting head, etching ultrafine grooves, 120 to 140 to the millimeter, in a master disc, which then stamps out replicas in thin plastic. In playback the plastic disc is placed in a special high-speed record player, where it turns on a spindle at 1,800 revolutions per minute, its free-floating surface lightly touching a diamond stylus. The stylus is moved in a straight line across the disc by a cam-and-pulley arrangement, translating pressure variations into pictures on the tube. A twelve-inch disc has twelve minutes' playing time in black-and-white, and is said to have the same playing time in color.

4. Holographic Tape—The most novel of the TV playback systems, depending on an entirely new technology, is RCA's holographic tape, called SelectaVision. It was demonstrated in 1969 but needs more development. Starting from a color film or video-tape program, the system first produces a special color-encoded film, which is converted by split laser beams (bouncing off four mirror reflectors) to a photoresist strip of holograms —pictures encoded in the strip's surface in almost invisible "interference patterns" of light from the images. The hologram film is then processed into a patterned, nickel-plated hologram master, which presses multiple copies on low-cost, transparent vinyl tape for packaging. In playback the tape passes between a small low-powered gas laser and a small camera, which reconstructs the hologram patterns into visible color images and converts them to video signals for transmission to the TV screen.

Victor Keppler

9. A Pro Never Stops Learning

BY VICTOR KEPPLER

Editor's note: In 1916, Victor Keppler bought a camera with pennies he had saved running errands. Its cost was $1.25. Beginning in the late 20's, he became so famous in the advertising-editorial fields that he used to attach two aspirin tablets to the huge bills he sent to clients. He was perhaps the first photographer ever to gross over four-million dollars from his talent-plus-camera skills. In his so-called "retirement," he became the Founder of the Famous Photographers School—an independent-study school based in Westport, Connecticut.

PROBLEM: TO PRODUCE AN OUTDOOR PORTRAIT WITH WELL-BALANCED LIGHTING

Bright 45° sunlight creates too much contrast: the deep shadows around the eyes and all areas shielded from the sun are unflattering to the girl's features and the picture's effectiveness.

Solution 1: Here the photographer, Victor Keppler, uses a stiff sheet of white cardboard so that sunlight is reflected back into the shadow areas of the girl's face. Notice how much more detail becomes visible in the eyes, throat, hair, and so on.

162

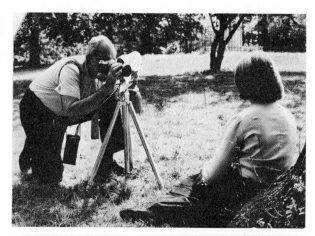

Solution 2: To lighten the shadow side of the face even more, Keppler now uses synchronized flash. Straight flash would be so strong that it would "wash out" all shadows and thus spoil the effect of outdoor naturalness. To soften and diffuse the light from the flash, Keppler has covered the flash reflector with his handkerchief. Compare this picture with the straight sunlight (45°) lighting effect of the first picture.

Subject: Five Basenji puppies whose one idea is to go places—anyplace—in different directions. *Problem:* How to bunch them together long enough to photograph them all looking toward the same spot. *Solution:* In this case, all five were placed on a raised surface so slippery they couldn't get traction (note the pup on the far right who tried). At the same time he made a sharp noise to attract their attention, the photographer clicked his shutter. Photo by Walter Chandoha.

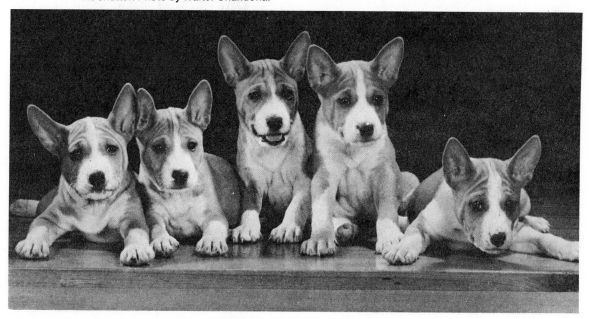

As a professional photographer for over 40 years, I've taken all kinds of pictures—illustrations, still lifes, scenics, news events, weddings, babies, the works. But when I started collaborating with ten of my fellow photographers to produce the independent-study course for Famous Photographers School, one of the most rewarding phases of this experience was learning things from them that I'd never known before.

This has convinced me that no professional is so expert or has so much experience that he can't learn more about his craft. In fact, I think it is characteristic of a good pro that he is always looking for fresh ideas, improved methods, new tricks, and different approaches. He never stops learning.

There's never a dull moment when Harry Garfield photographs a baby or child. There are fascinating toys, strange noises, sounds of cackling chickens, kittens mewing, dogs yipping, talking hand puppets, and adults performing strange and wonderfully amusing antics. This baby is delighted with the entertainment, as her expression so clearly shows. But although an assistant (Mrs. Garfield) is in this case providing the expression-evoking action, Harry has quietly arranged his camera angle and engineered the composition. Note how the baby's legs are crossed, and the hands are brought together. Neither is by accident. The baby has instinctively brought her hands together because a tiny piece of cellophane tape has been attached to one finger—invisible to the camera. All photos by Harry Garfield.

TIPS ON PHOTOGRAPHING BABIES

For example, I thought I knew a lot about photographing children, having used them many times as models for advertising pictures I've made. But watching Harry Garfield at work was an eye-opener to me. One of his methods that struck me as little short of miraculous is his technique for stopping a baby or very young child from crying.

When other methods don't work, Harry has the mother lie down on her back and seats the baby on the mother's stomach. This intimate contact with the mother almost instantly soothes the baby, and instead of an unhappy, crying child, you have a happy, cooperative one. The mother, of course, is cropped out of the picture when Harry makes the final print. It's as simple as twisting a piece of wire to make a hairpin—and just as ingenious.

Another of Harry's tricks that makes you say "Now why couldn't I have thought of that?" is

Problem: She is upset by strange surroundings, lights, crazy people who point things at her and gesticulate and make sounds she never hears at home. She has been abandoned by her mother. She's miserable and the tears flow.

Result: Photographers are nice people. A little crazy, perhaps, but ever so friendly and very, very amusing. This is fun, and her expression shows it. The black rectangle shows how the final enlargement was cropped. Who'd ever guess she was sitting on mother's tummy? All photos by Harry Garfield.

Solution: Mother lies down on a couch and is partially covered by a blanket. Feeling secure again, the child finds a toy enchanting. The tears stop. Maybe photographers aren't so dangerous after all—not with mother there.

using little pieces of Scotch tape to control the position of the baby's hands. You attach a piece of tape wherever you want the baby to touch himself—to a fingertip, for example, if you'd like him to put his hands together for a better pose and tighter composition. When the baby starts to pick off the tape, you or your assistant make a funny noise or do some trick that catches the baby's attention at the instant you snap the shutter.

TIPS ON STILL-LIFE PHOTOGRAPHY

I've been called upon to make many still-life pictures during my career, but I wish I'd known at the beginning some of the methods I picked up from Irving Penn.

For example, one of the most difficult subjects to photograph well is a glass of liquid with ice floating in it, set against a light background. The problem is to make the ice stand out clearly enough. A good solution, and one that had not occurred to me, is to place a small piece of black paper just behind the glass. The ice will pick up black reflections that outline its shape—sort of highlights in reverse. By adjusting the position of the black paper you can control the reflections and strongly reveal the shape of the ice.

Photographing ice cream is a difficult assignment, as you may know from experience. Richard Beattie has a wonderful method for handling this subject. He makes a mound of dry ice in a dish or container, covers it with ice cream built up to the desired size and shape, and then puts it in a freezer to let the ice cream harden. When the time comes to make the exposure, he takes out the dish, places it in position, and then goes over some of the surface edges of the ice cream with a heated knife, softening it and giving it that delicious, ready-to-eat look. However, the core of dry ice keeps the mound in shape and prevents the ice cream from melting quickly, even under hot incandescent lights.

EISENSTAEDT'S METHOD FOR CANDID PORTRAITS

Watching Alfred Eisenstaedt at work was a revelation, too. I was especially impressed with his method of getting candid close-up portraits. Often he puts his camera on a tripod and uses a long lens and cable release. Once he has focused on his subject he doesn't continue to look through the camera but gets up, moves around, talks to his subject. When he sees a good expression, he trips the shutter with his cable release. As Eisie says, "How can I expect you to behave naturally if I'm raising and lowering my camera continually and jumping around like a jittery monkey? With the camera on a tripod, you will watch *me*, not the camera, so you'll be relaxed."

I also was intrigued by a method Eisie sometimes uses for candid street scenes. He puts a 28mm or 21mm lens on his 35mm camera, presets the exposure, and focuses to get a useful depth of field—say about 6 to 15 feet. Then he carries the camera close to his chest as he walks along the street. When he comes within range of an interesting subject, he takes a picture *without raising the camera to his face.*

As long as you keep the camera close to your chest, most people won't realize you're taking their picture, Eisie has found. Of course, you can't compose very accurately this way, but the wide-angle lens gives you a margin for error, and you have a degree of control by tilting the camera and turning your body.

One of the many interesting methods I learned from Richard Avedon was his use of recorded music to help put his models in the right mood for a picture. A stranger walking into Avedon's studio during a working session might mistakenly imagine that a party was taking place: The hi-fi usually is turned on full blast. But music is just a part of the Avedon technique. He uses soft music for a soothing effect and loud, jazzy music to create an atmosphere of tension and excitement. Music helps his models to lose their self-consciousness so that Avedon can get the animation and spontaneity he wants.

From Arthur d'Arazien I gained a new respect for the wonderful versatility of a single flashgun, used in this way, can give you elabo-with the open-flash method for illuminating large exteriors or interiors. He creates some of his most spectacular effects, in both color and black-and-white, by leaving the shutter open and then firing off flashbulbs to illuminate different parts of the scene. If he wants to add color, he wraps the flashbulb in a piece of colored gel. Just one flashgun, used in this way, can give you elaborate multiple-flash effects.

A NEW SLANT ON OLD METHODS

In talking to other photographers you often get fresh ideas about methods you've already tried. Take window light, for example. I recall that many years ago, when I first started taking pictures with an old 4″ × 5″ view camera, I photographed my family with light from a window as the main source of illumination and a bedsheet as a reflector. Seeing Irving Penn's use of window light in his portraiture gave me a new appreciation of the beauty and effectiveness of this kind of light. I was impressed by the way Penn uses a large, neutral gray flat on rollers as a background, turning it at an angle to catch the light when he wants a light background, and turning it so it is in shadow for a dark background.

Bouncelight is another case in point. I've often used bounce electronic flash in my own work, but I learned some interesting methods from my colleagues. I was fascinated by Dick Avedon's electronic-flash studio, with white walls, white ceiling, and white flats above and behind the camera, giving him an almost completely enclosed "tent" of bounce surfaces. The light comes in from all directions, creating a nice clear, clean, soft effect, and allowing the subject complete freedom to look or move in any direction.

Quite different is Bert Stern's method of bounce backlighting. He sets up two umbrella bounce-flash units on each side and bounces them off a white wall behind his subject. To reduce flare and increase contrast, he blocks off excessive backlighting by placing two flats behind his subject, at right and left, just out of camera view. Sometimes he uses another bounce-flash unit in a high frontlight position to give him a little fill. By adjusting the lighting and exposure, he can create effects ranging from silhouettes to soft but fully detailed shadows. Often he deliberately emphasizes the grain in these pictures by using Tri-X or Isopan Record films and printing his enlargements on No. 6 Brovira.

MORE TIPS FROM OTHER PROS

Sometimes what you learn are little tricks that can help solve a common problem or enable you to do something more quickly and easily. Here are just a few that I've learned *after* I closed my own studio to "retire."

For a background, Harry Garfield suggests mounting a permanent sweep of white linoleum in your studio. Although the initial cost is more than that of seamless white paper, it will save you money in the long run—and rather quickly at that. You can easily wipe off dirt or footprints and keep using the same sweep over and over again. Also, linoleum doesn't tear or wrinkle the way paper does.

Philippe Halsman points out that some people are so camera conscious that they anticipate the clicking of the shutter and blink when they see your finger press the plunger on the cable release. To counteract this, Halsman simply uses a long cable release and holds it concealed in his pocket or behind his back.

From Walter Chandoha (see Part 4 of this Section) I learned that if you want to photograph a parrot or most any other kind of bird apparently looking straight at the camera, an assistant must stand at the bird's *side* and attract its attention. A parrot sees to each side, rather than straight ahead. When he looks at the assistant, he will be facing the camera head on.

Most of all, what a professional can get from

contact with other pros is a fresh viewpoint. We all tend to become set in our habits of working, and because a particular approach or technique has worked pretty well in the past it's only human to continue doing things in the same way. It takes effort to periodically reevaluate your work and methods of working to see if they can be improved. Learning how other photographers handle the same problem can be stimulating. It prevents mental hardening of the arteries and keeps a photographer young and growing—no matter what his age or experience.

Books by Victor Keppler: The Eighth Art, *Wm. Morrow Publishing Co.*; Commercial Photography, *Ziff Davis Publishing Co.*; Your Future In Photography, *Richard Rosen Press*; Victor Keppler: Man + Camera, a photo-biography, *Amphoto Publishing Co., Hastings House, Focal Press Ltd. (England).*

Arthur Goldsmith. Photo by Harry Garfield.

SECTION 9: BUSINESS POINTERS

1. Pricing Your Work

By Arthur Goldsmith

Editor's note: Arthur Goldsmith has authored hundreds of articles and a number of books on photographic subjects. Formerly the Director of Famous Photographers School, Goldsmith is now the Editorial Director of Ziff-Davis photographic publications.

What's a fair price for a photograph? For a full-time professional, setting the right price can mean the difference between a profit and bankruptcy. For the part-time pro the stakes may not be as high, but he, too, should price his work realistically.

There is no universally acceptable scale of prices for *most* kinds of photography. Your individual creativity and interpretative talent, your locale, the local competitive picture, the type and financial status of the client involved, the use to which a picture or series of pictures will be put, the cost of models and props, the shooting time, and distances to be traveled are but a few of the factors to be considered. Other variables are legion.

However, there are some basic rules of thumb to guide you. Before we probe some of the potential guidelines, let's take an overall look at the photographic market and some of its peculiarities.

Photography involves both a *product* and a *service*. The product, of course, is the print or transparency itself. The service is the skill, experience, and creativity of the photographer who produced the picture. The latter often is a decisive factor in determining value. An 8" × 10" color transparency for use in a brochure might be worth $100 if produced by a hack, and $1,000 if made by a highly-skilled, imaginative photographer. The difference lies in the quality of the service provided.

In metropolitan centers such as New York, Chicago, and Los Angeles, photographic prices tend to be higher than in smaller communities. Another decisive factor, of course, is the skill and reputation of the photographer himself. At one extreme are "name" professionals whose work is in such demand that they can command virtually any price. At the other extreme are those photographers—mostly amateurs, or neophyte professionals—who will work for next to nothing in exchange for a credit line, a chance to break into the market, or just for the fun and glory of being a photographer. In between are the vast majority of professionals and part-time professionals who want to make a fair profit without pricing themselves out of business.

FIND GOING RATES IN YOUR AREA

With these aspects of the market in mind, let's consider how you might go about setting realistic prices for your own work. A good starting point is to *check with professional photographers and studios in your area and find the going rates for* *the kinds of photography you plan to do. Your prices generally should be in line with these established rates.*

A full- or part-time professional who consistently undercuts minimum prices in his locality is

doing both himself and his profession a disservice. He may gain a temporary advantage, but is likely to find it unprofitable to stay in business for long. An amateur who consistently takes on work or sells his pictures for less than the going rate depresses the market for photographers who depend upon it for their living.

PRICING FACTORS

1. *Time.* One important cost factor is time—time spent on location or in a studio taking the picture, time spent in the darkroom processing and printing, time spent traveling to and from an assignment.

How much is your time worth? Only you can answer that realistically. One way to set a price tag on it is to equate the time spent in photography with the amount of money you might reasonably expect to earn working for the same length of time at something else. Let's say, for example, that you could earn $10,000 annually by putting in a 40-hour work week for 50 weeks each year. This means that the value of each hour comes to $5—a total of $40 a day. For comparison, here are the hour and day rates required for other levels of income:

Hourly rate	Daily rate	Annual income (salary only)
$2.50	$20	$7,500
5.00	40	10,000
10.00	80	20,000
15.00	120	30,000
20.00	160	40,000
25.00	200	50,000

If the $30,000 to $50,000 annual salary income looks pretty big at first glance, remember that this is *gross,* and as a self-employed businessman, a giant-sized bite will come out of it for materials, taxes, overhead, special expenses, and so on. In other words, your total billing to customers has to far exceed any figure you set as the annual salary required for the standard of living you hope to achieve. Let's go a little deeper into the income-versus-costs situation. . . .

Use of day rates ̓ASMP Code of Minimum Standards): Established *day rates* give a clue to the value that successful professional photographers put on their time. Day rates customarily are paid only for location work when a photographer is required to be away from his studio for a full day or the greater part of it. They usually do not include travel and other expenses, which are billed separately.

The ASMP (American Society of Photographers in Communication) sets a minimum day rate for its members at $150 to $200 per day shooting time, plus proportions thereof for incidental time—travel, standby, and the like. A number of other pricing surveys have indicated that a day rate of $100–$150 for black-and-white photography and $200–$350 for color is not an uncommon charge for a commercial studio. Time is money!

Of course, your skill and reputation may not be such that you can charge $350 a day or anything like it. But in general, an important element of a fair price is an adequate return for your time spent in producing the photograph.

2. *Materials and supplies.* This second item of cost is much simpler to evaluate. It includes the cost of film, paper, flashbulbs, processing chemicals, special props bought for the picture, and the like. The total might be very small, as in the case of a black-and-white available-light picture, or run to thousands of dollars, as with an elaborate studio setup photographed in color. If you don't bill these costs separately, they should be included in the price of the photograph.

3. *Overhead.* Under the broad category of overhead comes rent, heat, phone bills, electricity, salaries, insurance, and all the other operating costs of staying in business. For a professional with a studio, overhead can be a large and complex expense indeed. For an amateur or a part-time professional with only a closetful of equipment and a darkroom in the basement, it may be almost negligible.

4. *Depreciation of equipment.* This is one aspect of overhead that applies to almost every photographer. It may be a larger item than you suspect.

Let's assume your modest goal is to earn enough money at least to replace existing equipment when it wears out or becomes obsolete. First, total up the value of all the photographic equipment you own. Then divide the total by the number of years of useful life you can reasonably expect from it. The result is your yearly amount of depreciation. Now divide this figure by the average number of jobs you do during the year. The final figure will indicate the *average* amount you must clear on each job to cover replacement of equipment.

Let's say you own $700 worth of equipment and amortize this investment over a five-year period. Your annual depreciation is $140. If you have only two assignments a year, you would need to make $70 each time just to cover depreciation. For 20 assignments, an average of $7 would do it. For 40 assignments, $3.50, and so on. The moral, obviously, is "keep busy."

5. *Special expenses.* Take into account all special expenses—travel, car mileage (customarily 12-15 cents per mile for assignments more than 5 or 10 miles from your studio), model fees, meals, lodging, tips, studio rental, and so on. If you don't submit a separate bill for these items, their cost should be added to your other expenses.

Finally, check to see if a sales tax (state or local) is levied on photographs or photographic services in your area. If so, you should add this tax to your bill, and comply with the regulations requiring payment of the tax to the proper authority.

Obviously, you should keep accurate records of the time and money you spend on professional photography. These records not only are necessary for billing, but also are useful for income-tax purposes. You must declare any income you make from photography. However, if you establish yourself as a bona fide professional (part-time or full-time), you are entitled to deduct many of the expenses mentioned above—overhead, depreciation, cost of materials and supplies, and the like. See any current tax manual for details, or check with the nearest Internal Revenue Service office.

These simple cost-accounting methods may not pass muster with a CPA, but at least they will give you an approximate idea of where your break-even point lies. To illustrate how they add up, take an imaginary but not untypical case—a part-time free lance who is assigned by a local manufacturer to cover the ground-breaking ceremony for a new plant. The ceremony takes place a short drive from the photographer's home. How much should he charge?

SETTING A MINIMUM

Assume the whole job—shooting and darkroom work—won't take more than two hours, and the free lance figures his time is worth a modest $3 an hour. He has agreed to supply a single 8″ × 10″ print. The total cost for film, paper, and chemicals will come to about $1. Let's also assume his overhead, covering depreciation of camera equipment and maintaining his home darkroom, is approximately $3. Adding it all up, from this photographer's standpoint, $10 is a realistic *minimum* to charge.

But suppose the client balks at $10. He's accustomed to paying only $5 for a publicity shot. If our free lance is a good enough salesman, he'll work out an arrangement something like this: He agrees to shoot not just *one* picture of the ceremony but a series of 12 shots. (This won't require much extra time or effort once he's on location.) From the contact sheet the client can order as many pictures as he wants at $5 each, with a minimum guarantee of three. From the client's point of view, it's a bargain—he pays only $5 per picture instead of $10. The free lance, in turn, earns $15 or more instead of $5, with only a slight increase in his expenses.

The principle illustrated here is a valuable one to remember. It can be applied to many photographic jobs. *Once on location or set up in your studio, it costs you relatively little more to make a number of pictures rather than just one.* Then if you can convince the client or customer to buy several photographs, not just one, you can spread your costs thin, charging less per picture but making a bigger profit.

The established rates in your area and your personal break-even point on a job are two basic

items to consider when setting a fair price on your work. But here are some other items to keep in mind.

How will your picture be used? Will it hang in the customer's home? Will it be published, and if so, where—newspaper, house organ, trade magazine, brochure? Is it for advertising or editorial use? Inside or cover? How large will the photograph be reproduced? The answers to questions like these can greatly affect the price you should charge.

Photographs for advertising purposes usually command a higher price than photographs for editorial use. In general, you should expect a higher rate of pay from a publication with a large circulation than from one with small circulation, although there are many exceptions to this. Some publications have a *page rate* for photography, and pay on this basis for the space occupied by the photograph or photographs. For example, if the page rate is $100, a picture running half a page would bring $50; if it covered a two-page spread, $200. A photograph used on a cover customarily brings a higher price than one used inside.

Sell one-time rights (sometimes called single-reproduction rights), not all rights. Thus you may be able to build up, over a period of time, a valuable file of stock pictures, which you own and can resell. If a client requires full ownership of the negatives for unlimited use (as sometimes is the case in advertising photography) this should be reflected in the fee you charge for the job.

Another consideration is the number and size of prints you contract to deliver. Are these to be billed separately, or are they included in your over-all price for the job? Be sure to reach an understanding on this point beforehand. Sometimes it can make a big difference in your profit margin.

Finally, are you shooting in color or black-and-white? The rates charged for color photography generally are two to three times more than the rates charged for equivalent black-and-white photography.

PART-TIME PROFESSIONALISM

If you take on photographic work for pay, whether it's portraiture, small commercial jobs, weekend free-lancing, or any other assignment, don't take on a job you can't handle or promise more than you can deliver. This can only hurt your chances of establishing yourself in a highly competitive field.

In selling a photograph or accepting an assignment, always settle *beforehand* the price, rights, details of exactly what and when you are to deliver, what expenses are to be charged, and so on. It's best to get this in writing to avoid any possibility of misunderstanding. Settling these mundane but vital matters ahead of time can save hard feelings later on.

If you make only an occasional sale, or are just beginning to break into professional photography, that price is likely to be toward the minimum end of the scale for your area. You may find yourself doing the small, inconvenient jobs that aren't profitable for an established professional with high overhead. But if your work succeeds, and you begin to earn a reputation as a reliable, competent photographer, you should be able to raise your prices. If you're good enough, the ceiling is practically unlimited.

Books by Arthur Goldsmith: How to Take Better Pictures, *published by Arco;* The Photography Game, *Viking Press;* The Eye of Eisenstaedt, *Viking Press.*

2. What Is a Published Photograph Worth?

By Roy Pinney

©Roy Pinney from *Advertising Photography*, Amphoto Pub. Co. Reprinted by permission.

Editor's Note: In his book "Advertising Photography," Roy Pinney writes: "The value of a published photograph is dependent on its use, the photographer's reputation, client's budget, space, competition, geographic location, and other factors that may have little to do with the actual picture."

The prices shown here are meant only as a general guide. They were compiled from a survey Pinney made of prices currently quoted for the use of stock photographs in advertising by leading photo agencies, all members of the Picture Agency Council of America. Unless otherwise noted, they are for one-time reproduction rights with the lowest and highest quotations listed.

Rates

		COLOR		BLACK & WHITE	
Advertising	Exclusive international rights	$1500	5000	$500	2500
	Full-page magazine use	1000	2500	500	1000
	Multiple national magazine	1000	5000	500	1500
Annual Reports	Cover	200	500	125	300
	Inside	150	300	50	150
Artist Reference		50	100	35	50
Background Advertising		250	1500	100	500
Books	Cover	200	500	150	250
	Inside	150	300	35	100
	Frontispiece	200	350	35	100
	Paperback cover	150	450	100	250
	Foreign rights	50% additional per country			
Brochure	Cover	250	500	100	150
	Inside	150	250	50	100
Calendar	Exclusive one-year rights	350	1000	150	500
	Single sheet	400	1000	200	200
	Foreign rights (per country)	150	250	100	250
Car Card	One-time use	150	500	100	350
Catalog	Cover	250	750	100	350
Design Copy		150	300	50	150
Direct Mail		250	750	100	350
Encyclopedia	One-time use	150	350	50	150
	Foreign rights	50% additional per country			

Exhibition	150	250	50	150
House Organ Cover	150	500	125	250
......................... Inside	150	300	35	150
Jig-Saw Puzzle	150	500	100	250
Layout	35		25	
Presentation	35		25	
Sketch	35		25	
Stat	35		25	
Magazine Cover	150	2500	150	500
......................... Inside	150	500	50	300
Mural	150	750	75	350
Newspapers Advertising use—full page	500	1000	300	750
......................... Half page	350	750	150	500
......................... Quarter page	200	350	125	200
......................... One column	125	350	50	150
......................... Editorial	125	250	35	150
Outdoor Advertising 24 Sheet—National	500	1500	300	750
......................... 24 Sheet—Regional	350	1000	200	500
......................... 24 Sheet—Local	200	500	150	300
Package Design International	750	3000	500	1500
......................... National	500	2000	300	750
......................... Regional	350	1000	200	500
Point-of-Purchase One-time use	150	500	100	300
Poster Advertising National	750	1500	300	1000
......................... Regional	350	750	125	500
......................... Local	150	350	75	200
Public Relations	150	500	75	250
Records Cover	150	500	75	250
......................... Insert	150	300	50	150
......................... Back Cover	100	250	50	150
Sales Promotion	75	150	50	100
Service Charge	35	100	25	
Slide Film One-time use	75	150	35	75

Dorothy and Herb McLaughlin. Photo by Barry Goldwater.

3. How We Go After Photographic Business

By Herb McLaughlin

"Herb and Dorothy McLaughlin are recognized as one of America's leading man-and-wife camera teams. Individually and together, they have created a treasury of photographic excellence that spans more than two decades. Their pictorial interests have ranged over an almost endless spectrum of subjects, from the delicate mysteries of children's faces to the sprawling panorama of modern industry. For this outstanding series of pictures, the McLaughlins have turned their lenses toward the flowers of the Arizona desert. Each is a masterpiece of natural color and artistry to be enjoyed over the months and years to come."—from the foreword of a calendar produced by Western Savings and Loan Association. Reprinted here by permission.

It's well over 25 years ago that I met the author of this book. At that time I was a free-lance photographer working mostly on newspapers and magazine material, but also dabbling a little in commercial, industrial, and advertising photography. Art (as we knew him) Ahlers was an editor on several magazines, including a deluxe new publication aimed for well-educated and affluent farm managers. For several years we were a traveling team, producing illustrated articles on successful new innovations in farming—everything from exotic crop experiments and land conservation to the commercial raising of squabs and new breeds of livestock for meat.

Inevitably, however, our paths divided. He moved from Ohio to New York to become executive editor of a photography magazine. I moved from Indiana to Arizona to continue free-lancing. But although we haven't met in person since the late 40's, we've maintained constant contact by phone and mail. Late one afternoon he called me from New York and said in essence:

"When you have time, Herb, I'd like you to do a piece on the self-promotion, or 'business-getting' aspects of photography. In other words, focus upon some of the approaches you've used

to graduate from the role of a free lance who operated out of the trunk of his car to that of President of one of the most successful studio operations in the southwest."

Well, to begin with, I've always felt that it takes a lot more than the mechanical ability to produce a good photograph for a person to succeed as a free lance. For an amateur, a technically good photograph of a subject of his own choosing is in itself a satisfactory "end-product." The bread-and-butter professional working on assignment has no such choice in subject matter. His photographs must serve as key components for his *client's* end-product—an ad, brochure, magazine cover or editorial illustration, annual report, or whatever. If he is to stay out of the red, therefore, a pro has to have more on the ball than technical proficiency. He has to be able to analyze a client's photographic needs, then draw upon his creative talent to fulfill those needs with visual impact. Further, he must wear several other hats—a businessman's hat, a public-relations man's hat, a salesman's hat, and often that of a comptroller. In short, a pro has to be realistic in terms of time, production costs, and dollar *net* profits.

THE REALISTIC $ APPROACH

Too many talented young pros are having rough sledding these days because they aren't realistic

about the business side of photography. Take for example the young pro who looks at a job from

this standpoint: A roll of film costs so much, the processing and printing is so much—totaling, say, $10. His client likes one print and pays him $50 for it. He therefore reasons that he has made a profit of about $40.

Malarkey! If he took into consideration the hourly rate he owes himself for even a modest income, depreciation, overhead, and incidental expenses (travel, lunch, taxes, and so on), he'd realize that although he *grossed* $40 on the sale, his *net* return has dwindled to peanuts.

Whether he works from the trunk of his car, his basement darkroom, or a studio, a photographer must figure out his own financial "break-even" price on a job. To this, he must add whatever amount it will take to earn the salary he needs, or aspires to, in order to maintain a certain standard of living.

My experience has been that a free lance who wants to earn a salary of $10,000 a year must multiply his cost-of-materials by at least 10, then add to his billing all the actual expenses (travel, props, models, legitimate incidentals, and the like) involved in the job. Moreover, since time is money, he has to make the costs of his overhead, salaries, expenses, and so on, all of which involve about 20 per cent of his total time. The other 80% is eaten up in sales efforts, conferences, travel, and other non-photographic production time. We try to be occupied in taking photographs 25 per cent of the time; if we could reach 40 per cent, we'd be in Seventh Heaven.

How do you go about getting the volume of business you need to turn a profit?

IMAGE BUILDING

Some photographers, especially those near metropolitan advertising and publishing centers, make up portfolios and do a lot of calling upon potential buyers in person. Others hire personal representatives on a commission basis to make the personal calls and do the selling. Still a third group relies mostly upon mail, phone, and word-of-mouth recommendations. With occasional exceptions, we belong primarily in the third group.

As a free lance in Indiana, I concentrated mostly upon taking photographs for magazines and newspapers. This is where I developed the knack of (a) instilling an editorial "feeling" in other types of pictures—i.e., commercial, industrial, and advertising pix; and (b) using every feasible means to build and publicize a reputation for creativity, flexibility, and reliability.

Upon moving to Arizona, therefore, my first image-building step was to contact the local newspaper and magazine editors, company advertising managers, the Chamber of Commerce, and everyone else I could find who regularly made use of photography. Whenever my wife Dorothy or I came across something locally newsworthy or unique, we'd photograph it and send prints to the publication, company public-relations department, or organization most likely to make use of them. We didn't ask for payment, although some recipients insisted upon at least a token payment. At this point, cash wasn't our prime objective. What we wanted was goodwill, a credit line, and growing public awareness of our existence in the community. Photographs were in a sense the "calling cards" we used to help open future doors. We still follow this policy; hence, over the years we've offered free photographs by the thousands. As for results, I can't begin to estimate how many direct and indirect ways this policy has paid off in cash assignments.

HOW FREE PHOTOS HAVE PAID OFF

When a new firm or industry plans to move to our area, its representatives almost always consult the Chamber of Commerce and the business-page editors of local newspapers, civic or fraternal organizations, and so on. When asked whom they can recommend as local photographers, the goodwill spadework we've done frequently pays off with an assignment.

To cite a specific case history: When a large company decided to build a factory near Phoenix, we were recommended to handle their photographic work by a newspaper business-

page editor. The company liked our initial work, but when the ad manager decided he needed more photos, he picked a day when both Dot and I were booked for other assignments. He got another firm to handle his immediate needs, but thereafter began giving us assignments for jobs to be handled on specific days as much as six months ahead. Advance scheduling, once a novelty, has become fairly routine with us now. A number of national advertisers book their assignments well ahead of the actual shooting day. Since these dates preclude accepting other work, we naturally like them to be confirmed in writing.

A BUILT-TO-ORDER STUDIO

Perhaps I should have explained earlier that when it became obvious that we could no longer make-do without a highly efficient studio setup, we planned our own studio and had it built to order. The building provides 4,000 square feet, of which 1,000 are allocated to a general office, a private office, and filing space. A small (11 × 22-ft) studio is equipped for shooting table-top products and an occasional portrait, though we do very little portraiture and no fashion work at all. A large studio area is equipped for commercial work involving mass products, machinery, and the like. There are two small negative developing rooms and a 10 × 30-ft printing room in which four enlargers are wall-mounted at optimum working height.

The business and photo file room on the McLaughlins' built-to-order studio. Over 150,000 stock photos are stored in this room, with negatives and control indexes that make it possible to locate any photo in a matter of minutes. The McLaughlins sell stock photos directly to clients, but also make many of the same photos available through stock-photo agencies in North America and Europe.

The print developing room has all utility cabinets, washing trays, and so on mounted on wheels so they can be periodically moved out of the room at the door on the far left.

Here the lab equipment has been moved out (view from the doorway noted above). The wall-mounted enlargers will now be dusted and covered with waterproof plastic. The entire floor area can then be flushed with water, which will flow out through the floor drain. McLaughlin prints rarely require any kind of spotting from dust or chemical particles.

Building a set for an advertising client. The black stairstepped set is 24 ft. wide. In the final 8″ x 10″ color transparency, each step will be fully loaded with the client's huge line of packaged goods, and enlivened by a pretty girl. Set-ups of this type command a price of approximately $6,000 (and up) for a single final photograph, plus expenses.

As far as I know, we have one of the few existing studios in which virtually everything is mounted on wheels. A utility cart beneath each enlarger carries everything from printing materials and chemical trays to a voltage regulator and a print washing tank. This wheel-oriented setup has saved us thousands of man-hours of work in cleaning and print spotting. There are four sink drains built into the floor. To clean an area thoroughly, the equipment is wheeled out and the whole floor is hosed down with water. In the printing room, of course, the wall-mounted enlargers are dusted, cleaned, and then securely covered and made watertight before the area is flushed.

Since a setup of this kind enables us to work efficiently with a small staff, we are able to divert more time into increasing our volume of business. How? Well, we use more approaches than I have space to describe, but here are six ideas you might want to consider adapting to your own situation.

OUR SIX MAIN APPROACHES TO GETTING ASSIGNMENTS

1. We make heavy use of Uncle Sam's mail carriers. The first step in this direction began with planning a design for our letterheads, envelopes, labels, stickers and other mailing pieces that potential clients would begin to recognize at a glance. That the design we came up with serves its purpose has been proven time and again when an editor or client writes, in essence: "Your name came up the other day when I happened to drop into the office of Joe Doe of XYZ Mfg. Co. Although your letter was buried halfway down in the stack of mail on his desk, I spotted it immediately. The minute I mentioned your name, Joe reached into the stack and plucked it out. We both recognized it by the familiar colored plaid stripe that runs vertically the full

HERB AND DOROTHY McLAUGHLIN
PHOTOGRAPHIC ILLUSTRATORS

ARIZONA PHOTOGRAPHIC ASSOCIATES, INC.

Ervin R. Abramson - Milwaukee	International Harvester
A & M Associates - U-Haul	International Trail
Allison Steel	Jacobsen Manufacturing Co.
The American Banker, - N.Y.	Kaiser Aerospace
America Illustrated	Kennecott Copper Co.
American Olean Tile Co.	Kenworth Motor Trucks
American Sugar Co. - N.Y.	W. A. Krueger Co.
Annan Photo Features - N.Y.	London, England Observer
Applied Photography	McCann-Erickson - L.A.
Elizabeth Arden, Inc.	Melroe Manufacturing
Arizona Farm-Ranchman	Men of Action
Arizona Highways	Minnesota Mining & Mfg. Co.
Associated Press	Montana Power Co.
British Broadcasting Company	Motor Boating
Bagdad Copper Company	Motor Magazine
Frederick E. Baker, Adv. - Seattle	Motorola, Inc.
London, England	Motor Trend
Barnaby's Picture Library	Mountain States Telephone Co.
Bonanza Airlines	Newsweek
Borden's	The New York Botanical Gardens -Bronx
D. P. Brother & Co. - Detroit	Oldsmobile Div., General Motors
California Farmer	Paillard, Inc. -Linden, N.J.
Campbell-Ewald - Detroit	Palmer-Larson Advtg. -Santa Barbara
Campbell, Mithun, Inc. -Mpls. & Denver	Peterbilt Motor Co.
Chemmetals Corp.	Producer Cotton Oil
Chrysler Corp.	Reach-McClinton - L. A.
Coca-Cola Bottling Co.	Phillips Petroleum Co. - L.A.
Collier Macmillan Internat'l - N.Y.	T.J. Ross & Assoc. - San Francisco
Colorado Magazine	Royal Typewriter Co. -Hartford, Conn.
Commercial Car Journal	Santa Fe Railroad
Cudahy Packing Company	Savway Carton Forms, Inc. -Dallas
Dancer, Fitzgerald & Sample - N.Y.	Science Research Assoc. Inc - Chicago
Der Post - Belgium	Southern Pacific Railroad
Dickson Electronics	Southwest Forest Industries
The DuPont Co.	Spangler Public Relations Co. - L.A.
Daniel J. Edelman, Inc. - L.A.	Spreckels Sugar Co.
European Copyright Co.- London	Time
Evinrude	Time-Life International - N.Y.
Field Enterprises Educational Corp.	TVA - Jacques Lemoine Assoc. - N.Y.
- World Book Encyclopedia	Union Carbide
- Child Craft	U. S. Dept. of Commerce
FMC Corporation - Canning Mach. Div.	U. S. Information Agency
Foote, Cone & Belding - Chicago	U. S. News & World Report
Ford Motor Co.	U. S. Steel Corp.
Ford Times	Western Electric
Fuller & Smith & Ross - Cleveland	Western Horseman
General Electric Corp.	Westinghouse Electric Supply
G. M. A. C.	- Air Conditioning Div.
Will Grant Adv. Agency - L.A.	The Wheelabrator Corp. -Mishawaka, Ind.
The Griswold-Eshleman Co. -Cleveland	White Motor Trucks
Gulf States Land & Industries - N.Y.	Wrigley Chewing Gum
Guns & Ammo	Wyatt, Dunagan & Williams - Dallas
Hablemos Magazine	Yachting
Harley-Davidson Motor Co.	Young & Rubicam - Chicago
Hillyard Chemical Co. -St. Jos., Mo.	Frank Lloyd Wright Foundation

ADVERTISING PHOTOGRAPHY FACT SHEET

ARIZONA PHOTOGRAPHIC ASSOCIATES
I N C O R P O R A T E D

Date_____

Completion of this form will help to assure you that our conception of
the photograph will represent your ideas visually as accurately as
possible and at reasonable cost.

JOB No. _____ P.O. No._____ COLOR_____ BLACK & WHITE_____

FORMAT: Horizontal_____ Vertical_____ Square_____

AUTHORIZED BY: Name_____ Title_____

 Company_____

 Address_____

 _____ Zip Code_____

 Telephone_____ Area Code_____ Ext._____

CLIENT:_____

1. How will the photograph be used? (E.G. Newspaper, T.V., Point
 of Sale, Brochure, Direct Mail, Trade, Regional, National, etc.)

2. What is the purpose of the photograph?_____

3. Who are we trying to reach with this Photograph?_____

4. What is the most important thing this Photograph must say?

Advertising Photography Fact Sheet page 2

5. What is the second most important thing this Photograph
 should say?

6. What is the third most important thing this Photograph
 should say?

7. What are the things this Photograph should avoid showing? (Why)

8. A rough layout is attached. Yes_____ No_____

9. Estimated Photographic Budget for this Job $_____

 Models furnished by Client__ Agency__ APA__ $_____

 Properties_____ $_____

 Special Equipment_____ $_____

 Misc. (Mileage, Meals, Lodging, etc.) $_____

10. Date Proofs Required_____

11. Date Reproduction Prints Required_____

 Size of Print _____ No. Required _____

 Special Effects Required _____

CONTACT: Name_____ Title_____

 Company_____

 Address_____

 _____ Zip Code_____

 Telephone_____ Area Code_____ Ext._____

COMMENTS: _____

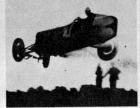

length of the left-hand side of your letterhead."

In terms of recognition value and easy retrieval on a client's loaded desk, none of the other designs we've experimented with can begin to match the effectiveness of an *edge-striped* mailing piece.

2. At one time we used to buy the biggest display ads we could get in the yellow pages of the phone directory. We discontinued the big ads not only because they were expensive, but because they rarely reached potential clients beyond our immediate area. The same money invested in postage, letters, color postcards of the studio, reprints of published material, and what we call "behind the scenes" mailing pieces, brings us a great deal of business from all over the nation.

This will give you an idea of one technique we use in soliciting new business: Each month, Dot and I scan trade journals of all types—advertising, construction, tourism, industrial, and so on. We also leaf through the best of the house or company-sponsored publications, annual reports, and newsletters. When we read of someone in an important company or organization who has been promoted, opened a new department, or is a newcomer to the company, and who *might* make use of photography, we write him a brief congratulatory letter and enclose several reprints of work we have performed for other companies. Typical of the reprint material is the four-pager reproduced here. Since the first question we ask every client is, "How do you plan to use the photograph(s)?" we also enclose a query sheet of the kind shown on page 180. We have found this technique (combination reprint and query sheet) an effective business-getter.

We also make use of simple color postcard campaigns. Here is a typical case history: A construction trade magazine supplied packets of 100 postcards that people in the construction

field could use in requesting free literature. In going through these cards, I checked the names and addresses of about 60 companies that I thought might be interested in our kind of photographic services. Then I wrote a postcard to the advertising manager of each company, saying in essence:

Dear Sir:

I think you might be interested in knowing about the professional photographic services we have to offer in Phoenix.

Although we cover Arizona primarily by ground and air, we also fill assignments in eleven other Western states, and occasionally get to Mexico and Alaska.

Please bear us in mind when you have need of black-and-white or color photographs "taken to order."

Sincerely yours, etc.

We had the first of several profitable replies within a couple of days. The ad manager of a company in South Dakota phoned that one of his company's machines was soon to be lowered to the bottom of the Grand Canyon by helicopter. Could we cover the lowering with an eye-catching photograph? We could and did; the fee was about $1,000 plus expenses. During the next year, we did an additional $3,000 worth of assignments for the same company.

3. We often use helicopters on assignments. Once the main job is finished, we often "chink in" with random shots of other subjects that will go into our stock-photo files. On one such assignment flight, I recalled a rumor that a major company that has more than 100 active subsidiaries, planned to make Phoenix their national headquarters. I had the pilot circle the site of the building they might move into and took four photos from different angles. As soon as 8″ × 10″ prints could be made, I airmailed a set to the president of the company. At the time, it seemed to me his name was vaguely familiar, but to play it safe I addressed him formally in a covering letter welcoming him to Phoenix. The pictures, I said, were complimentary and to be freely used in any way he chose. Moreover, I was giving the local Chamber of Commerce another set from which to choose a cover for their magazine.

Bingo! Back came a cordial letter beginning "Dear Herb," in which the president reminded me of a calendar we had produced twenty years ago when he was manager of the Phoenix branch of the company. Eventually the company did make their main headquarters in Phoenix, and the president has introduced and recommended us to everyone in the corporation who makes use of photography.

In connection with the same company, an amusing aftermath took place when the assistant to the PR director urgently needed extra copies of the four aerials. She didn't know the serial numbers of the photographs, but could we possibly find the negatives and rush new prints? She called about 10 o'clock in the morning; before 11 o'clock, the prints were there. Sounding a little overwhelmed, she phoned to say she'd never seen such service in her life.

The "secret" lay in our stock-photo files.

4. We now have over 150,000 different photographs in our stock-photo files. All but a handful of historical shots are the cream of what Dot and I have taken over the years, and we have retained all publication rights. In black-and-white material, our best stock photos are printed in anywhere from two to six duplicates, so it was easy to pull extra file copies and rush them by messenger to the PR assistant. At the same time, we wrote up a work slip (identifying the negative numbers) to have replacement prints made up to replenish the stock-file copies.

One-time publication rights to hundreds of our stock subjects have been sold over and over again. In addition to selling these directly from our own files, we have large selections that are sold on a commission basis by stock-photo agencies in the USA and overseas. Although we often have requests for a catalog showing samples of our stock photos, we have never felt it feasible to produce one. For one thing, the cost of reproducing enough black-and-white and color photographs to represent a cross section of our work would be prohibitive. Second, we'd rather slant samples of the kind of work we do to the direct interests of the picture buyer who queries us. If a company manufactures food products, machinery, or construction materials, we send him beautifully reproduced reprints of work we've already had published in those fields.

It's the same with those who query us about scenics, flowers, children, pets, ecological subjects, and dozens of other categories. Each query by phone or letter results in an immediate dispatch of the type of photographs the potential client is looking for.

5. How do we get reprints in sufficient quantity to fill our needs? In some cases we photograph a newspaper or magazine article, enlarge it, and make up a layout that we have printed ourselves. For high-quality color reproductions, we arrange to obtain whole copies or excerpt reprints of the publications that carry illustrations and text about our work. *Arizona Highways Magazine,* for example, is famous for its color reproduction quality. Its paid circulation is 455,000, and copies filter into many countries outside the USA. Even though we are not paid high rates for material, we have been providing the magazine with color transparencies of Arizona scenics for years. Recently our credit line appeared beneath the color shots of almost an entire issue. In cash, we received only a modest fee, but we knew that the free copies they gave us would stimulate far more than that in sales to clients as stock photos. As time permits, we mail our free copies to prospective new clients as well as some of our regular clients and editorial buyers. With each copy goes a brief letter highlighting the scenic material we can provide in their (the client's) area.

For advertising and industrial clients (both existing and potential), we have an issue of *Applied Photography,* published by Eastman Kodak Company, in which eight pages and the back cover carry superb color reproductions of our work.

To calendar and greeting-card companies, we send a variety of samples, including a calendar recently produced for Western Savings and Loan Association. The theme for this calendar is flowers in their natural habitat, and each month of the year is introduced by a different desert flower scene reproduced in excellent 7″ × 10″ full color.

So it goes with all types of subject matter from babies to bulldozers, animals to aquatic sports. We make heavy use of reprint materials selected to fit the interests of different buyers.

6. The image you create in your own community depends a lot upon your actually participating in community affairs. Although we belong to the Rotary, the Phoenix Press Club, Chamber of Commerce, and other organizations, I'm not suggesting that you become a "joiner" just to exploit business connections. True, we do get some recommendations that lead to assignments through various organizations, but we also contribute as much as we can to all kinds of groups without charge. We give slide shows and talks to civic and educational groups, provide photographic exhibits for store, bank, and museum displays, appear on radio and TV, speak at luncheons, benefits, or before practically any business, social, or fraternal group that calls upon us. Moreover, the doors of our studio are always open to editors, art directors, ad managers, visiting photographers, and even nonphotographic-minded groups that simply want to see what we do.

What does it all add up to? To me, it leads to several conclusions. You have to go after business to get it, and your best credentials are proven ability presented in a straightforward, business-like manner. What our clients want is a solution to their needs. To them, a photograph is a visual component—a tool—that will enhance (and thus help sell) the end-product they have in mind. From the practical point of view, our role is that of creative tool makers—people who forge each visual tool to meet the exact needs of a specific client. Our greatest source of satisfaction is a client who is so pleased with what we deliver the first time that he comes back again—and again.

The McLaughlin's book entitled Phoenix 1870–1970 *has been widely acclaimed, and a copy was included in the time capsule that was buried at the Phoenix Centennial in 1970. Their second book, tentatively titled* Arizona the Enchanted Land, *is now nearing completion.*

4.

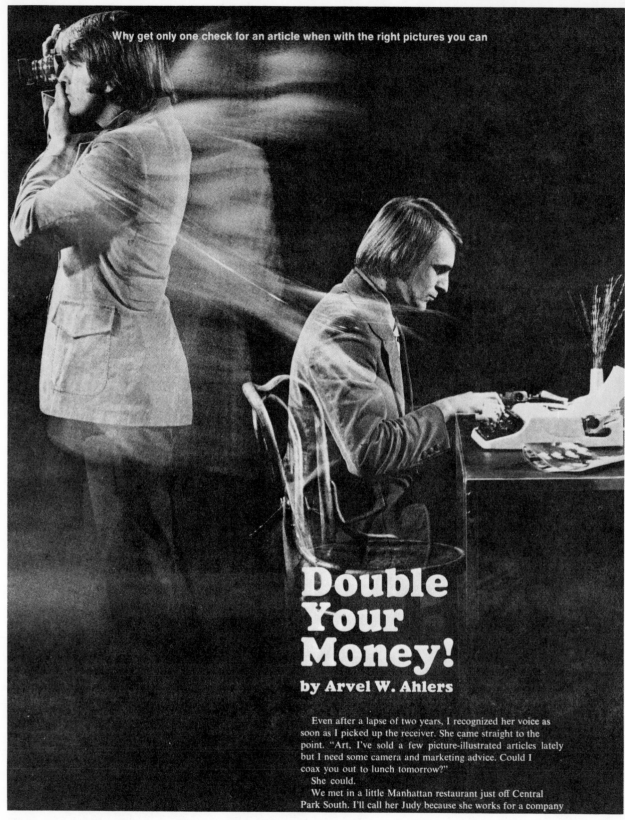

Why get only one check for an article when with the right pictures you can

Double Your Money!
by Arvel W. Ahlers

Even after a lapse of two years, I recognized her voice as soon as I picked up the receiver. She came straight to the point. "Art, I've sold a few picture-illustrated articles lately but I need some camera and marketing advice. Could I coax you out to lunch tomorrow?"

She could.

We met in a little Manhattan restaurant just off Central Park South. I'll call her Judy because she works for a company

that all but barbecues any employee who moonlights. Judy hopes sometime to make a career of writing. Her call was prompted by the fact that many editors today want "package deals"—text-*plus*-photos rather than text alone or photographs alone.

Over daiquiris, Judy told me about entering a slogan in a contest sponsored by a public relations agency. It had won second-prize—a week's paid vacation at an ultra swank winter resort in New England. That was fine, except that Judy isn't athletically inclined. So instead of joining the liniment, cocktail, and leg-cast set, she simply relaxed by sleeping late, jotting down article ideas, and taking photographs.

The pay-off began a few weeks after she returned to the city. Two New England newspapers bought text-plus-photos features, one paying $45 and the other $55. The editor of a house magazine paid $45 for a color cover shot of one of his company's snowmobiles zooming over the crest of a snowy hummock, then decided to buy a 3-page illustrated article to go with it for an additional $60.

There had been other sales, mostly picture-plus-caption material; a hippy couple hiking on snowshoes with a baby strapped to the mother's back, a snow-suited youngster dwarfed by a forest of skis planted upright in the snow, a 4-shot series of a handsome ski instructor performing acrobatic maneuvers on a steep slope. So far, Judy had netted about $230 above the cost of her film, processing, writing supplies and postage. But at this point, she was experiencing mixed emotions.

"A few years ago I'd have been walking on air," she said. "But after going over these—" she handed me a folder bulging with photographs, "I know I've muffed the ball. Maybe I need a better camera? Or some special courses on picture-taking and marketing. What do you think?"

The waiter brought our lunches before I finished glancing through the folder. It didn't matter; I'd seen enough. As we ate, I asked a few questions about her photo equipment, processing, and general approach to marketing. By the time we had finished dessert and moved to a shady park bench, I felt sure that Judy's main problem was the usual one—inexperience. The first clue was her reference to a "better camera."

Which Kind of Camera Is Best?

Nearly any professional photographer can take a photograph of salable quality with a $5 aim-and-click camera. But this is simply a show-off stunt to impress the natives. A camera capable of producing bread-and-butter quality consistently has to have a reasonably sharp lens and adjustable shutter speed, diaphram-opening and focusing controls.

It needn't be expensive. For $50 to $60 you can buy an adequate workhorse camera, especially by mail order, at discount stores, or at close-out sales. In the $60 to $100 range, there are a legion of cameras featuring various kinds of mechanical and automatic refinements. In my opinion, a budding photojournalist ought not invest over $100 in basic equipment until he has made some sales and is sure he likes the text-plus-photos approach to marketing. In addition to the camera and protective carrying case, the price should include a lens shade and, perhaps, a filter adapter ring with two filters—a yellow one for use with black-and-white film when darker skies and clouds are desirable, and a "haze" or "skylight" filter to be used with color film when there is heavy atmospheric dust or water vapor. An accessory flash unit of the type that can be easily detached from the camera for use at arm's length would justify an additional expenditure if pictures are to be taken indoors or at low light levels.

Which Negative/Transparency Size?

An editor/picture-buyer isn't concerned with the size of negative a black-and-white photograph is enlarged from. He is interested only in crisply sharp main images and good reproduction tones. In color transparencies, however, the minimum size an editor will consider is 35mm. Today's widespread acceptance of 35mm transparencies is relatively new; in the 1964 edition of *Writer's Yearbook* I wrote: ". . . your best bet is a camera which yields color transparencies no smaller than 2¼ inches square." In vogue at that time (and still the popular choice of many photojournalists) were the classic single and twin-lens reflex cameras.

In recent years, great progress has been made in perfecting various color film emulsions. This has triggered a trend among professional photographers to take full advantage of the unique compactness, versatility, and economy that 35mm cameras have to offer.

Don't be misled, however. Given a choice of two color transparencies that are identical in every way except size, an editor will invariably choose a 2¼ inch square, or larger, transparency over a 35mm. In commercial market listings, some die-hard editors say, *and mean,* that they will not consider anything smaller than 2¼ or even a 4x5 inch transparency. Others confuse matters by saying it even though those "in the know" regularly sell them 35mm color. The reason some buyers stipulate "no 35mm transparencies" is sometimes a ploy to discourage rank amateurs from deluging them with hopeless offerings.

Now let's get back to Judy. Her 35mm single-lens reflex camera with a carrying case, flash unit, and a few other basic accessories, mostly purchased at a close-out sale, cost just under $100. An instruction book came with the camera, and from this she learned how to make adjustments for different focusing distances, lens openings, and shutter speeds.

Even so, the quality of some of her pictures vacillated from very good down the scale to "hopeless." Camera or equipment shortcomings? No. Operator's shortcomings. Her camera instruction booklet dealt with the mechanical functions of levers and gimmicks. Such things as light flares, blank rolls of film, "red-eye" or "white-eye" in flash pictures, and straight or zig-zag streaks on her negatives and prints were beyond its scope. Zig-zag static marks, misty images etc. cannot be compensated for in printing. Static marks are electrical charges that result when film is advanced too rapidly in the camera on a frigid day; the misty look was moisture condensation on her lens when she stepped into the lodge to warm up, then returned to the cold. S-l-o-w, even film advancing will minimize static jumps; placing the camera in a plastic bag before entering a warm lodge will cause moisture to condense on the inside of the bag instead of the lens. But there are other picture-taking boo-boos for the tropics, at sea etc., too. The intelligent thing for Judy to do was to learn causes and effects where they can be handled in length.

But where? She had asked if I thought she should enroll in special courses on picture-taking techniques. In my opinion, a good picture-taking course is always helpful if a person can afford it in terms of time and money. But for a writer-photographer, most courses tend to be either too general, or too specialized.

Since Judy has to budget both her time and money, I suggested that she begin to acquire a small personal library of

specific information, with emphasis at this point on picture-taking faults and remedies. In addition to material available in camera stores and mail-order houses, an excellent source of thoroughly lucid information is Eastman Kodak Company. EKC produces over 700 leaflets, brochures, booklets, and comprehensive books on virtually all aspects of photography. This is not a plug; it's just a fact. Prices range from a few cents to $10 or more. A booklet on flash photography explains how to avoid red-eye and white-eye. Another on cold weather photography tells how to avoid zig-zag (static) streaks and the washed-out or misty looking pictures that result from moisture condensation on a cold lens. Their free publication AT-17 lists, geographically by state, all the schools offering courses and/or degree programs in photography. A free index of EK publications is available by sending a post card to Eastman Kodak Company, Dept. 412-L, Rochester, N.Y. 14650. Ask for a copy of the *Index to Kodak Information, Code L-5.*

As for Judy's present camera, it has more built-in capabilities than she's ever likely to use. It was for an entirely different reason that I suggested she buy a second camera for about $30. We'll talk about that in a minute.

What About Processing?

Some writer-photographers develop and print their own black-and-white films; a few even dabble with color transparencies. The majority, however, feel that top-quality processing is an art they have neither the time nor facilities to pursue. They rely upon professional custom lab processors to handle all the darkroom magic.

You can't obtain custom processing through all drugstores, and *never* from a "film-drop" outfit offering s-p-e-e-d-y service. Any "speed-service" is a slop-and-slosh operation in which many rolls of film are automatically machine-developed and printed at the same time in commercial batches of processing "soup." Most custom labs, by contrast, hand-develop each roll of film by inspection, using one of several choices of fresh chemical solutions. A technician literally keeps an eye on the film during development; if necessary, he can make minor compensations for exposure errors.

The average price across the nation for having a custom lab develop a 12-exposure roll of 120 or 620 black-and-white film is about $1, plus or minus a

Picture stories in *Today's Health* (see first two pages of a six-page story above) average $500-$1,000. *Grit* (right) is another publication that likes the photo story. While pay here for photos accompanying a feature is only $5 each, the publication buys 1,000 mss a year. So it's an active market. Rohn and Jeri Engh, use multiple-submission techniques when sending photo-stories to non-competing freelance markets, like the one below published in a Sunday supplement.

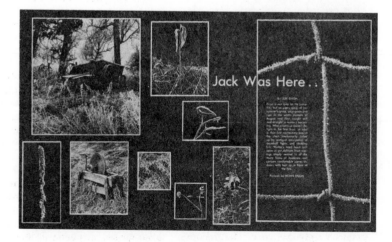

few cents. The price for developing a 20-exposure roll of 35mm film is about the same. Upon request, a lab will print a "contact sheet" of each roll of film on size 8x10 or 8½ x 11½ photographic paper. The contact sheet provides a positive print the actual size of each negative. Twelve 2¼ x 2¼ negatives can be contact-proofed on a single sheet of paper. For the same price (approximately $1), a 20 or 36-exposure roll of 35mm film can be contact proofed. (Custom labs usually charge by the sheet rather than the number of negatives that are printed on it.) Some labs quote prices ranging from $1.75 to $2.25 for developing and proofing a roll of film as a combined operation.

Most camera stores will obtain custom lab work (or perhaps do it themselves on the premises if they have the facilities) upon request. You can also obtain the names and addresses of custom labs from the yellow pages of a metropolitan phone book. Look under "Photo Finishing." If you shop around, you'll find that prices vary according to locale, competition, etc. in some areas, custom processing is a little higher than run-of-mill commercial processing.

By studying a sheet of contact proofs, using a reading glass if necessary, you can select the negatives you want to have enlarged. This is the time to decide how each negative should be cropped (masked off so that only the important images will appear in the enlargement.) A pair of small cardboard "L's" laid over a contact proof can be adjusted to mask off all but the main images. All boundary lines and directions pertaining to the area you want enlarged should be made with a red china marking pencil on the contact proof, not on the *negative*. (If you prefer, slip the negative into an acetate sleeve and make the proper markings on the acetate. In so doing, be sure to outline the entire negative so it can be realigned if it slips inside the sleeve.)

Most custom labs use a simple code to identify how a client wants an enlargement handled. Avoid using notes, overlays, etc. Some labs charge extra for these as "interpretative work!" (See the box on this page of the commonly used symbols and their meanings).

Contact-printed color proofs can be made from *color negatives*—the kind that produce color album prints. Few editors want *color prints* for reproduction, but negative color film is often used by professional photographers for these reasons: 1) The standard 3½ x 5 inch full color enlargement made from

CUSTOM LAB SYMBOLS AND WHAT THEY MEAN

Wavy vertical or horizontal lines:

"Approximate limits of the area of negative to be enlarged."

Straight vertical or horizontal lines:

"Specific boundries of negative area to be enlarged. Your marks will be followed whether or not the resulting enlargement fills a 5 x 7 or 8 x 10 inch sheet."

Small circles:

"Make images lighter than they would normally print in enlarging." Technically, this is known as "dodging".

Diagonal lines or cross-hatching:

"Darken the indicated area(s) by giving it or them extra exposure time." Technically, this procedure is known as "burning in".

a 35mm color negative is easier for an editor to study than is a 35mm color transparency. 2) If an editor likes what he sees in a color print, a color *transparency* can be made from the color negative. 3) Color negatives can as easily be enlarged as black-and-white photographs.

The prices for custom color processing vary so widely that we haven't space to go into details about them here. Except for color transparencies, go easy on ordering custom prints, spotting, corrections, etc. until you know what is actually essential—and what you'll have to pay for it.

What About Model Releases?

Having already learned about custom processing, Judy's enlargements were above average. On the back of each print, or the cardboard of each color slide, was a sticker bearing her name and address, the file number she had assigned to the picture, and a notice "One Time Publication Rights Only."

So far so good. But when I asked her about signed model releases on the photos of the ski instructor, the youngster standing between the upright skiis, and a 'teen-ager frolicking in the snow with her German shepherd, Judy looked perplexed. "Why would I need model releases for ordinary editorial use?"

She had a point of course. When used *strictly* for editorial purposes, written permission to reproduce a photograph of a person or a dog romping in the

snow is rarely mandatory. But the line that separates "editorial" and "advertising or promotional" use isn't always as distinct as one might think.

Take for instance a house magazine published not only for a company's employees but for stockholders and interested outsiders as well. Mightn't it be considered a form of promotional or advertising material? It might, indeed. The same goes for a company's annual report, mailing pamphlets, brochures, calendars, package labels, etc. Likewise for private, fraternal, or community sponsored booklets, decals, bumper stickers and other printed materials designed to promote tourism recreational facilities, real estate developments, or to attract new industries. In brief, any type of promotional or advertising media that features illustrations of identifiable people or private property raises a question of reproduction rights. Written consent in the form of so-called model releases are a desirable protection; in many cases they are mandatory.

For lack of signed model releases, Judy muffed all kinds of chances to parlay her photographs into multiple non-editorial channels. Perhaps you are wondering how she managed to sell the snowmobile photos to a house magazine. That was a stroke of sheer luck. While the company's equipment was dramatically identifiable, the operators were not. Judy learned about signed releases the hard way in connection with the picture of the 5-year-old dwarfed by upright skiis. By coincidence, all the visible skiis bore the trademark of a well-known manufacturer. From two library directories (*Standard Directory of Advertisers* and *Standard Directory of Advertising Agencies*), Judy got the name of the agency that handled the ski manufacturer's advertising and PR account. The ad agency's art director liked the photo and wanted to buy all rights to it for a very tidy fee. Naturally he would need a release signed by the winsom child's parents or guardian. What —no release? Sorry—no sale.

An Ice-Breaker Camera

Judy admittedly hadn't foreseen all the potentials of selling text-plus-photos, or photos without text, but there was more than inexperience behind her failure to obtain signed model releases. Like most of us, she felt hesitant to ask strangers for written permission to take their pictures for possible reproduction. Especially without offering them something in return. That's why I suggested a sec-

ond camera—an inexpensive Polaroid— (or the new Berkey instant camera) and a technique used by dozens of well-known professional photographers.

In addition to photographing a promising subject with their regular cameras, the pros also take several Polaroid-type snapshots. When they approach the subject, they make no bones about what they want. They are professional freelancers looking for interesting subject matter (or working on assignment, as the case may be.) In exchange for some snapshots, they'd like a signed model release in case an editor or art director required one. Most people, being slightly flattered, are glad to swap their signature for on-the-spot photos they can carry home. If a subject refuses, however, give him or her the snapshots anyway. This little gambit is particularly effective if the verbal exchange has attracted onlookers. Turn to other likely looking prospects and make the same offer—take-home snapshots in exchange for a signed model release. Chances are that you'll soon have more volunteers than you can handle.

Parlay—The Name Of The Game

Think always in terms of multiple sales for each photo—with or without text. Here, for example, is the path one seasoned pro took in order to quadruple (and more) his income from a typewriter and camera.

John Zielinski, originally a writer and editor for an Army publication, took up a camera because he didn't like the kind of pictures his staff photographers turned in. Upon leaving the Army he began to produce text-plus-photo feature articles on everything from modern houseboat living to the rise of reservation "Indian power" movements. By degrees he began to discover ways in which to *mass distribute* the same basic material to entirely different buyers. This will give you an idea of what he has and is doing with a series of photographs taken in an Amish community near his home in Kalona, Iowa . . .

First, Zielinski prepared a number of text-plus-photo articles in different lengths that have been published in a long list of newspapers as well as magazines—including *Life*. Next he wrote text to accompany traveling art museum displays of Amish photographs. Often publicized on TV programs, these exhibits led to more sales. Next, he had the most popular photographs reproduced as postcards, each bearing a brief explanatory legend. Since these sold by the thousands, he branched out into photo imprinted badges, booklets, complete books and educational audio-visual filmstrips. As of this writing, he has completed another traveling exhibit titled "Iowa's Indian Heritage" and is working on an exhibit for the Iowa Center for the Humanities tentatively entitled "Aging." Needless to say, he has plans for parlaying the sales of material from both of these subjects.

Unique? Yes, but *only* in the particular approach that Zielinski has taken to realize multiple rewards for his work. Peter Gowland, Herb and Dorothy McLaughlin, Rohn and Jeri Engh and countless other photojournalists depend upon multiple sales for a sizable chunk of their annual income.

To become a multiple-sale expert you first cover all the obvious sales angles, then dream up new ones on your own.

As for Judy—just give her a little more time and experience. She'll soon get the knack of selling and re-selling much of what she produces. Why not give this field a little thought yourself? You are already surrounded by opportunities.

And brand new ones are being born every day.

Some recent books on photography of interest to freelancers:

Photojournalism and *Special Problems*, by the editors of Time-Life Books, Time-Life Bldg., Rockefeller Center, New York, N.Y. 10020. $9.95 each volume.

Photographic Communication edited by R. Smith Schuneman. Hastings House, 10 E. 40th St., New York, N.Y. 10016. $16.50.

The Writer-Photographer by John Milton. Chilton Book Company, 401 Walnut St., Philadelphia, Pa. 19106. $4.95.

Custom Photo Labs

Prices for color and/or black and white professional film processing available from these firms:

Astra Photo Service, Inc.
6 East Lake St.
Chicago, Ill. 60601
B&W and Color Processing

B. G. & M. Color Labs, Ltd.
692 Adelaide Street, West
Toronto, 3 Ont., Canada
B&W and Color Processing

Berkey Prof. Processing
130 Front St.
Hempstead, N.Y. 11550
B&W and Color Processing

Lexington Labs, Inc.
55 West 45th Street
New York, New York 10016
B&W Processing

Meisel Photochrome Corp.
1330 Conant Street
Dallas, Texas 75222
Color Processing

Meridian Photographic Labs, Inc.
64 East 55th Street
New York, New York 10022
B&W Processing

Motal Custom Darkroom
18 West 45th Street
New York, New York 10036
B&W and Color Processing

PCL Professional Color Labs, Inc.
306 West First Avenue
Roselle, New Jersey 07203
Color Processing

Photographics Unlimited
G.P.O. Box 1562-W
New York, New York 10001
B&W and Color Processing

Planet Laboratories, Inc.
320 Ann Street
Hartford, Conn. 06103
B&W Processing

Portogallo, Inc.
1156 Avenue of the Americas
New York, New York 10036
B&W and Color Processing

Howard Thompson Photo Lab
2653 SW 27th Avenue
Post Office Box 736
Miami, Florida 33133
B&W and Color Processing

Veeder Photography
1922 North Haskell Avenue
Dallas, Texas 75204
B&W Processing

1. *Photographic Reference Sources*

SUPPLEMENTARY MARKET LEADS

No market listing of buyers for publications is ever complete in the sense that it includes *all* potential purchasers. Similarly, no market listing is ever totally up-to-date by the time it has been compiled, printed, and placed on the market.

There are a number of publications you can draw upon for current market listings or changes or for listings that do not appear in the directory in Section 11. Several of the leading photographic periodicals listed in Part 2 of this Section carry occasional items on new markets. Far more prolific in new and revised photo-market listings, however, are the following publications. (Yearly or per-copy prices as given refer only to information provided at the time we go to press.)

Thumbing through any annual directory of publication markets will turn up innumerable leads. Most—but not all—publications use photographs. Some use color only on their covers; others use color throughout. Some stick strictly to black-and-white photos. Prices paid for photographs in each field vary from poor to excellent. Jotting down the names and addresses of promising leads on file cards, with a notation of the kind of photos you may be able to supply, will serve as a reminder each time you riffle through your lead cards. Shown here is the *Gebbie Press House Magazine Directory*.

Gebbie House Magazine Directory, Gebbie Directory, Box 111, Sioux City, Iowa 51102. A public relations and free-lance guide to the nations leading house or company-sponsored magazines, none of which appear on the newsstands. The last revised edition contains approximately 400 pages of listings, plus 175 pages of related marketing information. Current price not received as we go to press. Query the publisher for complete information.

National Home Study Council, 2000 K St., Washington, D.C. 20006. Free material available on request, i.e., listings of accredited home-study schools, the courses offered in photography, tuition rates.

Photo Market Survey, School of Modern Photography, 1500 Cardinal Drive, Little Falls, N.J. 07424. A marketing directory originally published exclusively for students of the school, this book is now available to others in the free-lance field. The market listings and other materials are revised and/or expanded annually. Price: $10.

Writer's Digest, 9933 Alliance Rd., Cincinnati, Ohio 45242. Monthly, $5.95 per year. Although primarily intended for writers, the market data also includes current editorial needs for photographs. Articles on photojournalism are featured at regular intervals.

Writer's Market, same address as above. Hardcover book, revised each year. In approximately 800 pages, the editorial needs of over 4,350 publications are presented in detail. Although not all markets buy photos, many do. Price: $8.95.

Writer's Yearbook, same address as above. Annual, $1.50. Features in-depth articles (including photojournalistic subjects) and expanded market listings.

Writer, The, The Writer, Inc., Publishers. 8 Arlington St., Boston, Mass. 02116. Monthly, 60¢. Accent is on the interests of writers, but photojournalism is also covered. Each month a special market list covers a specific type of publication, i.e., general interest, sports, outdoors, cars, and so on. Descriptions include photo needs whenever applicable.

Reference Sources on Business Methods and Management

Basic Principles of Business Management For The Small Photographic Studio, Kodak Publication No. 0-1, $1.95. Available (by above code number) from Eastman Kodak Company, Department 412-L, 343 State Street, Rochester, New York 14660.

Estimating Manual For Professional Photography, published by Professional Photographers West, Inc., 550 North Larchmont Blvd., Los Angeles, Calif. 90004. A practical guide to pricing professional work above the break-even point. Query for current price.

Index To Photo Information, Eastman Kodak Company. Free upon request. Kodak produces approximately 700 different books, booklets, and data bulletins on virtually all aspects of the technical, commercial, and general fields of photography. Prices range from a few cents to several dollars each. A free index is available by requesting it by title, Code L-5, Eastman Kodak Company, Dept. 412-L, 343 State Street, Rochester, New York 14660.

Leave Room For Profit, a booklet produced by Harper Leiper, 2800 West Dallas, Houston, Texas 77019. Price: $5. Text, charts, methods of arriving at total costs of operation and pricing your output to leave a margin of profit.

Miscellaneous

Art Directors Annual, Watson-Guptill, 165 W. 46th St., New York, N.Y. 10036. Reference source book for advertising leads.

ASMP Guide Business Practices In Photography, 60 E. 42nd St., New York, N.Y. 10017. General pricing and business policy guideline published for members of The Society of Photographers in Communication, Inc.

European Travel Commission, 630 Fifth Ave., New York, N.Y. 10020. Information on all major European countries with regard to traveler's accommodations, custom regulations, major cities, scenic and historical sites, and so on. Valuable aids to photographers who plan to travel and want to try for advance assignments or increase their stock photo files.

Selected U.S. Government Publications, Supt. of Documents, U.S. Government Printing Office, Washington, D.C. 20402. An index to new publications, some of which pertain to photography, is free upon request. Periodic new listings will follow. The same address applies for price lists on hundreds of other Government booklets, i.e., National Parks and Monuments, Forestry, battlefields, ecology, agriculture, mining, and so on.

Society of Illustrators Annual, The, Hastings House, 10 E. 40th St., New York, N.Y. 10016. Lead source in advertising field.

Standard Directory of Advertising Agencies, 20 E. 46th St., New York, N.Y. 10017. Available in most reference libraries (price now over $50 per year). Pinpoints U.S. advertisers, their clients, art directors in charge of various accounts.

Tax Guide For Small Business (for each current tax year). Available from U.S. Government Printing Office (address above), and from some local post offices and Federal Internal Revenue offices. Price is usually about 75¢.

Washington International Arts Letter, The, Box 9005, Washington, D.C. 20005. A 76-page listing of available grants and aids to individuals in the arts, including photography. Note: This information reached us too late to be personally checked out by the authors. Price: $7.95.

2. Photographic Magazines, Newsletters, Periodicals

Only the leading advanced amateur and semiprofessional photographic publications receive wide newsstand distribution. In addition to general interest articles, they present a wide variety of special columns, equipment test reports, contest announcements, photo gallery listings, and occasional new market leads for free-lance photographers.

The majority of photographic publications, however, are available only by subscription. Some are substantial in size and well edited. Others are of value to photographers interested in a specific field of photography such as science and technology, professional studio or commercial operations, photojournalism, and the like. Still another group deals with various aspects of retail merchandising, the photo trade industry, and so on.

Price alone offers no clue as to the size, contents, or actual quality of a publication.

Neither does the name of a society or organization that sponsors a publication. Some of the skimpiest and least informative publications of all are sponsored by photographic groups or societies and sent free to their own members. For nonmembers, their subscription prices are on a par with those of the leading newsstand publications.

In choosing photo publications for your personal library, never buy a "pig in a poke." Examine sample copies of a publication before you subscribe to it. Some nonnewsstand photo publications may be available in the reference racks of your local library or camera club. Others can be obtained by writing the circulation manager of a publication and enclosing the price of one or more *current* sample copies. Make sure you'll be getting your money's worth *before* you subscribe.

Album, 103 Norwich Rd., Wisbech, Cambridgeshire, England. Monthly, $20 per year in U.S. Dedicated to photography of outstanding historical and artistic importance. Acclaimed for contents and reproduction quality.

American Cinematographer, the International Journal of Motion Picture Photography and Production Techniques. ASC Agency, Inc., 1782 North Orange Drive, Hollywood, Calif. 90028. Published monthly, $7 per year. Accent on professional film-making methods, techniques, equipment.

Australian Photography, Box 321 Pitt St., Sydney, Australia. Published 12 times a year plus annual directory issue. $7 per year in Australian currency value. Advanced amateur and semi-pro interests. Buys photos and articles.

Camera, C.J. Bucher Ltd., Zurichstrasse 3, Lucerne, Switzerland. Monthly. American edition, $18 per year. High-quality color and black-and-white reproduction. General photo interest range of subjects. Minimum advertising.

Camera 35, 132 W. 31st St., New York, N.Y. 10001. Bimonthly, $5 per year. Photo essays and articles, featuring work of pros of all ages. Emphasis on photo crafts; minimal "test-report" or equipment-catalog material. Buys photos and text.

Camera Mainichi, P.O. Box 5091, Tokyo International, Japan. $20 per year. Text in Japanese with summaries and captions in English. General subject interests. Purchases photos in black-and-white and color.

Camera World, Box 517, North Sydney, N.S.W., Australia. Emphasis on advanced amateur and professional interests.

Canadian Photography, MacLean-Hunter Ltd., 481 University Ave., Toronto 2, Ontario, Canada. $6 per year. Advanced amateur and professional interests slanted primarily for Canadian readership.

Color Photography, Ziff-Davis Pub. Co., One Park Ave., New York, N.Y. 10016. Annual, $1.50. Presents some text but emphasis is on reproductions of striking color photos through a wide range of subject matter. Purchases photos. Good rates.

Dignan Photographic Inc., 12304 Erwin St., N. Hollywood, Calif., 91606. Produces two monthly newsletters. One focuses exclusively on equipment, chemistry, and so on for black-and-white photography. The other does the same for color. Price for each newsletter is $10 for 12 issues; both newsletters (24 issues) are $18 a year.

Donnybrook Report: Photography, Donnybrook Enterprises, Inc., 347 E. 51 St., New York, N. Y. 10022. 22 issues per year, $20. Terse 6-page newsletter on photographic subjects ranging from equipment to conventions. Straightforward comments with no dependency upon advertisers.

Electro-Optical Systems Design, 222 W. Adams St., Chicago, Ill., 60606. Advanced theory, research, designs of lasers, holographic systems, diodes, cathode ray tubes, and the like.

Fotocamera (con Popular Photography), Rivadavia 926, Buenos Aires, Argentina. Text in Spanish; new products, personalities, and achievements in photography. $5 per year.

Fotomundo, Mex Abrie, S.A., Avenida Morelos 16 4a, Piso, Mexico 1, D. F. Spanish text. General interest for advanced amateurs and professionals. $13 a year.

Fox, Shiryoku, Inc., P.O. Box 188, Wellesley, Mass. 02181. Bimonthly, $40 a year. High-quality reproduction of photographic portfolios,

caliber of Karen Tweedy Holmes, Eva Rubenstein, and the like.

Freelance Photographer, P.O. Box 61, Urbana, Ill. 61801. Bimonthly, $10 a year. Tabloid-style newspaper featuring articles on various aspects of making money by freelancing.

Graphic Antiquarian—see "Miscellaneous" at the end of alphabetical listings.

Image Technology, Acolyte Pubs., 825 S. Barrington Ave., Los Angeles, Calif. 90049. $15 a year. Review copies not received in time to be described here.

Infill/Phot, 220 N. El Camino Real, No. 29, Oceanside, Calif. 92054. A quarterly nonprofit publication that reviews and indexes contents of photographic periodicals in the general interest, industrial-commercial-professional, journalistic, and motion-picture fields. Minimum donation per year, $20.95.

Institute of Incorporated Photographers, Amwell End, Ware, Hertfordshire, England. Review copies not received in time to be described here.

International Photo Technik, Verlag Grossbild Technik, GmbH, 45, Rupert-Mayer Strassa, 8 Munich, West Germany. English editions, $7.50 per year. Large format, excellent reproductions in black-and-white and color. Claimed to be the "largest and leading professional photographic magazine printed in multi-languages." Emphasis is on applied photography in science, industry, and technology.

Journal of the SMPTE (Society of Motion Picture and Television Engineers), 9 E. 41st St., New York, N.Y. 10017. To nonmembers, $2.50 per single copy; to subscribers, $26 a year.

Leica Fotografie, E. Leitz, Inc., Rockleigh, New Jersey 07647. Primarily edited in Germany for Leica users. Bimonthly, $9 a year in English text edition. Covers picture taking, darkroom subjects, equipment. Heavy emphasis on "how-to" material.

Leica Photography, same address as above. Published irregularly; mailed free to registered Leica equipment owners. Emphasis on results obtained by photographers using various types of Leica equipment.

Lights and Shadows, Whitemarsh Hall, 3011 Rebel Rd., Lafayette Hill, Pa. Buys photos and articles—sports, glamour, oddities, how-to-do-its, and so on. Rates vary up to $100 for color covers.

Lights and Shadows, 2801 W. Cheltenham Ave., Phila., Pa. 19150. Buys black-and-white and color. Minimum transparency size 2¼" x 2¼". Scenics, human interest, seasonal, travel, animals, glamour, human interest, and the like. Rates vary.

Modern Photography, One Astor Place (1515 Broadway), New York, N.Y. 10036. Monthly. Single copy, $1; subscription, $7 a year. Pays good rates for black-and-white and color photographs. "The magazine itself," says the editor, "is the best guide to our subject matter needs."

Modern Photography Annual, same address as above. $1.50 per copy. Heavy use of black-and-white and color photographs; selected illustrated articles. Good rates on all material purchased for publication.

National Press Photographer, (National Press Photographer's Association), 367 Mendenhall, Pa. 19357. Accent on events and achievements in press photography. Sent free to members of the Association. Subscriptions for nonmembers, $5 a year.

Nikon World, Box 520, Garden City, New York, N.Y. 28043. Published 3 times a year. $1.50 per year subscription. Emphasis on use of Nikon cameras and equipment in both text and photos.

Photo, l'Union des Editions Modernes, 65 Champs Elysees, Paris-8, France. Monthly, $12 per year. French language throughout. Comparable in size, format, contents, and reproduction quality with other leading European and U.S. publications. Articles and photos are of advanced-amateur and professional level.

Photo Buying Guide, 165 W. 46th St., New York, N.Y. 10036. Annual, $1.25. A compilation of the test reports on all types of equipment as previously published during the year by *Modern Photography*.

Photo Information Almanac, 164 W. 46th St., New York, N.Y. 10036. Published once every second year. Last issue, $1.35 a copy. Basically a compilation of selected informational charts and diagram materials previously published in *Modern Photography*.

Photo Marketing (Publication of the MPDFA or Master Photo Dealers & Finishers Association), 603 Lansing Ave., Jackson, Mich. 49202. Monthly. Subscription $3 a year to nonmembers of MPDFA. Buys articles of interest to its readers at 3¢ to 5¢ per word. Pays minimum of $7.50 per black-and-white photo accepted.

Photo Methods of Industry (PMI), One Park Ave., New York, N.Y. 10016. Monthly. Wide range of subject matter dealing with the technical aspects of photography in industrial, scientific, TV, audio-visual, and motion picture fields. Also buys articles and photos. Query first.

Photo-Technik und Wirtschaft, Eichborndamm 141, 1 Berlin 52, West Germany. Technical and scientific photographic publication; German language. Further details not available at press time.

Photographic Applications in Science, Technology, and Medicine, 250 Fulton Ave., Hempstead, New York 11550. Published six times a year. Free to qualified persons engaged in research in above fields. To all others, subscriptions are $5 per year. Buys some material; query first. Rates fair on accepted material.

Photographic Business and Product News, same address as above. Monthly, $4 per year. Material of interest to professional photographers in the fields of portraiture, commercial, advertising, and free-lance photography. Buys photos (b&w) with text. Fair rates.

Photographic Quarterly, 8490 Sunset Blvd., Los Angeles, Calif. 90069. Aims and future policies not clarified in response to queries.

Photographic Science and Engineering (Published by the Society of Photographic Scientists and Engineers), Suite 204, 1330 Massachusetts Ave., N.W., Washington, D.C. 20005. Bimonthly. Sent free to members of the society; $4 per year for nonmembers.

Photographic Trade News (PTN), 250 Fulton Ave., Hempstead, N.Y. 11550. Published 24 times a year. Serves the field of retail distribution of photographic equipment and related devices and materials. Query for further details.

Photographic Trade News (PTN) Master Buying Guide and Directory, same address as above. Published in June of each year. In addition to listing retail goods, the directory also lists manufacturers, trade names, photographic services, distributors and importers, and the like. Query for further details.

Photography, 46-47 Chancery Lane, London WC2, England. A leading advanced-amateur and professional publication comparable with the same types in U.S. One of several photographic publications available from the same address. Buys articles and text. If interested, request data from the publisher.

Photography Annual, One Park Avenue, New York, N.Y. 10016. $1.50 per copy. Compiled by editors of Popular Photography. Emphasis on quality reproduction of fine photos in black-and-white and color. Pays good rates for accepted single photos and portfolios.

Photography Directory and Buying Guide, same address as above. Annual, $1.50 per copy. Lists and describes (usually illustrates) wide range of photographic equipment from cameras and accessories to darkroom and specialized equipment. Each item priced.

PSA Journal, (Published by the Photographic Society of America). Monthly. Free to qualified members; $4 per year for nonmembers. Accent is on advanced-amateur club competitions, traveling salon exhibits, and the like.

Contributors are often professionals. No payment for articles or text.

Popular Photography, One Park Avenue, New York, N.Y. 10016. Monthly, $7 per year. One of the several leading U.S. publications aimed for advanced-amateur and semi-professional readership.

Popular Photography's Invitation To Photography, same address as above. Annual, $1.50 per copy. Emphasis is on basic principles of photography, covering a wide range of subjects of particular interest to beginners. Buys text and photos at good rates.

Popular Photography's Woman, same address as above. Issued twice a year, $1.50 per copy. Photos of women around the world taken by both amateurs and professional photographers. Little or no text, no other subject matter. Welcomes photos of women taken in all countries. Contributions should be accompanied by self-addressed stamped envelope. Payment rates on a par with other leading photographic publications in U.S.

Spie Glass (Published by Society of Photo-Optical Instrumentation Engineers), P.O. Box 288, Redondo Beach, Calif. 90277. Technical information in its specialized field. Also news, new products, and techniques.

Super 8 Research News, Box 1166, Dubuque, Iowa, 52001. A newsletter, prepared by TV station KDUB, Dubuque, in which research on the use of Super 8 movies in newscasts is shared by WGN-Chicago. Query for further details.

Technical Photography, 250 Fulton Ave., Hempstead, N.Y. 11550. Monthly, $5 per year. Subject matter covers industrial equipment and photography, and material of interest to the armed forces and government.

The Journal of Photographic Science, Maddox House, Maddox Street, London WI, England. Query for specific details.

The New York Photographer, 180 Claremont Ave., New York, N.Y. 10027. Bimonthly, $4 for 12 issues. A newsletter filled with short articles

from historical to modern. Includes book reviews, exhibit reviews, and the like. Title may be misleading, for the contents are of interest to photographers outside the New York area.

The Photo Reporter, 319 E. 44th St., New York, N.Y. 10017. Monthly, 16-page illustrated newsletter. $5 per year. Emphasis is on up-to-date news coverage of all aspects of wide photographic interest.

The Photographer (The Journal of the Institute of Incorporated Photographers), 81 High Holborn, London WC1, England. Subjects of interest in all aspects of professional photography internationally.

The Professional Photographer (Official publication of PPA—the Professional Photographers of America). 1090 Executive Way, Oak Leaf Commons, Des Plaines, Ill. 60018. Monthly, $7.50 per year to nonmembers. Strictly professional approach to covering a wide range of subject matter in the fields of industrial, commercial, and free-lance photography.

The Quill (Published by Sigma Delta Chi Professional Journalistic Society), 35 E. Wacker Drive, Chicago, Ill. 60601. Emphasis on journalism, including photojournalism.

The Rangefinder, Box 2549, 1300 N. Wilton Place, Hollywood, Calif. 90028. Monthly, $5 per year. Material is slanted for career photographers with emphasis on studio technical and operational methods.

The Wolfman Report on the Photographic Industry, 165 W. 46th St., New York, N.Y. 10036. Annual, $7.50. A statistical guide compiled for members of the photographic industry engaged in research on equipment sales, photofinishing, sales, imports, and the like.

35mm Photography, One Park Ave., New York, N.Y. 10016. Annual, $1.50 per copy. Articles on uses of 35mm cameras and equipment. Features fine photographs produced with 35mm cameras by amateurs and pros. Good rates paid for accepted material; query first.

Zeiss Information, published four times a year in five languages. English editions available from Carl Zeiss Inc., 444 Fifth Ave., New York, N.Y. 10018. Specific information of the use of all types of Zeiss equipment—cameras, lenses, surveying instruments, microscopes, and so on.

Miscellaneous Photographic Periodicals

Antique Collecting and Historical interests. The following includes groups and societies that publish both regularly and irregularly.

Graphic Antiquarian, Graphic Enterprises, 3851 Esquire Place, Indianapolis, Ind. 46226. Quarterly, $4 per year. Emphasis on articles, illustrations, and so on of interest to collectors of antique cameras, prints, and miscellaneous equipment.

Leica Collectors International, c/o Dr. Alfred Clarke, 4016 Windemere Rd., Columbus, Ohio 43221. Membership $10 per year. Members receive bulletins, data, and so on.

News, Photographic Historical Society of New York, 244 Fifth Ave., New York, N.Y. 10001. A 10-page newsletter published 10 times a year. Free to members of the society; membership fee is $12 per year. Newsletter only to nonmembers, $6 per year.

Ohio Camera Collectors Society, Inc., P.O. Box 4614, Columbus, Ohio. Membership fee, $10 annually. Subscription to newsletter, $4. Conducts meetings and annual trade fair for members and friends.

The New Pictorialist, 613 E. Main St., Forest City, N.C. 28043. Membership fee is $4 per year. This group seeks to recapture the pictorial era of photography by sharing information on soft-focus lenses, paper negatives, gum and bromoil processes, and so on.

The Photographic Historical Society, P.O. Box 9563, Rochester, New York, 14604. The oldest photographic historical group in America. Query for details.

Classified Market Listings

PREFACE

Neither this nor any reputable collection of market listings can represent itself as being complete, definitive, or totally accurate. There are approximately 30,000 reasonably well-known consumer, trade, and company periodicals in the USA alone. Added to these are scores of newspapers and Sunday supplements, mountains of state, city, and federal agencies, along with innumerable other organizations, agencies, and travel/tourism bureaus, all buyers of photographs that the compilers of market directories do not attempt to include in their listings.

Moreover, the publishing industry per se is in a constant state of flux. Each day some periodicals are discontinued while others are being born. Still others are merging, changing their name or policies, or are undergoing total changes in their editorial needs. For example, over 95 per cent of the following market listings had to be altered during the several years it took to revise this book. The author and publisher, therefore, can assume no responsibility beyond that of listing each periodical or organization according to the best information available at the time the listing went to press. In other words, each market listing is intended to serve *only* as a guidepost—an arrow pointing in the direction of a market that existed at the time a set of listings were compiled.

Experienced photographers rarely submit material on the basis of a printed listing alone. Instead, they save time and postage by studying sample copies of the periodicals that interest them *prior* to making a query or submitting their work. In short, they do everything possible to minimize "guess-ology."

TIPS ON MARKETING YOUR PHOTOGRAPHS

• Many magazines once considered general-interest or family periodicals have gradually become special-interest publications. This has made some of them difficult to classify under a specific heading. Rather than repeat the same listing under several headings, therefore, a paragraph at the beginning of several of the following categories refers to other groups of listings where periodicals with related photographic needs appear under a different heading. In studying any group of listings, you should also refer to Part 16 "Miscellaneous—Varied Interests" for possible additional leads.

• If you plan to submit material to Canadian publishers, it is easier to enclose Canadian postage stamps than it is to make a special trip to the post office to buy International Reply postage coupons. To obtain Canadian stamps, simply address a request to the Postmaster of any city or town in Canada. Designate the kind of stamps you want and enclose either an International Reply coupon to cover the cost, or send a certified money order or bank check. Do not enclose a personal check or cash. In addition to your check and request, enclose a self-addressed return envelope *without* US postage; the Canadian postmaster will undoubtedly deduct the cost of return postage from the stamps you have requested.

• When submitting a query or otherwise communicating with a picture buyer, use a printed letterhead or enclose a business card if at all

possible. Either (or both) will help establish your status as a professional photographer or photojournalist.

• In replying to queries, some editors use the short form of state abbreviations, i.e., *CA* for California. Others cling to the old form, i.e., *Calif.* Use your own judgement in this matter, but make sure that your *MA* doesn't look like an *MO.* Be equally careful about the digits in each zip-code number.

To conserve space in the listings that follow, these abbreviations frequently appear:

acc., acceptance.
an., annual.
bian., biannual.
bimo., bimonthly.
b&w, black and white.
caps., captions.
comm., commission.

ea., each.
50/50, 60/40, and so on: The first figure is the share a photographer gets on a sale made by an agency or syndicate.
gl., glossy prints.
illus., illustration.
int'n., international.
min., minimum.
mo., monthly.
ms, manuscript.
negs, b&w or color negatives.
pay, pays on, or payment on.
pic, single photograph.
pix, several photographs.
pub., publication.
qt., quarterly.
rep, representative.
S.A.S.E., Self-addressed stamped envelope.
tech., technical.
trans., transparency.
wk., weekly.

INDEX TO MARKET LISTING CATEGORIES

1. Agriculture, Farm, Livestock

Agway Cooperator, Agway Inc., Box 1333, Syracuse, N.Y. 13201. Mo., illus. agricultural features from 12 northeastern state areas. No purchases from other areas. Articles with b&w illus., approx. $75. Other captioned pix, $5–$10. S.A.S.E. Pay on acc.

American Agriculturalist and The Rural New Yorker, P.O. Box 370, Ithaca, N.Y. 14850. Uses photos only with captions or ms. Subjects of general farm interest. Pay $5 ea. photo on acc. Free sample copy on request. Submit material with S.A.S.E.

American Fruit Grower, 37841 Euclid Ave., Willoughby, Ohio 44094. Covers fertilization, spraying, care of fruits, nuts, berries, all other aspects. Single captioned photos or photos with ms, $5. Cover trans. on same subjects. Price varies. Pay on acc.

American Vegetable Grower, same address as above. Same coverage as above as applied to commercial vegetable growing. Uses captioned photos as filler items. $5 ea. S.A.S.E.

Beef, 1999 Shepard Rd., St. Paul, Minn. 55116. All material must have relationship to cattle, i.e. commercial feeders and beef producers. Photos with ms. Min size color trans 2¹/₄″ x 2¹/₄″ with tie-in to inside story for cover use, $100. Query first. S.A.S.E. required for return of material.

Big Farmer, 131 Lincoln Hwy., Frankfort, Ill. 60423. Accent on management aspects of large-scale farming. Livestock, large-scale farming methods in illus. feature articles—agricultural and agronomic subjects. Sample copy on request. Submissions must have S.A.S.E. B&w and color purchased with ms. Payment varies with subject and presentation quality.

Carolina Cooperator, Carolina Cooperator Pub. Co., 125 E. Davie St., Raleigh, N.C. 27601. Mo. Pix of subjects related to farming, southeast area; seasonal and holiday features, with farm or traditional angle; co-op features slanted for Carolina and some public service material. B&w $5; cover (b&w), $5-15. Pay on pub.

Cattlemen, Room 251, 1632 14th Ave., N.W., Alta., Canada. Mo. with special issue on cattle health in Sept. Other subjects on raising beef successfully in Can. Only shots of Canadian stock used. Sample copy for 25¢. Pay up to $10 for b&w and $35 for color, min. size 2¹/₄ ×2¹/₄. Query first. Submissions must be accompanied by self addressed envelope and Int'n postage coupon.

Country Guide, The, 1760 Ellice Ave., Winnipeg 21, Manitoba, Canada. In b&w, prefer 8×10 glossies with ms and captions. Pay $5 and up. Color trans 2¹/₄×2¹/₄ and larger, $50 and up. Subjects mainly homemaking and how-to-do. Query. Submissions must have self addressed reply envelope with Int'n Reply Coupon.

Country Living Magazine, 4302 Indianola Ave., Columbus, Ohio 43214. Mo. Free sample on request. Photos of electric power use with human interest, do-it-yourself power appliances and uses. B&w $5 and up. Color trans for covers, $20. (B&w pix must have ms or captions.) Enclose S.A.S.E.

Dakota Farmer, The, P.O. Box 910, Aberdeen, S.D. 57401. Human interest pix to go with ms of interest to N. and S. Dakota farm people. Agriculture, beef raising, history or human interest material of Dakota people, successful farm business management, etc. B&w photos with ms or captions only. Color trans for covers, $50 max. Query first. Include S.A.S.E. with submissions.

Electricity On The Farm, 466 Lexington Ave., New York, N.Y. 10017. Published mo. Sample copy $1.00. Pix with captions of new or unusual and profitable uses of electricity on farms. B&w, $7.50 with caps. Color covers, $100. Pay on acc. Query if desirable. Submissions must include S.A.S.E.

Farm Journal, Washington Square, Philadelphia, Pa. 19105. Mo. Managing Editor: Lane M. Palmer. B&w and color pix of farm news of interest to the farm audience. B&w $10-50; inside color (min. size trans. 2¹/₄×2¹/₄) $25-100; color covers (prefer 4×5 trans.) $100-400. Pay, on acc.

Farm Quarterly, The, 222 E. Central Parkway, Cincinnati, Ohio 45202. This publication appears to have changed hands and slant since our reply was received on a query sheet. Suggest obtaining sample copy, $1.00. Request detailed need sheet if available as this is a high-quality, exacting market, above average pay rates.

Farmer-Stockman magazines are a unit published in three separate editions, each primarily circulated in its own state areas:
The Kansas Farmer-Stockman, 3435 W. Central Ave., Wichita, Kan. 67203.
The Oklahoma Farmer-Stockman, 500 N. Broadway, P.O. Box 25125, Oklahoma City, Okla.
The Texas Farmer-Stockman, 10111 N. Central Expressway, P.O. Box 31368, Dallas, Texas 75231.
Basic requirements for all three are local area farm scenes, indoor and outdoor homemaking, agricultural scenes with full captions. B&w pix (8×10 glossy) $10 to $50 ea. Color trans. min. size 2¹/₄×2¹/₄, $25 to $100. Pay on acc. Suggest query first. Include S.A.S.E. with submissions. Ferdie J. Deering, Editor and Manager, Oklahoma address above.

Fertilizer Solutions, Suite 910, Lehman Bldg., Peoria, Ill. 61602. Covers various crops successfully grown with liquid fertilizer. Pays $75 for ms illustrated by 8 to 10 b&w photos. Query first. Include S.A.S.E. for submissions.

Furrow, The, Deere & Co., John Deere Rd., Moline, Ill. 61265. Aimed at upper-income farm families. Special style of its own, with socioeconomic slant. Sample copy on request. Uses both color trans. and color prints. Payment for illus. feature articles (up to 1,500 word length), $100 to $200. Enclose S.A.S.E. for material to be returned.

Indiana Rural News, 29 W. 9th St., Indianapolis, Ind. 46204. Diversified subjects; also special issues. Send 25¢ for a sample copy to learn photographic slants, rates on b&w and trans.

Michigan Farmer, 4415 N. Grand River Ave., Lansing, Mich. 48906. Human interest material on agriculture of interest to Michigan farmers and farmwives. Rates are variable per printed page. B&w pix with captions, some color trans. for covers. Query first. Include S.A.S.E. with submissions.

Montana Farmer-Stockman, 510 First Ave., North Great Falls, Mont. 59401. Slanted to interests of farmers, ranchers of Montana and northern Wyoming area—innovations, practical new methods, successfully proven practices. Photo rates not available. Query.

National Future Farmer, Box 15130. Alexandria, Va. 22309. Bimo. Covers: action pix involving Future Farmers of America. Inside: pix of FFA member involved in farm activities, sports scenes, etc. Query for details. B&w captioned pix, $5. Pic stories, captioned, min. $5 per shot. Color cover, $100. Include S.A.S.E. with submissions.

National Live Stock Producer, 155 N. Wacker Dr., Chicago, Ill. 60606. Color pix of beef cattle (not dairy), hogs and sheep. Captioned b&w pix, $25 and up. 4×5 min. size trans. Quality pub. worth studying and querying. Send S.A.S.E. with submissions.

Ohio Farmer, The, 1350 W. Fifth Ave., Columbus, Ohio 43212. Interesting action farm pix of Ohio, preferable with human interest. Slanted toward both general and specialized Ohio farmers. B&w with captions or ms, up to $10 ea. Query. Send S.A.S.E. with submissions.

Organic Gardening and Farming. Emmaus, Pa. 18049. Single b&w pix of story-telling type, captioned. Color cover trans., prefer 4×5 but will consider 2¼×2¼. No 35 mm. Gardening procedures and activities, very specific, highly functional. Current issue and Authors Photo Guide Handbook sent free upon request. Pays up to $15 for b&w pix, up to $100 for color trans. Study publication first. Send S.A.S.E. with submissions.

Pennsylvania Farmer, P.O. Box 3665, Harrisburg, Pa. 17105. Semimo. Slanted to farm families of all ages. Practical information on farming (especially in Pa.), how-to's, the business end of farming, home interest material for farmwives and farm families. B&w pix (glossies) and color trans. with ms preferred. Also buy captioned single pix. Color trans. for covers (also prints) $50. Request free sample and study departments, features, and style before querying on specific subjects. Include S.A.S.E. with submissions.

Rural Electric Missourian, 2722 E. McCarty St., Jefferson City, Mo. 65101. Photos in size 8×10 glossy purchased with ms or captions. Subjects preferred include use of electricity in homes (not necessarily rural), on farms, shops, etc. Pay on acceptance; rates vary with quality of material. Prefer query first. Include S.A.S.E. with submissions.

Rural Gravure, 20 N. Carroll St., Madison, Wis. 53703. Mo. B&w only of interesting general farm and home subjects. Uses captioned b&w singles and series pic stories. Pix with text, $40 to $150. Query first. Include S.A.S.E. with submissions. Pay. on pub.

Rural Living, 205 W. Franklin St., Richmond, Va. 23220. Slanted to interests of member-owners of rural electric co-ops in Virginia and Maryland area. Request free copy before shooting pix to gain insight into style of presenting technical material with human interest. Query first. Include S.A.S.E. with submissions. Pays up to $10 ea. for glossy 8×10 pix.

South Carolina Farmer-Grower, 476 Plasamour Dr., P.O. Box 13755, Atlanta, Ga. 30324. Mo. Slanted toward commercial farming interests in S. Carolina area. Subjects vary from successful farming methods to how-to-do-it material. B&w and color trans accompanied by ms up to $50. Query first. Include S.A.S.E. with submissions.

Wallace's Farmer, 1912 Grand Ave., Des Moines, IA 50305. Semimo. Examine recent issue for slant. In general, aimed to interests of Iowa farmers and families. Iowa farm photos used as captioned singles, or with ms. Pay on acc. up to $15 for b&w, trans in sizes 2¼×2¼ to 4×5 $50 to $100 for cover use. Enclose S.A.S.E. with submissions.

Western Horseman, The, 3850 N. Nevada, Colorado Springs, Colo. 80901. Sample copy, 60¢. Emphasis on western outdoor life and ranches involving horses. B&w pix with ms. Color trans in 4×5 only. Payment varies. Query first. Include S.A.S.E. with submissions.

Western Producer, Second Ave. North, Daskatoon, Sask., Canada. Also **Prairie Books** (Calendar Dept.) same address. The **Producer** is a regular general-interest publication with emphasis on Western Canadian agriculture and world marketing. Also action shots on farms or in small rural areas showing the nature of life. How-to and money saving ideas put to work on the farm. Pay varies for b&w upon use. Min. size color transparencies 2¼×2¼. Western Canadian scenics—countrysides, fields, farming in areas of Manitoba and Alberta. Pay up to $35 ea. Pay on acc. Suggest query and study copies first. Include S.A.S.E. with submissions with postage in form of Int'n. Reply Coupon.

Wisconsin Agriculturist, 1125 W. 6th St., Racine, Wis. 53401. Bimo. Feature articles (short) on Wisconsin farmers' activities. Captioned how-to-do-it photos, successful Wis. farm operations. Study samples, query. B&w glossy photos up to $10 ea. Color trans., min size 2¼×2¼ up to $100. Buys all rights to photos. Enclose S.A.S.E. with submissions.

Wyoming Stockman-Farmer, 100 17th St., Cheyenne, Wyo. 82001. Formerly a popular publication with ranchers, farmers, even urbanites in Wyo., Mont., Colo. area. Needs and rates were not received at press time. Query.

2. Aircraft and Aviation

Aero Magazine, 499 E. Rowland Ave., Suite 445, Covina, Calif. 91722. Bimo. Sample copy, 25¢. Slanted strictly to interests of licensed owners and users of business and pleasure aircraft. Query first. Pays up to $50 per printed page (text and photos); $50 for color (trans.) covers; up to $35 for interior color. Enclose S.A.S.E. with submissions.

Air California Magazine, Urbanus Sq., Newport Beach, Calif. 92660. Mo. Published for inflight readers traveling by Air California (intrastate). Photos purchased with articles dealing with Calif. living, history, etc. with strong preference to interesting material that passengers are unlikely to have seen printed elsewhere. Payments are negotiable. Enclose S.A.S.E. for return of unaccepted submissions.

Air Line Pilot, 1329 E. St., N.W., Washington, D.C. 20004. Mo. Material of interest to airline pilots—historical development of aviation, aircraft safety, hobbies, weather, etc. Also read by airline stewards and stewardesses, private business aircraft pilots, and others involved in airline industry. Query first. B&w and color trans. purchased with ms. Pay varies. Covers $100 and up. Include S.A.S.E. with submissions.

Air Progress, 8490 Sunset Blvd., L.A., Calif. 90069. Mo. (Four special-subject issues per year.) Slanted for pilots and others interested in various aspects of professional, private, military, pleasure material. Up to $100 per printed page; uses b&w and color transparencies. Include S.A.S.E. for return of unaccepted material.

Air Transport World, 333 Shoreham Bldg., Washington, D.C. 20005. Mo. Specialized material slanted to interests of air transport management, operators, military, and others engaged in the technical and operational aspects of the industry. Query first. Payment of $50 (including photos) per printed page. Enclose S.A.S.E. with submissions.

Air Travel Magazine, 211 E. 43rd St., New York, N.Y. 10017. Mo. Slanted to specialized interests of experienced airline traffic managers, travel agents, sales personnel. Sample copy sent on request. Query on illustrated story ideas. Payment varies. Send S.A.S.E. with submissions.

Airport World and Aviation Systems Management, 49 Riverside Ave., Westport, Connecticut. Mo. Slanted for all categories of world's major airport users—carriers, operators, catering, maintenance, passenger/personnel/ground services, etc. Query first. B&w photos purchased with manuscripts or separately. Enclose S.A.S.E. with submissions.

Aloft, 4025 Ponce de Leon Blvd., Coral Gables, Fla. 33146. Quarterly publication, travel-oriented for passengers of National Air Lines. Emphasis upon little-known places to visit, dine, etc. along NAL routes. Query first. Color trans. purchased with captions or ms on a variety of subjects. Payment rates negotiable.

American Way (The), 420 Lexington Ave., New York, N.Y. 10017. Mo. inflight publication for passengers of American Airlines. Emphasis upon general-interest material rather than travel per se. Query Art Director with ideas before

197

submitting material. Only top quality color with ms considered. Good rates.

AOPA Pilot (The), 4650 East-West Highway, Bethesda, Md. 20014. Official monthly magazine of Aircraft Owners and Pilots Assoc. Factual material of interest to all flying enthusiasts from novices to professionals (no military or commercial airline material). Very wide range of subjects covered in various lengths from photo-illustrated 300-word featurettes up. Study sample copies and query first. Payment for b&w and color pix varies. Include S.A.S.E. for submission returns.

Aviation Travel, P.O. Box 7070, Arlington, Virginia, 22207. Quarterly. Full details not available as we go to press. Query for specific subject range, slant, payment rates, etc.

Braniff International Magazine, Braniff Airways, 300 E. 42nd St., New York, N.Y. 10017. Bimo. Predominant slant is for middle to upper income bracket males who travel frequently to South American destinations. Study contents and style; query first. Uses 35mm color. Rates vary for pix plus text. Enclose S.A.S.E. for queries and submission returns.

Business And Commercial Aviation, One Park Ave., New York, N.Y. 10016. Mo. Sample copy sent for $1. Edited for pilots, and uses only material based upon a technical and operational knowledge of practical use. Query first. Enclose S.A.S.E. with submissions. Payment rates for b&w photos with ms vary; color covers up to $300.

Canadian Aviation, 481 University Ave., Toronto 2, Ontario, Canada. Interested only in material of specific interest to Canadian pilots; airports, corporate and commercial topics. Buys text, captioned photos, etc. B&w photos, $5 and up. Query first, as most pix are provided by regular contributors.

Clipper, 48th Floor, Pan-Am Bldg., New York, N.Y. 10017. Bimo. Slanted to interests of Pan-Am passengers inflight to Atlantic, Pacific, Latin American, and island destinations. Query first with S.A.S.E. Good rates, but only pix and topics of top-rate quality are accepted. Most photos are done on assignment or obtained from stock.

Esso Air World, Esso International Inc., 15 W. 51st St., New York, N.Y. 10019. Bimo. Illustrated text, technical and semi-technical, for worldwide audiences. Study for topic range and style. Query first on subject matter, rates, etc. Enclose S.A.S.E. with submissions.

Flightime Magazine, 3540 Wilshire Blvd., Suite 707, L.A., Calif. 90010. Mo. Sample copy, 60¢. Inflight magazine published for passengers of Pacific Southwest and Continental Airlines. Material range wide (travel, sports, personalities, etc.), but primarily slanted to interests of businessmen. Photos purchased with ms; rates negotiable. Enclose S.A.S.E. with queries and submissions.

Flying, One Park Ave., New York, N.Y. 10016. Mo. Study samples of long and short illustrated features for topic range and slant. Rates vary with length and quality. Pay on acc. Enclose S.A.S.E. with queries and submissions.

Jet Cargo News, 5314 Bingle Road, Houston, Texas, 77018. Sample copy, 25¢. Emphasis is strictly on interests of executives and corporate managers who use or are potential users of air cargo shipping facilities. No interest in airplane topics per se. Knowledge of containerization, marketing, distribution, etc., is essential. Text at 4¢ per word; b&w photos with ms, $7.50. Query first. Include S.A.S.E. with submissions. Pay on pub.

Northliner Magazine, 1999 Shepard Rd., St. Paul, Minn. 55116. Quarterly publication of North Central Airlines slanted to the interests of inflight passengers. Sample copy on request. Predominantly male interest in sports, business topics, humor, travel, etc. Photos generally purchased with text; $50 for inside color (transparencies); $200 for covers. Enclose S.A.S.E. for return of unaccepted submissions.

Passages, 420 Lexington Ave., New York, N.Y. 10017. Bimo. Inflight magazine for passengers of Orient Airlines. Color trans. usually purchased with appropriate text; subjects range from business, sports, personalities, to food, the arts, etc. Query the Art Director first on subject, length, illustrations, and payment rates. Enclose S.A.S.E. with both queries and submissions.

Plane And Pilot, Box 1136, Santa Monica, Calif. 90406. Sample copy $1. Slanted at pilot audiences for improving flight skills, safety, proficiency. Requires experienced and technical accuracy in reportage. 8×10 glossy photo illustrations purchased with ms. Query first. Payments on pub. up to $150 per article. Include S.A.S.E. with queries and submissions.

Private Pilot, 3 W. 57th St., New York, N.Y. 10019. Mo. 75¢ copy. Slanted to interests of beginners and airplane enthusiasts as well as professional pilots (no military interests). Study copies and query first. Payments vary with subject, length, ms and photo (b&w) quality. Include S.A.S.E. with queries and submissions.

Roto And Wing, News Plaza, Peoria, Ill., 61601. Mo. Sample sent on request. Accent on helicopters and their various uses, particularly commercial. Study magazine carefully. Query on subject possibilities, length, rates, etc. Enclose S.A.S.E. with queries and submissions.

Roto Breeze, P.O. Box 482, Ft. Worth, Texas 76101. Mo. Sample copy free. Devoted to helicopter service and maintenance, and interesting/outstanding work performed with helicopters. B&w photos purchased with ms and captions only. Query first on material, rates, etc. Enclose S.A.S.E. with queries and submissions. Pays on acceptance.

Southern Scene, PR Dept., Southern Airways Inc., Atlanta Airport, Atlanta, Ga. 30320. Quarterly. Sample free upon request. Inflight magazine for passengers, predominantly affluent males, of Southern Airways. Prefer a southern flavor to articles about travel, business, sports, etc., in both the South and northern metropolitan areas. Photo-text material up to $400. Captioned pix assignments up to $200. Query first. Send S.A.S.E. with queries and submissions.

T.W.A. Ambassador, 1999 Shepard Rd., St. Paul, Minn. 55116. Mo. Free sample and editorial specifications sheet upon request. Inflight publication for passengers slanted to domestic and international interests, i.e., personalities, sports, human interest, travel, humor, etc. Query first. Photo illustrated articles up to 1,500 words pay up to $500. Color trans. for inside use, up to $50; for cover use, $250. Accept sizes 35mm and larger. Pays on acceptance. Enclose S.A.S.E. for queries and submissions.

United Aircraft Quarterly Bee-Hive, United Aircraft Corp., 400 Main St., East Hartford, Conn. 06108. Issued free (copy available upon request) to persons interested in aircraft, space propulsion and technology, historical and off-beat items related to aviation. Exceptional material is sometimes purchased even though unrelated to the corporation's main interest objectives. Query about subject matter, length, illustrational preferences, rates, etc. Enclose S.A.S.E. with all queries and submissions.

3. Animals and Pets

There is an enormous market for photographs of animals and pets, but most of the magazines directly devoted to these subjects (listed here) are not the best paying markets. They are primarily of value to a photographer as showplaces. Higher-paying markets are among the

general consumer-interest publications, trade journals, house or company magazines, greeting-card and calendar publishers, and so on in other categories. Stock-photo agencies also sell thousands of animal-pet pix to special markets a photographer normally cannot reach.

American Dachshund, 15011 Oak Creek Rd., El Cajon, Calif. 92021. Will send sample on request. Up to $5 for interesting, captioned b&w photos of dachshunds. Pay on acc.

Appaloosa News, P.O. Box 403, Moscow, Idaho, 83843. B&w and color trans. are bought with articles and paid for, on pub., with ms payment. Sample copy sent on request. S.A.S.E. with submissions.

Aquarium, 87 Rt. 17, Maywood, N.Y. 07607. Mo. Text mainly devoted to care of fish and aquarium plantlife, informative experiences of experienced fishkeepers, etc. Pays on pub. Photos should accompany ms submissions. Also buys captioned photos. Pays up to $25. Sample copy on request. Query first. Include S.A.S.E. with submissions.

Canadian Horse, Box 127 Rexdale, Ontario, Canada. Slanted to interests of Canadian breeders, thoroughbred owners, ms on historical and current personalities and horses. Sample copy, $1. Pays 3¢ a word on ms; $10 per 8×10 glossy. Query first. Submit S.A.S.E. with International Reply coupon.

Cat Fancy, 641 Lexington Ave., New York, N.Y. 10022. Mo. Sample copy, $1. Subjects cover cat breeding, grooming, care, etc. Photos purchased only with ms. Pays $10 for b&w glossies, captioned. Color trans. min. size 2¹/₄×2¹/₄ or larger, $50. Pays on pub. Include S.A.S.E. with submissions.

Cats Magazine, 10 California Ave., Pittsburgh, Pa. 15202. Mo. Sample copy free on request. Cat care and health, outstanding or famous personalities who are cat lovers, etc. Pays on pub. B&w up to 8×10. No color. Include S.A.S.E.

Chronical of the Horse, Middleburg, Va. 22117. Action pix of horses, hounds, polo shots, related subjects. B&w captioned pix, $3. Pays on acc. Submit with S.A.S.E.

Horseman, The Magazine of Western Riding, 5314 Bingle Rd., Houston, Tex. 77018. Sample copy free. Requires expert knowledge of handling ranch horses—breaking, etc. $6 ea. for pix used with ms. Query first. Include S.A.S.E. with submissions.

Horsemen's Journal, 425 13th St. N.W., Suite 1038, Washington, D.C. 20004. Mo. Pix of thoroughbred racing, breeding horses, owners, trainers. B&w only, captioned. Query first. Include S.A.S.E. with submissions. Pays $3 to $5 with captions, size 8×10 only.

Hunting Dog, Box 330, Greenfield, Ohio 45123. Mo. Photos of dogs (captioned), preferred with text—training, hunting, etc. Does not use show-dog material. B&w for inside use, up to $5 ea. Min. size 2¹/₄×2¹/₄ for cover, $50 per trans. Sample copy on request. Query first. Include S.A.S.E. with submissions.

National Humane Review, Box 1266, Denver, Colo. 80201. Bimo. Pix of animals and animals with children. B&w, $5. Pay on pub. Send S.A.S.E. with submissions.

National Stock Dog Magazine, R.R. 1, Butler, Indiana 46721. Qt. Sample copy 50¢. Prefers b&w photos accompanied by ms on dogs working livestock. Query first. Pay negotiable. Include S.A.S.E. with submissions.

Quarter Horse Of The Pacific Coast, Box 4822, Sacramento, Calif. 95825. Sample copy on request. Quarterly issues devoted to special subjects. Photo subjects, captioned, emphasize quarter horse being used at work, in shows, etc. Pays $25 for acc. b&w pix. Send S.A.S.E. with submissions.

Tropical Fish Hobbyist, 245 Cornelison Ave., Jersey City, N.J. 07302. Sent monthly to tropical fish fanciers, retail dealers, naturalists, etc. Sample copy 50¢ on request. Photos in b&w with ms on aquarium care/breeding of tropical fishes, new/unique species of fishes, etc. Pays on acc. B&w glossy, $3. Color trans. any size from 35mm up, $5. Include S.A.S.E.

Western Horseman, 3850 N. Nevada, Colorado Springs, Colo. 80901. Query first for special interests. Photos paid for on acc. with ms. For return, submissions must include S.A.S.E.

4. Art, Movie, Music, Theater, TV

After Dark, 268 W. 47th St., New York, N.Y. 10036. Slanted for an adult readership on all types of entertainment: movies, books, nightclubs, TV, stage shows, etc. Sample copy on request. Buys appropriate captioned b&w and color trans. $20 to $50 ea. on pub. Include S.A.S.E.

Afternoon TV, 185 Madison Ave., New York, N.Y. 10016. Mo. Personalities, interviews, etc., on TV afternoon shows. Four to eight page, double-spaced typed ms, $50 to $100. Photos purchased with ms, up to $15 ea. Query first. Include S.A.S.E. with submissions.

American Artist, 165 W. 6th St., New York, N.Y. 10036. Mo. Slanted for both amateur and professional artists in all types of fine arts and commercial fields. Sample copy sent for $1. Buys ms up to approx 2,500 words on professional working methods of artists, sculptors, designers, etc. Pays $50 to $150 for ms; uses captioned 8×10 b&w glossy prints only. Query on subject. Include S.A.S.E. with submission.

Art In America, 158 E. 58th St., New York, N.Y. 10022. Buys some free-lance material on various aspects of American art. Must be typewritten and include illustration suggestions. Query first. Pays on pub., $100 to $300 for accepted ms. Photos supplied by author can be 35mm if excellent quality. Prefer 2¹/₄×2¹/₄ or larger trans. Also use b&w glossies, size 8×10. Include S.A.S.E. with submissions.

Auction (Parke-Bernet Galleries), 200 W. 57th St., New York, N.Y. Slanted to interests of affluent collectors of art, antiques, vintage cars, rare books, etc. Sample copy available, $1.50. Query on a subject first. Photos purchased with ms, lengths from 1,500–2,000 words. Must be well researched and authentic. Pays on pub., $125 to $200. Send S.A.S.E. with submission.

Audio Magazine, 134 N. 13th St., Phila., Pa. 19107. Mo. Sample copy available on request. Each issue has a special theme emphasis: tuners, turntables, speakers, etc. Interested in accurate, illus. articles (8×10 glossies) on hi-fi construction, music, equipment reviews, and tests, etc. Query first. Include S.A.S.E. with submissions.

Biograph, P.O. Box 31236, 4808 St. Barnabas, Washington, D.C. 20031. Bimo. Slanted to interests of movie enthusiasts—current interviews with people connected with movie industry, history of the cinema, etc., including captioned story-telling pix of movie productions. Photos are purchased with text; pay varies according to content. Query first. Include S.A.S.E. with submissions.

Contempora, P.O. Box 673, Atlanta, Ga. 30301. Bimo. Sample copy sent on request. Slanted to well-informed readership—study

copy for subject matter range. Pays on pub. Photo prices range up to $250 for trans. with text-captions. Query first. Send S.A.S.E. with submissions.

Dance Magazine, 268 W. 47th St., New York, N.Y. 10036. Mo. Sample copy on request. Addressed to interests of both professional dancers and those interested in the art of the dance. Photos purchased only with ms or captions. Query first. Include S.A.S.E. with submissions.

Exhibit, Box 23505, Ft. Lauderdale, Fla. 33307. Bimo. Produced for art-hobby shop customers. How-to articles with b&w glossy photos on wide range of subjects, both commercial and fine arts. Best to study sample copies for approach and subject coverage. Pays on acc., approx. 5¢ a word on text up to 1,000 words, plus $5 per photo used. Query first on special subjects. Include S.A.S.E. with submissions.

Guitar Player Magazine, 348 N. Santa Cruz Ave., Los Gatos, Calif. 95030. Publishes eight issues a year. Will send sample copy on request. Very wide range of subject matter from interviews with personalities to techniques, history, etc. Magazine is best guide to its needs. Pays on acc. up to 3¢ per word for illus. text, plus up to $15 for b&w glossies accepted. Query first. Submit S.A.S.E. with material to be returned if rejected.

High Fidelity, Publishing House, Great Barrington, Maine 01230. Mo. Slanted to interests of all who are interested in hi-fi stereo equipment, recordings, music, etc. Also how-to material, interviews, etc., related to music or hi-fi. Buys b&w glossies with ms of 1,000 to 3,000 length. Price varies. Query first. Include S.A.S.E. with submissions.

Modern Keyboard Review, 436 Via Media, Palos Verdes Estates, Calif. 90274. Pub. six times per yr. Sample copy sent upon request. For students, teachers and others interested in contemporary popular piano, organ, accordian music. Photos purchased with articles. (Study magazine for interest range.) Pay varies. Query first. Include S.A.S.E. with submissions.

Modern Screen Magazine, 750 3rd Ave., New York, N.Y. 10017. Mo. Uses articles of popular interest on show business personalities, stars of movies, TV, etc. Buys pix with ms, or captioned b&w to size 8×10, either singles or

story-telling series. $20 ea., pay on acc. Best to study contents and style, then query. Include S.A.S.E. with submissions.

Motion Picture, Macfadden-Bartell Corp., 205 E. 42nd St., New York, N.Y. 10017. Mo. Will send sample copy on request. Wide range of slanted material in text interests. Magazine is best guide to needs. Study first, then query. Pays well on acc. for top-quality b&w and color trans, 35mm and up in size. Include S.A.S.E. with submissions.

Movie Life, 295 Madison Ave., New York, N.Y. 10017. Mo. Emphasis on interesting angles of private lives of movie and TV celebrities. Accepts captioned b&w and color pix as singles, or as story-telling series. $20 and up per photo accepted. Study magazine contents, query first. Include S.A.S.E. with submissions. Pays on pub.

Movie Mirror and **Movie Mirror Yearbook**, 315 Park Ave. S., New York, N.Y. 10010. Mo. (magazine). Study contents for type of material aimed for movie and TV readership. Also covers recording stars. Query concerning person(s) you can cover in b&w or color. Pay varies on acc. Include S.A.S.E. with submissions.

Movie World, 625 Madison Ave., New York, N.Y. 10022. Mo. Slanted for readers interested in movie, TV, popular music. Study magazine, then query. Photos purchased only with text. Photos included bring extra payment ranging from $10 to $200. Pay on acc. Include S.A.S.E. with submissions.

On Film Magazine, 133 W. 14th St., New York, N.Y. 10011. Bimo. Sample copy sent on request for $2. Articles from 100 words to 1,000 or more. Prices from $10 to $400 depending upon subject, style, etc. Study samples for type of copy wanted on film personalities and industry. Photos purchased with text, color only. Price negotiable. Pays on pub. Query first. Submit S.A.S.E. with material.

Photo Screen, 315 Park Ave. S., New York, N.Y. 10010. Mo. Material aimed for movie and TV readership. Sample copy sent for 35¢ and S.A.S.E. Personal interviews with movie, TV celebrities. Study style, query first including S.A.S.E. Captioned b&w and color trans. purchased; prices negotiable. Pays on acc. Send S.A.S.E. with all submissions.

Photoplay, 205 E. 42nd St., New York, N.Y. 10017. Mo. Contents slanted to women readers, 'teens on. Strong emotional accents. Sample copy sent on request. Study, then query. Photos of stars in all entertainment media purchased with or without text. If without text, caption accurately. Pay varies with subject, quality. Include S.A.S.E. with submissions.

Revue Des Beaux Arts, Allied Pubs., Inc., Box 23505, Ft. Lauderdale, Fla. 33307. Bimo. Interviews, profiles, trends in art field. Also historical material, info for art collectors, news in art media, etc. Pays 5¢ per accepted word, $5 per photo bought with text. Query first. Include S.A.S.E. with submissions.

Rolling Stone, 746 Brannan St., San Francisco, Calif. 94103. Semi-mo. Study free sample copy sent upon request. Essential to study slant of magazine for contents, style, interest range. Buys photos for inside use, up to $50; more for cover photos. Query first. Photos not with text must be fully, accurately captioned. Enclose S.A.S.E. for return of unaccepted material.

Take One, Box 1778, Sta. B., Montreal 110, Quebec, Canada. Bimo. Sample copy on request. Interested in all aspects of film and TV but definitely not a fan-type magazine. Articles on actors, players, stars, current or historical film/TV interest. Study mag., then query on specific subjects you can offer. Photos, 8x10 glossies, are purchased with text. Payment varies. Include S.A.S.E. with Int'l Reply postage coupon with submissions.

TV Guide, Radnor, Pa. 19087. Not normally a free-lance market as most pix are shot on assignment. If you think you can qualify in top-notch photo bracket, try a query with a few samples, preferably trans. in vertical 4×5 format. Payment for acc. material good. Include S.A.S.E. with submissions.

TV Star Parade, 295 Madison Ave., New York, N.Y. 10017. Mo. Accent on interesting aspects of the private lives of TV stars—informal approach. If photo includes identifiable people not connected with TV celebrity, model release a must. Buys b&w glossy pix and color as captioned singles, or story-telling series. Query first. Include S.A.S.E. with submissions.

5A. Autos, Bicycles, Motorcycles, Sports Cars
5B. Commercial Vehicles, Trucking, Related Periodicals

A. Autos, Bicycles, Motorcycles, Sports Cars

AMA News, American Motorcycle Association, Box 231, Worthington, Ohio 43085. Mo. B&w pix and color trans. purchased with text on safe

motorcycling practices, interviews, travel pieces, and other nontechnical subjects of interest to readers who are mostly in the late

twenties and early thirties age group. Sample copy on request. Submissions should have S.A.S.E. Pay varies on pub.

American Bicyclist And Motorcyclist, 461 8th Ave., New York, N.Y. 10001. Mo. Merchandising ideas, repair techniques, material slanted for dealers and mechanics who work with bikes, mini-bikes, motorcycles and other wheelgoods. Uses b&w photos only; accompanying text essential. Query first. Enclose S.A.S.E.

Auto Racing Magazine, 211 W. 58th St., New York, N.Y. 10019. Mo. Sample copy 75¢. Buys assigned articles-plus-text only. Query first. Slanted towards auto-racing buffs interested in race and pit activities, drivers, racing personalities, etc. Include S.A.S.E. with submissions. Pays up to $100 for text; $5 for b&w illus., up to $20 for color trans. Repeat: query first.

Autoweek, Competition Press, Inc., Autoweek Bldg., Lafayette, Calif., 94549. Weekly. Requires quality writing, buys exclusive rights, pays on pub. Slanted to interests of auto and motorcycle industries. Occasional feature stories (nonfiction) on drivers, antique/vintage equipment, races, etc. Sample copy on request; query first about features. Include S.A.S.E. with submissions.

Bicycle Journal, The, 3339 W. Freeway, Ft. Worth, Tex. 76101. Mo. B&w pix of bicycle leg art with model releases (can use two poses of each model). Also bicycle store interiors, exteriors, display ideas, etc. Pays $10 for b&w photos, on acceptance. Enclose S.A.S.E. with submissions.

Big Bike Magazine, 16200 Ventura Blvd., Encino, Calif., 91316. Mo. Sample copy, $1. Edited for motorcycle enthusiasts who like to maintain, modify, repair their own wheels. Good deal of technical "how-to" material. Photos purchased with text; price varies with quality. Query first, if you like. Include S.A.S.E. with submissions.

Canadian Motorcycling, Box 100, Oslington, Ont., Canada. Mo. Sample copy, 50¢. General interest topics on motorcycling, particularly with Canadian locale or twist. Prices vary on pub. Query first. B&w photos only. Enclose International Reply Coupon with submissions.

Car and Driver, 1 Park Ave., New York, N.Y. 10016. Mo. Slanted to interests of readers up to early 40's. Interesting cars and personalities, racing, automotive industry, and sports. Buys b&w glossy pix with text. Rates vary with quality. Query first. Enclose S.A.S.E. with submissions.

Car Craft, 8490 Sunset Blvd., Los Angeles, CA. 90069. Mo. 50¢ for sample copy. Interests of readership from early teens through mid-30's. Stock car racing, drag racing, how-to material on souping up vehicles. Buys b&w and

color trans. with ms. Pays on acceptance. Best to query first. Enclose S.A.S.E. with material.

Car Life, 1499 Monrovia Ave., Newport Beach, CA 92663. Mo. 50¢. B&w photos only, singles and in series, on automotive subjects; humorous, new products, custom cars, etc. Pays on pub. $5 to $25 per photo (captioned fully and accurately). Additional for text. Enclose S.A.S.E. with submissions.

Cars Mag. Group: Cars, Rodder And Super/Stock, Speed And Supercar, Super/Stock And Funny Car, 1560 Broadway, New York, N.Y. 10036. Monthlies. Sample copies, 25¢. Edited for readers of all ages interested in racing and high performance cars. How-to-do-it material, interviews, profiles. Buys all rights; pays on pub. Length open on feature photos plus text. Rates: b&w photos & text, about $50 per page; color trans. with text, about $75 per page. Query if possible. Include S.A.S.E. with submissions.

Cycle, 1 Park Ave., New York, N.Y. 10016. Mo. Payment relatively good for b&w and/or color trans., with captions and/or text, but best bet is to study contents and query first. Include S.A.S.E. with submissions.

Cycle Illus. Group: Cycle Illustrated, Motorcycle World, 222 Park Ave., New York, N.Y. 10003. Bimo. Tech. reports, road and travel tests, vintage and custom cycles, etc. Pays up to $175 for articles with b&w photos. Captioned photos, up to $15 ea. No color. Include S.A.S.E. with submission.

Cycle News Group: Cycle News East, Cycle News North, Cycle News West, Dixie Cycle News, Box 498, Long Beach, Calif. 90801. Best to study samples first and query on rates.

Cycle World, 1499 Monrovia Ave., Newport Beach, Calif. 92663. Mo. Sample copy, 75¢. Material slanted to interests of readers from teens to mid-40's. Travel articles for dirt and road enthusiasts, special or custom bikes, spot news, profile personalities, etc. B&w and color trans. purchased only with text and captions. Query on subject matter and rates. Include S.A.S.E. with material.

Dune Buggies And Hot VW's—The Fun Car Journal, Box 1757, 1499 Monrovia Ave., Newport Beach, Calif. 92663. Mo. B&w and color trans. purchased with text only for inside use. Color trans. for covers up to $75 ea. Study sample issues first. Accent on activities with dune buggies and Volkswagens, how-to and technical articles. Enclose S.A.S.E. with submissions.

Hot Rod, 8490 Sunset Blvd., Los Angeles, Calif. 90069. Mo. Sample copy 75¢. Automotive interests, action, how-to, racing, car features. B&w thoroughly captioned pix, up to $20. Color trans., 35mm and up, purchased with text, $25 to $250 as complete package. Pays on acceptance. Include S.A.S.E. with material.

Hot Rod Industry News, Petersen Pub. Co., 8490 Sunset Blvd., Los Angeles, Calif. 90069. Query for status, interests, rates.

Motor, 250 W. 55th St., New York, N.Y. 10019. Unusual pix with automotive relationship, stressing humor and the odd (in good taste), etc. Also pix of attractive gals on the job in any segment of the automotive trade. With accurate captions, b&w pix, $15. Pay on acc. Enclose S.A.S.E. with submissions.

Motor Trend Magazine, 8490 Sunset Blvd., Los Angeles, Calif. 90069. Interested in creative photography, b&w and color, with emphasis on performance automobiles, antiques, classics, etc. Captioned b&w, $5–$10. Color covers (2¼×2¼ and 4×5 preferred) from $50 to $150. Payment on acc. Send S.A.S.E. with submissions.

Motorcycle Dealer News, P.O. Box 288, South Laguna, Calif. 92677. Stores, dealer activities, specific industry problems. Buys b&w photos with captions or text. Prices negotiable. Query for details.

Motorcycle Sports Quarterly, 8490 Sunset Blvd., Los Angeles, Calif. 90069. Covers all types of motorcycle competitions. Detailed captions required for photos; payment up to $25 on acc. Query first. Include S.A.S.E. with submissions.

Motorcyclist, Box 638, Sierra Madre, Calif. 91024. Mo. Captioned motorcycle action pix. B&w only: $5 to $50. Pays on pub.

Popular Hot Rodding, 131 S. Barrington Pl., Los Angeles, Calif. 90049. Mo. published for readers interested in hot rods, how-to, etc. Query first. Photos purchased only with captions or ms. Min. size trans. 2¼×2¼. Pays $50 per printed page on pub. Send S.A.S.E. with all submissions.

Road Test, 6675 26th St., Los Angeles, Calif. 90022. Sample copy, 60¢. Edited largely for audiences over 35, affluent, well-educated, mainly interested in uses of what is now the family car. Don't let the title mislead you into expecting hot-rod or sports-car emphasis. B&w pix with text; payment varies with length, subject, quality. Study first, then query. Include S.A.S.E. with submissions.

Stock Car Racing Magazine, 522 N. Pitt St., Alexandria, Va. 22314. Mo. Sample copy 60¢. How-to material, profiles, new product and techniques, personality profiles, related subjects of interest to racers and stock-car racing fans. Photos purchased with ms. Buys all rights on text, first rights on photos. B&w glossies and transparencies with captions and/or text, $15 to $200. Pays on pub. Send S.A.S.E. with submissions.

Street Chopper Group: Street Chopper, Hot Bike, Chopper Guide, 731 Melrose Ave., Placentia, Calif. 92670. Mo., bimo., quarterly.

Slanted for age groups of teens through mid-40's. How-to's, technical material on high-performance cycles, historical, mechanical interests. Buys all rights, pays on acc. Text and captions with b&w glossies, or transparencies ($2^1/_4 \times 2^1/_4$ size and larger preferred). $50 to $100 per printed page. Include S.A.S.E. with submissions.

Supercycle, 1460 Broadway, New York, N.Y. 10036. Ms and captions with photos on subjects of interest to motorcyclists. Buys all rights at about $30 printed page. Pays on pub. Include S.A.S.E. with submissions.

USAC (United States Auto Club) News, 4910 W. 16th St., Indianapolis, Ind. 46224. Wk. newspaper. Buys b&w glossies with ms or captions only. (Buys all rights.) Query first for needs and pay rates.

Volkswagen Owners Annual, Rajo Pubs., 319 Miller Ave., Mill Valley, Calif. 94941. Requires ms with b&w photos. Sample issue $1. Slanted for VW owners and those who enjoy, live, work with VW's. Best query for details on proposed articles. Pays up to $25 per printed page after pub. Send S.A.S.E. with submissions.

World Car Guide, same address as above. Mo. Slanted for foreign cars enthusiasts. Same requirements and payments, but subject matter includes travel/camping, dune buggies, snowmobiles, antique cars, etc. Heavy use of pro quality photos with ms.

B. Commercial Vehicles, Trucking, Related Periodicals

These are primarily trade journals sold by subscription to readers with specialized trade/business interests. Many other periodicals in this general category are not listed because they are largely staff produced, or pay too little for their material to be worth most photographers' time, effort, and postage.

Automotive Rebuilder, 11 S. Forge St., Akron, Ohio 44304. Mo. Sample copy, 50¢. Uses text and b&w photos slanted to business interests of remanufacturers of automotive motors, transmissions, various major components. Study sample issue and query first, especially on possible major feature articles/photos.

Business On Wheels, 200 York Rd., Oak Brook, Hinsdale, Ill. 60523. Quarterly. Edited to interests of owners and operators of carrier-trucks, truck fleets, etc. Uses both b&w and color trans. Study first, then query on specific subject possibilities. Payment up to $300 on complete package assignments.

Canadian Transportation And Distribution Management, 1450 Don Mills Rd., Don Mills, Ont., Canada. Sample copy 75¢. Uses b&w photos with text/captions on Canadian activities in the carrier, shipping (truck, air, marine) industries. Also rail. Study first, then query on possible package (text-photo) submissions.

Commercial Car Journal, 56th & Chestnut, Phila., Pa. 19139. Mo. Buys photos with articles on management and operation of truck and bus fleet carriers. Pays up to $100 for complete text/photo articles; up to $20 for captioned b&w photos. Query first. Enclose S.A.S.E. with submissions.

Heavy Duty Trucking, Box W, Newport Beach, Calif. 92663. Mo. Edited to equipment, maintenance, operational interests of truck fleet operators. B&w photos with text and captions, up to $150. Query first. Enclose S.A.S.E. with submissions.

Motor, 250 W. 55th, New York, N.Y. 10019. Mo. Edited to interests of auto dealer service, owners of service and repair shops, promotion and sales managers. Up to $100 per package text/photo feature story; up to $12 for b&w single captioned photos. Query first. Include S.A.S.E. with submissions.

Motorcycle Dealer News, Box 288, S. Laguna, Calif., 92677. Mo. Send for guide sheet on interests, needs, and pay rates. Query on specific subjects and indicate the coverage you can give. Include S.A.S.E. with submissions.

Refrigerated Transporter, 1602 Harold St., Houston, Tex. 77006. Mo. Free copy available. Wide range of interests in refrigerated truck handling, cargos, equipment, operational problems, and solutions. Prefers complete package of text/photo submissions. Pays minimum of $45 per page. Study first, then query on feature material. Include S.A.S.E. with submissions.

Tire Review, 11 S. Forge St., Akron, Ohio 44304. Mo. Edited to interests of independent tire dealers, retreaders, tire company stores, and management personnel. Buys text/photo package coverages and b&w captioned single photos. Study sample copies first. Include S.A.S.E. with submissions.

Warehouse Distribution, 7300 N. Cicero Ave., Lincolnwood, Ill. 60646. Published eight times per yr. Sample copy, $1. Edited to interests of businessmen doing high yearly volume of business in the field of automotive parts distribution. Rates vary with length and quality of text/photo package offerings. Single b&w photos with captions, up to $6. Study first, then query on specific subjects. Enclose S.A.S.E. with submissions.

6A. Calendars, Greeting Cards, Related Products
6B. Post Cards Manufactured "To Order"

A. Calendars, Greeting Cards, Related Products

The European photo markets for calendars, greeting cards, and related products has long dwarfed the North American markets. In recent years, however, U.S. and Canadian markets have skyrocketed. But while many buyers need top-quality photos in black-and-white, color transparencies, or both, they are frequently reluctant to publicize their needs. For one thing, they hesitate to go on record for photo needs that may be temporary, limited in scope, or undergo changes overnight. For another, they may not want to give competitors a clue to the photo-illustrated lines they plan to introduce or expand. Most of all, they don't want to invite a deluge of amateur offerings and professional left-overs.

Because of this reluctance to air their needs, many buyers fill their need lists by tracking down published photographers whose work interests them, or by selecting from the masses of photo-

graphs they can obtain from stock-photo agencies on approval.

Calendars: In the following listings, details are included only if provided by a printing house. In any given local area, you will find far more leads under the heading of "Printers" in the yellow pages of a phone directory. Although the printing house that manufactures calendars may rarely if ever do the actual buying, it can refer you to previous customers who had calendars printed and who may be in the market for another.

Greeting Cards: Some greeting-card manufacturers use photographs regularly, others make use of them sporadically or never. In reply to our queries, some manufacturers state clearly that they do or do not use photographs; others send guideline sheets that include photographs under the word *art,* while others seem to consider *art* to be confined to pen and brush work. Those that have specifically indicated interest in photographs are identified in the listings that follow by an asterisk (*). No asterisk appears beside the names of manufacturers who are not now using photographs (but may change their art policies in the future), or those who failed to mention photographs in defining their current "art" interests.

Your first steps toward breaking into the greeting-card field should be as follows:

1. Visit the largest greeting-card retail outlets in your area. Note the names of manufacturers who use photos; rarely if ever will their complete address appear on the card.

2. Make a note of the variety of photographic subjects each manufacturer uses.

3. Check the following listings for a complete address.

4. Select a dozen or so samples of your *best* work in the subject-matter fields the manufacturer is covering; i.e., holidays, special occasions, scenics, babies, pets, humor, and so on.

5. Mail your samples with a *brief* note to the art director or art buyer of the manufacturer. In your note, mention the existence of other material in your files, or your facilities for producing photographs to order. Also ask for a guideline or spec sheet if the manufacturer produces one. Be sure to enclose with your query and samples a *self-addressed, stamped return envelope.*

Related Products: Many manufacturers of greeting cards also print posters, puzzles, calendars, note pads, stationery boxes, tags, seals, plaques, buttons (badges), gift wraps, bumper stickers, decals, and the like reproduced from black-and-white photos and color transparencies. Here again your best approach is to look for these items in retail stores, note the manufacturer's address in the following listings, and follow through with samples of your own work.

Note: Only manufacturers whose names are preceded by an asterisk () have specifically indicated, or are known from their products, to reproduce photographs.*

Amberly Greeting Card Co., Box 37902, Cincinnati, Ohio 45237. Greeting cards and related products.

American Greetings Corporation, 10500 American Rd., Cleveland, Ohio 44144. Greeting cards and related products.

Berliner & McGinnis, 109 N. Pine St., Nevada City, Calif. 95959. Greeting cards and related products.

***Carol Pub. Co.**, P.O. Box 382, 12815 Finchley St., Baldwin Park, Calif. 91706. Greeting cards in variety of subjects. Related products. Prices negotiable. Include S.A.S.E.

***Engagement Calendars**, Berkshire Pub. Co., Valley Falls, New York 12185. B&w and color trans. of historic houses, special points of interest, horses, birds, scenic shots and people in specific states (Maine, Mass., particularly Cape Cod and Berkshires). Min. size trans. 4×5. Prices vary. Submit b&w during Feb.–March; color trans. during Nov.–Dec.

Gemini Rising, Inc., 139 Spring St., New York, N.Y. 10012. Greeting cards and poster products. Query first. Include S.A.S.E. with submissions.

***Hallmark Cards Inc.**, 25th & McGee, Kansas City, Mo. 64141. Wide range of card subjects and related products. Study samples in cardshops; query. Send S.A.S.E. with submissions.

***Looart Press, Inc.**, Box 2559, Colorado Springs, Colo. 80901. Write for specifications, enclosing S.A.S.E. Buys for posters and related products. Enclose S.A.S.E. for submission returns.

***Osborne-Kemper-Thomas, Inc.**, Calendar Hill, Cincinnati, Ohio 45206. Various calendars and greeting cards. Color pix of landscapes, human interest, hunting, fishing, etc. Min. size transparency 4×5. Rates vary according to use. Initial query preferred. Include S.A.S.E.

***Paramount Line, Inc., The**, Box 678, Pawtucket, R.I. 02862. Produces both everyday and seasonal/special occasion cards. Include S.A.S.E. with queries and submissions.

Roberts, Mike, Color Productions, 2023 Eighth St., Berkeley, Calif. 94710. Postcards, related products. Query first, enclosing S.A.S.E.

Rust Craft Greeting Cards, Inc., Rust Craft Road, Dedham, Mass. 02026. Wide variety of greeting cards. Occasionally uses b&w photos. Query for current needs, enclosing a S.A.S.E. for reply. Payments are negotiated.

Sawyer Press, P.O. Box 46-578. Los Angeles, Calif. 90046. Variety of themes in greeting-card lines. Also related products—poster art, etc. Query first, enclosing S.A.S.E.

Sidney J. Burgoyne & Sons, Inc., 2120 West Allegheny Ave., Philadelphia, Pa. 19132. Seasonal (Christmas) color transparencies. Include S.A.S.E. with submission.

Wallace Berrie & Co., Inc., 7628 Densmore Ave., Van Nuys, Calif. 91406. Greeting cards and special related products.

Warner Press Publishers, Fifth & Chestnut St., Anderson, Ind. 46011. Greeting card in wide variety (general themes, seasonal, etc.). Query first. Include S.A.S.E. for reply.

B. Postcards Manufactured "To Order"

Many professional photographers have developed a lucrative business by producing color postcards and related products to order for individual clients.

Prospective customers are literally unlimited. Every restaurant, motel, tourist resort, industrial company, shopping center, independent service company, housing development, and large retail outlet store is a potential client for both introductory and repeat sales. Color postcards for customers of this type are usually put to advertising and/or public relations use. A second opportunity lies in producing scenic postcards of community or area interest to be retailed through card shops, drugstores, variety stores, newsstands, and the like.

To succeed in this field, one must be a salesman as well as a photographer. While the potential customers are there, it's up to the photographer to go after their orders. The minimum order accepted is usually about 3,000 standard-size ($3\frac{1}{2}'' \times 5\frac{1}{2}''$) color postcards of each subject.

Some photographers have local printers (listed in the yellow pages of metropolitan phone directories under "Printers—Postcards") fill their orders. The average cost of 3,000 color cards of a single subject is $115 to $140. To this, the photographer must add a markup that will cover his time, expenses, and margin of profit. This takes careful figuring in advance lest the costs-plus-markup prove too high to meet with competition.

Most photographers prefer (at least in the beginning) to work with the big postcard manufacturers who specialize in this field. Some of these companies produce sample cards, order blanks, price lists, visual aids, and otherwise do everything possible to help a talented photographer-distributor build up a business of his own. The commission rates and policies of the individual manufacturers vary, but the following will give you a rough idea of how they operate.

Let's say for example that a manufacturer agrees to accept your orders for a minimum of 3,000 color postcards of each subject, the suggested selling price to be $90. In closing the sale, you require a deposit of $35 with the signed order. *This deposit is your commission; you keep it.* The balance of $55 is remitted to the manufacturer when the postcards are delivered to the customer. In other words, the manufacturer allows the photographer up to 40% of the suggested selling price as his commission. If a photographer can up the selling price, the extra income is his. If a customer orders a rerun, the manufacturer will usually lower the cost to the customer, but the photographer's commission remains the same as it was. Much the same type of commission policy is applied to follow-up orders the photographer obtains from customers in need of calendars, brochures, business cards, letterheads, special Christmas cards, and so on.

If interested in this field, begin by gathering as much information as possible about the number and variety of potential customers you can reach in a given selected area, the existing competition (if any), future potentials such as you can obtain from the local Booster's Club, Chamber of Commerce, and other organizations interested in local and area improvements. Then write to one or more of the following companies, briefly stating your photographic experience, available equipment, the area you can cover, and your subject interests. Finally, ask for whatever they have to offer in the way of informational brochures, sales aids, price lists, terms, and the like.

Colourpicture Publishers, Inc., 76 Atherton Street, Boston, Massachusetts 02130.

Dexter Press, Inc., Route 303, West Nyack, New York 10994.

Dukane Press, Inc., 2901 Simms Street, Hollywood, Florida 33020.

Garrison Corporation, 40 Washington Avenue, Dumont, New Jersey 07628.

Koppel Color, 153 Central Avenue, Hawthorne, New Jersey 07507.

McGrew, Henry, Printing, Inc., 1615 Grand, Kansas City, Missouri 64108.

MWM Color Press, Inc., Washington at Olive, Aurora, Missouri 65605.

Shelton Color Corporation, 12-16 Lafayette Street, Hackensack, New Jersey 07602.

7. Children, Teenagers, Young Adults

Accent On Youth, 201 8th Ave., Nashville, Tenn. 37023. Mo. Edited for teenagers. Photos (b&w only) purchased with articles—science, youth accomplishments, nature, etc. Sample copy on request. Payment varies with quality.

Action/Impact, American Baptist, Valley Forge, Penn. 19481. Edited for teenagers. Prefer articles with b&w photos. Emphasis on youth's participation in current problems, i.e., racism, poverty, drugs, social/community problems, ecology, etc. Text maximum 5¢ per word; photos paid for accordingly.

Alive!, P.O. Box 179, St. Louis, Mo. 63166. Mo. Replaces former "Vision." Edited for junior-high ages. Interested in whole spectrum of youth life—their scenes, thinkings, feelings, activities, creativity. Sample copy, 25¢. Prefer b&w glossies with articles. Photos $5 to $10 each.

Allied Youth, The, 1901 Ft. Meyer Drive, Arlington, Va. 22209. Published 3 times a year. Edited for mid to late teens. Subject interests focus upon youth's day-by-day problems, conflicts, authoritative facts about drugs, alcohol, social pressures. B&w photos purchased with text. $5 each, on acc.

American Girl, The, 830 3rd Ave., New York, N.Y. 10022. Mo. Edited for teenage girls. Interested in teenage personality, fashion, careers, sports, activities worldwide. Query first. B&w glossies only; picture series with factual captions/text preferred.

Baptist Leader, Valley Forge, Pa. 19481. Mo. B&w pix of inspirational value to junior-high age boys and girls. Action, church or church outdoor school activities. Pays $5 to $10 per glossy 8×10 within six weeks of acc.

Boys Life, Boy Scouts of America, Route 1, New Brunswick, N.J. 08902. Mo. Free copy on request. Buys some photos with ms. Top-quality portfolios considered, but study contents for subject coverage first. Pays $100 per page for b&w. $200 for full color page. Larger trans. preferred, but will consider 35mm size. Top quality only. Include S.A.S.E.

Brownie Reader, The, 1100 Waterway Blvd., Indianapolis, Ind. 46202. Ten issues a year, edited for Brownie Girl Scouts in seven to nine age group. Sample on request. Prefer query first.

Campus Life Magazine, 360 North Main Pl., Carol Stream, Ill. 60187. Mo. Edited for teenage readership. Youth activities and interests. B&w and color trans. as photo stories, article illustrations, etc. with text/captions only. B&w, $5 and up. Enclose S.A.S.E.

Canadian Boy, Box 5112, Station F., Ottawa 5, Ontario, Canada. Mo. For Canadian boys 8 to 18 years of age. Youth, action, featuring Canadians wherever possible. If subject matter or location is not Canadian, "it should not be easily identified as specifically any other nationality or location." B&w photos, $10 and up. Covers, 35mm and larger color transparencies, $75. Query first. Enclose International Reply Coupon for return of submissions.

Catalyst, P.O. Box 179, St. Louis, Mo. 63166. Mo. Edited for senior-high youths. Sample copy for 12¢ mailing cost. B&w photos of teenagers of all colors engaged in subjects of interests to sincere, inquiring, intelligent high-school youths. Prices negotiable. Include S.A.S.E. with submissions.

Charlie, 360 Park Ave. South, New York, N.Y. 10010. Edited for mid-teen-aged girls interested in fashions, rock, self-improvement, etc. Photos purchased by special arrangements. Study publication and query on photo-buying policies before submitting unsolicited material.

Child Life Magazine, 1100 Waterway Blvd., Indianapolis, Ind. 46202. Monthly except for July–Aug. B&w pic. stories on animals, nature, hobbies, trips, humorous subjects to appeal to children four through nine years of age. Pay on pub. $5 and up per photo.

Children's Day, Fawcett Publications, 1 Astor Plaza, New York, N.Y. 10036. Annual. Edited for children 6 to 14 years of age. Query first on top quality material only. Pay negotiable.

Children's Playmate, 1100 Waterbury Blvd., Indianapolis, Ind. 46202. Pub. 10 times per year for children three to eight. B&w photos with ms approx. $3.

Circle K Magazine, 101 East Erie St., Chicago, Ill. 60611. Pub. five times a year for college males in Kiwanis International organ. Sample copy on request. B&w photos bought with ms or captions. Payment negotiable. Enclose S.A.S.E. with submissions.

Climb, Warner Press, 1200 E. 5th St., Anderson, Ind. 46011. Weekly edited for ten-year-olds. Sample copy on request. Emphasis on current Christian living—accomplishments, athletes, community problems and solutions—of children 9–11. B&w glossies $5 and up. Enclose S.A.S.E. with submissions.

Conquest, 6401 The Paseo, Kansas City, Mo. 64131. Mo. for junior and senior age group, sponsored by the Church of the Nazarene. B&w pix of teens in action, adventure, school and church and community activities. Photos bought with ms only, pay $7.50 and up. Send for sample copy and guide sheet. Enclose S.A.S.E. with submissions.

Crusader, 1548 Poplar Ave., Memphis, Tenn. 38104. Edited for Southern Baptist readership of boys 6 to 11. B&w photo stories with captions/text of special interest to this age group. Pay $5 and up. Include S.A.S.E. with submissions.

Discovery, Light and Life Press, Winona Lake, Ind. 46590. Weekly edited for boys and girls who attend Sunday School, ages 9 through 11. Accepts simultaneous submissions of material. B&w photos with captions/text; seasonal, home, school, hobby, personal adventure, how-to subjects. Pay $4 and up. Enclose S.A.S.E. with material.

Earth, Agricultural Bldg., Embarcadero at Mission, San Francisco, Calif. 94105. Publishes "in-depth" pix (captioned or with text) of people and events of young readers 16 to 26. Not necessarily ecological, though this theme is used. Prefer photoessays in b&w or color; also buys for large-size photographic posters. Good rates for photographs, but best to query first. Enclose S.A.S.E. with all submissions.

Encounter, Wesleyan Pub. House, Box 2000, Marian, Ind. 46952. Weekly, edited for teenagers 15 to 19. Sample copy on request. B&w photos with emphasis on teenage activities,

nature, travel, science, seasonal, etc. Pay up to $10 ea. Include S.A.S.E.

Equal Opportunity Magazine: The Minority Student Magazine, Equal Opportunity Publications Inc., P.O. Box 202, Centerport, N.Y. 11721. Annual; sample copy $3. Edited primarily for minority readership; Black, Indian, Latin, etc. of college age. Wide range of subject interests—job opportunities, own-business operations, careers, historical, etc. Best to query first. Include S.A.S.E. with submissions.

ETC, 6401 The Paseo, Kansas City, Mo. 64131. (Church of the Nazarene.) Edited for 18–24-year-old students, servicemen, young professionals. Sample copy on request. B&w photos, $5 to $15. Include S.A.S.E.

Event, 127 9th Ave., Nashville, Tenn. 37203. (S. Baptist.) Edited for youths 12–17. Sample copy on request. Hobbies, sports, do-it-yourself, inspirational themes. B&w photos with captions/ms $5 and up. Enclose S.A.S.E. with material.

Explore, Box 179, St. Louis, Mo. 63166. Weekly, edited for children in grades one through three. Buys some photo-illus. articles on how-to and other subjects. B&w, $5 and up. Include S.A.S.E.

Exploring, Boy Scouts of America, Rt. 1, N. Brunswick, N.J. 08902. Edited for youths 15 to 20 with wide range of interests—sports, careers, travel, career opportunities, etc. Uses some photo-illustrated articles. $100 per page for b&w; $150 for inside color, approx. $250 for color covers. Pays on acc. Include S.A.S.E. with all submissions.

Face-To-Face, 201 8th Ave., South, Nashville, Tenn. 37203. (United Methodist Church). Mo. Edited for 15- to 18-year-olds. Interested in wide range of contemporary themes. Buys single photos with captions, or ms. B&w glossies or matte, $15. Color transparencies, $35. Pays on acc. Include S.A.S.E.

Five/Six, 201 8th Ave., South, Nashville, Tenn. 37203. (United Methodist Church.) Published in weekly format for children in the five to six age group. B&w and color trans. purchased with ms. Pay up to $25. Enclose S.A.S.E.

Flip Magazine, 505 Park Ave., New York, N.Y. 10022. Monthly, edited for girls 11 through 17. Emphasis on teen-idol pop personalities, personal interviews. Also TV and recording artists. Photos purchased with captions only or with articles. Pay negotiated. Query first, giving details of both the proposed subject and your qualifications to cover.

Girl Scout Leader, Girl Scouts of the U.S.A., 830 Third Ave., New York, N.Y. 10022. Mo. Candid pix of Girl Scout leaders in correct uniform and Girl Scouts engaged in various scout activities. B&w $10.

His, 5206 Main St., Downers Grove, Ill. 60515. (Evangelical Christian.) Monthly from Oct. through June. Edited for college students, faculty members, graduate students of the Evangelical faith. Study current issues for theme guides. B&w (only). Pay from $6 to $10 per photo on acc. Enclose S.A.S.E. with submissions.

Kindergartner, The, 201 8th Ave., South, Nashville, Tenn. 37203. Weekly, edited for children four through five. Photo stories (b&w) on subjects of kindergartner's interest levels. Sample copy on request. Payment varies with theme and photo quality. Send S.A.S.E. with submissions.

Light And Life Evangel, Winona Lake, Ind. 46590. Weekly, edited for college age and young adult Methodists. Wide range of contemporary subjects. Free sample copy on request. Photos with ms bring up to $10. (B&w only.) Include S.A.S.E.

Lighted Pathway, 922 Montgomery Ave., Cleveland, Tenn. 37321. Monthly, edited for interests of youths 15 through 19. Sample copy on request. Photos, with religious tie-in or slant, purchased only with captions or ms. Pays on acceptance, up to approx. $6. Include S.A.S.E.

More, 127 Ninth Ave., North, Nashville, Tenn. 37203. Weekly, edited for first and second graders in Southern Baptist churches. Sample copy on request. Include S.A.S.E. with submissions.

Nursery Days, 201 8th Ave., South, Nashville, Tenn. 37202. Weekly, edited for two- and three-year-olds. Study free sample available upon request. Photos usually purchased with ms. B&w only, approx. $7.50. Pays on acc. Include S.A.S.E.

On The Line, 610 Walnut St., Scottdale, PA 15683. Weekly, edited for 9- through 14-year-olds. Sample copy on request. B&w only of animals, human interest involving children, etc. Photos with captions only, or ms. Pays on acc. $5 to $10 per photo. Enclose S.A.S.E. with submissions.

On The Move, Canadian Red Cross Society, 95 Wellesley St. East, Toronto 5, Ontario, Canada. Published nine times a year for children up to ninth grade. Sample copy is best guide to subjects covered; sample copy, 50¢. Photos purchased with ms or with captions only, up to $10. Include International Reply coupon with submissions.

Primary Treasure, Pacific Press Pub. Assoc., 1350 Villa St., Mountain View, Calif. 94040. Weekly, published for Seventh-Day Adventist children in the seven through nine age bracket. B&w photos purchased for cover use; study sample copies. Include S.A.S.E.

Probe, 1548 Poplar Ave., Memphis, Tenn. 38104. Monthly, edited for boys 12 through 17. Subjects include sports, how-to's, nature, travel, inspirational material of reader-level interest. Sample copy on request. B&w photos purchased with captions or ms only. Pays up to $10. Include S.A.S.E. with submissions.

Reachout, Light and Life Press, Winona Lake, Ind. 46590. Weekly, edited for early teenagers. Sample copy on request. Contemporary subjects of junior-high-school interest with a Christian orientation, i.e., school, home, community activities, sports, hobbies, inspirational pieces. B&w photos purchased with ms. Pays up to $10. Include S.A.S.E. with material.

Reflection, Pioneer Girls, Box 788, Wheaton, Ill. 60187. Published ten times a year; edited for girls of junior and senior high school age. Sample copy, 35¢. Study, then query on prices paid for photography. Include S.A.S.E. with submissions.

Scholastic Publications, Inc., 50 W. 44th St., New York, N.Y. 10036. This company produces a number of publications for juveniles and young people. Most photographs are purchased with full captions and/or text material, often based upon a planned theme and shot on assignment. It is suggested that you obtain locally (or write for) sample copies. If the latter, state your interests and qualifications, and enclose S.A.S.E. for reply.

Science World, see Scholastic Magazines, Inc.,above.

Scouting Magazine, North Brunswick, N.J. 08902. Bimonthly, edited for leaders conducting Cub Scout, Boy Scout, and Explorer activities. Preferred subjects include activities and interests of all groups. Buys both b&w and color (minimum size trans. 35mm). Pays on acceptance according to quality and use from $25 to $400. Include S.A.S.E. with all submissions.

Senior Hi Challenge, 922 Montgomery Ave., Cleveland, Tenn. 37311. (Evangelical Christian.) Weekly, edited to interests of high school youths—school, family and community life, travel, nature themes, etc. Sample copy and guide sheet upon request. Uses b&w photos only. Include S.A.S.E. with submission.

Seventeen, Triangle Publication, Inc., 320 Park Ave., New York, N.Y. 10022. Mo. Pix and pic. stories of stage, screen and radio personalities, fashion, beauty features, home decorating, food, community activities—all with teen-age slant. B&w, $150 per page; color $250 per page; cover color $500. Pay. on acc.

Spirit Talk, Concordia Pub. House, 3558 S. Jefferson Ave., St. Louis, MO 63118. Quarterly, edited for youths 13 through 18. Query for specific subject possibilities. Publishes both

b&w and color; rates vary with usage and rights being sold.

Straight, 1821 Hamilton Ave., Cincinnati, Ohio 45231. Weekly. B&w, singles and pic. stories; teen-age (12–18) activities, projects, programs, hobbies, sports; also pix to illustrate ms on teen-age accomplishments, unusual hobbies. Religion and character building emphasized. B&w $15 max.; pic. stories rates vary. Pay on acc.

'Teen Magazine, 8490 Sunset Blvd., Hollywood, Calif. 90028. Mo. Edited for girls 12 through 18. Emphasis on outstanding teenager accomplishments recognized on a national level, profiles, interesting events, etc. Photos purchased with ms only. Pay approx $12 for photos in text-photo package deal. Include S.A.S.E.

Teen Screen Magazine, 6381 Hollywood Blvd., Hollywood, Calif. 90028. Monthly, edited for teenage girls. Emphasis on candids of stars of screen, TV, and recording studio artists. Uses 8×10 b&w and color trans. (min. size 2¹/₄ ×2¹/₄), mostly shot on assignment. Pay up to $50. If you query, state your qualifications and experience as well as specific subject coverage.

Teen Time, Winona Lake, Ind. 46590. Weekly, edited for boys and girls involved in hobbies, travel, family, group activities. Photo stories only, or photos with articles. B&w, $5 to $10, pay on acc.

Teens Today, 6401 The Paseo, Kansas City, MO 64132. Weekly, edited for senior-high age levels. Sample copy on request. B&w photos purchased with ms, pays up to $6. Contemporary subjects based upon wholesome teen living, activities. Enclose S.A.S.E.

Three/Four, 201 8th Ave., South, Nashville, Tenn. 37203. (United Methodist Church.) Weekly, edited for children in the three and four age group. B&w captioned pix, photo features of general-interest subjects including nature, animals, science, children, and customs of other countries, etc. Pays on acc. Include S.A.S.E. with each submission.

Today's Girl, 1518 Walnut St., Philadelphia, PA 19102. Published ten times a year under sponsorship of Camp Fire Girls, Inc. Edited to interests of girls 9 through 13. Best guide to range of subject interests is the magazine

itself. Query first, stating your experience and qualifications as well as proposed topics. Include S.A.S.E. with all submissions.

Trails, Pioneer Girls, Box 788, Wheaton, Ill. 60187. Published ten times a year for girls 8 through 11 or 12. Sample copy upon request (state your interests and qualifications). B&w pix usually paid for with text material. Enclose S.A.S.E. with submissions.

Venture, Box 150, Wheaton, Ill. 60187. Edited to interests of boys (8 to 18) in the Christian Service Brigade. Subjects cover a wide range including outdoors, hobbies, sports, self improvement, etc. Uses b&w and color trans., size 35mm and up. Payment up to $15 for one-time publication rights. Free sample upon request. Include S.A.S.E. with each submission.

World Week, 50 W. 44th St., New York, N.Y. 10036. Edited for junior-senior high-school age group. Uses captioned b&w pix of life and activities in foreign countries, especially those involving young people. Query first, stating your photographic qualifications as well as specific subjects you have or can cover.

8. Fraternal, Armed Forces, Organizations

Air Force Magazine, Air Force Assoc., 1750 Pennsylvania Ave., Washington, DC 20006. Mo. Edited to interests of members of the U.S. Air Force, past and present. Wide range of authoritative subjects; study contents and query first. B&w prints usually purchased with text. Include S.A.S.E. with submissions.

Air University Review, U.S. Air Force, Air Univ., Maxwell Air Force Base, AL 36112. Professional military journal edited for A. F. officers and others interested in aerospace doctrines, plans, programs, etc. Uses b&w photos only. Query first. Include S.A.S.E.

American Legion Magazine, The, 1345 Ave. of Americas, New York, N.Y. 10019. Mo. Photos usually accepted only on assigned articles. Query on ideas.

Army Magazine, 1529 18th St., N.W., Washington, DC 20036. B&w and color trans. with articles or captions on military subjects. Study contents; query first. Include S.A.S.E. Pays on pub. $5 to $25 for b&w; up to $100 for color.

Dynamic Maturity, American Association of Retired Persons, 1225 Connecticut Ave., Washington, DC 20036. Bimo. Edited to interests of pre-retirees. Articles on health, living, investments, personal experiences, etc. Study

first, then query. Pays approx. $15 per b&w; additional for color trans. Include S.A.S.E.

Eagle Magazine, 2401 W. Wisconsin Ave., Milwaukee, Wis. 53233. Mo. except Jan.–Feb. and Sept.–Oct. Edited to interests of male readers. Sports, adventure, travel, etc. Query first. B&w photos, $5 to $15.

Elks Magazine, The, 425 W. Diversey Pkwy., Chicago, Ill. 60614. Mo. Edited to interests of Elks and their families. General interest, seasonal, sports, business, historical, etc. Sample copy on request. Study sample query first. B&w only, $15.

Family Magazine, 475 School St., S.W., Washington, DC 20024. Semimo. Edited as a supplement to the Army, Navy, and Air Force Times publications. Sample upon request. General military-civilian readership interests, worldwide subject matter and audience, with military tie-in. Query first. B&w and color purchased with ms. Include S.A.S.E.

Future Magazine, (U.S. Jaycees 21-36), Box 7, Boulder Park, Tulsa, Okla. 74102. Mo. Sample copy on request. Edited for young men involved in Jaycee work. Query first. Include S.A.S.E. with submissions.

Infantry, Box 2005, USAIS, Ft. Benning, Ga. 31905. Bimo. Military, tactics, equipment leadership, infantry related subjects. Readership primarily U.S. Army officers. Subject-matter guide on request. Query first. Photos usually bought with text.

Junior League Magazine, 825 Third Ave., New York, N.Y. 10022. Bimo. Edited for readers interested in Assoc. of Junior Leagues of America. Sample copy on request. B&w photos usually purchased with text authoritatively written on subjects of health, education, performing arts, welfare, etc. Query first. Include S.A.S.E. with submissions.

Kiwanis Magazine, The, 101 E. Erie St., Chicago, Ill. 60611. Pub. ten times per year. Sample copy on request. Photos accepted with ms. Payment varies with subject and illustration quality.

Leatherneck, P.O. Box 1918, Washington, DC 20013. Edited primarily for contemporary enlisted marines and their families. Large portion of pub. is staff-written. Query first on photos and/or illustrated articles.

Lion, The, York & Cermak Rds., Oak Brook, Ill. 60521. Pub. 11 times per year. Sample copy on request. Edited to interests of N. A. mem-

bers of Lions Club. Travel, sports, adventure, community, outstanding Lion personality-service projects. Query first. Photos bought with ms, $10 ea. Up to $300 for photo spreads. Rarely uses color. Send S.A.S.E. with submissions.

Lookout, The, (Seaman's Church Institute), 15 State St., New York, N.Y. 10004. Edited to interests of merchant mariners—factual material both new and historical. Photos purchased with ms, or misc. photos/captions. Query first; enclose S.A.S.E.

Marine Corps Gazette, Marine Corps. Assoc., Box 1775, MCB, Quantico, Va. 22134. B&w pix and pic. stories of U.S. and foreign marines and equipment; Navy photos if connected with amphibious operations. B&w $5; photo stories $5 per photo plus 3¢ per word. Cover $10–$25. Query first. Include S.A.S.E.

Military Life, 6 E. 43rd St., New York, N.Y. 10017. Mo. Sample copy on request. Edited to interests of young military families, i.e., topics that appeal to young military wives with children, sports-hobby interests for men, etc. Slanted to all three service readerships. Uses b&w glossies and color trans., preferably with text or captions. Include S.A.S.E.

Military Living And Consumer Guide, P.O. Drawer P., Bowie, MD 20715. Mo. Sample copy, 10¢. Photos purchased with ms (b&w) on subjects of interest to military families in all areas. Pay approx $5 per photo.

Military Review, U.S. Army Command and General Staff College, Ft. Leavenworth, Kan. 66027. Mo. Sample copy on request. Professional military journal requiring specific, factual material of interest and significance pertaining to defense policies, U.S. and foreign military and strategic affairs, etc. B&w photos purchased with ms; all references must be cited. Payment varies with length and quality.

Modern Maturity, 215 Long Beach Blvd., Long Beach, Calif. 90801. Bimo. publication of the Amer. Assoc. of Retired Persons. Sample copy upon request. Material of interest to older people—health, hobbies, current trends, nostalgia, etc. Will consider captioned picture stories, picture-illustrated essays. Pays approx $15 per b&w, more for color covers. Include S.A.S.E.

Moose Magazine, 100 E. Ohio St., Chicago, Ill. 60611. Pub. by Loyal Order of Moose. Study sample copies; query on specific subjects before you submit.

National Bowlers Journal And Billiard Revue, 1825 N. Lincoln Plaza, Suite 214, Chicago, Ill. 60605. Mo. Free sample copy on request. Edited to interests of proprietors of bowling/billiard centers, dealers, distributors of equipment and professional players. B&w photos purchased with ms. Query first, enclose S.A.S.E.

National 4-H News, 59 East Van Buren St., Chicago, Ill. 60605. Edited for older teenagers and adults who work with 4-H club members in a wide range of activities. Essential to study editorial needs; write for sample copy and guideline material. Buys b&w and transparencies with ms and/or captions. Query first; enclose S.A.S.E.

National Guardsman, 1 Massachusetts Ave. N.W., Washington, DC 20001. Mo. Buys b&w pix only with ms or captions on National Guard disaster duty in floods, tornadoes, forest fires, etc. Rates vary. Enclose S.A.S.E.

National Humane Review, P.O. Box 1266, Denver, Colo. 80201. Bimo official publication of the American Humane Association. Sample copy, 25¢. Editorial slant for free-lance material is on organized humane movement. B&w pix only; $5 up.

Navy, The Magazine Of Sea Power, 818 Eighteenth St. N. W., Washington, DC 20036. Mo. Sample copy on request. Edited for military and civilian personnel interested in U.S. and foreign naval materials and services. Emphasis on importance of the seas and sea power to U.S. B&w photos purchased with ms. Query before submitting. Include S.A.S.E.

NRTA Journal, 215 Long Beach Blvd., Long Beach, Calif. 90801. Bimo publication of the National Retired Teachers Assoc. Sample copy sent upon request. Buys seasonal photos, picture stories related to retired teachers and their interests in health, hobbies, income, reminiscence, etc. B&w approx. $15; more for color trans. suitable for covers. Include S.A.S.E.

Optimist Magazine, The, Optimist Int'l, 4494 Lindell, Blvd., St. Louis, Mo. 63108. Mo. Sample copy on request. Edited to interests of U.S. and Canadian businessmen voluntarily involved in important social or community problems. Query first. Photos bought with ms or captions, $5 & up. Enclose S.A.S.E.

Our Navy Magazine, 1 Hanson Pl., Brooklyn, N.Y. 11217. Mo. Cheesecake with nautical motif. Pays on pub. B&w, $5; color trans., $10.

Postmasters Gazette, 348 Pennsylvania Bldg., 13th and Pennsylvania Ave., Washington, DC 20004. (Pub. by National Association of Postmasters.) Edited to interests of postmasters, P.O. Dept. personnel, and Inspection Ser., etc. Buys photos with ms on well researched articles having to do with historical/current postal interest themes. Query first. Pays approx. $100 per printed page, including photos. Enclose S.A.S.E.

PTA Magazine, The, 700 N. Rush St., Chicago, Ill. 60611. Mo. except July/Aug. Buys photos with ms on subjects of pertinent interest to parents, teachers, educators, and others involved in problems of child guidance, teenage problems, educational trends, etc. Query first, include S.A.S.E. with submissions. Payment varies.

Retired Officer Magazine, The, (Retired Officers Association), 1625 Eye St., N.W., Washington, DC 20021. Sample copy sent upon request. Edited to interests of the officers and families of all branches of the uniformed services. Wide range of subject interests. Buys b&w photos with ms. Pay varies. Enclose S.A.S.E.

Rotarian, The, 1600 Ridge Ave., Evanston, Ill. 60201. Mo. Will send sample, 25¢. Edited to interests of Rotarian businessmen, professional men, organizations dedicated to improving international understanding, raising ethical community standards, etc. Slant is altruistic and international in scope. Study copies, then query on specific subjects you can offer. Buys both b&w and color trans.; vertical format usually preferred. Also color covers. Payment varies according to subject/coverage. Include S.A.S.E.

Scouting Magazine, North Brunswick, N.J. 08902. Bimo. Edited to needs and interests of leaders and supporters of Boy Scouts, Cub Packs, Explorer Posts. Send for free guideline sheet and study sample copies. Photos used with articles, in series, with captions only. Good rates on b&w and color transparencies. Enclose S.A.S.E.

U.S. Coast Guard Academy Alumni Association Bulletin, U.S. Coast Guard Academy, New London, Conn. 06320. Bimo edited to interests of Coast Guard Officers. Sample copy available upon request. Subjects dealing with marine activities of special interest to professional sailors. Photos to illus. ms; captioned marine scenes, etc. $5 to $25 depending upon use. Enclose S.A.S.E. with all submissions.

9. Ecology, Conservation, Wildlife

There is often a very thin line between publications devoted *exclusively* to ecology, conservation, nature, and wildlife preservation, and other publications that include these subjects as a segment of their editorial interests. The listings that appear below are *primarily* devoted to ecology, conservation, and the preservation of natural resources. Bear in mind, however, that many photographs that might be acceptable in these markets could be captioned or provided with text that would meet the editorial needs of publications elsewhere listed under sports, travel, regional, or general interest categories. Remember, too, that many newspapers are also potential markets for this type of subject matter whether or not the papers are listed by name in this book.

American Forests, 919 17th St., N.W., Washington, DC 20006. Mo. Edited to interests of well-educated readership interested in forests, preservation of wildlife, outdoor recreational facilities. Buys b&w and color prints as well as color trans. Photographs purchased only with ms and/or captions. Payment varies with quality and subject matter. Query first. Include S.A.S.E.

Animal Kingdom, New York Zoological Park, Bronx, N.Y. 10460. Bimo. Edited to interests of members of zoological societies and others interested in conservation, natural history, wildlife, zoos, aquariums, etc. Photos purchased with ms. Rates negotiable. Include S.A.S.E.

Audubon Magazine, 132 West 31st St., New York, N.Y. 10022. Pub. six times per year. Write for detailed sheet of current needs. Recent interests were for b&w and color trans. of wildlife in pristine, unpolluted natural habitat and photos taken in locales off the beaten path; i.e., whales, denizens of the sea, sequence shots of normal eating, fighting, mating young-raising habits of animals. Emphasis is on factual treatment of behavioral patterns in natural surroundings. Good rates on acceptance. Query first,. Include S.A.S.E.

B. C. Outdoors, 5543 129th St., Surrey, B.C. Canada. Bimo., edited to interests of B.C. readership only. Subjects include B.C. conservation, wildlife, travel, historical, and scenics. (Regional material only.) B&w single shots, or with ms, $5. Color trans. of wildlife/scenics, $15. Pays on acceptance. Include S.A.S.E. and Int'n. Reply coupon with submissions.

Canadian Audubon, 46 St. Clair Ave., East, Toronto 7, Canada. Pub five times a year; free sample on request. Subject matter includes ecology, nature, conservation, wilderness preservation—all with emphasis on Canadian situations and interests. Buys b&w pix with captions/ms. Best to query first. Enclose Int'n postage return coupon with submissions.

Clear Creek—The Environmental Viewpoint, 617 Mission St., San Francisco, Calif. 94105. Mo. Sample copy 50¢. Well illustrated, factual articles on ecological/environmental issues and problems. B&w photos. Payment and rights by negotiation. Query first. Enclose S.A.S.E. with submissions.

Earth, Agricultural Bldg., Embarcadero at Mission, San Francisco, Calif. 94105. Slanted primarily for people aged 16 to 26. Interests not entirely confined to ecological themes. Prefer photo essays with captions in b&w and color. Also uses some full-size photographic posters. Basic prices range to about $200 per page. Query first. Enclose S.A.S.E. with submissions.

Environment, 438 N. Skinker Blvd., St. Louis, MO 63130. Pub ten times per year. Sample copy on request. Emphasis on factual and technical information on conservation and pollution. B&w photos with ms/captions only. Query first. Enclose S.A.S.E.

Environmental Quality Magazine, P.O. Box 683, Chatsworth, Calif. 91117. Quarterly slanted to college-age readership. B&w photos purchased with text on environmental problems. Query first. Payment is negotiable; enclose S.A.S.E.

National Parks & Conservation Magazine, 1701 18th St., N.W., Washington, DC 20009. Mo. Buys captioned photos with ms on wide range of environmental, endangered wildlife, park and wilderness preservation, etc. Size 8×10 glossies or 4×5 transparencies preferred. Rates variable. Query first.

National Wildlife and **International Wildlife,** 534 Broadway, Milwaukee, Wis. 53202. Bi-monthly. Study sample copies before querying; most photographic needs are handled on assignment. Buys some b&w and color for illustrations, as captioned features, covers, etc. Rates vary with quality and use from moderate to good. Enclose S.A.S.E. with queries/submissions.

Natural History, 79th & Central Park West, New York, N.Y. 10024 Mo. Sample copy $1. Edited for intellectual readership with a wide range of interests. Uses b&w and color trans. illustrations in articles on biological sciences, geology, astronomy, ecology, archeology, anthropology. B&w glossies in 8×10, up to $50 per page. Color trans. range from $75 to $100, according to use. Query first. Include S.A.S.E.

Oceans, 1150 Anchorage Lane, San Diego, Calif. 92104. Editorially aimed toward educated laymen interested in marine sciences related to the sea. B&w and color widely used; payment varies with subject and illustrational quality. Query first. Submit S.A.S.E. for return of materials.

Ontario Naturalist, The, 1262 Don Mills Rd., Don Mills, Ontario, Canada. A nonprofit organization sponsoring nature recreation, education, and conservation. Most wildlife and nature photos provided by the organization contributors. Occasionally, however, specialized environmental photos (Canadian interests) are purchased if otherwise unobtainable. Query for specific needs.

Outdoor World, 1645 Tullie Circle N.E., Atlanta, GA 30329. Bimo. $1.25. B&w subject interests include nature, conservation, preservation of natural resources, outdoor activities, and recreation which promote nature appreciation, how-to-do-it activities, and how-to-make-things. Buys single captioned photos but prefer photo-article packages. Min. size color trans. 35mm. Interested in esthetic photo series in color, $35 to $100. Pay on acc. Study photo treatments. Enclose S.A.S.E.

Pacific Discovery, California Academy of Sciences, Golden Gate Park, San Francisco, Calif. 94118. Edited for knowledgeable readership interested in natural history/science, archaeology, scientific explorations, biological discoveries, anthropology, etc. Photos purchased with ms, as captioned photostories, etc. Pay $10 and up per photo. Query first. Enclose S.A.S.E.

Wisconsin Tales & Trails, 6120 University Ave., Madison, Wis. 53705. Quarterly, $1.50.

(Issued seasonally with appropriate photo-text contents.) Wisconsin subjects of statewide interest, including people, history, places, scenics, etc. Prefer b&w photos in a series that accompany or amplify text, $10 each. In color, scenic views of Wis. are used. Min. size trans. $2^1/_4 \times 2^1/_4$. Pays $50 per trans. on pub. Query first. Enclose S.A.S.E.

World Wildlife Illustrated, 221 Baker Ave., Concord, Maine 01742. Pub. six times a year. Publishes educationally-oriented, illustrated material of interest to readers involved in or concerned with conservation, wildlife preservation, etc. B&w and color photographs are purchased for both article illustrations and feature story use. Specific details available upon request. Enclose S.A.S.E.

10. Family, Home, Gardening Publications

Atlantic Advocate, The, Phoenix Square, Fredericton, N.B., Canada. Mo. 50c per copy. Single captioned pix and text/photo articles, subject matter covering children, animals, children, action, scenics, etc.—*all pertaining* to Atlantic Provinces of Canada. Particularly interested in distinctive photography "that shows imagination, feeling for subject, out-of-the-rut" composition. Accepts 35mm but prefer trans. in $2^1/_4 \times 2^1/_4$ min. size. B&w glossies, $5 and up. Trans. $35 to $40 for covers. Include S.A.S.E. with submissions.

Better Homes And Gardens, 1716 Locust St., Des Moines, Iowa 50303. Mo. Study first, then query. Subjects cover variety of subjects shot under direction (assignment) of editors. Good rates.

Canadian Homes Magazine, Suite 1100, 401 Bay St., Toronto, Canada. Mo. rotogravure magazine distributed through Canadian newspapers. Captioned photos (for Canadian application) on ideas for home-improvement, home decorating, etc. Good rates on accept. Include S.A.S.E. with Int'l. Reply coupon.

Co-op Report, 59 E. Van Buren St., Chicago, Ill. 60201. Bimo. Slanted to interests of members of co-ops—housing, farm, students, etc. Profiles and articles with captioned pix on successful co-op operations. B&w only. Photos up to $10 each on acc. with copy. Query first; enclose S.A.S.E.

Daily Word, Unity Village, Mo. 46063. Mo. 15c. B&w and color pix to illus. poems and ideas; mostly scenic and seasonal. B&w $5-6; color (for cover, min. size trans. 4×5 vertical only) $25-50. Pay on acc.

Family Handyman, The, 235 E. 45th St., New York, N.Y. 10017. Bimo. Action shots (must show details clearly) with text or full captions of home repairs, before-and-after scenes, home-made devices to simplify work. B&w pix, $7.50 and up. Now using some color also. Study, query, and enclose S.A.S.E.

Flower and Garden Magazine, 4251 Pennsylvania, Kansas City, Mo. 64111. Mo. Photos related to gardening topics, with pleasant home atmosphere, not clinical. Single pix and in series. B&w $12.50 max.; color ($2^1/_4 \times 2^1/_4$ min.) $75 max. for inside use; $125 max. for cover. Pay on acc.

Hearthstone, M.P.O. Box 179, St. Louis, Mo. 63166. Mo. 35c. Pix of family situations, home life, children, young people, older adults, some scenics and seasonal pix. B&w $3-10. Pay on acc.

Home Garden Magazine, 235 E. 95th St., New York, N.Y. 10016. B&w and color pix of well landscaped, colorful gardens, closeups of flowers, house plants, flower arrangements, photo studies of flowers, vegetables, fruit, trees, lawns; how-to-do it pix either singles or series. B&w $5-12.50; color (min. size trans. 35mm), color covers $100 and up.

Home Magazine, 441 Lexington Ave., New York, N.Y. 10017. Mo. Sample copy, 50¢. Slanted to interests of married women, 25 to 50, with children and middle-class income. Subjects include gardening, decorating, cooking, family raising, etc. Uses b&w glossies and color trans.; rates vary with quality. Study, query, enclose S.A.S.E. with submissions.

House & Garden, 420 Lexington Ave., New York, N.Y. 10017. B&w and color singles and pic. stories; travel, decoration, gardening. Rates vary. Pay on acc.

House & Home, McGraw-Hill Pubs., 330 West 43rd St., New York, New York 10036. Mo. B&w and color pix of merchant-built houses, garden apartments, town houses, exteriors and interiors. Assignments at rate of $150 per day plus expenses. B&w $35; color (min. size trans. 4×5) $100; cover (color—8×10 vertical) $150.

Magazine Of Apartment Living, Box 18387, Wichita, Kan., 67218. Mo. Sample copy on request. Edited for people interested in apartment living—decorating, cooking, entertaining, travel, activities, etc. Photos, $10 and up. Query first. Enclose S.A.S.E.

Marriage, St. Meinrad, Ind. 47577. Mo. Pix of family activities and children. B&w $25 and up. Pay on acc.

Modern Living, P.O. Box 23505, Ft. Lauderdale, Fla. 33307. Bimo. Buys b&w photos with captions/text on subjects of interest to homeowners, i.e., decorating, family activities, children, hobbies, pets, travel/vacations, etc. Query first and enclose S.A.S.E. for reply. Pay approx. $5 per b&w.

Organic Gardening And Farming, Organic Park, Emmaus, PA 18049. Mo. Sample copy and guideline on request. Buys b&w and color trans. with captions and/or text on subjects related to organic (natural) plant raising, farming, etc. Also use of organic fertilizers, mulching, etc. in flower raising, fruit growing, soil building, etc. B&w glossy prints, up to $15. Color for covers, up to $75. $2^1/_4 \times 2^1/_4$ color trans., or 4×5. No 35mm. Query first. Enclose S.A.S.E.

Perfect Home Magazine, 427 6th Ave. S.E., Cedar Rapids, Iowa 52401. B&w and color pix of home exteriors and interiors. Good idea shots preferred. B&w rates vary; color (min. size trans. $2^1/_4 \times 2^1/_4$) rates vary. Pay on acc.

Pool 'N Patio, 3923 W. 6th St., Los Angeles, Calif. 90020. Published every six months. Edited to interests of owners of swimming pools. Photos purchased with captions/text. Subject matter includes unusual pools, pool maintenance, equipment uses, etc. Query first, enclose S.A.S.E. Rates vary.

Popular Gardening & Living Outdoors Magazine, 383 Madison Ave., New York, N.Y. 10017. B&w and color transparencies of flowers, landscapes, gardens, patios, terraces. Query first. B&w $5-10; color (min. size $3^1/_4 \times 4^1/_4$, no 35mm) $75-$100.

Royal Neighbor, 230 16th St., Rock Island, Ill. 61201. Mo. Organ of Royal Neighbors of America. B&w human interest pix of children and animals; also pertaining to the family or current month of news. B&w cover $10-15. Pay on acc.

Together, Box 423, Park Ridge, Ill. 60068. Mo. B&w and color pix, singles and in series. Dramatic with human interest. B&w $10; color (35mm and up) $25. Pay on acc.

Toronto Calendar Magazine, 65 Front St., Toronto, Ont., Canada. Pub. fortnightly. Send Int'n Reply Coupon for sample copy, 35¢. Interested in people doing things and glimpses of life in metropolitan Toronto and southern Ontario. Include explanatory captions but no text. B&w pix, $20–25. "Will consider color shots of city of Toronto and environs—lively, leisure-time subjects, strong contrasty colors." Accept size 35mm trans. and larger. Pay $50

to $100 on pub. Enclose Int'n. Reply coupon with submissions.

Woman's Day, 1515 Broadway, New York, N.Y. 10036. Distributed through Amer./Can. supermarkets, 8-million copies per issue. Uses color throughout. Interested in professional quality b&w and color trans., on subjects such

as home decorating, family living, food, health, and nutrition, finance problems. Inside color, $200 ea.; color cover, $1,400. Address submissions to the Art Director; enclose S.A.S.E.

Yard And Fruit, Box 1651, Nashville, Tenn. 37202. Bimo. Slanted for homeowners who

have limited space for raising plants, shrubs, trees, gardens, etc. Study magazine for idea of wide range of interests, then query first. Pays on pub. $15 for b&w glossies, $75 and up for color trans. covers. Include S.A.S.E. with all queries/submissions.

11. General Consumer Periodicals

Also see Parts 2,3,4,9,10,12,16,17,19,20,23.

Afro Magazine, Information Press Service, Key Colony Beach, Fla. 33051. Quarterly; sample copy, $1. Primarily slanted to the interests of black audiences, but not politically oriented. Readers interested in Negro personalities, successes, low-cost travel, self-improvement (especially financially), money-saving consumer practices, etc. Captioned b&w glossies, $10–25. Enclose S.A.S.E. with queries and submissions.

Analog-Science-Fiction, Street & Smith Pub., 420 Lexington Ave., New York, N.Y. 10017. Mo. B&w pix as illustrations for science-fact articles only—usually the author supplies them. Pay $5 each.

Bronze Thrills (also **Jive, Hep**), 1220 Harding Street, Ft. Worth, Tex. 76102. Monthlies. Uses b&w and color pix—"sharp, sexy matter, Negro." Buys pix with captions and/or text. Payments made every Thursday following acc. B&w glossies, $20. Min. size color trans. 2¹/₄×2¹/₄. Color: $35 to $75 ea. Enclose S.A.S.E. with all queries/submissions.

Canadian Geographical Journal, 488 Wilbrod St., Ottawa 2, Canada. Mo. 60¢. Pix to illus. ms; also pic stories (6–12 pix) with brief text and caps. Pay $3–10.

Coronet, 315 Park Ave., New York, N.Y. 10010. Not giving out assignments as of this printing, but the Art Director is interested in topical, accurately captioned b&w photo stories submitted on speculation. Top-pro quality essential. Subjects needed include current fads, fashions, new trends that are American and of particular interest to women. Pay is approx. $200 per picture-sequence story. Include S.A.S.E. with all queries/submissions.

Ebony, 1820 S. Michigan Ave., Chicago, Ill. 60616. Mo. 50¢. B&w pic. stories primarily of interest to Negro Americans. Achievement, beauty, human interest, etc. Color pix of Negro personalities, sports and entertainment stars, beautiful Negro girls. B&w pic. stories, $100 and up per story; color $50 and up. Pay on acc.

Essence, 102 E. 30th St., New York, N.Y. 10016. Mo. Sample copy, 60¢. Slanted primari-

ly to the interests of black women who are modern and young in thinking if not in years. Study magazine first, then query as to your subject matter and qualifications. Photos (b&w and color trans.) are purchased with captions only, or with text. Pay varies with quality. Enclose S.A.S.E. with queries/submissions.

Globe Newspaper Group, 1440 St. Catherine St., Montreal, Canada. Group of weekly tabloid newspapers; write for samples, enclosing Int 'n Reply Coupon to cover mailing. Require exceptional photos (b&w only) of sensational news, off-beat, human interest, sex, crime, exposé, etc. $10 to $50 per photo. Reply in seven days. Enclose S.A. envelope with International Reply Coupon with submissions.

Hep—see **Bronze Thrills.**

Holiday, 641 Lexington Ave., New York, N.Y. 10022 Mo. B&w and color pix; scenics, pictorials and activities of recreational or travel interest. B&w $15–100; inside color $100–250 (min. size trans. 35mm); color covers $250–500. Pay on pub.

Holiday Inn Magazine, P.O. Box 18256, 3791 Lamar Ave., Memphis, Tenn. 38118. Query for current photographic needs.

Jet Magazine, 1820 S. Michigan Ave., Chicago, Ill. 60616. Publisher: John H. Johnson, B&w and color pix of celebrities, entertainment personalities, sports figures, public affairs, gimmicks and gag pix; cheesecake; Negro interest. B&w $10–25; color (min. size trans. 4×5) rates open. Pay on pub.

Jive, see **Bronze Thrills** for photo needs.

Maclean's, 481 University Ave., Toronto 101, Canada. Mo. Buys captioned photos and photos with text primarily of Canadian subjects of interest to Canadian readers. Wide range of Canadian subject matter; study magazine first, then query. Good rats on acceptance. Include Int' Reply Coupon and S.A.E. with submissions. Address material to Graphics Director.

Mechanix Illustrated, 1515 Broadway, New York, N.Y. 10036. Study magazine for wide range of subjects having scientific or mechani-

cal tie-in. Buys photos for cover, with captions, with complete and lucid text. Query first. Good rates; pays on acc. Enclose S.A.S.E. with all queries and submissions.

Modern Living, P.O. Box 23505, Ft. Lauderdale, Fla. 33307. Bimo. Edited for readers interested in home improvements, decorating, children, home life and activities, recreation, sports, etc. Buys photos with text. Query first. Include S.A.S.E.

National Geographic, 17th and M Streets, Washington, DC 20036. Mo. Magazine itself offers best picture of the wide range of photo/illustrated material used, style of presentation, etc. Makes heavy use of color at excellent rates. Study, query, enclose S.A.S.E. with all submissions.

National Informer, The, 3550 N. Lombard, Franklin Park, Ill. 60131. Weekly. Emphasis on photo/text coverage of exposé, exciting, informative material, often with strong sex-oriented slant. Best to study several issues first, then query with S.A.S.E. Uses b&w glossies; pays up to $100 per illustrated feature with complete captions plus text.

National Insider, The, 2713 Pulaski, Chicago, Ill. 60639. Weekly. Buys sensational, factual exposé and informative illustrated articles on a wide range of subjects. Study newspaper first, then query. Rate varies with quality. Enclose S.A.S.E. with all submissions.

National Tattler, same address as above.

New Lady, P.O. Box 3755, Hayward, CA 94544. Mo. Sample copy on request. Edited primarily to the interests of Black Americans, particularly women occupied with family activities, home decorating and improvements, children, community affairs, how-to's, inspirational profiles and interviews. Uses b&w and glossies with captions and/or text. Study first, then query. Prices vary with quality. Include S.A.S.E. with all queries and submissions.

Pageant, 205 E. 42nd St., New York, N.Y. 10017. Mo. Sample copy on request. General-interest subjects slanted to predominantly

young, married female readership. Best guide to subject range and style is the magazine itself. Buys 8×10 glossies; will judge from contact prints. Query first and enclose S.A.S.E. Pay varies.

Popular Mechanics Magazine, 224 W. 57th St., New York, N.Y. 10019. Mo. B&w and color pix of new and unusual subjects, new developments in science, mechanics, achievement and discovery. Also how-to-do-it pix. Single photos with brief text, feature-length articles with 12 or more photos. B&w, $15 and up; color (min. size trans. 2¼×2¼) at variable rates. Pays on acc. Will judge suitability of photo subjects from contact proof sheets. Enclose S.A.S.E. with all queries and/or submissions.

Popular Science Monthly, 355 Lexington Ave., New York, N.Y. 10017. Mo. B&w pix of new mechanical products; new developments in science and industry; how-to pix for autos, home and workshop. Color cover shots. Query. B&w $20 to $25; color rates vary. Pay on acc.

Reader's Nutshell, P.O. Box 23505, Ft. Lauderdale, Fla. 33307. Bimo. Slanted to interests of all members of a family. Study copies for editorial contents and style. Buys b&w glossies with text. Enclose S.A.S.E.

Realities, 301 Madison Ave., New York, N.Y. 10017. Wide but specific subject ranges. Study copies, then query. Variable rates according to coverage and quality. Enclose S.A.S.E. with queries/submissions.

Science And Mechanics, 229 Park Ave. S., New York, N.Y. 10003. Mo. Broad range of authoritative subject coverage on new inventions, scientific and medical discoveries/techniques, gadgets, boating, aeronautics, rocketry, engineering, etc. Study copies for range and style. Buys b&w glossies with captions and complete, lucid text; color trans for covers. Good idea to query first with S.A.S.E. Good rates vary with length, subject, quality.

Science Digest, 224 W. 57th St., New York, N.Y. 10019. Mo. Edited for readers of all ages interested in science-oriented coverage of new inventions, techniques, discoveries, etc. Read copies for content and style. Photos (b&w glossies & color trans.) purchased only with captions/text. Uses 35mm color trans., but prefer larger. Query first; enclose S.A.S.E. Good rates for acceptable material.

Science Service, 1719 N St., N.W., Washington, D.C. 20036. B&w pix pertaining to fully authenticated science subjects. Rates vary.

Sepia, 203 N. Wabash Ave., Chicago, Ill. 60601. Mo. Edited to appeal to black readership, all ages. Sample copy on request. Quality pix/prose on wide range of subjects including interesting personalities, profiles, exposés, successful business, homelife, sports, recreation. Study presentation style thoroughly, then query. Uses b&w and color trans., preferably to illustrate text. Enclose S.A.S.E. with queries/submissions. Good rates for acceptable material.

Signature—The Diners' Club Magazine, 660 Madison Ave., New York, N.Y. 10017. Mo. Edited to interests of members of the Diner's Club—predominently businessmen travelers, affluent, well educated. Wide coverage of business, sports, travel, recreation, food and drink, etc. Study copies; include a few b&w samples to establish quality of your work with query (most articles are assigned to photographers). Include S.A.S.E. with queries/submissions. Good rates for suitable material.

Soul Illustrated, Soul Pubs., 8271 Melrose Ave., Los Angeles, Calif. 90046. Magazine edited to interests of predominently black readership. Buys photos with text/captions featuring black people in business, entertainment, education, professions, community activities and a broad range of other interesting, worthwhile projects and activities. Query first; include S.A.S.E.

Soul, same address as above. Weekly newspaper having same basic needs described for *Soul Illustrated.*

TV Guide, Triangle Publications, Radnor, PA 19087. Weekly. Most photo illustrated articles on TV personalities and related subjects are handled on an assignment basis. Only top professional quality in text/photos are suitable. Best to query, establish qualifications after studying back issues. Enclose S.A.S.E. for reply/return. High rates paid, two pages of b&w or color running about $250. Color preferred in transparency renditions.

TV Star Parade, Ideal Publishing Corp., 295 Madison Ave., New York, N.Y. 10017. Mo. Girls—¾ figure or head shots. Pix of TV personalities. B&w rates vary; color cover (min. size trans. 2¼×2¼) $200.

Weekday, 20 N. Wacker Dr., Chicago, Ill. 60606. Single pix of human interest, children, animals; particularly humorous and unusual situations. B&w $7.50.

12. Hobby and Craft Periodicals

Also see Parts 2, 3, 4, 5A, 10, 18, 19, 21.

Antiques Journal, The, Box 88128, Dunwoody, Ga. 30338. Mo. Sample copy, 60¢. Edited to interests of dealers and popular collectable items. (Not interested in material on displaying antiques or historical buildings, etc.) Query first. B&w glossies purchased with text. Enclose S.A.S.E.

Boat Builder, 229 Park Ave. South, New York, N.Y. 10003. Pub. three times per year. Edited for people interested in clear details on how to build different types of boats. Buys captioned b&w glossies with text. Query first. Enclose S.A.S.E.

CB Yearbook, 229 Park Ave. S., New York, N.Y. 10003. Interested in wide range of material related to Citizen's Band radio industry. Study previous issues for style and subject range. Buys photos with ms. Rates vary. Query first. Enclose S.A.S.E. with all submissions.

Coin World, P.O. Box 150, 119 East Court St., Sidney, Ohio 45365. Weekly. Edited entirely to interests of numismatic indoctrinated readership. Buys numismatic photos with factual text only. Prices vary. Query first. Enclose S.A.S.E.

Collector's World, 110 W. Elizabeth St., Austin, Tex. 78741. Bimo. Sample copy 25¢. Wide range of subject coverage of items/antiques of interest to collectors of modest means. No expensive rarity of museum type coverage. Study publication for style and subject range. Query first. Enclose S.A.S.E.

Contest Magazine, Upland, Ind. 46989. Edited to interests of participants in prize contests. Buys captioned photos pertinent to preparing, entering contests. Query. Enclose S.A.S.E.

Craft Horizons, 16 E. 52nd St., New York, N.Y. 10022. Bimo. Sample copy on request. Edited to interests of professional and hobbyists engaged in creative work in ceramics, woodwork, metalwork, jewelry, etc. Ideas, materials, techniques, etc. Buys b&w photos with captions/text. Query first. Enclose S.A.S.E.

Craftsman, The, P.O. Box 1386, Ft. Worth, Tex. 76101. Bimo. Sample copy on request. Edited to interests of teachers, pros and semi-pros, and hobbyists in leathercraft. Emphasis on clear, detailed, lucid "how-to" articles with illustrations, including captioned photos. Query on longer article ideas. Enclose S.A.S.E.

Creative Crafts Magazine, 31 Arch St., Ramsey, N.J. 07446. Sample copy, 50¢. Bimo. Edited to interests of mature craftsmen—teachers, hobbyists, therapists, etc. Buys b&w photos with clear, complete text (which includes material sources, etc.) as well as how-to. Include S.A.S.E.

Decorating And Craft Ideas Made Easy, P.O. Box 9737, Ft. Worth, Tex. 76107. Sample copy on request. Edited primarily for women interested in making objects with which to decorate their homes. Articles must be complete in detail, utilizing easily available materials. B&w & color trans. purchased with text. Rates vary with length and quality. Enclose S.A.S.E

Electronics Hobbyist, 229 Park Ave. S., New York, N.Y. 10003. Semiannual. Wide range of coverage on electronic equipment, projects, etc. Study publication for coverage and presentation style. Query on specific ideas. Enclose S.A.S.E. with all queries and submissions.

Electronics Illus., 1515 Broadway, New York, N.Y. 10036. Bimo. Pix of interest to electronic hobbyist. B&w singles, $20. One- or two-page pic. sets, $100-$200. Color cover only, $300 with 2¹/₄″ min. size considered. Pay on acc.

Family Handiman, 235 E. 45th St., New York, N.Y. 10017. Edited to interests of do-it-yourself readers. Text must be detailed and clear; materials must be readily available. Photos purchased with articles on home projects, maintenance, repairs, etc. Study magazine; query first with S.A.S.E.

Gems And Minerals, P.O. Box 687, Mentone, Calif. 92359. Mo. Sample copy 50¢. Edited to interests of amateur gem workers (cutting, faceting, tumbling, mounting, etc.). Also mineral collectors. Study back issues for coverage. Query first on subjects (including field trips, etc.). Enclose S.A.S.E.

Ham Radio Magazine, Greenville, N.H. 03048. Mo. Copy 75¢. Edited to interests of licensed radio operators, electronic experiments, etc. How-to material on radio equipment, techniques. Study copies first, then query. Enclose S.A.S.E.

Home Workshop, 229 Park Ave. S., New York, N.Y. 10003. Semiannual. Sample copy on request. B&w glossies purchased only with captions/text. Subjects cover step-by-step details on worthwhile build-it projects. Study publication first, then query. Color trans. used for covers. Enclose S.A.S.E.

Lapidary Journal, P.O. Box 2369, San Diego, Calif. 92112. Mo. Sample copy, 60¢. Edited to interests of amateur gem/mineral hobbyists, gem cutters (faceting, slabbing, jewelry casting and mounting, etc.), gem collectors, rockhounds, jewelers. Wide range of coverage includes techniques, field trips, collecting, etc.

Uses wide selection of b&w photos with captions/text. Also inside and cover color; min. size color trans. 4×5. Important to study magazine, then query. Enclose S.A.S.E. with all queries/submissions.

Model Airplane News, Air Age, Inc., White Plains Plaza, One N. Broadway, White Plains, N.Y. 10601. Mo. B&w pix of all model activities, human interest as well as flying; group activities important. Single pix preferred. Buy color trans. for cover only. Seldom arrange for assignment but when do, use photographers who have background in model and full-scale aviation. B&w $5 min.; color (min. size trans. 2×2) rates vary. Pay on pub.

Model Railroader, 1027 N. Seventh St., Milwaukee, Wis. 53233. Mo. 60¢. Pix of scale-model miniature railroads and related equip., i.e., cars, locomotives, etc. B&w $5-$15. Pay on pub. Some color used but suggest query.

Newspaper Collector's Gazette, The, 259 Y Street, Newburgh, N.Y. 12550. Mo. Edited to collectors of newspapers, historians, researchers of American press before 1900. Study publication before submitting. Also query first. Enclose S.A.S.E.

Numismatic Scrapbook Magazine, P.O. Box 150, Sidney, Ohio 45365. Mo. Edited to interests of coin collectors, mostly middle-income, middle-aged, and people who specialize in American coins, medals, paper currency, related materials. Photos purchased with captions/text. Query. Enclose S.A.S.E.

Old Bottle Magazine, The, Box 243, Bend, Ore. 97701. Mo. Sample copy on request. Specific factual material on old bottles, relics, canning glassware and jars, etc. Study magazine; then query on specific subjects. Buys b&w glossies with captions/text. Color trans. for covers, $50. Enclose S.A.S.E.

Popular Ceramics, 6011 Santa Monica Blvd., Los Angeles, Calif. 90038. Mo. Sample copy on request. Edited to all ages of ceramic hobbyists, teachers, etc. How-to and technical articles with photo illustrations. Uses b&w glossies and color trans. Essential to study magazine for needs, style, etc. Then query. Send S.A.S.E. with all queries/submissions.

Quest, 10169 Sherman Rd., Chardon, Ohio 44024. Mo. Sample copy on request. Circulated only in Ohio. Photos (b&w) purchased only with text. Subjects are on collecting, collector's items, auctions, flea markets, etc. Also dealers, individuals with outstanding collections, etc. Submit S.A.S.E. with queries/submissions.

Radio-Electronics, 200 Park Ave. S., New York, N.Y. 10003. Mo. Sample copy 60¢. Edited for technicians and hobbyists interested in electronics, TV, and radio, servicing, how-to material. B&w photos purchased with captions/text. Query. Enclose S.A.S.E.

Railroad Model Craftsman, Model Craftsman Pub. Corp., 6 East Main St., Ramsey, N.J. 07446. Mo. Pix and illustrated articles, about scale-model railroads and home-built lay-outs. For pic. stories query editor first. B&w $5 and up. Pay. on pub. Note: The publishers of **Railroad Model Craftsman** also publish **Flying Models** (airplanes). Rates are approximately the same. Needs are for captioned photos of interesting flying model airplanes in action, on the ground, etc.

R/C Modeler Magazine, P.O. Box 487, Sierra Madre, Calif. 91024. Mo. 75¢ copy. Slanted to interests of adult enthusiasts of radio-controlled model aircraft, boats, competitions, etc. Buys illustrated authenticated/factual/detailed how-to material (with radio control angle). Study magazine; query first. Enclose S.A.S.E.

Relics, P.O. Box 3338, Austin, Tex. 78704. Bimo. 35¢ copy. General collectables (bottles, wire, various types of yesteryear relics). Must be American origin. Also personal collections with photos and complete captions/text requirements. Enclose S.A.S.E.

Spinning Wheel, The, Everybody's Pub. Co., Hanover, Pa. 17331. Authentic material for antique collectors and dealers. Query.

Treasure World, Box 90, 27 N. Jefferson St., Knightstown, Ind. 46148. Weekly. 20¢ copy. Primarily slanted to interests of hobbyists, antique collectors, etc., in lower Great Lakes and Ohio area. Also factual material on places of historical interest, antiques, etc. in other central states. Want text and/or detailed captions with photos. Study pub.; query first. Rates negotiable. Enclose S.A.S.E.

True Treasure, P.O. Box 1, Conroe, Tex. 77301. Bimo. 50¢. Edited to interests of those intrigued by lost mines, buried treasures, sunken treasures, etc. Articles must be documented with factual source material. Photos with text/captions. Enclose S.A.S.E.

Western Collector, 511 Harrison St., San Francisco, Calif. 94105. Published ten times a year. Sample copy on request. Need factual material with quality photos to illustrate well written text/captions. Subjects include wide range of collector's subjects—glass, antiques, dolls, bottles, silver, etc. Query first. Also use some color, trans. preferred. Enclose S.A.S.E.

Woman's Circle, P.O. Box 428, Seabrook, NH 03874. Sample copy on request. Slanted primarily to interest of women—handicraft, hobbies, collecting, etc. Buys b&w photos with text, color trans. for covers. Query. Enclose S.A.S.E.

Workbench Magazine, 4251 Pennsylvania, Kansas City, Mo. 64111. Bimo. 35¢. Pix to illustrate ms. about home workshop, home repair and improvement projects. B&w $10 and up. Pay on acc.

World Coins, P.O. Box 150, Sidney, Ohio 45365. Mo. 60¢ copy. Factual data on non-American coins, numismatic subjects researched in depth and well illustrated. Study contents of magazine first, then query. Rates vary with subject contents and quality of photos. Enclose S.A.S.E.

13. House Magazines

House magazines (also known as *House Organs, Internal-External Company Publications,* etc.) number into the multithousands. A high percentage of them purchase professional quality black-and-white photographs and color transparencies, especially when the illustrations are accompanied by well-documented, factual, informative, and interesting captions/text. The following represent a sample cross-section of house magazines rather than a special selection or definitive list.

Allis Chalmers Reporter, Box 512, Milwaukee, Wis. 53201. Quarterly. Sample copy on request. Accent on construction projects of importance utilizing Allis-Chalmers equipment, and having human interest. Material must be accurately documented and dramatically presented. Prefer package submissions of photos, captions, text. Rates range from $10 to $200 depending upon contents, quality, etc. Uses both b&w and color. Query first, enclosing S.A.S.E.

American Farm And Home Marketer, (American Oil Co.), 910 S. Michigan Ave., Chicago, Ill. 60680. Quarterly. Edited to interests of suppliers of diesel fuel, heating fuels, pesticides, fertilizers, etc. for homes and farms. Study publication for coverage and style. Buys b&w and color trans. only with complete captions/text. Query first. Enclose S.A.S.E.

Arco Spark Magazine, (Atlantic Richfield Co.), 260 S. Broad St., Philadelphia, Pa. 19101. Quarterly. Sample copy on request. Distributed to employees and others interested in company's activities. Material must have product tie-in. B&w and color trans. purchased only with captions/text. Query first. Rates vary with quality and needs. Enclose S.A.S.E.

Bausch & Lomb Focus, 619 St. Paul St., Rochester, N.Y. 14602. Sample copy on request. Edited for students, professors, others interested in use of scientific optical instruments in professions, industry, experimentation, etc. Buys photos with captions/text. Query first. Enclose S.A.S.E.

Bell Helicopter News, P.O. Box 482, Ft. Worth, Tex. 79901. Biweekly; sample copy on request. Articles involving products and/or employees at work. B&w glossies purchased with captions and text. Rates vary with contents/quality. Query. Enclose S.A.S.E. with submissions.

Best Western Way, 1999 Shepard Road, St. Paul, Minn. 55116. Quarterly. Edited to interests of guests of the company's chain of motels. Travel, business, interesting personalities, etc. Requires top-quality photos in b&w and color trans. Rates vary with subject matter, length, text, use of photos. Study publication first, then query. Enclose S.A.S.E.

Blazes, (American LaFrance), Elmira, N.Y. 14902. Mo. Sample copy on request. Photos purchased only with captions/text involving fires, firefighting, use of company products, historical interest, etc. Study contents and style. Query first with S.A.S.E.

Celanese Coatings Company News, 224 E. Broadway, Louisville, Ky. 40202. Mo. Sample copy on request. Photos purchased with captions/text on subjects of interest to company employees. Study magazine for coverage and style. Enclose S.A.S.E. with submissions.

Compass, The, (Mobil Sales & Supply Co.), 150 E. 42nd St., New York, N.Y. 10017. Quarterly. Buys photos in b&w or color (min. size 2¼×2¼) on marine/maritime subjects. Study pub. for coverage and style. Query, enclosing S.A.S.E.

Conoco Today, (Continental Oil Co.), P.O. Box 2197, Houston, Tex. 77001. Mo. Sample copy on request. Edited to interests of Conoco wholesale distributors and service station operators. Uses b&w and color trans. Query first; enclose S.A.S.E.

Conoco Brander, same address as above. Bimo publication.

Dodge News Magazine, 5435 W. Fort St., Detroit, Mich. 48209. Mo. B&w and color. Scenics, travel, sports, human interest, personalities. Query first for feature story material. B&w $25 and up. Color: negotiated. Min. size trans. 35mm. Pay on pub.

Dow Diamond, (Dow Chemical Co.), Midland, Mich. 48209. Quarterly. Photos in b&w and 4×5 color trans. purchased with captions/text on subjects of interest to company employees, stockholders, customers. Study magazine for coverage and style. Query, enclosing S.A.S.E. Rates vary with subject, quality.

Duncan Register, (Duncan Electric Co.), Box 180, Lafayette, Ind. 47902. Quarterly. Edited to interests of those engaged in or otherwise interested in public utility industry. Buys color trans. (2¼×2¼ or 4×5) for cover use. Enclose S.A.S.E.

Du Pont Magazine, (Du Pont Co.), Wilmington, Del. 19898. Bimo. Buys top-quality b&w and color trans. accompanied by captions/text. Requires well-researched material of pertinent interest to business and industrial executives. Study magazine for coverage and style. Query, enclosing S.A.S.E. Good rates. Address submissions to Du Pont Company Advertising Dept.

Enka Voice, (American Enka Co.), Enka, NC 28728. Mo. Sample copy on request. Edited to interests of company employees. Magazine itself is best guide to editorial coverage. Buys b&w photos with captions/text. Query. Enclose S.A.S.E.

Esso Air World, (Esso International Inc.), 15 W. 51st St., New York, N.Y. 10019. Colorful cover pix of interest to international aviation trade. Rates vary.

Field Notes, (Northwestern Mutual Life Insurance Co.), 720 E. Wisconsin Ave., Milwaukee, Wis. 53202. Mo. All types of scenery—scenes from New York and San Francisco—industrial scenes, appropriate holiday photos, B&w $15. Pay on acc.

Ford Times, (Ford Motor Co.), The American Road, Dearborn, Mich. 48121. Mo. Sample

copy on request. Wide range of subject matter coverage edited to appeal to all ages. Material must have automotive tie-in. Very high standards in text/photo quality, so study contents carefully and query first with S.A.S.E. B&w and color trans. purchased with captions/text. Good rates on acceptance.

Ford Truck Times, 420 Lexington Ave., New York, N.Y. 10017. Issued four times per year. Sample copy on request. Wide range of subject interests, both general and promotional, with Ford truck tie-ins. Uses b&w photos of high quality with captions/text. Also 35mm and larger color trans. for covers. Good rates; bonus on cover transparencies. Enclose S.A.S.E. with queries/submissions.

Friends Magazine, 17390 W. 8 Mile Rd., Southfield, Mich. 48075. Color cover pix, usually seasonal; general-interest pic. stories of high technical quality. B&w spread $250; color spread, $300 plus expenses (exclusive rights). B&w $75 per page; color, $125. $25 to Chevrolet owner for pix on owners' pages.

FWD News, Clintonville, Wis. 54929. (FWD Corporation.) Bimo. Free. Color pix only of FWD trucks in action in oil fields, highways, road building, maintenance types of service, utility fields, logging, FWD fire engines. Rates vary. Pay on acc.

Geyer's Dealer Topics, 51 Madison Ave., New York, N.Y. 10010. Single pix and pic. stories covering events in the stationery and office equip. field on dealer level. Use free lances to cover out-of-area events. B&w $5. Pay on acc.

Goodyear Orbit Magazine, 1144 E. Market St., Akron, OH 44316. Mo. Sample copy on request. Edited for worldwide readership. Emphasis on people-oriented articles with background of social/cultural heritage. Essential to study magazine, then query with S.A.S.E. Buys b&w glossies and color trans. of high quality both with text, and identified for use with text already on hand. Good rates on acc.

Grace Log, The, 3 Hanover Sq., New York, N.Y. 10004. Quarterly. Edited to interests of teachers, company employees, stockholders, business leaders. Wide range of general and specific (product) subject matter. Study magazine; query with S.A.S.E. Buys b&w and color trans. of top pro quality. Good rates.

Harvest, Campbell Place, Camden, N.J. 08101. Quarterly. Sample copy on request. Edited primarily to interests of employees and families connected with Campbell Soup Co. Wide range of subject interests; company tie-ins are especially welcome. High standards in both b&w and color photography; pix mostly bought with captions/text as package deals at negotiable rates. Query first; enclose S.A.S.E.

Hughes Rigway, (Hughes Tool Co.), P.O. Box 2539, Houston, Tex. 77001. Quarterly. Edited for oil and gas drilling personnel. Study publication for subject range and style. Query first with S.A.S.E. Pays $50 per printed page on acc.

Industrial Progress, 2000 York Rd., Oak Brook, Hinsdale, Ill. 60523. (Goodyear Tire & Rubber Co.) Bimo. Edited to interests of company employees; study sample copy (available upon request) for range of subject matter. Uses b&w and color trans. with captions/text. Query first with S.A.S.E. Good rates which vary with subject and quality.

International Harvester Farm Magazine, 401 N. Michigan, Chicago, Ill. 60611. Quarterly. Sample copy on request. Edited to interests of users of International Harvester farming equipment. Articles centering around successful how-to's, personal experiences, rural life, etc. Top-quality photos required, preferable with tie-in captions/text. Min. size color trans. 35mm. Query first about specific material, enclosing S.A.S.E. Good rates on acc.

J-M Action, (Johns-Manville Corp.), 22 E. 40th St., New York, N.Y. 10016. Quarterly; sample copy on request. Edited for distributors, customers, prospective users of company's products. Photos purchased with captions/text, and preferably have product tie-in. Query first; include S.A.S.E. with submissions. Rates vary with contents and quality.

Lufkin Line, (Lufkin Foundry & Machine Co.), P.O. Box 849, Lufkin, Tex. 75901. Editor: Virginia R. Allen. Manufacturer oil pump units, gas engines, commercial & marine gears, truck-trailers. Scenics for inside covers. B&w $5-7.50. $2\frac{1}{4} \times 2\frac{1}{4}$ or larger color cheesecake subjects for cover, $75-100.

Marketing News, (Standard Oil Of California), 225 Bush St., San Diego, CA 94120. Sample copy on request. Edited for company's employees and families. Wide range of subjects from hobbies to community projects, interviews, spot news, etc. Tie-in with company essential. Buys photos with captions/text only. Up to $150 for photo feature stories. Query first; enclose S.A.S.E. with all submissions.

Merchandiser, (American Oil Co.), 910 S. Michigan, Chicago, Ill. 60680. Quarterly. Edited for dealers, jobbers, and others who handle company products. Articles on special subjects best understood by studying sample issues. Query first. Pix bought only with captions/photos, or seasonal content. Enclose S.A.S.E. with queries/submissions.

Mobile Life, 229 Park Ave. S., New York, N.Y. 10003. Mo. Write for guide sheet on needs. Broad range of subjects including travel by recreational vehicle on N. A. continent (motor home, truck camper, etc.). Photos purchased only with captions/text, up to $200 per pack-

age deal. Color trans. for covers, additional $100–200. Study pub.; query first. Include S.A.S.E. with queries/submissions.

New Holland News, (Div. of Sperry Rand Co.), New Holland, Pa. 17557. Pub. ten times per year. Sample copy on request. Edited primarily for farmers, agriculturists. Emphasis on successful methods, experiments, techniques. Company product tie-in always welcome but not always essential. Photos purchased with captions/text in b&w and color trans. of large size. Query first; enclose S.A.S.E. with submissions.

Parts Pups, P.O. Box 54066, Atlanta, GA 30308. Mo. Sample copy on request. Edited for customers and jobbers of NAPA (Genuine Parts Co.). Purchases captioned pin-ups, $10 ea. Enclose S.A.S.E. with submissions.

Punch Magazine, The, 222 N. Rampart St., New Orleans, LA 70112. Mo. (New Orleans Athletic Club.) Sample copy $1. Edited for businessmen interested in athletic club activities, sports, Olympics, physical fitness, etc. B&w glossies purchased with captions/text. Enclose S.A.S.E.

Roseburg Woodsman, (Roseburg Lumber Co.), 601 Terminal Sales Bldg., Portland, OR 97205. Mo. Edited to interests of dealers/distributors of building materials. Photos purchased with captions/articles only. Subjects include interior-exterior use of wood in commercial, industrial, home-building projects. Query first; enclose S.A.S.E. Rates per b&w and color trans. accepted range from $10 to $50.

Safeway News, P.O. Box 1168, Oakland, Calif. 94604. Mo. Edited to interests of company employees. Study copies; query first, enclosing S.A.S.E.

Sentinel, The, 85 Woodland St., Hartford, Conn. 06102. Bimo. Edited to interests of industrial fire protection men. Photo needs: top-quality b&w, 8×10 glossies of industrial fires; color trans. from 35mm up, 4×5 preferred. Pays on acceptance from $15 to $25 in b&w, $25 to $75 for color. Enclose S.A.S.E.

Seventy-Six Magazine, (Union Oil Co.), Box 7600, Los Angeles, Calif. 90054. Edited for company employees. Articles should have tie-ins with products and/or customers. Study copies for coverage and style, then query with S.A.S.E. Good rates on acc.; buys all rights.

Sikorsky News, (Sikorsky Aircraft Co.), Stratford, Conn. 06602. Emphasis on use of helicopters in business, industry, civic, community, military, etc. B&w glossies in 8×10 bought only with captions/factual and documented text. Query with S.A.S.E. Pays on acceptance, variable rates.

Singer Light, 30 Rockefeller Plaza, New York, N.Y. 10020. Sample copy to pro photographers

on request. Want captioned photos and picture series of Singer products tie-in. Single b&w captioned, $10–25. B&w pic stories with captions/text, $50–250. Photos must be top quality; prefer 8×10 glossies. Payment on acc. Enclose S.A.S.E. with submissions.

Small World, (Volkswagen of America), 818 Sylvan Ave., Englewood Cliffs, NJ 07632. Issued five times per year. Guideline sheet on request. Edited to interests of Volkswagen owners with emphasis on people and uses/modifications of product rather than travel experiences. Photos used with factual captions/text. B&w prints, size 8×10 glossy; color trans. from 35mm up, larger preferred. Prices vary up to $250 for color cover. Study magazine, then query with S.A.S.E.

Sun Topics and **Sun Light**, (Sun Life Insurance Co. of America), Sun Life Bldg., Charles Center, Baltimore, MD 21201. Former title is bimo for company personnel in offices; latter is bimo edited for company's outside agents. Study sample copies for coverage and style, then query with S.A.S.E. Pays for photos on acc.

Timken Magazine, (Timken Company), Canton, OH 44706. Printed eight times per year. Edited for employees and interested only in product-related photos with factual data/text. Query first with S.A.S.E. Rates negotiable.

Toledo System, (Toledo Scale Co.), 5225 Telegraph Rd., Toledo, OH 43612. Quarterly; sample copy on request. Buys 8x10 glossies and color trans. (larger sizes preferred) with

captions/text on subjects related to company employees, products, uses, etc. Query, enclosing S.A.S.E. Payments vary with quality/use on acc.

U.S. Steel News, (U.S. Steel Corp.), 600 Grant St., Pittsburgh, PA 15230. Photos purchased only with captions/text with company tie-in connected with use of steel, steel products, etc. Study magazine, then query with S.A.S.E. Pay $5–10 for b&w pix; $10–25 for color trans.

Walgreen Pepper Pod, (Walgreen Co.), 4300 W. Peterson, Chicago, IL 60646. Mo. Single b&w pix with captions, exciting modern photo series with captions/text. Human interest; role of drugs and the drug store, pharmacy—anything that isn't routine or dull. No stock pix, please. Pay varies. Enclose S.A.S.E.

14. Male Interest

Adam, Publishers Ser. Inc., 8060 Melrose Ave., Los Angeles, Calif. 90046. Mo. Sample fact sheet (for obtaining caption/text data) on request. Study magazine for style of handling material on morality/sex. All photos require valid model release. Uses b&w single pix and pix in series; color trans. for interior, centerfolds, covers. Query on text subjects. Enclose S.A.S.E. with queries/submissions. Good rates, pays on pub.

Adam Reader, same address as above. Quarterly: $1. Basically same requirements as **Adam,** same rates of payment.

Adventure Magazine, 205 E. 42nd St., New York, N.Y. 10017. Bimo. B&w singles and pic series with captions/text data. Glamour, pin-ups, exotic material. Study subject coverage and style, query for specific needs. B&w, $50 per page, less for singles. Enclose S.A.S.E. for return of unsolicited material.

Argosy, 205 E. 42nd St., New York, N.Y. 10017. Mo. Edited for men interested in sports, camping, hunting, fishing, power vehicles, adventure, etc. Wide range of subjects but study magazine for presentation style. Best to query with S.A.S.E. on major photo and caption/text packages. Editors will judge b&w and color pix from contact sheets. Basic rates are good; exceptional quality/contents command even better rates. Include S.A.S.E. with all submissions.

Bluebook, Man's Illustrated, 235 Park Ave., New York, N.Y. 10003. Bimo. Emphasis on adventure, war, etc., factual happenings thoroughly documented. Magazine is best guide to contents and presentation style. Query first on specific material. Photos bought with captions/text as package deals. Enclose S.A.S.E. Pays on acceptance.

Broadside, 7311 Fulton Ave., N. Hollywood, Calif. 91605. Quarterly. Subjects of general interest to male audiences—famous personalities, exposé, sex, drinking, etc. Study presentation style. Photos purchased with text. Enclose S.A.S.E.

Cavalcade, Challenge Pubs., 7950 Deering Ave., Canoga Park, Calif. 91304. Mo. One of a group of related pubs. Aimed for readership of male audience from about 20 to mid-30's. Free sample on request to pro photographers. Study contents and presentation style. B&w photos purchased with captions/text. Enclose S.A.S.E. with submissions.

Cavalier, 236 E. 46th St., New York, N.Y. 10017. Mo. Edited to interests of young, affluent males. Wide range of subject matter includes ecology, business, social activities, sports, adventure, men's fashions, new trends, travel, etc. Not a cheesecake-oriented magazine. Study contents and slant. Query, enclosing S.A.S.E. Pays on or before pub. Rates vary.

Climax, Challenge Pubs. Same general needs and rates as **Cavalcade** (see above).

Debonair, 6340 Coldwater Canyon, N. Hollywood, CA 91606. Mo. Edited for sophisticated, young to middle-aged readership. Best guide is to study magazine for contents and slant, then query on specific subject matter you can provide with pix and captions/text. Enclose S.A.S.E.

Esquire, 488 Madison Ave., New York, N.Y. 10022. Mo. Copy $1. Wide range of subject matter edited to interests of sophisticated, intelligent (but not highbrowish) readership. Essential to study magazine for contents and style, then query on specific photo-caption-text offerings with S.A.S.E. B&w's can be judged from good contact sheets; color trans. from

35mm up in size. Address queries and submissions (photos) to the Art Director. Top pro quality required. Good rates paid on acceptance.

Fling's Film Festival, Box 151, Evanston, IL 60204. Annual: $1.25. Buys single b&w and photo series with captions/text. Model releases required where necessary; will use authorized stills from unusual motion pictures. Subject matter ranges from exploitation through "nudie movies, underground films." Color trans. from 35mm up in size; same subject as above including "far out scenes." Pay on acc. at rates varying up to $100–200 per set. Only pros should query editor on specific subjects, rates, etc. Enclose S.A.S.E.

Fling Magazine, same address as above. Bimo. Query on subject ideas after studying sample copies. Enclose S.A.S.E.

For Men Only, Magazine Management Co., 625 Madison Ave., New York, N.Y. 10022. Emphasis on exotic, thoroughly documented and factual subjects of interest to adventure-minded readers. Subjects range from war combat through epic disasters to great hoaxes, swindles, etc. Best to study magazine, then query editor on topics you can cover with photo/captions/text. Enclose S.A.S.E.

Front Page Detective, 1 Dag Hammarskjold Plaza, New York, N.Y. 10017. Mo. Sample copy 50¢. B&w single pix and photo series sequences with captions/text. Must be well documented with factual data. Wide coverage of subject matter on crime, police/detective deduction, dramatic action, etc. Payment varies from $10 and up on captioned singles to $100–125 for photo sequence stories. No color. Pro quality 8×10 glossies preferred. Model releases required if necessary. Payment on acc. Enclose S.A.S.E. with all submissions.

(Also publishes **Inside Detective;** same requirements.)

Grit, 208 W. 3rd St., Williamsport, PA 17701. Weekly; 15¢ copy. Subject matter for photos with authentic captions/text include men and women with human-interest angle engaged in small-town celebrations and anniversaries, hunting, fishing, outdoor camping and related activities, news features, sports action, etc. Buys b&w and color (35mm and up) with captions and/or with text for package deals. Pays on acc. from minimum of $5–10 in b&w pro quality through $35 for color. Enclose S.A.S.E.

Humorama, Inc. (803), 299 Madison Ave., New York, N.Y. 10017. Publishers of a group of magazines, some of which (but not all) feature b&w pix of charming girls, cheesecake, party games, satires, etc. Your best bet here is to query, showing proof in b&w contact sheets of abilities after studying publications for contents and presentation style. Enclose S.A.S.E. with queries/submissions. Prices for b&w's (glossy 8×10's preferred) range upward from $7.50. Pay on acc. (Other photo-oriented titles include **Gaze, Stare, Gee-Whiz,** etc.)

Inside Detective, see **Front Page Detective** (above) for address, requirements, pay rates.

Knight, (Pub. Ser. Inc.), 8060 Melrose Ave., Los Angeles, Calif. 90046. Mo. Wide range of male-interest subjects from current social trends to contemporary personalities, life styles, etc. All erotically oriented but carefully documented. Model releases required where necessary. Study magazine for coverage and style. Fact sheet sent upon request. Query on specific subject matter, enclosing S.A.S.E. Prices vary on publication.

Male Call, 6 E. 43rd St., New York, N.Y. 10017. Mo. Sample copy to pro photographers on request. Slanted primarily to young men in armed services—sports, adventure, personalities, etc., preferably with military tie-in for reader identification. B&w and color trans. purchased with captions/text. Rates depend upon quality, length, and use. Enclose S.A.S.E.

Man To Man, 21 W. 26th St., New York, N.Y. 10010. Buys b&w and color (color trans. 2¼×2¼ and larger in size) on wide range of subjects including sports, travel, music, etc. of interest to men. Strong sex orientation; model releases required where necessary. B&w singles/series can be selected from good contact sheets. Factual data sheets/captions/text needed with pix. Both copy and photo standards are relatively high in quality requirements; pay rates (on or before pub.) are scaled accordingly. Enclose S.A.S.E. (Also publishes **Mr.** and **Sir** with approx. same needs.)

Man's Conquest and **Man's Illustrated,** Sterling Pub. Co., 419 Park Ave. South, New York, N.Y. 10016. This publisher produces a long list of titles, formerly periodicals and now both hardcover and paperback books. As we go to press we have not been able to confirm the status of the periodicals. Suggest that if interested, you query with S.A.S.E.

Man's Pleasure, see **Debonair,** above.

Men, 625 Madison Ave., New York, N.Y. 10022. Mo. 35¢. B&w singles and pic. stories; glamour, personalities, news, sports. Pay rates vary on usage. Pay on acc.

Modern Man, 8150 N. Central Park Ave., Skokie, IL 60067. Mo. Sample copy to pro photographers on request. Slanted to interests of readers interested in both human and bizarre elements of sex, but requires factual/informative approach. Pix purchased with captions/text. Query first, enclosing S.A.S.E.

Mr., see **Man to Man,** above.

Penthouse Magazine, 1560 Broadway, New York, N.Y. 10036. Mo. Study magazine for contents and presentation style. Buys color trans. singly and in series from size 35mm up. Query on specific photo-article ideas. Address submissions, with S.A.S.E., to the Art Director. Good rates.

Playboy Magazine, 919 N. Michigan Ave., Chicago, IL 60611. While all of Playboy's service features (foods, fashions, modern living) are shot specifically on assignment, picture submissions from free-lance contributors are encouraged for other pictorial features, including the monthly Playmate pic spread. Study magazine before submitting. Query. Pay on all-rights basis: b&w $100; color (35mm and larger trans.) $200. Both are graded upwards according to space used. Payment on acc.

Rampage, 3550 N. Lombard St., Franklin Park, IL. 60131. Weekly; sample copy 25¢. Edited to interests of sophisticated adults. Subjects handled with humor, in exposé style, etc., with strong sex orientation. B&w glossy photos purchased with captions/text. Query, enclosing S.A.S.E.

Saga, 333 Johnson Ave., Brooklyn, N.Y. 11206. Mo. Edited primarily for males approaching 20 and up. Subjects cover wide range from adventure, exploration, crime, sports, and science to exposé material. All must be factual and provable. No emphasis on sex. Photos purchased with captions/text only. Query first, enclosing S.A.S.E. Good rates for b&w and color trans. (4×5 color trans preferred.)

Sir, see **Man To Man,** above.

Stag Magazine, 625 Madison Ave., New York, N.Y. 10022. Mo. Dramatic, factual material on adventure, personalities, crime, etc. Some sex angle acceptable, if and when appropriate. Color used only for covers; b&w pix used as illustrations singly or in series. Study magazine, then query. Rates vary; payment on acc. Enclose S.A.S.E. with submissions.

Topper, Captain Pubs., 95 Madison Ave., New York, N.Y. 10016. Bimo. Off-beat material, often with man-woman angle with erotic (but not porno) angle. Pix (b&w and color) bought as singles or in series with caption/factual data/text. B&w can be judged from crisp contact proofs. Enclose S.A.S.E. with submissions. Rates vary. Pay on pub.

True, Fawcett Pubs., 1515 Broadway, New York, N.Y. 10036. Mo. Study magazine for wide range of subjects of interest to men, predominantly sports, fishing, hunting, exposé articles, adventure, etc. B&w and color bought with captions/text. Rates vary with contents, length, quality. Enclose S.A.S.E. with all queries/submissions.

True Adventures, 205 E. 42nd St., New York, N.Y. 10017. Emphasis on adventure articles that appeal to all ages of male readers. Must be factual and provable; foreign or distant locales often used. Buys b&w glossies with captions/text. Query first. Submit material with S.A.S.E. Rates vary.

15. *Medical, Dental, Health*

Accent on Living, Accent On Living, Inc., P.O. Box 726, Bloomington, Ill. 61701. Quarterly. Ideas, inventions, and self-help devices designed to help the handicapped live easier and better. Success stories and home-operated businesses of seriously handicapped persons. B&w $5 and up; pic. stories $10 and up.

American Dental Association News, 211 E. Chicago, Chicago, IL 60611. Biwk. Buys b&w photos with captions/text only. Factual materi-

al must be well documented. Query first with S.A.S.E. Pays on acc.

American Medical News, The, American Medical Assoc., 535 N. Dearborn St., Chicago, Ill. 60610. Weekly. Subjects with medical or physician angle. B&w (5×7 or 8×10) $7.50 and up.

Apothecary, The, The Apothecary Pub. Co., 375 Broadway, Boston, Mass. 02111. B&w pix and pic. stories of subjects related to pharmacy, druggist human interest in New England and Northeast only. B&w (3×5 to 8×10) $5 ; pic. stories $10 and up; cover, $7. Pay on pub.

Audecibel, National Hearing Aid Soc., 24261 Grand River, Detroit, Mich. 48219. Bimo. Pix related to hearing aids—design, engineering, production—audiometric testing, and fitting the hearing aid; medical subjects related to hearing; sound and acoustics. B&w $3–5; pic stories, same rate. Pay on acc.

Bedside Nurse, 250 W. 57th St., New York, N.Y. 10019. Mo. $1 copy (free copy to pro photographers on request). Edited to interests of licensed practical nurses. Study first, then query with S.A.S.E. Rates negotiable.

Cal Magazine, 3737 W. 127th St., Chicago, Ill. 60658. Mo. Sample copy to pro photographers on request. Pub. by T.G. Baldaccini Coe Labs., mfr. of dental supplies. Mo. Sample copy on request. Buys b&w pix only with captions/text on dentists/dentistry. Study for coverage and style. Query first. Enclose S.A.S.E. Prices vary for complete package deals up to $100.

Canadian Doctor, Gardenvale 800, Quebec, Canada. Mo. Buys b&w pix only with captions/ms. Edited for professional men/women in Canadian private, hospital, or institutional practices. Study copies for subject coverages. Enclose Int'n Reply Coupons and S.A.E. with queries/submissions.

Confidential Health, 3550 N. Lombard St., Franklin Park, Ill. 60131. Edited to varied interests in general health, new medical advances/techniques, etc. Study back issues. Buys b&w pix with well-documented and factual captions/text. Rates negotiable. Include S.A.S.E. with queries/submissions.

Dental Economics, 708 Church St., Evanston, Ill. 60201. Mo. Sample copy on request. B&w pix bought with captions/text on subjects pertaining to dental practices, administration, etc. Enclose S.A.S.E. with submissions. Rates vary on pub.

Dental Management, Ridgeway Center Bldg., Stamford, Conn. 06905. Mo. Buys b&w pix with articles/captions related to dentistry management; i.e., fees, collection methods, patient relations, etc. Best to study back copies and query first with S.A.S.E. Pays on acc.

Drug Topics, 330 W. 34th St., New York, N.Y. 10001. Buys b&w pix with articles, and as captioned news items. Edited to interests of retail drug store owners, wholesalers, and manufacturers. Also interested in ideas/ techniques used in selling, displays, product promotions, etc. Query with S.A.S.E.

Family Health, 1271 Ave. of Americas, New York, N.Y. 10020. Mo. Publishes articles on family health and relationships, nutrition, physical fitness, child raising, mental health, new techniques/methods in medicine. Query with S.A.S.E. on photo needs.

Fitness For Living, 33 E. Minor St., Emmaus, PA 18094. Bimo. Pro quality b&w glossies and color trans. (35mm and larger) bought with captions/text. Edited to interests of men and women in business/professions with emphasis on nutrition, exercise, physical fitness programs, recreation, etc. Query first. Good rates on acc.

Health, (Amer. Osteopathic Assoc.), 212 E. Ohio St., Chicago, Ill. 60611. Pub ten times per year. Sample copy on request. Buys b&w pix (8×10 glossies preferred) with captions/text only. Material is edited for general public readership interested in personal/family physical fitness and health. Copy must be factual and authoritative. Query first, enclosing S.A.S.E.

Hearing Dealer, 1 E. First St., Duluth, MN 55802. Mo. B&w glossies bought only with captions/text pertinent to interests of dealers in hearing aids, industry, etc. Best to study back issues, then query. Enclose S.A.S.E. with submissions.

Hospital Physician, 550 Kinderkamack Rd., Oradell, NJ 07649. Mo. Contributors-guideline sheet on request. Wide range of subjects include personal experiences through clinical and diagnostic problems, workloads, etc. Documented and factual source material a must. Study magazine, then query on photo needs, rates, etc. Enclose S.A.S.E. with query/submissions.

Laboratory Management, 200 Madison Ave., New York, N.Y. 10016. Mo. Edited for persons engaged at various levels of biomedical research and clinical practice. Circulated to professional biomedical personnel, hospitals, pharmaceutical lab personnel, etc. Photos in b&w purchased with factual, pertinent captions/text. Query first, enclosing S.A.S.E.

Life and Health, 6856 Eastern Ave., N.W., Washington, D.C. 20012. Mo. B&w and color landscapes, home scenes, figures out of doors, doctor and patient. B&w $5–6; color covers (min. size trans. 4×5) $50. Pay on pub.

Listen, 6840 Eastern Ave. N.W., Washington, D.C. 20012. Mo. Pix of human interest, scenics, skid row scenes, pix of either specific or general nature dealing with alcoholism or drug addiction, scenic news. Pay varies on acc. Enclose S.A.S.E.

Medical Lab, 200 Madison Ave., New York, N.Y. 10016. Mo. Photos bought with captions/text. Edited to interests of clinical lab employees, technicians, etc. Query, enclosing specific suggestions. (Best study magazine first.) Include S.A.S.E.

Midwestern Druggist, P.O. Box 668, Lincoln, Neb. 68501. Mo. B&w glossies bought with articles/captions of interest to druggists, i.e., management methods, displays and merchandising, promotions, etc. Pays on pub. Query, enclosing S.A.S.E.

Modern Nursing Home, 230 W. Monroe St. Chicago, Ill. 60606. Mo. Buys 8×10 glossies accompanied by factual captions/text on subjects pertaining to business management/operation/administration/other subjects related to nursing homes. Query first, enclosing S.A.S.E.

Modern Veterinary Practice, 300 E. Canon Perdido, Santa Barbara, Calif. 93102. Buys 8×10 pro-quality b&w pix with articles/ captions pertaining to veterinarian practices/ problems. Query first, enclosing S.A.S.E. for reply.

Norden News, (Norden Laboratories), 601 W. Cornhusker Hwy., Lincoln, Neb. 68521. Quarterly. Sample copy on request. Edited for students and practicing doctors of veterinary medicine. Interested in both technical and nontechnical material but to comprehend coverage and presentation style, study the magazine. Then query, enclosing S.A.S.E. B&w photos purchased with articles/captions at varying rates. Also reproduces some color trans. from size 35mm up.

Patient Aid Digest, 2009 Morris Ave., Union, NJ 07083. Bimo. Buys photos with articles/captions on subjects of interest to those interested in home health care, pharmacists who feature departments with products for home health care, manufacturers of those products, etc. Also uses seasonal material. Query first, enclosing S.A.S.E.

Popular Medicine Magazine, 1116 First Ave., New York, N.Y. 10021. Bimo. Subject matter ranges from nutrition and medicine to mental health and new medical innovations/discoveries. Query first, enclosing S.A.S.E.

Prevention, 33 E. Minor St., Emmaus, PA 18049. Mo. Sample copy on request. Edited for health and physical-fitness minded people, mostly middle-aged. Buys b&w photos with captions/text. Must be well documented and factual. Subjects include safety-first recommendations, exercise, etc. Study contents for coverage and style. Query; enclose S.A.S.E. Rates on package deals relatively good; pay on acc.

Private Practice, 1029 Union Founders Tower, Oklahoma City, Okla. 73112. Mo. Sample copy on request. Edited for physicians with

private practices; i.e., medical practices, problems, hospital activities, etc. Buys 8×10 glossies (b&w) with text only. Must be factual, documented. Pay varies. Enclose S.A.S.E.

Products For Patients, P.O. Box 373, Cedarhurst, N.Y. 11516. Quarterly. Sample copy on request to qualified writer/photographers. Buys photos with articles/captions. Edited for retail outlets for convalescent aids and appliances. Coverage includes promotions, displays, etc. Query first. Enclose S.A.S.E. Pay varies on pub.

Resident And Staff Physician, The Resident Inc., 80 Shore Rd., Port Washington, N.Y. 11050. Mo. Buys b&w single pix and pix-sequence stories with factual captions/text. Material slanted to interests of hospital doctors. Single photos, up to $35. Photo series, $100 and up. Covers $50–150. Quality and contents important. Study magazine first, then query. Enclose S.A.S.E.

RN, (National Magazine for Nurses), Oradell, NJ 07649. Mo. Contributor's guideline sheet on request. Pix must be accompanied by pertinent captions/text. Subject matter must be factual and have to do with the professional aspects of nursing—therapy, clinical techniques, etc. Also the relationship with patients, medical associates, etc. Study magazine for other types of subject coverage and style. Query first with S.A.S.E.

RX For Better Living, 10169 Sherman Rd., Chardon, OH 44024. Quarterly. Edited to interests of community retail druggists and their customers; accent on health, exercise, related subjects. Uses b&w and color trans. with text/captions. Rates negotiable; query first with S.A.S.E.

Surgical Business, 2009 Morris Ave., Union, NJ 07083. Mo. Sample copy, $1. Edited for dealers in medical products, including retailers and manufacturers of surgical products. Study magazine for coverage and presentation style.

Photos purchased with articles/captions. Rates vary. Query, enclosing S.A.S.E.

Tic Magazine, Box 407, N. Chatham, N.Y. 12132. Mo. Edited to interests of dentists, oral hygienists, others involved in the dentistry profession. Study magazine for wide range of subject coverage and style. Pix bought in form of sequence stories with pertinent data. B&w only; rates negotiable. Enclose S.A.S.E. with queries/submissions. Pays on acc.

Today's Health, 535 N. Dearborn St., Chicago Ill. 60610. Mo. Slanted to interests of teenagers and young adults. Study sample copies for style and subject coverage; accuracy a must in health/medical articles. Query. Most photo stories assigned. Good rates. Pays on acc.

Veterinary Economics Magazine, 2828 Euclid Ave., Cleveland, OH 44115. Mo. Buys b&w photos submitted with captions/text on subjects dealing with various type of problems faced by practicing veterinarians. Query, enclosing S.A.S.E.

16. Miscellaneous—Varied Interests

The following periodicals are not included in the accompanying 23 Parts of Section 11 for one or more of a number of reasons: Some did not lend themselves to specific classification; some underwent total changes in their photographic needs; some came into existence after the previous and following categories of subject matter had been completed. Part 16, therefore, should always be reviewed as you browse through other Parts of Section 11 for potential photo markets.

Art and Archaeology Newsletter, Douglass College, Rutgers Univ., New Brunswick, NJ 08903. Quarterly. Sample copy, 80¢ in stamps. Uses b&w photos only with authentic captions/text resulting from visits to archaeological sites located off the beaten path. Best to study, then query. Enclose S.A.S.E.

Bookstore Journal, 1722 Ridge Rd., Homewood, Ill. 60430. Edited to interests of owners and employees in Christian bookstores. Buys b&w glossies with caption/copy on bookstore management, selling, related subjects, $5 ea. Buys covers, mostly seasonal, at $25 ea. Pays on acc. Query first, enclosing S.A.S.E

Broadcast Engineering, 4300 W. 62nd St., Indianapolis, IN 46206. Edited to interests of those technically involved in cable TV, TV broadcasting equipment, design, radio maintenance, etc. Buys b&w glossies with captions and text. Buys 2¼×2¼ color trans. for covers. Study for coverage/style. Query, enclosing S.A.S.E. Rates vary on acc.

Business Abroad, 466 Lexington Ave., New York, N.Y. 10017. Edited to interests of those engaged in international business management and operational methods. Buys photos

with captions and text; pays on acc. Study, then query. Enclose S.A.S.E.

Ceramic Scope, 6363 Wilshire Bldg., Los Angeles, Calif. 90048. Edited to interests of ceramic dealers/retailers, craft teachers, ceramic studios, management methods, etc. B&w photos bought with captions/text. Study copies for coverage style and subject range. Query first, enclosing S.A.S.E.

Church Administration, 127 9th Ave., Nashville, Tenn. 37203. Photojournalists may send for free copy. Edited to interests of Southern Baptists—pastors, volunteer leaders, etc. Uses b&w glossies in 8×10 size with captions/text on church management, financing, administrative methods. Up to $10 per photo, text extra. Pays on acc. Study, then query, enclosing S.A.S.E.

Church Management, Commercial Bldg., 115 N. Main St., 201-12, Mt. Holly, N.C. 28120. Mo. Buys b&w glossies with articles/captions, on church financing, management, administration, etc. Pays on pub. Best to query first with S.A.S.E. for reply.

College Management, 22 W. Putnam Ave., Greenwich, Conn. 06830. Mo. Guideline sheet

and sample copy on request. Edited to interests and needs of college administrators and management. Study first, then query. Photos purchased with captions/copy. Rates vary; pays on acc.

College Store Executive, 211 Broadway, Lynbrook, N.Y. 11563. Mo. Sample copy 65¢. Edited to interests of owner, managers, etc., of campus bookstores. Buys photos with captions/ms on unusual displays, merchandising methods, store expansions, etc. Pays on acc.; rates vary. Enclose S.A.S.E. with queries/submissions.

Communications News, 402 W. Liberty Drive, Wheaton, Ill. 60187. Mo. Edited to interests of industry-wide personnel engaged in phone, TV, or other forms of communication services. Buys b&w glossies only with captions/text. Subjects range from how-to operations to service and technical material. Study free sample copy first, then query. Enclose S.A.S.E. Pays on pub.

Electronic Servicing, 1014 Wyandotte St., Kansas City, Mo. 64105. Mo. Guideline sheet sent on request. Buys b&w photos with captions/ms; pays on acc. at varying rates.

Emphasis on how-to of diagnosing and servicing electronic equip. Query first. Enclose S.A.S.E.

Elementary School Journal, Univ. of Chicago Press, 5835 Kimbark Ave., Chicago, IL. 60637. Mo during school year. Action photos in b&w of children in play/work activities, with captions/ms. Rates vary. Enclose S.A.S.E. with queries/submissions.

Epic, 338 Mountain Rd., Union City, NJ 07087. Mo. Sample copy sent on request. Buys b&w glossies only with captions/text. Emphasis on nontechnical use of computers in offices, small industries, companies, etc. Pay varies on pub. Send S.A.S.E. with all queries/submissions.

Farm Building News, 610 N. Water, Milwaukee, Wis. 53202. Pub. six times per year. Sample copy on request. Buys b&w glossies and color trans. with captions/feature-article use. Emphasis on farm building construction, news in industry, etc. Pays on acc. up to $200 per package deal feature. Pays on acc. Enclose S.A.S.E. with all queries/submissions.

Fence Industry, 307 N. Michigan Ave., Chicago, IL 60601. Mo. Pays up to $10 per photo, extra for text, on material of interest to dealers and installers in farm-fencing industry. Best to study first, then query. Pays on pub. Enclose S.A.S.E. with queries/submissions.

Florafacts, Box 9, Leachville, AR 72438. Mo. Free copy to photojournalists on request. Buys b&w glossies with captions/text on subjects of interests to retail florists—merchandising innovations, services, promotions, etc. Preference given to material for and about Floral Delivery, Inc. (a wire service for florists). Pays on pub. Enclose S.A.S.E.

Florist, 900 W. Lafayette , Detroit, MI 48226. Mo. Edited to interests of wholesale and retail florists—management, how-to techniques, merchandising, promotions. Sample copy sent on request. Buys b&w photos and color trans. with captions/ms. Rates vary on acc. Enclose S.A.S.E. with submissions.

Glass Digest, 15 E. 40th St., New York, N.Y. 10016. Mo. Free copy available on request. Buys b&w glossy pix with captions/text on subjects of interest to glass plants, jobbers, installers, contractors, etc. Wide range of coverage in glass products. Study first. Rates vary. Enclose S.A.S.E. with submissions.

Industrial Arts And Vocational Education, CCM Professional, 22 W. Portman Ave., Greenwich, Conn. 06830. Mo except June and July. B&w photos with captions/text of school shops. Rates vary. Enclose S.A.S.E.

Juvenile Merchandising, Empire State Bldg., Suite 4719, 350 Fifth Ave., New York, N.Y. 10001. Mo. Sample copy on request. Buys b&w photos with captions/text on material slanted to interests of independent, discount houses, other retailers of juvenile hard goods. Wide range of coverage. Study, then query. Enclose S.A.S.E. with all submissions. Rates vary.

Key To Christian Education, 8121 Hamilton Ave., Cincinnati, OH 45231. Quarterly. Buys b&w pix with captions/ms. Edited to interests of ministers, leaders, administration, teachers in Christian education. Study first, then query. Enclose S.A.S.E. Photos up to $10 ea.

Land And Water Development, 200 James St., Barrington, Ill. 60010. Bimo. Sample copy available on request. Buys seasonal pix and both b&w and color trans. for feature articles (captions/copy required). Edited to interests of those involved in land improvement, conservation, construction projects. Study, then query. Rates vary on pub. Enclose S.A.S.E. with submissions.

Management Digest, Box 23505, Ft. Lauderdale, Fla. 33307. Uses b&w glossies with captions/text on subjects of interest to executive/administrative personnel— merchandising methods, profiles, interviews, business methods. Pays on acc. Enclose S.A.S.E. with queries/submissions.

Mature Years, Methodist Pub. House, 201 Eighth Ave., S., Nashville, Tenn. 37202. Buys b&w glossies (8×10) with captions/copy. Special needs include unposed pix of older adults and activities in which they are especially interested. Pays up to $10 ea. for b&w's. Pays on acc. Enclose S.A.S.E. with queries/submissions.

Military Market, 475 School St., S.W., Washington, DC 20024. Sample copy on request. Edited to interests of civilian buyers and managers of military retail outlets, both exchanges and commisaries. Buys b&w glossies with captions/copy on how-to techniques pertinent to retail merchandising, buying, displays, etc. Best to study sample copies, then query. Pays on acc. Enclose S.A.S.E. with submissions/queries.

Milk Hauler And Food Transporter, 221 N. La Salle St., Chicago, Ill. 60601. Edited to interests of transporters of milk from dairies, tank truck haulers of molasses, juices, transporting of cheese and dairy products, etc. Buys b&w pix only with captions/copy. Rates vary on acc. Query, enclosing S.A.S.E. with all communications.

Modern Tire Dealer, Box 5417, 77 Miller Rd., Akron, OH 44313. Mo. Edited to interests of independent tire retailers who also sell batteries, offer services in wheel alignment, brakes, mufflers, etc. Buys b&w glossies with captions/ms. Rates vary on pub. Enclose S.A.S.E. with query/submissions.

National Police Journal, 3033 Excelsior Blvd., Minneapolis, Minn. 55416. Quarterly. Sample copy on request. Edited to specific interests of law-enforcement executives/ administrators. Buys b&w glossies and color trans. with captions/copy. Study first for coverage/style. Rates vary on pub. Enclose S.A.S.E.

Police Times Magazine, 1100 N.E. 125th St., N., Miami, FL 33161. Bimo. Sample copy available upon request. Buys b&w glossies with captions/copy for up to $15 ea. Wide coverage of subjects of interest to law-enforcement officers at all levels in USA, Canada, Mexico. Emphasis on short articles prepared in newspaper style. Best to study first. Enclose S.A.S.E. with submissions.

PSM: Pets/Supplies/Marketing, 1 E. 1st St., Duluth, Minn. 55802. Mo. Sample copy on request. Buys b&w glossies and color trans. only with captions/text. Edited to interests of manufacturers, wholesalers, retailers of pet supplies. Features include care of pets, merchandising, pet care, etc. Study guideline sheet and sample copy, then query. Rates vary on pub. Enclose S.A.S.E. with all communications.

Resource, 2900 Queen Lane, Philadelphia, PA 19129. Mo. Sample copy on request. Pays up to $15 ea. on pub for b&w glossies with captions/text. Edited to educational needs of Lutheran church school teachers. Study, then query. Enclose S.A.S.E. with all communications.

Scholastic Coach, 50 W. 44th St., New York, N.Y. 10036. Monthly ten times per year. Buys b&w photos singly or in series with captions/copy; pays on pub. up to $15 ea. Edited to interests of coaches and physical education personnel in high schools and colleges—all types of sports. Enclose S.A.S.E. with queries/submissions.

Scholastic Teacher, same address as above. Buys b&w glossies and color trans. for covers; rates vary on acc. Edited to interests of teachers from first grade through senior high. Sample copy sent on request. Essential to study subject range and style, then query. Enclose S.A.S.E. with all submissions.

School and Society, 1860 Broadway, New York, N.Y. 10023. Emphasis on college administration, teaching, trends, personality profiles in successful educational activities, etc. Best to query first with photo-illustrated article ideas. Enclose S.A.S.E.

Science Activities, 8150 Central Park Ave., Skokie, Ill. 60076. Sample copy available on request. Pays approx. $10 ea. for b&w photos with captions/copy. Pays on pub. Edited to interests of science teachers in elementary and high schools. Enclose S.A.S.E. with submissions.

Teach Magazine, Box 1591, Glendale, CA 91209. Quarterly. Sample copy available on

request. Buys b&w photos with captions/text; rates vary on acc. Edited to interests of Christian education directors, administrators, pastors, teachers, etc. Important to query first. Enclose S.A.S.E. with all communications.

Today's Catholic Teacher, 38 W. 5th St., Dayton, OH 45402. Mo., Sept. through May. Sample sent on request. Edited to interests of administrators and teachers in Catholic schools. Wide range of subject matter. Rates for b&w photos with captions/text vary on pub. Enclose S.A.S.E. with queries/submissions.

Today's Education: NEA Journal, Nat. Ed. Assoc., 1201 16th St., N.W., Washington, DC 20036. Buys only 8×10 b&w and color trans. of school situations and scenes with model releases. Study, then query. Rates per photo,

$10 to $100 (in b&w and color respectively) according to use. Enclose S.A.S.E. with all submissions.

Unity, Unity Village, MO 64063. Scenic, seasonal, and dynamic color transparencies on various subjects. Study, then query with enclosed S.A.S.E. Pays $25 per trans. and up on acceptance.

Wallcoverings, 65 E. 55th St., New York, N.Y. 10022. Mo. Sample copy sent on request. Interviews, merchandising, promotion ideas of interest to wallpaper dealers. Buys b&w photos with captions of displays, people interviewed. Pays by page rate for package (photo/text) material. Include S.A.S.E. with submissions.

Woodmen Of The World Magazine, 1700 Farnam St., Omaha, Neb. 68102. Mo. Buys b&w glossies and color trans. (4×5 size) with captions/text. Subjects include travel, human interest, scenic, seasonal, patriotic, and general interest. Rates per b&w up to $20 ea. Color trans., up to $35. Pays on acc. Enclose S.A.S.E. with all communications.

World Wood, 500 Howard St., San Francisco, Calif. 94105. Buys b&w glossies (8×10) and color trans. with captions/text; also color covers. Edited to interests of equipment-minded readers engaged in wood industry—logging, sawmills, plants, equipment operation, maintenance, etc. Rates vary on pub. Best to study, then query. Enclose S.A.S.E. with all communications.

17. Newspapers, Supplements, Syndicates

Alabama Sunday Magazine, P.O. Box 950, Montgomery, Ala. 26102. Wk. Sunday Sup. Buys color trans. for covers, b&w pix with captions/text for interior. Sample copy on request with postage included. Most pix used are of Alabama locale and personalities. Enclose S.A.S.E. with submissions/queries.

Arizona Magazine, Arizona Republic, 120 Van Buren St., Phoenix, Ariz. 85004. B&w glossies (8×10) and color trans. bought with captions/text. Arizona locales, people, personalities, activities, etc. Study the quality and style first, then query. Rates vary from fair to good on package (photo/text) deals. Include S.A.S.E. with your submissions.

Authenticated News International, 170 Fifth Ave., New York, N.Y. 10010. A supplier of news/photos for syndication to newspapers, company, and trade publications, Sunday supplements, etc. Subjects range from well captioned single news photos through photo-feature stories of broad interest, i.e., travel, hobbies, education, construction, art, science, etc. Must have model releases where required. Buys 8×10 glossies and 35mm and larger trans. with captions/text. Pays royalty of 50% on sales.

Billings Gazette, The, Billings, Mont. 59101. Wk. Buys photos with accurate captions/text of people, events, history of circulation area (Mont. and N. Wyo.), or of former residents elsewhere who have become engaged in newsworthy or human-interest activities. Enclose S.A.S.E. with queries and submissions.

Black Press Service, 166 Madison Ave., New York, N.Y. 10016. Worldwide supplier to newspapers and other publishers interested in factual news stories, personalities, achievements, sports, etc. involving black people. B&w gloss-

ies of pro quality only. Rates vary by negotiation. Enclose S.A.S.E. with all material.

Canada Wide Feature Ser., 345 St. James, W., Montreal 126, Quebec, Canada. Wide range of coverage in b&w and color trans. of human interest, sports, feature-story pix with captions. Accepts photos only on assignment to be sold on royalty basis. Query with Int'n Reply Coupon covering postage.

Capital Magazine, St. Paul Sunday Pioneer Press, 55 E. 4th St., St. Paul, Minn. 55101. Top-quality b&w and color trans. with captions/text. Emphasis on feature stories of interest to readers in N. Central states. Also uses short features with one or more thoroughly documented photos. Rates vary. Query first.

Central Press Assoc., 1380 Dodge St., Cleveland, OH 44114. Wide range of subject matter with photos/text accepted for syndication. Query first with S.A.S.E.

Chicago Sun-Times' Midwest Magazine, 401 N. Wabash, Chicago, Ill 60611. Wk. Sample copy on request. Pro-quality pix accepted with captions/text only. Emphasis on Chicago readership area people, events of timely, seasonal interest. Uses both b&w and color trans. Query first with S.A.S.E.

Christian Science Monitor, The, 1 Norway St., Boston, Mass. 02115. Photos purchased at varying rates depending upon use. Covering captions/text required. Study first for coverage and editorial style, feature, human interest sections, etc. Enclose S.A.S.E. with queries and submissions.

Coloroto Magazine, New York Daily News, 220 E. 42nd St., New York, N.Y. 11017. Study copies for coverage and style. Only top-quality b&w glossies and color trans. (35mm accepted

but larger preferred). Good rates on feature-photo stories with captions/text. Enclose S.A.S.E. with queries and submissions.

Columbus Dispatch Sunday Magazine, 34 S. 3rd St., Columbus, Ohio 43216. Wk. B&w and color pix of Ohio interest only. B&w $3-5; cover (color), $25-50. Pay 10th of mo. following pub.

Contemporary Magazine, (Denver Post), 650 15th St., Denver, Colo. 80201. Wk. Free copy on request. Edited to interests of adult readership. Contemporary subjects covering a wide range; important to study coverage style. Uses seasonal material as well as topical. Include S.A.S.E. with queries/submissions.

Des Moines Register Picture Magazine, 715 Locust St., Des Moines, Iowa 50304. Buys b&w pro-quality singles with captions/text. Also color trans. as captioned singles, series, or with text. Iowa subject matter only. Up to $50 for color covers. Query or submit with S.A.S.E. enclosed.

Dixie Roto (Sunday Magazine of The Times Picayune), 3800 Howard Ave., New Orleans, La. 71040. Wk. B&w and color pix of general interest with regional tie-in for La., most of Miss., Gulf Coast, etc. B&w $5; color (min. size trans. 2¹/₄×2¹/₄) $25. Pay on pub.

Emerald Empire Magazine, Box 1232, Eugene, Ore. 97401. B&w and color trans. with captions/text outdoor subjects involving human interest, preferably with Oregon-area tie-ins. Study Sunday Supplement magazine issues for coverage and style. Pays at various rates up to $35 for color covers. Enclose S.A.S.E. with queries/submissions.

Empire Magazine (Rotogravure Sunday Supplement to Denver Post), Box 1709, Denver,

Colo. 80201. Wk. B&w and color story illustration pix. Prefer pix pertaining to Colo. and surrounding states—scenics, livestock, children, pets, etc. B&w $10, inside color, $15-25; color covers, $50 (min. size trans. 2¹/₄×2¹/₄). Pay b&w on acc.; color on consignment.

Enterprise Science Service, 230 Park Ave., New York, N.Y. 10017. Buys top quality b&w and color trans. with captions/text only. Emphasis on accuracy in feature-type articles of current scientific interest. Query first; enclose S.A.S.E. with queries and submissions. Rates vary.

Family Weekly, 641 Lexington Ave., New York, N.Y. 10022. Buys top-quality 8×10 glossies and color trans. from 35mm up. Accent on interesting, unusual activities in picture-story form. Study copies for coverage and style. Pays up to $150 for photo features, $250 for color covers. Query first. Include S.A.S.E.

Feature Parade Magazine, Worcester Sunday Telegram, 20 Franklin St., Worcester, Mass. 01601. Uses b&w and color trans. as captioned singles or in picture-story form with captions/text. Emphasis on appeal to New England audiences. (No historical material.) Query first, enclosing S.A.S.E.

Globe Photos Inc., 67 W. 44th St., New York, N.Y. 10036. Distributes b&w and color trans. feature stories on commission basis (50% to photographer on b&w, 60% on color features.) Pays when feature is sold. Query first; enclose S.A.S.E.

Herald-Dispatch/Advertiser, 946 5th Ave., Huntington, W.Va. 25720. Daily. Spot news and features. Newsworthy pix of former residents. B&w $3-10. Pay on pub.

Hinky-Dinky News, 4206 South 108th St., Omaha, Neb. 68037. Mo. Free. Purchase news pix on assignment to local photographers to meet special needs only.

Houston Chronicle Rotogravure Magazine, 512-20 Travis, Houston, Tex. 77002. Wk. No more than 200 words of copy. Prefer Texas angle. B&w $25 tabloid page, art and copy; color (min. size trans. 2¹/₄×2¹/₄) rates vary.

Information Press Service, Key Colony Beach, Fla. 33051. Buys photo features to submit to clients. Wide range of coverage with special emphasis on adventure, exposés, male interests, etc. Study copies for style. Enclose S.A.S.E. with submissions.

Insight (Sunday Magazine of The Milwaukee Journal), 333 W. State St., Milwaukee, Wis. 53201. Text and pix on subjects of interest to Wis. and area readership. B&w $15 and up; cover color trans. (min. size 35mm) $100 to $150. Inside color, $35 and up. Pays on pub. Enclose S.A.S.E. with submissions.

King Features Syndicate, 235 E. 45th St., New York, N.Y. 10017. Top-quality pix used with wide range of feature subjects. Query first, enclosing S.A.S.E.

Los Angeles Times Home Magazine, Times-Mirror Square, Los Angeles, Calif. 90053. Occasionally buys outside photos in top quality 8×10 glossies and size 4×5 color trans. Limited subjects, so query first with S.A.S.E.

Miami Herald Tropic Magazine, 1 Herald Plaza, Miami, Fla. 33101. Wk. Sample copy on request. Uses top quality b&w glossies and color trans. Wide range of subject coverage, mostly with tie-ins to interests of Florida audiences. Study style, query first. Enclose S.A.S.E. Good rates vary on quality, length, etc.

Michiana (The South Bend Tribune Sunday Supplement Magazine), Colfax at Lafayette, South Bend, Ind. 46626. Wk. Uses b&w pix with captions/text of interest to area readership. Study coverage and style. Rates vary. Include S.A.S.E. with submissions.

National Inquirer, Latana, Fla. 33460. By unconfirmed report as we go to press, this publication pays top rates for "once in a lifetime" photos. Best to obtain sample issues and query first, enclosing a S.A.S.E.

NC News Service, U.S. Catholic Conference, 1312 Massachusetts Ave., N.W., Washington, DC 20005. Edited to interests of large Catholic readership. Buys b&w glossies with captions/text. Religious photo features, seasonal material, general features considered. Query first. Rates vary. Enclose S.A.S.E.

New York Times Magazine, The, Times Square, New York, N.Y. 10036. Buys top-quality b&w in size 8×10 and color trans. Study style and wide coverage. Note the news tie-in ranging from science and sports to social trends, personalities, trends in family activities, etc. Pays up to approx. $35 per b&w, up to $300 for color covers. Also does some assignment of work to professionally proven photographers. Pays on acc. Query first, enclosing S.A.S.E.

News Pictorial, 30 N. MacQuesten Parkway, Mt. Vernon, N.Y. 10550. Buys pix of human interest, hobbies, children and adults of all races. Also produces full-color poster subjects. One-time use of color trans. with signed release, $75 min. B&w, $15 min. Enclose S.A.S.E. with queries/submissions.

Newscene (The Daily News), P.O. Box 520 O'Leary Ave., St. John's, Newfoundland. Sunday supplement; sample copy on request. Buys b&w pix with captions/text. (Rarely uses color unless exceptional in subject matter and quality.) Coverage must have Newfoundland angle, historical, modern, etc. Query first, enclosing Int'n. Reply Coupon and self-addressed envelope.

Newsday's Weekend Magazine, 550 Stewart Ave., Garden City, L.I., New York 11530.

Sunday supplement; sample on request. Edited to interests of sophisticated suburban readership. Factual, news-oriented feature articles/captions purchased with photos. B&w glossies, $10 and up. Color trans., $50 and up. Query. Enclose S.A.S.E.

North American Newspaper Alliance, 1501 Broadway, New York, N.Y. 10036. Syndicates short newsfeatures (with 8×10 b&w glossies only) to papers in N.A., Europe, Asia, etc. Study specialized coverage and slant before submitting. Enclose S.A.S.E. with queries.

Northwest Magazine (The Sunday Orgonian), 1320 S.W. Broadway, Portland, Ore. 97210. Wk. Edited to interests of northwestern area readership. Buys b&w pix with captions/text on travel, social subjects, wildlife, etc. Pays on pub. Query with S.A.S.E.

Parade, The Sunday Newspaper Magazine, 733 3rd Ave., New York, N.Y. 10017. Wk. Sample copy on request. (Enclose S.A.S.E. with all queries, submissions, etc.) Emphasis is on photos with captions/text on subjects of family interest—personalities, health, science, child raising, etc. Best to study coverage and style, then query. Rates vary.

Picture Magazine, Minneapolis Sunday Tribune, 425 Portland Ave., Minneapolis, Minn. 55415. Uses top pro-quality b&w and color trans. with captions/text. Most illustrated feature articles slanted to interests of Minn. area readership. Rates vary. Query first, enclosing S.A.S.E.

Plain Dealer, The, 1801 Superior Ave., Cleveland, Ohio 44114. B&w pix with feature and general interest subjects having captions/text. Color trans. of local human interest, Ohio scenics, etc. (No sports coverage.) B&w rates vary; also color for inside and cover use. Query. Enclose S.A.S.E.

Potomac, The Washington Post, 1515 L St., N.W., Washington, DC 20007. Weekly Sunday supplement largely edited to interests of Washington area readership. B&w glossies and color trans. of pro quality purchased with captions/text. Audience tends to be sophisticated with wide range of interests, but magazine should be studied before material is submitted. Enclose S.A.S.E. with all submissions. Pays on pub.

Rhode Islander Magazine, 75 Fountain St., Providence, RI 02902. Wk. Buys b&w pro-quality pix and color trans. (35mm and larger) with captions/text. Preferred subject matter is RI-oriented. B&w pix in package (caption/text) sets $15 to $50. Color trans. $15 to $200. Pays on pub.

Royal Leader, The, 1078 Argyle St., Regina, Sask., Canada. Wk. Sample copy to pro photographers on request. Buys b&w glossies on subjects of regional events and interest to Saskatchewan readership. Rates vary. En-

close S.A. envelope and Int'n. Reply Coupon with submissions.

Rural Gravure, 2564 Branch St., Middleton, Wis. 53562. Mo. Buys b&w quality glossies with captions/text only. Human interest, subjects (not agricultural) of general interest to midwestern readership. Sample copy on request; enclose S.A.S.E. with queries, submissions. Rates vary with subject, length, quality.

San Diego Union, The, 940 3rd Ave., San Diego, Calif. 92112. Wk. Buys photos only with captions/text. Mainly interested in brief, factual, well documented historical material of Calif., Arizona, neighboring states. Pays on pub. Rates vary. Send S.A.S.E. with queries/submissions.

Seattle Times Rotogravure Pictorial, Seattle Times Co., P.O. Box 70, Seattle, Wash. 98111. Wk. Pix of general interest subjects in Pacific Northwest area. B&w $5; color cover (4×5 trans.) $75. Pay on pub.

Sioux Falls Argus-Leader, 200 S. Minnesota St., Sioux Falls, S. Dak. 57102. Sunday supplement. Copy, 25¢. Uses some b&w picture stories on S. Dak. subjects and/or of area interest. Query first, enclosing S.A.S.E.

Southland Sunday Magazine, Sunday Independent Press-Telegram, 6th and Pine Sts., Long Beach, Calif. 90801. Sample copy on request to pro photographers. (Enclose S.A.S.E. with queries/submissions.) B&w glossies with captions and factual data, mostly of subjects of general interest to area readership. Pays on pub.

St. Petersburg Times/The Floridian (Sun. supplement), Box 1121, St. Petersburg, Fla. 33731. Wk. Sample copy on request to pro photographers; enclose S.A.S.E. with all submissions/queries. Good rates for top-quality picture stories with captions/text data. Study for coverage and style.

Sunday Blade, The, 541 Superior St., Toledo, OH 43604. Sample copy on request. Wide range of coverage with special emphasis on pertinent area subject matter. 8×10 glossies and pro-quality trans. purchased with captions/factual text. Study first, then query on specific offerings.

Sunday Magazine Of The Spokesman Review, The Spokesman Review, Spokane, Wash. 99210. Pro-quality b&w glossies and 4×5 color trans. purchased with captions/copy data only. Center of readership interest lies in Pacific Northwest, but extends also to northern Rocky Mtn. states. Study coverage first, then query. Rates vary. Enclose S.A.S.E. with all submissions.

Tacoman, Tacoma News Tribune, 711 St. Helens Ave., Tacoma, Wash. 98401. Sunday supplement edited to interests of Pacific Northwest readership. Buys photos with captions/text on northwest travel, history, etc. Buys some color trans. for covers. Query first. Enclose S.A.S.E.

Timely Features, Inc., 299 Madison Ave., New York, N.Y. 10017. Edited to interests of adult audiences. Buys b&w glossies of semi-nudes, pinups, nudes, etc. Will consider either 8×10 b&w or choose from contact prints. Enclose S.A.S.E. Pays $10 on acc. Buys one-time rights.

Today, The Philadelphia Inquirer Magazine, 400 N. Broad St., Philadelphia, PA 19130. Edited to interests of a sophisticated readership, primarily urban. Sample copy to pro photographers on request. Buys photos mainly with captions/text of local area subjects. Query first on photo needs, enclosing S.A.S.E. with all queries/submissions.

U-B Newspaper Syndicate, 15155 Saticoy St., Van Nuys, Calif. 91406. Syndicates non-fiction photo-illustrated (b&w glossies) to many leading newspapers. Subject range includes photo-stories with detailed captions on do-it-yourself projects. Query first, enclosing S.A.S.E. with all queries/submissions. Buys all rights at negotiable rates.

Universal Science News, 314 W. Commerce, Tomball, Tex. 77375. Buys first rights on feature articles syndicated throughout U.S. and foreign countries. Coverage includes wide range of science-oriented material presented as single features or in series. Important to query first, enclosing S.A.S.E. with all queries and correspondence/submissions. Will consider b&w contact sheets on pic features.

Weekend Magazine, 245 St. James St. West, Montreal, Quebec, Canada. Supplies feature material to a number of Canadian newspapers. B&w and color trans. accepted with captions/factual text only. Broad range of subject interests, but must be pertinent to Canadian audiences. Pays on acc. Query first. Enclose S.A.E. and Int'n Reply Coupon with all queries/submissions. Pay varies with subject matter, length, quality.

West Magazine, Los Angeles Times, Times-Mirror Square, Los Angeles, CA 90053. Sunday supplement directed largely to Southern California readership interests, but also expands to general interest features of interest to readers in nearby states, Hawaii, etc. Requires top-quality pix in illustrated photo/text packages, or for cover use. Good rates on acc. Query first, enclosing S.A.S.E. with all material submitted.

World In Focus, The, Room 360, United Nations, N.Y. 10017. Buys all rights to b&w and color trans. supplied with factual captions/text. Best to study type of material supplied to N.A. and foreign newspapers. Enclose S.A.S.E. with queries and submissions.

18. Oceanography, Boating, Marine

Related interests may also be included in publications listed in Parts 9, 12, 13, 14, 19, 20 and 23.

Boating Industry, The, 205 E. 42nd St., New York, N.Y. 10017. Mo. Sample copy to pro photographers on request. Edited to interests and needs of those engaged in the retail/distribution aspects of boating industry. Study sample copies, especially dealer "success" techniques. Query first. Uses b&w glossies with captions/text. Enclose S.A.S.E.

Boating Magazine, Ziff-Davis Pub. Co., 1 Park Ave., New York, N.Y. 10016. Mo. For cover: action photos, unusual angles, family boating. B&w pix of sailboats, inboards and outboards. B&w highest rate in field; color cover (min. size trans. 35mm, vertical format) rates vary. Pay on acc.

Canadian Sailing, 626 Main St., Penticton, B.C., Canada. Quarterly. Uses b&w pro-quality pix with captions/text on sailboat design, construction, cruising, safety-first aspects, etc. Sample copy on request. Query first, enclosing Int'n Reply Coupons with all queries/submissions. Rates vary. Pays on pub.

Dive Magazine, P.O. Box 7765, Long Beach, CA 90807. Bimo. Sample copy to pros on request. Edited to interests of scuba divers, scientists, marine buffs, all others interested in ocean subjects from mid-teens up. Uses b&w and color trans. with captions/text only. Study mag. and query first, enclosing S.A.S.E. Pay varies with subject, length, quality.

Lakeland Boating, 416 Longshore Drive, Ann Arbor, MI 48107. Pub ten times per year. Sample copy to pros on request. Also interested in material for special seasonal issues. Accent is on well-documented pix with captions/text on a wide range of subjects from

how-to to general outdoor adventure boating techniques. Study, then query with specific subject coverage ideas. (This magazine is reputed to be especially receptive to producers of high-quality photos/copy.) Enclose S.A.S.E. with queries/submissions. Pay varies with quality.

Marine Engineering Log, 350 Broadway, New York, N.Y. 10013. Buys b&w glossy prints with captions/text only. Edited to interests of audience interested or engaged in marine industries—shipbuilders, marine engineers, ship owners or operating companies, etc. Pays on pub. Query first. Enclose S.A.S.E. with queries/submissions.

Modern Outboard, 1680 N. Vine, Suite 600, Hollywood, Calif. 90028. Mo. Sample copy to pros, 75¢. Buys b&w glossies for inside, color trans. for cover. Edited to interests of outboard enthusiasts, marathons, drag racing, record setting, etc. Rate varies with length, quality of photo-text package offerings. Query. Enclose S.A.S.E.

Motor Boating, 224 W. 57th St., New York, N.Y. 10019. Mo. Buys b&w top-quality glossies on boating and related activities, water sports (both sail and power) cruising, repairs, maintenance. Buys pix with captions only, or in series with text. Color trans. for covers are generally of large boats (25 ft or larger), human interest related to boating, eye-catching action. Publishes a monthly memo to established photographers, mailing list open to all pros. Rates vary according to length, subject, quality of pix. Rates considered good. Pays on acc. Enclose S.A.S.E. with queries/submissions.

Naval Engineers Journal, Suite 507, Continental Bldg., 1012 14th St., N.W., Washington, DC 20005. Buys b&w glossies with captions/text on a wide range of subjects of interest to those engaged in design, construction, management of naval vessels. Also many related subjects. Study before submitting material. Enclose S.A.S.E. Rates vary.

Oceanology International, Beverly Shores, Ind. 46301. Mo. Free copy on request. Edited to interests of professional people involved in ocean science and technology. B&w and color trans. purchased with highly accurate, documented captions/text. Pay varies. Query first, enclosing S.A.S.E.

Oceans Magazine, 1150 Anchorage Lane, San Diego, Calif. 92106. Bimo. Guideline for photographers/writers on request. Wide range of subject interests from boating and water sports to marine science, technology and preservation of ocean resources. Top-quality b&w glossies and color trans. purchased as captioned singles or in series to illustrate text. Pays on pub. depending upon use, up to $75 for b&w, up to $100 for color. Color covers up to $150. Query first, enclosing S.A.S.E.

Powerboat Magazine, P.O. Box 3842, Van Nuys, Calif. 91407. Mo. Sample copy to pro photographers on request. Edited to interests of readers interested in power boats, maintenance, how-to techniques, water skiing, competitions, etc. Uses 8×10 b&w glossies with captions/authentic text. Prices vary according to length and contents. Also uses seasonal pix. Query first. Enclose S.A.S.E.

Rudder, 1 Astor Place, New York, N.Y. 10036. Mo. Buys 8×10 b&w pro-quality glossies with captions/text as package deal. Rates average about $50 per printed page, on acc. Accent on all aspects of pleasure boating. Query. Enclose S.A.S.E.

Sail, 38 Commercial Wharf, Boston, Mass. 02110. Mo. Sample copy to pro photographers on request. Edited to interests of young to middle-aged sailing enthusiasts. Special issues include boat show, special race issues, etc. Wide range of related subject interests. B&w glossies purchased with captions/text. Color trans. purchased for covers. Rates per photo from $10 to $125 (sometimes more for covers). Study thoroughly, then query. Enclose S.A.S.E.

Sailing, 125 E. Main St., Port Washington, Wis. 53074. Bimo. Copy on request to pro photographers. Enclose S.A.S.E. with all queries/submissions. Uses b&w glossies (8×10 preferred) on boats under sail and other subjects of interest to sailing enthusiasts. Pays on pub.

Salt Water Sportsman, 10 High St., Boston, Mass. 02110. B&w action shots of salt water fishing, surf, inshore or big game; also pic. stories of salt water sport fishing. B&w $3 and up; color cover $50. Pay on pub.

Sea And Pacific Motor Boat, P.O. Box 20227, Long Beach, Calif. 90801. Mo. Sample copy to pro photogs. Buys contemporary and seasonal b&w glossies (8×10) and color trans. (2¼× 2¼) only with authentic captions/text. Edited to interests of 35 to 45 age group of owners of sail and power boats, cruising, maintenance, racing, etc. Most material slanted to western readership area. Pays $5 to $75 per photo in caption/text package. Enclose S.A.S.E. with queries/submissions.

Sea Frontiers (Int'n Oceanographic Foundation), 10 Rickenbacker Causeway, Virginia Key, Miami, Fla. 33149. Sample copy on request. Study magazine first because it is edited to specific interests of members of the foundation. Captions/text accompanying b&w glossies must be factual and pertain to the science of the sea, work in progress of scientific nature, etc. Enclose S.A.S.E. with queries/submissions. Rates vary on pub.

Seaway Review, 3750 Nixon Rd., Ann Arbor, Mich. 48105. Quarterly. Pro-quality 8×10 glossies and 4×5 trans. purchased with captions/text only. Edited to interests of those professionally involved in shipping in the St. Lawrence and Great Lakes inland areas. Study publication first, then query on feature material that can be documented with authenticity. Pays $25 per b&w, $100 for color. Also uses some scenics and port activities pix. Send S.A.S.E. with submissions. Pays on acc.

Skin Diver, 8490 Sunset Blvd., Los Angeles, Calif. 90069. Buys 8×10 b&w glossies and trans. from 35mm up in size. Photos bought with captions/text on skin diving activities, equipment, maintenance, underwater adventure (treasure hunting, fishing, etc.) and related subjects. Rates: approx. $35 per inside page, $100 per cover shot. Query first, enclosing S.A.S.E. Pays on pub.

Skipper, The, Second St. at Spa Creek, Annapolis, Maryland 21404. Outstanding pix of ships, yachts, the sea, people who work or play on the water. Particularly interested in new or novel approach to subject with strong human interest and good composition. B&w $10 min.; $25 full page; b&w cover $50; color cover (35mm and up) $100. Pay on pub. except by special arrangement.

Surfer, P.O. Box 1028, Dana, Calif. 92629. Bimo. Sample to pro photographers on request. Buys 8×10 glossies (will judge from contact proofs) and color trans. from 35mm up in size. Pix must be accompanied by factual captions/text. Interested in any form of west-east coast surfing activities—emphasis on action and pleasures of sport, not dangers, accidents, sharks, etc. Prices vary with content and quality. Query first with return S.A.S.E. Pays on pub.

Swimming Pool Merchandizer, P.O. Box 7196, Ft. Lauderdale, Fla. 33304. Mo. Sample copy on request. Slanted to interests of merchandizers of portable pools, patio/recreational home furniture, accessories, equipment. B&w glossies purchased with captions/text. Enclose S.A.S.E. Pays on acceptance.

Swimming Pool Weekly and **Swimming Pool Age,** P.O. Box 7196, Ft. Lauderdale, Fla. 33304. Wk. Sample copies on request. Buys b&w glossies with captions/text. Aimed to interests of swimming-pool manufacturers and distributors. Wide coverage of subject interests, including seasonal material, maintenance, merchandizing success articles, etc. Study first. Enclose S.A.S.E. with submissions.

Swimming World, 12618 Killion St., N. Hollywood, Calif. 91607. Mo. Sample copy to pro photographers on request. Edited to interests of those who enter swimming competitions, coaches, etc. Photos (b&w) bought only with text. Query, enclosing S.A.S.E.

Underwater News, 20712 Farnsworth La., Huntington Beach, Calif. 92648. Biwk. Guide-

line sheet on request. Buys b&w glossies and color trans. from 35mm up in size. Must be accompanied by factual captions/copy. Wide range of interests but relatively low rates for pix at this time. Possible "prestige" advantages in being published for some photographers who can supply photo/text material. Enclose S.A.S.E. with queries/submissions.

Water Skier, The, 7th St. and Ave. G, S.W., Winter Haven, Fla. 33880. Published seven times per year; sample copy to photographers on request. Buys some unusual or offbeat photo stories with captions/text. Query first, enclosing S.A.S.E.

Watersport (Boat Owners Council of America), 534 N. Broadway, Milwaukee, Wis. 53202.

Sample copy on request. Edited to interests of average income families who enjoy boating, fishing, water sports. Buys b&w glossies and color trans. 35mm and larger, with full captions/text. Study first, then query. Enclose S.A.S.E. Rates vary from $35 and $100 up depending on content, quality, and use made.

Work Boat, P.O. Box 52288, New Orleans, LA 70150. Mo. B&w pix of boat work construction and operation news to accompany articles only. Must be factual, documentary. Pay for b&w glossies normally included in payment for package deal.

World Dredging And Marine Construction,

P.O. Box 20810, Long Beach, Calif. 90801. Sample copy to pro photographers on request. Buys photos with captions/text as package deals, 8×10 glossies preferred. Sophisticated audience of readers engaged in marine industry and dredging. Study first, then query with S.A.S.E. Pays on pub. at rate of about $50 per printed page, including photos.

Yachting, 50 W. 44th St., New York, N.Y. 10036. Mo. Nautical pix used as singles or in series with full captions/factual text. Pro-quality b&w glossies (8×10) from $10 up. Color trans. from $25 up. Study style and coverage. Query on material you can supply. Enclose S.A.S.E. with all queries/submissions.

19. Sports Publications

Also see parts 2, 5A, 9, 12, 18, 20.

Alaska, Box 4-EEE, Anchorage, AK 99503. Mo. Edited for readers interested in Alaskan and Northwest Canadian wildlife, hunting, fishing, adventure, etc. Uses b&w glossies and color transparencies with captions/text. Rates vary. Enclose S.A.S.E.

Alaska Hunting Annual, (also **Alaska Fishing Annual**), same address as above. Accent on first-person, factual experiences.

American Field, The, 222 W. Adams St., Chicago, Ill. 60606. Wk. B&w pix of sporting dogs, hunting, upland game birds and field shooting. Query first. Pays on acc. Enclose S.A.S.E. with queries/submissions.

American Judoman, The, 4917 Date Ave., Sacramento, Calif. 95841. Pub. six times per year. Sample copy $1. B&w photos purchased with captions on technical aspects of judo, group action, competitions, etc. Study copy for coverage and style. Enclose S.A.S.E. with queries/submissions. Rates vary. Pays on pub.

American Rifleman, The, 1600 Rhode Island Ave., N.W., Washington, DC 20006. Mo. (Official publication of the National Rifle Association of America.) Study magazine for wide range of subject coverages, style. Free sample to pro photographers on request. Uses one- or two-page captioned photo articles inside, color trans. for covers. Rates vary; pays on acc. Enclose S.A.S.E.

Archery, P.O. Box 1877, Salinas, Calif. 93901. Mo. Sample copy free to pro photographers on request. Edited to interests of both members and nonmembers of the National Field Archery Association. Buys b&w captioned/text photos

for inside use, 4×5 color trans. (vertical format) for covers. Wide coverage of subjects related strictly to bow and arrow hunting, fishing, equipment handling, maintenance, recreational benefits, etc. Rates vary; pays on pub. Enclose S.A.S.E. with queries/submissions.

Arizona Wildlife Sportsman, 1103 N. Central, Phoenix, Ariz. 85004. Mo. Buys b&w pix only with captions/text. Outdoor sports, hunting, scenics, fishing, ecology, wildlife, related subjects from Arizona locales. Pay varies with quality/subject matter. Enclose S.A.S.E.

Basketball Weekly, 15885 Woodward, Detroit, Mich. 48203. Mo. Produces 18 issues during basketball season. Send large S.A.S.E. for free copy to study for style and coverage. Buys 8×10 b&w glossies with captions/text on teams, individuals, etc. in both college and pro levels. Rates vary with quality/contents. Pays on pub. Enclose S.A.S.E. with all queries/submissions.

Blackbelt Magazine, 5650 Washington Blvd., Los Angeles, Calif. 90016. Buys 8×10 pro-quality b&w glossies with captions/text. Also photo stories in series. Wide interests, international coverage of competitions, outstanding athletes, coaches, techniques, related martial arts. Best to study publication, then query. Rates on important coverages negotiable. Pays on pub. Enclose S.A.S.E. with queries/submissions.

Boating Magazine, see Part 18.

Bow And Arrow, 130 Olinda Pl., P.O. Box 305, Brea, Calif. 92621. Bimo. Buys b&w glossies (8×10) with factual captions/text. Also color trans. for covers. Sample copy on

request to pro photographers. Study style and coverage. Latter includes tournaments, bow-hunting, equipment and maintenance, champion techniques, etc. Query first. (Editors will judge pix needs from contact sheets.) Rates vary; pays on acc. Enclose S.A.S.E.

Bowling, (Official journal of the American Bowling Congress,) 1572 E. Capitol Dr., Milwaukee, Wis. 53211. Mo. Uses b&w glossies with captions/text of important ABC leagues, competitions, personalities, etc. Requires factual data from contributors well acquainted with bowling vernacular and approved practices. Rates vary; pays on pub. Enclose S.A.S.E. with queries/submissions.

Boxing Illustrated/Wrestling News, 303 W. 42nd St., New York, N.Y. 10036. Mo. Buys 8×10 b&w pix, 4×5 color trans. with captions/text as package deals. Study magazines first, then query. Enclose S.A.S.E. with queries/submissions. Pays on pub.

Canada Ski, P.O. Box 180, Pointe Claire, Dorval 700, Quebec, Canada. Pub. five times a year, Oct.–March. Buys b&w glossies and 4×5 color trans. with captions/text on Canadian ski scenes and activities. Pays on pub. Enclose self-addressed envelope and Int'n Reply Coupons with queries/submissions.

Canadian Outdoorsman, The, 37 Isabella St., Toronto, Ont., Canada. Buys b&w glossies and color trans. with factual caption/text. Canadian locales in hunting, fishing articles. Rates vary. Enclose Int'n Reply Coupons with queries/submissions.

Carolina Sportsman, Box 2581, Charlotte, N.C. 28201. Copy to pro photographers on

request. B&w glossies and color trans. bought with ms. Accent on Carolina hunting, fishing, outdoor sports. Enclose S.A.S.E. with queries/submissions. Rates vary.

Delaware Conservationist, Board of Game and Fish Commissioners, Dover, Del. 19901. Qt. Pix on fishing, wildlife, animals, sports and pictorial subjects in Del. B&w only, $5.

Field And Stream, 383 Madison Ave., New York, N.Y. 10017. Mo. Buys captioned pix with text for inside use. Prefers color trans. to b&w in most cases. Also buys captioned single shots and story-telling series, plus color covers. Extremely wide range of subject interests; best guide to range and style are copies of back (current year) issues. Best to query first on text subjects, enclosing photos or contact sheets and outline of subject coverage/handling. Only top-quality pix and factual writing accepted. Rates vary with length/quality. Enclose S.A.S.E. with all submissions/queries.

Fish And Game Sportsman, P.O. Box 1654, Regina, Sask., Canada. Buys b&w quality glossies ($10 and up) on Canadian fishing, hunting, camping, outdoor recreation, snowmobiling, etc. Inside color trans. prices vary. Color trans. bought for covers. Pays on acc. Enclose Int'n Reply Coupon with queries/submissions.

Fishing And Hunting News, 1202 Harrison St., Seattle, Wash. 98109. Wk. Sample copy on request to pro photographers. Buys b&w glossies with captions/text, singles or series, for inside use. Buys color trans. $2^{1}/_{4} \times 2^{1}/_{4}$ and larger for covers. Rates vary. Slanted to readership interests of those in Rocky Mountain and Pacific coast area. Wide coverage of hunting/fishing activities, guidelines. Must be current and detailed with authenticity. Query. Enclose S.A.S.E. with submissions.

Fishing World, 51 Atlantic Ave., Floral Park, L.I., New York 11001. Bimo. Sample copy on request to pro phtographers. Buys b&w glossies amd color trans. (both inside and cover material) and good rates. Pays on acc. Edited for people of all age groups deeply interested in freshwater and saltwater angling, boats, etc. Info. on equipment, species, techniques must be documented and accurate. Study magazine, then query with specific outline on photo/text offerings. Enclose S.A.S.E. with all submissions.

Fly Fisherman, 111 S. Meramec St., St. Louis, Mo. 63105. Sample available free to pro photographers. Buys b&w glossies only with captions/ms. Study magazine for style, coverage. Enclose S.A.S.E.

Flyfisher, The, 600 West End Ave., New York, N.Y. 10025. Quarterly. 8×10 quality photos purchased with captions/ms only. (B&w only.) How-to material on flyfishing locales, equip.,

techniques. Also conservation as related to flyfishing, documented historical-interest pieces, etc. Pays on pub. Rates vary. Enclose S.A.S.E. with queries/submissions.

Georgia Game And Fish Magazine, (Ga. Game & Fish Commission), 270 Washington St., S.W., Atlanta, Ga. 30334. Mo. Guideline available to photographers. Buys some 8×10 glossy b&w pix with captions/ms. How and where material on hunting/fishing must be of Georgia locale or compatible with what the state has to offer of similar nature. Some color trans. purchased for covers. Enclose S.A.S.E. with queries/submissions.

Golf And Club, 631 Wilshire Blvd., Santa Monica, Calif. 90406. Mo. Sample copy to pro photographers on request. Buys b&w glossies and color trans with captions/text. Info. must be factual and to pertinent interests of average golfer as well as coverage of PGA and pro tournaments. Study contents for coverage/style. Enclose S.A.S.E. with queries/submissions. Up to $150 for package (photo/text) deals. Pays on pub.

Golf Canada and **Le Golf,** 50 Cartier St., St. Lambert, Quebec, Canada. Pub. nine times per year. Buys b&w glossies and color trans. ($2^{1}/_{4} \times 2^{1}/_{4}$), of interest to amateur-pro golfers. Especially interested in Canadian activities, locales, golf courses, etc. Rates vary. Pays on pub. Enclose Int'n Reply Coupon with submissions.

Golf Digest Magazine, 88 Scribner Ave., Norwalk, Conn. 06850. Mo. Golfers and golf scenes. B&w $15–$25; color trans. up to $100. Pay on pub.

Golf Magazine, 235 E. 45th St., New York, N.Y. 10017. Mo. Sample copy on request to pro photographers. Emphasis on how-to instructional tips and related subjects slanted to interests of average golfer. Study contents/style. B&w glossies and color purchased only with captions/ms. Rates vary. Pays on acc. Enclose S.A.S.E. with queries/submissions.

Great Lakes Sportsman, 30555 Southfield Rd., Southfield, Mich. 48076. Mo. Sample copy on request to photojournalists. Very wide range of outdoor subject matter slanted to interests of all ages. Readership centers around Great Lakes area, including southern Canada—recreational facilities, camping, trailer living, conservation, boating, snowmobiling, etc. Study, then query. B&w glossies and pro-quality trans. purchased only with captions/ms. Enclose S.A.S.E. with queries/submissions. Pays on pub.

Gun World, 130 Olinda Place, Box 305, Brea, Calif. 92621. Mo. Sample copy on request to pro photogs/writers. Buys quality b&w glossies and color cover trans only with full, factual captions/text. Edited to readership between

ages of 30–50 who know firearms; absolute accuracy in all material is a must. Study contents, then query. Rates vary. Pays on acc. Enclose S.A.S.E.

Guns And Ammo, 8490 Sunset Blvd., Los Angeles, CA 90069. Mo. Sample copy free to pro photographers; 8×10 b&w glossies and color trans. only with detailed, factual captions/ms. Study magazine's rather wide range of related-subject coverage. Rates vary with subject, contents, length, quality. Enclose S.A.S.E.

Guns Annual, 8150 N. Central Park, Skokie, Ill 60076. Edited to interests of gun users, collectors, hunters, enthusiasts of all ages. Buys b&w glossies and color trans. only with accurate captions/ms. Study annual; enclose S.A.S.E. with submissions.

Guns Magazine, Publishers Development Corp., 8150 N. Central Park Ave., Skokie, Ill. 06850. Mo. Pix of guns, shooting, gun selling; illus. articles—pix with text. B&w $5; cover in color (4×5) $100.

Handloader Magazine, Box 3030, Prescott, Ariz. 80301. Bimo. Buys b&w glossies only with captions/ms. Edited to interests of gun enthusiasts who reload their own ammunitions. Material must be technically accurate and of pertinent value as well as thoroughly understandable in details. Query first. Rates vary. Pays on pub. Enclose S.A.S.E.

Hunting Dog, (Hunting Dog Pub. Co.), 215 S. Washington St., Greenfield, OH 45123. Mo. Buys b&w glossies and color trans. ($2^{1}/_{4} \times 2^{1}/_{4}$ min.) only with captions. Sometimes accepts longer captioned photo-series features. Material must be related to dogs used in hunting. All breeds covered. No show or obedience material needed. Trans. for color covers, $50. Other rates vary. Pays on pub. Query first. Enclose S.A.S.E.

Illinois Wildlife, P.O. Box 116, 13005 South Western Ave., Blue Island, IL 60506. Mo. tabloid-style publication edited to interests of conservationists, naturalists, sportsmen. Buys b&w glossies with captions/factual text. Sample copy (25¢) sent on request. Payment varies. Enclose S.A.S.E.

Inside Golf, 3100 Riverside Drive, Los Angeles, Calif. 90027. Quarterly. Sample copy free to photojournalists. B&w quality glossies and color trans. bought only with factual captions/ms. Prices paid for photos from $10 in b&w to $150 in color. Golf personalities, action shots, tournament coverages, etc. of interest to golf enthusiasts. Query first. Enclose S.A.S.E. with submissions.

International Sportsman, 3106 Clayton Rd., Concord, Calif. 94520. Mo. Edited to interests of outdoor sportsmen, action shots, behind-the-scenes activities, scenics, etc. No dead

animals in any shot. Buys b&w glossies and color trans. with captions/text. Accuracy required. Rates vary. Query first. Enclose S.A.S.E.

Judo Illustrated, 3445 N. Broadway, Chicago, Ill. 60657. Bimo. Sample copy $1. Buys b&w glossies only of "name" athletes, tournaments, etc. Must have full captions/text with accurate details. Best to query on subjects you can offer, rates to be paid, etc. Enclose S.A.S.E. for replies/return submissions.

Letterman Magazine, Box 804, 330 Naperville Rd., Wheaton, IL 60187. Mo. Sample copy, 25¢. Buys b&w glossies and color trans. only with factual, detailed captions/ms. Edited to interests of high-school athletes and those associated with interscholastic events. Best to study magazine for coverage, interests, and style. Uses contemporary material largely, some seasonal/historical/profiles, etc. Enclose S.A.S.E.

Maryland Conservationist, State Office Bldg., Annapolis, MD 21401. Bimo. Sample copy to pro photographers on request. Edited to interests of people interested in nature, travel, outdoor life in Maryland. Buys b&w glossies with captions/text, approx. $15 each. Uses color trans. for covers, $50. Pays on pub. Query first. Enclose S.A.S.E.

Michigan Out-of-Doors, 2101 Wood St., P. O. Box 2235, Lansing, Mich. 48911. Mo. Sample copy on request to pro photographers. Buys b&w glossies and color trans. with captions/ms. Edited to interests of Michigan nature lovers, sportsmen, hunters, snowmobilers, trail hikers, fishermen, etc. Rates vary. Pays on pub. Enclose S.A.S.E. with queries/submissions.

Michigan Snowmobiler, 207 Main St., East Jordan, Mich. 49727. Mo. Sample copy 35¢. Buys photos to illustrate articles on snowmobile travel, equipment, maintenance, races, club activities, related subjects. Query first. Rates negotiable. Enclose S.A.S.E.

National Sportsman's Digest (Nat. Sportsman's Club, Inc.), 12011 Coit Rd., Box 2003, Dallas, Tex. 75221. Buys color trans. with captions/ms and for cover use. Accent on big game locales, hunting procedures, species, seasons, regulations, related subjects. Rates vary with subject, length, quality of material. Best to query after studying publication. Enclose S.A.S.E.

Northeast Outdoors, 90 Church St., Naugatuck, Conn. 06770. Mo. Sample copy on request. Emphasis on family camping, outdoor activities, wide range of related subjects and sports. Uses b&w pix as captioned singles, photo features, article illus. Uses 35mm & larger trans. for covers. Study magazine, then query. Rates vary. Enclose S.A.S.E. with all submissions.

Northwest Skier, 903 N.E. 45th St., Seattle, Wash. 98105. Biwk. Sample copy, 35¢. Buys pro-quality b&w glossies and color trans. with captions/text. Wide range of winter sports activities besides skiing. Readership interest centers upon Pacific Northwest and Western Canada, but unusual settings outside area (foreign, etc.) occasionally purchased. Rates negotiable. Query first, enclosing S.A.S.E.

Outdoor Life, 355 Lexington Ave., New York, N.Y. 10017. Mo. Write for free guideline sheet, then study recent issues for broad subject coverage and demanding style (authoritative facts, etc.). Pays top rates for top-rate material; buys b&w glossies and color trans. preferably with ms as well as captions. Outdoor activities, hunting, fishing, true adventures, woodcraft, how-to methods, equipment choices and maintenance, conservation—many other subjects considered. Query first, enclosing contact sheets and text outline if possible. Enclose S.A.S.E. with all submissions.

Outdoors, Outdoors Bldg., Columbia, Mo. 65201. Guideline sheet on request. Uses pro-quality b&w glossies with captions/ms. Accent is on boating, water-skiing, how-to, where-to-go, camping, outdoor recreation and related subjects—all with tie-in to use of Mercury outboard motors used with power boats. Uses b&w quality photos (glossies in 8×10 preferred) with factual captions/ms. Human interest, action, family involvement welcome. Pays on acc. Query first. Enclose S.A.S.E.

Par Magazine, 200 W. 57th St., New York, N.Y. 10019. Pub. nine times per year. Slanted to interests of average golfers—how-to, pro tips, personality profiles, etc. Photos bought with factual captions/ms. Rates vary. Enclose S.A.S.E. with all correspondence and submissions.

Pennsylvania Angler, c/o Pennsylvania Fish Commission, Harrisburg, PA 17120. Mo. Buys b&w glossies with captions/ms. Uses color trans. for covers. Emphasis on how and where to enjoy fishing, boating, camping, etc. in Pa. Also uses some material on ecology, conservation. Study free sample copy available upon request, then query. Prices vary—up to $150 for color covers. Best to query first. Enclose S.A.S.E. with all submissions.

Pennsylvania Game News, Box 1567, Harrisburg, PA 17120. Mo. Sample copy to photojournalists on request. Study for coverage and style. Buys b&w glossies with captions/text. Accent on outdoor camping, game hunting, equipment, maintenance, archery, nature. (Not fishing.) Query first, enclosing S.A.S.E. Rates vary.

Rifle Magazine, The, Box 3030, Prescott, Ariz. 86301. Bimo. Buys pix with accurate and detailed captions/ms as package deal. Readers are highly knowledgeable gun enthusiasts, so study publication ($1 per copy) thoroughly

for subject depth and presentation style. Best to query first, enclosing outline of coverage and photo possibilities. Rates vary. Pays on pub. Send S.A.S.E. with queries/submissions.

RX Sports And Travel (RX Golf and Travel, Inc.), 447 S. Main St., Hillsboro, Ill. 62049. Bimo edited to interests of physicians and their use of recreational time. (No medical or related subjects considered.) Travel, sports, outdoor activities, where-to-go and what-to-enjoy there on vacation. B&w pro glossies with identified captions or factual data, $10 and up. Color trans. also used; rates hinge upon subject, quality, length. Query first. Enclose S.A.S.E. with all submissions.

Senior Golfer, Box 4716, Clearwater, Fla. 33518. Quarterly. Pro photojournalists may obtain sample copy on request. Buys b&w glossies with captions/ms of subjects of interest to nonpro, senior age golfers. Study contents, then query, enclosing S.A.S.E. Rates vary. Pays on acc.

Shooting Times, News Plaza, Peoria, IL 61601. Free sample copy on request to pro photojournalists. Buys 8×10 glossies singly or in series with detailed, accurate caption/text data. Contributor must know subject matter thoroughly; magazine is largely read by pro and semipro workers and firearms enthusiasts. Special issues in Feb., March. Study, then query. Uses wide range of guns, ammunition, reloading, major shooting sports material. Enclose S.A.S.E. Rates vary.

Skating, 178 Tremont St., Boston, Mass. 02111. Mo. Sample copy to pro photographers on request. B&w glossies purchased with captions/ms. Covers interests of amateurs, pro figure and exhibition skaters, etc. Query first, enclosing S.A.S.E.

Ski Magazine, 235 E. 45th St., New York, N.Y. 10017. Oct.-March. B&w and color snow scenes, ski resorts, action shots of prominent skiers. Rates vary according to quality. Pay on pub.

Skier, United States Eastern Amateur Ski Assn., 20 Main St., Littleton, N.H. 03561. Six times/year (Oct.-March). Scenics and action pix of subjects related to skiing. Also buy color trans. for cover. B&w $5-10; color cover $50.

Skiing, One Park Ave., New York, N.Y. 10016. Mo. Sept. to Mar. Action, aprés ski life, pro racers. B&w. $100 page. Color, $125 page. Pay on pub.

Skiing Illustrated, Box 307, Abbotsford, B.C., Canada. Three issues each winter. Buys b&w glossies with captions/ms on all aspects of skiing, resorts, travel, limelight personalities, techniques, adventures, etc. Study magazine, then query. Rates vary. Pays on pub. Enclose Int'n Reply Coupons with submissions.

Skin Diver, see Part 18.

Snow Goer, 1999 Shepard Rd., St. Paul, Minn. 55116. Sept.-Feb. Buys b&w glossies with captions/ms. Some color trans. for cover use. Slanted to interests of snowmobile users—travel, pleasures, some racing coverage, etc. Query. Enclose S.A.S.E. Rates variable.

Snow Sports, 1500 E. 79th St., Minneapolis, Minn. 55420. Six issues per year, beginning in Aug. Sample copy 50¢. B&w glossies bought with captions/ms. Occasional color trans. for covers. Rates vary; pays one mo. after acc. Accent on snowmobiling pleasures, races, how-to, and related subjects of interest to whole families. Study copies first, then query. Enclose S.A.S.E. Rates vary.

Sport, 205 E. 42nd St., New York, N.Y. 10017. Mo. Edited to interests of spectator fans from late teens to mid 30's. Staff covers most routine subjects. Occasional market for off-beat photos with captions or basic text data. B&w, $15; accepted color trans. $50 plus regular page rate; cover trans., $250. Require pro-quality photos/copy. Best to query. Enclose S.A.S.E. with submissions.

Sport Magazine, 575 Lexington Ave., New York, N.Y. 10022. Mo. B&w action pix; color shots of sports personalities. B&w $10-25; inside color $50; color covers $100-$500. Pay on acc.

Sport Scene, 444 Madison Ave., New York, N.Y. 10022. Bimo. Sample copy, 50¢. Uses b&w glossies with captions/ms. Color trans. purchased for covers. Emphasis on dramatic spectator sports events, games, etc. Study current issues, query first. Rates vary with material and quality. Pays on acc. Enclose S.A.S.E.

Sportfishing, Yachting Pub. Corp., Rm. 600, 50 W. 44th St., New York, N.Y. 10036. Mo. from Jan.–June; bimo July-Dec. Sample copy to photographers on request. Emphasis on dramatic salt- and fresh-water fishing with authentic documentation and how-to tips. Buys 8×10 glossy prints with factual captions singly and in series, preference runs to photo/text package deals. Rates vary. Pays on acc. Enclose S.A.S.E. with queries/submissions.

Sports Afield, 575 Lexington Ave., New York, N.Y. 10022. Mo. B&w and color action pix on hunting, fishing, boating, camping; single or in series, b&w $10 and up; color (min. size trans. 2¼×2¼, prefer larger) $50 and up. Pay on acc.

Sports Canada, 88 Argyle Ave., Ottawa, Canada. Mo. Sample copy, 50¢ in Int'n Reply Coupon. Uses b&w glossies (8×10) and color trans. of general sports activities. Study contents and style, then query. Rates from $10 in b&w to $50 for color trans. Pays on acc. Enclose Int'n Reply Coupon and self addressed envelope with submissions.

Sports Digest, Suite 1706, 999 S. Bayshore Dr., Miami, Fla. 33131. Mo. Best approach is to obtain current copies and study subjects, presentation, style, etc. Queries not encouraged. Uses some b&w with captions/text, but seems to prefer color. As of this writing, we have no confirmation of editorial preferences, rates, etc.

Sports Illustrated, Time-Life Bldg., Rockefeller Center, New York, N.Y. 10020. Heavily staff prepared. Will consider some outside freelance offerings, but leans heavily on photo-writer combos. Prefers ms or outline thereof before negotiating over pic/copy packages. Requires top quality; good rates on acc.

Texas Parks And Wildlife, John H. Reagan Bldg., Austin, Tex. 78701. Mo. Color pix for covers only (trans.); b&w glossy photos of Texas game, hunting, and related subjects purchased only with captions/ms. 2¼×2¼ photos, $45. Pays on pub. Enclose S.A.S.E.

Turf and Sport Digest, 511-513 Oakland Ave., Baltimore, Md. 21212. Mo. B&w pix to illustrate ms on thoroughbred horse racing. Color pix of racing including famous jockeys, thoroughbred horses and turf personalities. B&w $7; color covers (min. size trans. 2¼×2¼) $75-100. (Pay on acc.)

Virginia Wildlife, Box 11104, Richmond, VA 23230. Sample copy on request. Buys b&w glossies with captions/ms only; uses 4×5 color trans. for covers. Rates vary. Subject coverage emphasis on Virginia wildlife, conservation, factual hunting and fishing material. Query first, enclosing S.A.S.E.

Western Ski Time, companion publication with similar photo requirements and payment range as **International Sportsman** (above).

Woman Bowler, The, 1225 Dublin Rd., Columbus, OH 43215. Edited to interests of WIBC members of all ages. Sample copy on request. Buys b&w glossies with captions/ms on women bowlers, competitions, senior citizens, interesting personalities, etc. Pays on acc. Rates vary. Enclose S.A.S.E. with queries/submissions.

20. Regional, Outdoor Living, Travel

Also see Parts 1,3,8,9,10,12,17,18, and 19.

Alaska Journal, 422 Calhoun Ave., Juneau, AL 99801. Quarterly. Buys b&w and color trans. only with captions/ms. Material must be authentic, well-documented. Edited to readers interested in general history and related material pertaining to Alaska, Canada, Yukon area. Rates vary; pays on pub. Query, enclosing S.A.S.E.

American West, The, 599 College Ave., Palo Alto, Calif. 94306. Bimo. Buys b&w and large size color trans. with captions/ms. Send for free copy of guidelines. Requires accurate, well-documented material dealing with history, personalities, related material for readers largely located west of the Mississippi. Also uses some western scenics. Rates vary. Query, enclosing S.A.S.E.

Arizona Highways, 2039 W. Lewis, Phoenix, Ariz. 85009. Mo. Buys mainly color trans. but also some b&w 8×10 glossies on travel, scenes, history, economic development of Arizona. Rates vary with subject, length, quality. Considered by many top photographers a "showcase" publication in which prestige is worth as much or more than payment they receive. Enclose S.A.S.E. with all queries/submissions.

Atlanta, 1104 Commerce Bldg., Atlanta, GA 30303. Mo. Sample copy, $1. B&w glossies and color trans. purchased only with captions/text. Important to study style and coverage first, then query. Readership predominently male. Enclose S.A.S.E. with queries/submissions. Pays on pub. Rates vary.

Automobilist, The, 1047 Commonwealth Ave., Boston, Mass. 02215. Quarterly edited to interests of members of the ALA Auto & Travel Club. Sample copy to pro photographers on request. B&w glossies purchased with captions/ms. Subjects include wide range, most features emphasizing New England locales. Up to $20 per b&w. Query, enclosing S.A.S.E.

Better Camping, 500 Hyacinth Place, Highland Park, Ill. 60035. Sample copy to pro photographers on request. Edited to interests of campers of all ages, loners, family groups, etc. Prefers meaty, informative tips of pertinent value to both beginner and experienced campers. Buys b&w glossies and color trans. 2¼×2¼ or larger. Rates vary per page for

inside material; color covers to $150. Pays on acc. Query, enclosing S.A.S.E.

Better Homes And Gardens Travel Ideas, 1716 Locust St., Des Moines, IA 50314. Annual; sample copy, $1.35. Magazine is best guide to material needed in family travel, scenics, etc. Pay varies on acc. (Rates good.) Query first with S.A.S.E.

Bon Voyage Magazine, 4700 Belleview, Kansas City, MO 64112. Bimo. Sample copy, 50¢. Edited to interests of sophisticated, middle-aged, affluent readership. Best bet is to study magazine for style and coverage. Buys b&w glossies and color trans. with captions/ms, occasionally photo-essay style in series. Query first, enclosing S.A.S.E. Rates vary. Pays on pub.

Camper Coachman, Box 500, Calabasas, Calif. 91302. Mo. Slanted to interests of camper owners. Wide range of coverage interests. Buys b&w and color trans. preferably with captions/ms. Study magazine first, then query with S.A.S.E. Rates vary with use, quality, length. Pays on pub.

Camping Guide, Rajo Pubs., 319 Miller Ave., Mill Valley, Calif. 94941. Mo. Prefer b&w glossies with ms/captions; occasionally buys color. Material on family camping equipment, how-to tips, etc. in greatest demand, but wide range of other subjects also used. Most purchases are for package deal (photos/text), but color trans. for covers (min. size $2^{1}/_{4} \times 2^{1}/_{4}$) average about $50. Query, enclosing S.A.S.E.

Camping Journal, 229 Park Ave. South, New York, N.Y. 10003. Mo. Sample copy to pro photographers on request. Buys b&w 8×10 glossies with captions/ms. Study magazine first for coverage and style. Then query. Rates vary, pays on acc. Enclose S.A.S.E.

Chevron USA, Box 6227, San Jose, CA 95150. Quarterly. Edited to interests of Chevron Travel Club. Important to study sample copy, which is available to pro photojournalists on request. Buys top-quality b&w glossies in 8×10, color trans. from 35mm up (larger preferred). Rates variable, but good, depending on subject, length, quality. Pays within two months of acc. Query first with S.A.S.E.

Chicago Guide, The, 500 N. Michigan Ave., Chicago, Ill. 60611. Mo. Sample copy, 75¢. Slanted to interests of 30–50 age group, affluent, educated, sophisticated tastes. Material mostly of Chicago and immediate area interests. Buys b&w color with captions/ms as package deals. Rates vary with quality, length, usage. Query first. Enclose S.A.S.E. with queries/submissions.

Colorado Magazine, 7190 W. 14th Ave., Denver, Colo. 80215. Published six times per year. Edited to interests of readers in Rocky Mountain area of Wyo., Mont., Utah, New Mex., and especially Colorado. Wide range of coverage —scenics, history, ecology, sports, recreation,

etc. Photos preferred with captions/ms. Best to study publication to note featurettes, covers, photo spreads, etc. Uses trans. $2^{1}/_{4} \times 2^{1}/_{4}$ and larger. Rates vary. Pays on acc. Query first with S.A.S.E.

Cue, The Weekly Magazine Of New York Living, 20 W. 43rd St., New York, N.Y. 10036. Wk. Emphasis on photos with captions/ms of interest to sophisticated, well-educated, affluent readers in N.Y. metro. area. Best to study first, then query. Rates good on pub. Send S.A.S.E. with all queries/submissions.

Desert Magazine, Palm Desert, Calif. 92260. Mo. Sample copy to pro photographers on request. Emphasis on family travel, recreation, etc. in historic or otherwise interesting back-country areas. Wide coverage of subjects from nature and plantlife to tour trips, camping tips. Study, then query. Prefers pix with captions/text. Uses b&w quality glossies and color trans. (min. size $2^{1}/_{4} \times 2^{1}/_{4}$). Wants vertical format of color. Rates vary. Include S.A.S.E. with queries/submissions.

Down East Magazine, Down East Enterprise, Inc., Camden, Me. 04843. Pix and illus. articles of Maine scenes and activities—water sports, camping, hunting, travel highlights, human interest. B&w $3–5; pic. stories $3–5 per pic.; color (min. size trans. 4×5) $25. Pay on acc.

Fairfield County Illustrated, 45 Riverside Ave., Box 269, Westport, Conn. 06880. Mo. Special issues seasonally. Sample copy on request. Buys b&w glossies and color trans. with captions/ms. Primarily local-interest subjects but enough general historical, personality, general material to interest nonarea residents. Rates vary on pub. Query first with S.A.S.E.

Family Houseboating, Box 500, Calabasas, Calif. 91302. Bimo. Sample copy to photojournalists on request. Accent on various types of photo-illustrated articles of interest to owners and would-be owners of houseboats. Study, then query. Prefers package photo/text package deals. Rates vary. Enclose S.A.S.E.

Frontier Times, Box 3338, 1012 Edgecliff Terrace, Austin, Tex. 78704. Bimo. Uses b&w glossies inside, vertical format color trans. covers. Factual, interesting, well documented text/photo pieces on Western life circa 1910 back to 1830. Study copies, then query. Rates vary on acc. Enclose S.A.S.E. with queries/submissions.

Georgia Mazagine, Box 1047, Decatur, GA 30031. Mo. Sample copy, 60¢. Buys b&w glossies with captions/ms. Rates vary. Subject matter ranges from travel and interesting profiles to business operations and historical pieces. All should be about or related to Georgia locales. Enclose S.A.S.E. with submissions.

Los Angeles Magazine, 342 N. Rodeo Dr., Beverly Hills, Calif. 90210. Mo. Buys pro-quality b&w glossies with captions/ms, approx

$15 ea. Uses color trans. covers, min. size $2^{1}/_{4} \times 2^{1}/_{4}$, $100 and up. Edited to interests of metro/urban readership in L.A. area. Human interest, recreation, contemporary living, etc. Readership is largely well-educated and affluent. Enclose S.A.S.E with all queries/submissions.

Maryland Magazine, Rm. 409, State Office Bldg., Annapolis, Md., 21401. Quarterly. Guidelines sheet sent on request. Broad range of subject coverage on history, industry development, ecology, natural resources, outstanding personalities—all related to interests of Maryland residents. Pays on pub. Buys b&w glossies with captions/ms (will judge from contact sheets); color trans. from 35mm up, larger sizes preferred. Rates vary.

Metropolitan Hampton Roads Scope Magazine, Box 7088, Norfolk, VA 23509. Mo. Sample copy to pro photographers on request. Buys 8×10 glossies with captions/ms. Color cover trans. (min. $2^{1}/_{4} \times 2^{1}/_{4}$) up to $100. Emphasis on carefully researched and documented material of interest to readership in Hampton Roads area comprised of six cities, and eastern Virginia overall area. Study first, then query with S.A.S.E. Pay on package deals varies on publication.

Minnesota Motorist, 7 Travelers Trail, Burnsville, Minn. 55378. Mo. (AAA publication.) Buys b&w 8×10 pro-quality glossies, $10 and up; 4×5 color cover trans., $75. (Will also consider exceptional $2^{1}/_{4} \times 2^{1}/_{4}$ trans.) Pix should be accurately captioned. Also buys photo-series stories with captions/ms. Subject range emphasizes travel, car care, hunting/fishing/camping equipment and how-to material, etc. Query first, enclosing S.A.S.E.

Missouri Highways, Highway Comm. Bldg., Jefferson City, MO 65101. Bimo. Sample copy on request to pro photographers. Buys b&w 8×10 glossies with captions/ms. Accent on Missouri travel, people, environmental changes, etc. Rates vary. Pays on pub. Send a S.A.S.E. with queries/submissions.

Montana West (Magazine Of The Northern Rockies), Box 894, Helena, Mont. 59601. Quarterly. Sample copy to pro photographers on request. Heavy user of well-reproduced color. Buys trans. from 35mm up in size with authentic captions/ms. Wide range of coverage, chiefly Montana locale but also occasional pieces on nearby states—nature, wildlife, ecology, outdoor travel, camping, sports, etc. Rates vary. Pays on pub. Enclose S.A.S.E.

Motor News, 150 Bagley Ave., Detroit, Mich. 48226. Buys 8×10 glossies with captions/ms. Very wide range of subject coverage includes not only Michigan area material but also special issues on other areas and specific subjects (such as Outdoors and Camping issue in March). Study coverage, style, use of pix. Prices vary and are negotiable on outstanding material. Repeat: Study first, then query with

229

specific photojournalistic outlines. Enclose S.A.S.E. on all queries/submissions.

My Golden West, 1509 8th St., S.W., Calgary 3, Alberta, Canada. Quarterly. Buys only b&w glossy pix with captions/ms. Subject coverage both Canadian and American West, send Int'n Reply Coupon (65¢) for sample copy, and with all submissions. Rates vary on pub.

Nation's Motorist, 65 Battery St., San Francisco, Calif. 94111. Buys photos only with captions/ms. Study first, then query. Price varies with subject, handling, quality. 8×10 b&w glossies, $10 and up. Color trans., $25 and up. Enclose S.A.S.E.

Nevada Highways and Parks, Nevada Highway Dept., Carson City, Nevada 89701. B&w and color pix and pic. stories; scenics. pic. stories on Nevada subjects—national parks, shrines, travel, sports, wildlife, flowers, historical subjects. B&w (4×5 and up) rates vary; color (min. size trans. 2¹/₄×2¹/₄) rates vary.

New England Guide, The, P.O. Box 108, Concord, N.H. 03301. Annual. Pix of New England scenes, historic sites, old buildings including interiors; old signs, prints, impressions. Primarily for vacationers in N.E. B&w $5 per column, pic. series negotiated; color (4×5 min.) negotiated. Enclose S.A.S.E.

New Hampshire Profiles Magazine, N.H. Profiles Corp., P.O. Box 900, Portsmouth, N.H. 03801. Mo. Picture Editor: Paul E. Estaver. B&w and color pix and pic. stories of New Hampshire activites, scenics, etc. Query for possible assignment. B&w $5; pic. stories $50–100; color cover (4×5 trans.) $25–50.

New Mexico Magazine, 113 Washington Ave., Santa Fe, N.M. 87501. Bimo. Buys b&w pro-quality glossies (8×10) and color trans. dealing with any New Mexico subject (people, scenery, etc.). Editors encourage innovative, experimental photography. Nearly everything assigned to established pro photographers, but will consider portfolios from talented newcomers. Use mostly color, but also interested in creative b&w. No straight newspaper photography. B&w up to $30 ea. Color (primarily 35mm) up to $36 ea. Assignments up to $200, occasionally more. Mileage, expenses, film and processing paid on assignments. Address all queries and submissions with S.A.S.E. to Associate Editor.

New South, 5 Forsyth St., Atlanta, GA 30303. (Publication of Southern Regional Council.) Quarterly. Sample copy on request to pro photographers. Primarily edited to interests of Southerners of all ages, races, creeds. Emphasis on civil rights, race relations, education, environmental problems and solutions, development of the South. Study, then query. Rates vary. Enclose S.A.S.E. with queries/submissions.

North Carolina Coastal & Vacation Guide, 418 S. Dawson St., P.O. Box 9118, Raleigh, N.C. 27603. Annual. Editor: Braxton Flye. B&w and color pix on N.C. coastal subjects. B&w $6; color (2¹/₄×2¹/₄ and up) $15–100. Queries welcomed.

Ohio Motorist, 6000 S. Marginal Rd., Cleveland, OH 44103. Mo. Pro photographers may obtain sample copy free. B&w glossies (8×10) purchased with captions/ms. Wide subject coverage of U.S. and foreign travel, cars and maintenance, hotels and motels, Ohio scenery, etc. Best to study, then query with S.A.S.E. Rates vary.

Outdoor Arizona, 1103 N. Central, Phoenix, Ariz. 85004. Mo. Sample copy, 50¢. Buys b&w glossies and color trans. with captions/ms. Bulk of contents have Arizona slant—camping, travel, how-to, historical sites, conservation, flora and fauna, etc. Study, then query with S.A.S.E. Rates vary; pays on pub.

Ozarks Mountaineer, The, Box 646, Forsyth, MO 65653. Published 11 times per year. Pro photographers should request sample copy on letterhead or with business card; study before submitting with S.A.S.E. Buys b&w glossies and color trans. 35mm and up in size. Must be accompanied by factual captions/ms. Subjects have regional slant—wildlife, travel, history, natural resources, some history pieces, interesting profiles, human interest, etc. Rates vary.

Pacific Discovery, California Academy of Sciences, Golden Gate Park, San Francisco, Calif. 94118. Pub. six times per year. Pro photographers should send 75¢ for sample copy and request guideline sheet. Latter details subject/photo needs.

Passport—For Canadians Going Places, 228 Bloor St. West, Toronto 5, Ont., Canada. Bimo. Sample copy, 50¢ in Int'l Reply Coupon. Magazine title offers the key to subject matter, but study style and presentation first, then query. Uses b&w glossies and 35mm and larger (preferably 2¹/₄×2¹/₄) trans. with captions/ms. Rates negotiable. Enclose S.A.S.E. with Int'n Reply Coupon.

St. Croix Guide, 4A Caravelle Arcade, Christiansted, St. Croix, Virgin Islands (USA) 00820. Annual. Sample copy, $1. Slanted to interests of tourists and covers Caribbean/Florida area. Buys photos (color trans. only) from 35mm up with preference for 2¹/₄×2¹/₄ up. Must be accompanied with factual captions/ms. Some Caribbean scenes also used for postcards. Rates vary. Query, enclosing S.A.S.E.

San Diego Magazine, 3254 Rosecrans, San Diego, Calif. 92110. Sample copy, $1. Photos purchased with captions/ms on travel, regional, cultural interest to readership in Southern Calif. and Mexico. Study, then query, enclosing S.A.S.E. Rates vary on publication.

San Francisco Magazine, 120 Green St., San Francisco, Calif. 94111. Mo. Buys pro-quality 8×10 glossies with captions/ms only, rates $15 min. ea. Accent on local historical, contemporary subjects, exposes, social interest topics for S.F. readership. Pays on pub. Enclose S.A.S.E. with queries/submissions.

Scenic South, Box 1446, Louisville, KY 40201. Bimo. (Standard Oil Co. publication.) "Photos—$10 to $15 for use of black and white (8×10) glossy prints preferred with identification captions only. Subjects must be Alabama, Florida, Georgia, Kentucky, Louisiana, Mississippi, S. Carolina, Tennessee." Also used are pro-quality color trans. (min. size 2¹/₄×2¹/₄). Model releases required where necessary. Pays on acc. Enclose S.A.S.E.

South Carolina Magazine, Box 89, Columbia, S.C. 29202. Mo. Copy to pro photographers on request. Buys glossy b&w photos with captions/text. Travel, history, industries, nature, topics of interest to area readership. Enclose S.A.S.E.

Southern Living, 821 N. 19th St., Birmingham, Ala. 35202. Mo. Sample copy to pro photojournalists on request. Buys top-quality pix with captions/ms only. Subjects cover wide range of topics from travel, food, and recreation, to gardening—all slanted to southern living and readership. Rates vary on acc.; $25 up on b&w, $100 to $300 for color trans. depending upon quality and use. Enclose S.A.S.E.

Spectrum, 407 Security Bank Bldg., Sioux City, IA 51101. Mo. Pro photojournalists may obtain sample copy for S.A.S.E. B&w glossies with factual captions/text slanted to interests of readers in Sioux City and surrounding area. Study first, then query on specific subjects. Rates vary. Enclose S.A.S.E.

Sunset Magazine, Menlo Park, Calif. 94025. Mo. Uses b&w glossies (will judge from contact prints) on topics such as travel, gardening, crafts, etc. primarily with western-area locale of Rocky Mountain states and Hawaii. Query first, enclosing S.A.S.E.

Texas Metro Magazine, Drawer 1166, Arlington, Tex., 76010. Mo. Sample copy to photojournalists on request. Wide coverage of topics of interest to residents of north-central Texas; also special section for surrounding states. Travel, nature, human interest, etc. Rates vary on length, quality, usage. Query, enclosing S.A.S.E.

Texas Parade, Box 12037, Austin, Tex., 78711. Mo. Sample copy on request. Buys 8×10 pro-quality photos with captions/ms. Coverage includes Texas-slanted articles on travel, history, outdoors, nature, sports, business and industries. Photos $10 and up. Enclose S.A.S.E. with submissions.

Trailer Topics Magazine, 28 E. Jackson Blvd., Chicago, IL 60604. Mo. Buys only b&w pix with captions/ms. Coverage includes trailer parks, trailer life, interiors with human interest angle, scenics for cover. Low rates on pub. Enclose S.A.S.E.

Travel, Travel Bldg., Floral Park, N.Y. 11001. Mo. Copy 50¢. B&w captioned human interest shots which illustrate specific articles of identifiable places; i.e., Eiffel Tower, London Tower, etc. Photos purchased with text as package deals, $100 to $200 with color trans. Enclose S.A.S.E. with submissions.

Trip And Tour, Allied Pubs., Inc., Box 23505, Ft. Lauderdale, Fla., 33307. Bimo. Buys b&w photos with captions/ms. Emphasis on travel outside USA. Enclose S.A.S.E. with queries/submissions.

Vacation and Travel Service, Wisconsin Dept. of Natural Resources, P.O. Box 450, Madison, Wis. 53701. Color trans. B&w negatives (no prints). Prefer 4×5 negs. and trans. Subjects to publicize Wis. recreational advantages only. Scenics, news, human interest, sports. Model releases important. Rates quoted immediately upon receipt of acc. material.

Vacations Unlimited, 112 N. University Dr., Fargo, N.D. 58102. Sample copy $1. Semiannual published primarily for members of Vacation Travelers Association. Requires pro-quality b&w glossies and color trans. with captions/ms. Very wide range of subject interests best understood by careful study of publication itself. Rates vary with length, subject, quality. Enclose S.A.S.E.

Vermont Life Magazine, 63 Elm St., Montpelier, VT 05602. Quarterly. Buys b&w pro glossies and color trans. (35mm to 4×5 size) with captions/ms only. Edited to interests of readership in Vermont and adjacent area. Study magazine, then query. B&w, $10. Inside color $50; covers $100. Enclose S.A.S.E. with all queries/material.

Washington Magazine, 1218 Connecticut Ave., N.W., Washington, DC 20036. Mo. Sample copy, $1. B&w pro-quality glossies and color trans. purchased with captions/ms from $15 to $100. Pays on acc. Edited to interests of residents of Washington DC and adjacent areas. Wide range of subjects best understood by studying the magazine. Enclose S.A.S.E. with submissions.

Western Gateways Magazine, Box 269, Palm Desert, Calif. 92260. Photojournalists may obtain free sample copy. Buys pro-quality 8 × 10 glossies and trans. 2¹/₄ × 2¹/₄ and larger with captions/ms. Rates vary with subject, length, quality. Emphasis is on what to see and do in four-corner states of Colo., Ariz., Utah, New Mexico. Occasionally buys captioned photo-feature story spreads. Query first. Enclose S.A.S.E.

Western Homes And Living, 1012 Hornby St., Vancouver, B.C., Canada. Photos purchased only with captions/ms. Uses b&w glossies at $10 and up, color trans. up to $50. Emphasis on regional interests of readers in western Canada—homes, recreation, travel, history, wildlife, etc. Query first. Enclose Int'n Reply Coupon with submissions.

Westways, 2601 S. Figueroa St., Los Angeles, Calif. 90054. Mo. Captioned or with text photo stories on unusual, scenic, historic, contemporary events in 13 western states, British Columbia, Alberta, Mexico. B&w, $25. Color trans. (35mm and larger) $50 to $200. Query first. Pays on acc. Enclose S.A.S.E.

Wheeled Sportsman Magazine, The, 1105 Madison St., Red Bluff, Calif. 96080. Mo. Buys b&w glossies and color trans. with captions/ms. Variable prices on pub. Wide coverage of subjects from recreational vehicles to sophisticated mobile homes. Accent on pleasure-use vehicles. Query first. Enclose S.A.S.E.

Wheels Afield, 8490 Sunset Blvd., Los Angeles, Calif. 90069. Mo. Guidelines sheet upon request. Buys b&w glossies with captions/ms. Also color trans 2¹/₄×2¹/₄ and larger. Edited to interests of recreational vehicle users, camper and tent trailers, travel, etc. Rates vary on pub. Query first. Enclose S.A.S.E.

Wilderness Travel Magazine, 1105 Madison St., Red Bluff, Calif. 96080. Buys some b&w glossies and color trans. with captions, rates range up to $100 for color covers. Emphasis is on nonvehicular outdoor activities—canoeing, horseback riding/pack trips, wildlife observation, rock hunting, ecology, conservation, how-to illustrated articles, tips. Pays on pub. Query. Enclose S.A.S.E.

Wisconsin Trails, 6120 University Ave., Madison, Wis. 53705. Quarterly. Buys b&w glossies, $10; 2¹/₄×2¹/₄ color trans., $50. Sample copy on request. Emphasis on Wisconsin area nature, sports, industry, history, folklore, environment, etc. Has certain taboos, so query first, enclosing S.A.S.E.

Woodall's Trailer Travel Magazine, 500 Hyacinth Pl., Highland Park, Ill. 60035. Mo. Sample copy, 50¢. Buys photos and photo stories on wide range of topics related to family trailer travel and camping, motor homes, recreational vehicles, maintenance, equipment, etc. Query first, enclosing S.A.S.E.

Yankee, Inc., Main St., Dublin, N.H. 03444. Mo. Sample free to working photojournalists. Buys 8×10 pro-quality b&w and some color trans. (min. size 2¹/₄×2¹/₄) only with factual captions/ms. Accent is on New England and its residents—past or future if there is a contemporary tie-in. Best to study style and coverage, then query. Pays on acceptance; rates vary with length, subject, quality of photos and text, etc. Enclose S.A.S.E. with all submissions.

21. Religious Publications—Adult

Many of the following publishers produce photo-illustrated materials not included by name in this listing. A query accompanied by cash or stamps to help cover mailing costs will usually result in sample copies and/or complete title listings.

Additional markets also appear in Parts 7 and 17. Some stock-photo agencies (see Part 22) are regular suppliers to religious publications edited for readers of all ages.

American Atheist Magazine, The, Box 2117, Austin, Tex. 78767. Quarterly; sample copy on request. Buys b&w pix with captions/text. Edited to well-educated readership interests. Rates vary. Pays on pub. Enclose S.A.S.E.

American Review Of Eastern Orthodoxy, 1908 Hwy. 17-92 Fern Park, Fla. 32730. Pub ten times per year. Sample copy on request. Buys b&w glossies only with captions/text. Historical, profiles, personalities, exclusively

Eastern Orthodox orientation. Pays on acc. Enclose S.A.S.E.

Annals Of Good St. Anne, Basilica of St. Anne, Que., Canada. Mo. Sample copy on

request. Uses b&w glossies only with captions/text as singles or in series. Catholic subject matter, human interest, activities, etc. B&w rates vary. Occasional color trans. for up to $40. Study contents, then query. Enclose Int'n Reply Coupon with submissions.

Arkansas Baptist Newsmagazine, 525 W. Capitol Ave., Little Rock, Ark., 72201. Wk. Edited to interests of Baptist family life and activities in Arkansas. B&w photos with captions/ms. Rates vary on pub. Enclose S.A.S.E. with queries/submissions.

Baptist Leader, Valley Forge, PA 19481. Mo. Copy on request. Edited to needs and interests of ministers, teachers, students in Baptist Church schools/organizations. B&w photos of Church activities, seasonal events, etc. purchased with captions/ms. Rates vary on acc. Enclose S.A.S.E.

Baptist Men's Journal, 1548 Popular, Memphis, Tenn. 38104. Quarterly. Human interest, Baptist Christian activities and missions, etc. edited to interests of Baptist men. Buys b&w glossies with captions/ms. Pix up to $10 ea. Pays on acc. Enclose S.A.S.E. with queries/submissions.

Canadian Churchman, 600 Jarvis St., Toronto 5, Canada. Mo. Sample copy on request. Accent on general religious aspects of teenage and adult life. B&w 8×10 glossies with captions/ms only. Pays $10 ea. and up. Enclose Int'n Reply Coupon with submissions. Pays on pub.

Catholic Digest, The, Box 3090, St. Paul, Minn. 55101. Mo. Buys b&w glossies (8×10) with captions/ms singly or in photo features. Color trans. for cover use only. Religious themes—people, children, Catholic events/activities, strong family appeal in photos of children/adults. Up to $150 per b&w series; $100–150 for covers. Pays on acc. Query first. Enclose S.A.S.E.

Chaplain, The, 122 Maryland Ave., N.E., Washington, DC 20002. Bimo. Sample copy on request. Edited to interests of interfaith chaplains and civilian clergymen. Personality biographics, human interest, domestic and foreign activities. Uses b&w glossies with captions/ms. Rates vary. Query. Enclose S.A.S.E.

Christian, The, Box 179, St. Louis, Mo. 63166. Wk. Editor: Howard E. Short. B&w pix of scenery, young adults and adults; religious pix. Pay $4.50 on acc.

Christian Advocate, The, Box 423, Park Ridge, Ill. 60068. Biwk. Uses b&w glossies with captions/text, $7.50. Query first. Enclose S.A.S.E. with submissions. Pays on acc.

Christian Century, The, 407 S. Dearborn St., Chicago, Ill. 60605. Wk. Buys b&w glossies

with captions/ms. Edited to interests of clergy and laymen of all faiths. Pays on pub. up to $35. Enclose S.A.S.E. with queries/submissions.

Christian Herald, 27 E. 39th St., New York, N.Y. 10016. Mo. Send for guideline sheet. Uses 8×10 b&w glossies with captions/ms of interdenominational interest. Rates vary on acc. Enclose S.A.S.E. with queries/submissions.

Christian Home, Methodist Pub. House, 201 Eighth Ave. S., Nashville, Tenn. 37203. Mo. Human interest pix of children and adults. B&w $6; cover (color, min. color trans. 4×5) $50. Pay on acc.

Christian Life Magazine, Gundersen and Schmale Drives, Wheaton, Ill. 60187. Mo. Buys b&w glossies with captions/ms of religious news or other significant events—Christian family life, school/college developments, etc. Best to send for sample copy and study first. Rates vary. Enclose S.A.S.E. with queries/submissions.

Christian Science Monitor, The, One Norway St., Boston, Mass. 02115. Daily. Buys b&w glossies of pro quality of general human interest and for "People Page." Study first. Pays up to $10 per photo with caption. Pays on acc. Enclose S.A.S.E.

Church Herald, The, 146 Division Ave., N., Grand Rapids, Mich. 49502. Wk. B&w photos with captions/ms to illustrate Christian life in homes, marriages, Church and youth groups. Religious slant important. Rates vary on acc. Enclose S.A.S.E.

Columbia, Drawer 1670, New Haven, Conn. 06507. Mo. Buys 8×10 b&w glossies with captions/ms. Edited to interests of Catholic readership—family life, social problems, Catholic activities in both Church and leisure-time living. Rates vary. Enclose S.A.S.E. for queries/submissions.

Daily Blessing, Box 2187, Tulsa, Okla. 74102. Quarterly. Send for guideline sheet. Buys b&w pro-quality glossies and color trans. from 35mm to 4×5. Rates vary from approx. $7.50 in b&w to $75 for color. Enclose S.A.S.E. with submissions.

Daily Meditation, Box 2710, San Antonio, Tex., 78206. Bimo. Query for needs in illustrational photography. Enclose S.A.S.E.

Episcopalian, The, 1930 Chestnut St., Philadelphia, PA 19103. Mo. Buys b&w glossies only with captions/text; rates vary with subject, use, etc. Edited to interests of Episcopalians—their daily lives and relationships with the Church, domestic and foreign missions, etc. Study, then query. Pays on pub. Enclose S.A.S.E. with queries/submissions.

Evangelical Friend, Box 232, Newherg, Ore. 97132. Mo. Buys b&w glossies with

captions/ms only. Edited primarily for Quaker readership. Best to study, then query. Rates vary. Enclose S.A.S.E.

Evangelican Beacon, The, 1515 E. 66th St., Minneapolis, Minn. 55423. Biwk. Buys b&w glossies with captions/ms only. Edited to interests of Evangelican and Protestant readership. Rates vary on acc. Send S.A.S.E. with queries/submissions.

Event, 422 S. 5th Ave., Minneapolis, Minn. 55415. Mo. Sample copy sent on request. Study first for special issue coverages of social interest (law and order, American Indians, racial problems, etc.). Edited primarily to interests of American Lutheran readership. Rates vary on publication for b&w pro-quality glossies accompanied by captions/ms. Query. Enclose S.A.S.E.

Family Digest, Noll Plaza, Huntington, Ind., 46750. Mo. Buys b&w glossies only with captions/text. Rates vary. Buys color trans. also (one-time rights to all pix). Slanted primarily to young Catholic readership interests—family, Church, community betterment, education, etc. Study sample copy available upon request. Enclose S.A.S.E. with submissions.

Franciscan Message, Franciscan Publishers, Pulaski, Wis. 54162. Mo. Edited primarily to interests of Catholic adults, particularly women of middle-age with families. Study sample copy available on request. B&w glossies purchased only with ms/captions. Variable rates; pays on acc. Enclose S.A.S.E.

Hearthstone, (Christian Bd. of Pubs.), MPO Box 179, St. Louis, MO 63166. Pub. 11 times per year. Sample copy, 25¢. Buys 8×10 glossies with captions/ms. Pays up to $15 ea. a month after acc. Emphasis on individuals and family-life interests of Baptist and Christian Church audiences. Enclose S.A.S.E.

Home Life, 127 Ninth Ave. N., Nashville, Tenn. 37203. Mo. Edited to interests of Christian parents, children, family development, family problems, etc. B&w glossy photos purchased with captions/ms. Pays up to $10 ea. on acc. Enclose S.A.S.E. with submissions.

Interaction, 3558 S. Jefferson, St. Louis, Mo. 63118. Mo. except for combined mid-summer issues. Emphasis on education and topics of interest to church school teachers. Buys b&w glossies 5×7 and larger with captions/ms. Pays up to $10 ea. on acc. Enclose S.A.S.E. with all queries/submissions.

Jewish Current Events, Box 418, Oakland Gardens Sta., Flushing, N.Y. 11364. Biwk. Emphasis on current events and other Jewish-oriented topics of interest to Jewish children and adults. Buys b&w pix only with captions/ms. Rates vary. Enclose S.A.S.E. with submissions.

Lamp, The, Graymoor, Harrison, N.Y. 10524.

Mo. Copy available upon request. Study for coverage and style. Buys 8×10 glossies with captions/ms. Rates vary. Enclose S.A.S.E.

Liberty, 6840 Eastern Ave., N.W., Washington, DC 20012. Bimo. Sample on request. Buys b&w glossies and color trans. to illustrate ms only. Emphasis on subjects pertaining to religious liberty, church-state relations, etc. Rates vary. Enclose S.A.S.E. with queries/submissions.

Liguorian, Liguori, Mo. 63057. Mo. Edited to interests of Catholic audience. Study for subject coverage. Seasonal material required four to six months in advance. Buys b&w glossies with captions/ms. Rates vary on acc. Enclose S.A.S.E.

Lookout, The, 8121 Hamilton Ave., Cincinnati, OH 45231. Wk. Guideline sheet upon request. Study for b&w photo use (inside); vertical format 8×10 seasonal pix (glossies), human interest subjects used on covers. Pays up to $15 ea. on acc. Include S.A.S.E. for queries/submissions.

Lutheran, The, 2900 Queen Lane, Philadelphia, PA 19129. Semimo. Sample copy on request. Study for main subject coverages and presentation style. Buys b&w glossies (8×10) with captions/ms. Pays up to $20 ea. on acc. Enclose S.A.S.E.

Lutheran Forum, 315 Park Ave., S., New York, N.Y. 10010. Mo. Sample, 50¢. Edited to needs and interests of Lutheran clerical and lay students, Church leaders. Emphasis on Lutheran Church issues and activities. B&w glossies (8×10) purchased with captions/ms. Vertical format preferred. Pays $5 ea. and up on pub. Query first. Enclose S.A.S.E.

Lutheran Woman, 2900 Queen Lane, Philadelphia, PA 19129. Sample copy, 20¢. Emphasis on topics of interest to Lutheran women—working women of all ages, family life, activities, Church work and related subjects. Buys b&w glossies with captions/ms only. Pays on pub. Enclose S.A.S.E. with queries/submissions.

Marian Helpers Bulletin, Eden Hill, Stockbridge, MA 01262. Quarterly. Emphasis on topics of interest to middle-aged Catholic readership. Study sample copy (available on request). Buys b&w glossies, preferably 8×10. Pays up to $10 ea. on acc. Enclose S.A.S.E. with submissions.

Marriage, The Magazine For Husband And Wife, St. Meinrad, Ind. 47577. Mo. Copy on request, 10¢. Emphasis on human aspects of husband/wife relationships, betterment of marriage, etc. Best to study for style and full coverage. Buys b&w glossies and color trans. with model releases where necessary. Photos are purchased with captions/ms only. Rates vary on acc. Enclose S.A.S.E.

Maryknoll Magazine, Maryknoll, N.Y. 10545. Mo. Sample copy on request. Edited to interests of Maryknoll mission workers and missionaries with emphasis on challenges and problems encountered in underdeveloped foreign countries. Prefer factual photo-series coverage with captions/ms. Uses both b&w glossies and color trans. Rates vary on acc. Include S.A.S.E. with all queries/submissions.

Message Magazine, (Southern Pub. Assoc.), Box 59, Nashville, Tenn. 37202. Bimo. Copy sent to pro photographer/writers on request. Handling of specialized subjects covering problems and aspirations of people of all races/colors/locales needs study in order to understand objectives and style. Pay varies on acc./pub. from $7.50 up in b&w glossies to $100 per color trans. Include S.A.S.E. with queries/submissions.

Messenger, 1451 Dundee Ave., Elgin, Ill. 60120. Semimo. Copy available upon request. Pays $7.50 and up for b&w glossies purchased with captions/text. Emphasis is upon people and groups involved in Christian services/missions, homemakers, family life, etc. Include S.A.S.E. with queries/submissions.

Moody Monthly, 820 N. LaSalle, Chicago, Ill. 60610. Mo. Photojournalists should request sample copy for study. Wide range of subjects slanted to the interests of various age groups. B&w pro-quality 8×10 glossies and color trans. purchased with captions/ms. Rates vary on pub. Enclose S.A.S.E.

New World Outlook, 475 Riverside Dr., New York, N.Y. 10027. Mo. Sample copy on request. Edited to interests of Christians of United Methodist and United Presbyterian members concerned with major social issues, church mission, church problems, etc. B&w glossies purchased with captions/ms for inside use, up to $15 ea. Color trans. used for covers average $100, sometimes more. Enclose S.A.S.E. with queries/submissions.

Our Family, Box 249, Dept. E., Battleford, Sask., Canada. Mo. Sample copy and guideline sheet on request accompanied by S.A.S.E. and Int'n Reply Coupon or Canadian stamps. (Also enclose above with all queries/submissions.) Best to study wide range of coverage including seasonal and special-issue materials. Buys single b&w glossies with captions/ms. Also photo-series features, and color covers. Rates vary; pays on acc.

Our Lady Of The Snows (Nat. Shrine of Our Lady of the Snows), Belleville, Ill. 62223. Pub. six times per year. Study copies for coverage/style. Buys b&w glossies with captions/ms. Photos, $10 and up on acc. Include S.A.S.E. with submissions.

Our Sunday Visitor, Noll Plaza, Huntington, Ind. 46750. Wk. Pix with captions/ms of religious interest to Catholic readership—human

interest, family and Church activities, youth groups, etc. B&w, $10; color trans. $25. Pays on acc. Enclose S.A.S.E. with queries/submissions.

Pentecostal Evangel, The, 1445 Booneville Ave., Springfield, Mo. 65802. Wk. Sample copy on request. Edited primarily to needs and interests of members of Assemblies of God churches. Buys b&w glossies with captions/ms only. Also 35mm trans. Rates vary. Enclose S.A.S.E. with all communications.

Pentecostal Testimony, 10 Overlea Blvd., Toronto 17, Canada, Mo. Best studied for coverage and style; Canadian viewpoint essential. Uses some b&w glossies in 8×10 size. Low rates. Enclose Int'n Reply Coupons and S.A.S.E. with all queries/submissions.

People, 127 Ninth. Ave. N., Nashville, Tenn. 37203. Mo. Uses b&w glossies with captions/ms as singles and in photo feature stories. Pays up to $10 ea. per photo. Edited primarily to interests of general adult Southern Baptist audiences. Best to study magazine first, then query. Enclose S.A.S.E.

Presbyterian Life Magazine, Witherspoon Bldg., Philadelphia, Pa. 19107. Semimo. B&w pix with caps. of religious nature. Color for covers. B&w $12.50; color cover $50 and up.

Presbyterian Record, 50 Wynford Dr., Don Mills, Ont., Canada, Mo. Edited to interests of Canadian Presbyterian readership. Best to study before submitting material. Buys color trans. for covers. Include Int'n Reply Coupons with all communications.

Purpose, 610 Walnut Ave., Scottdale, PA 15683. Wk. Sample copy on request. Buys 8×10 pro-quality pix with captions/ms. Study magazine for subject coverage and style. Photos (b&w only), $10. Enclose S.A.S.E. with submissions.

Queen Of All Hearts, 40 S. Saxon Ave., Bay Shore, N.Y. 11706. Bimo. Sample copy on request. Emphasis on Catholic Marian themes. B&w glossy 8×10 photos purchased with captions/text. Prices vary. Pays on acc. Enclose S.A.S.E. with all communications.

St. Anthony Messenger, 1615 Republic St., Cincinnati, OH 45210. Mo. Sample copy on request. Also guideline sheet. Edited to interests of Catholic readership, young adults, and family members. Buys pro-quality 8×10 glossy b&w picture features on family activities, human interest, personalities, etc. Rates vary on acc. Enclose S.A.S.E. with queries/submissions.

Saint's Herald, Box 1019, Independence, MO 64051. Mo. Pays on acc. for captioned pro-quality b&w glossies. Topics of family interest to members of Reorganized Church of Jesus Christ of Latter Day Saints. Enclose S.A.S.E. with submissions.

Scope, 422 S. Fifth St., Minneapolis, Minn. 55451. Mo. Sample copy available on request. Pays up to $10 ea. for captioned b&w glossies. Uses seasonal material, subjects of interest to women members of American Lutheran Church. Pays on acc. Include S.A.S.E. with queries/submissions.

Sunday Digest, 850 N. Grove, Elgin, Ill. 60120. Wk. Copy available upon request. B&w glossies purchased only with captions/text at $10, on acc. Church, family, self-help, personality, etc. subject matter. Enclose S.A.S.E.

Sunday School Times And Gospel Herald, The, Box 6059, Cleveland, OH 44101. Semi-mo. Sample copy on request. Uses b&w photos with captions/ms of interdenominational interest—seasonal, church, social, community work, youth and family activities, scenics, etc. Rates vary; pays on acc. Enclose S.A.S.E.

These Times, (Southern Pub. Assoc.), Box 59, Nashville, Tenn., 37202. Mo. Sample copy available. Buys pro-quality pix with captions/ms. Wide coverage range but requires study to acquire editorial slant. Pix bought for covers up to $75 ea. Pays on acc. Queries and submissions must be accompanied by S.A.S.E.

Together, 1661 N. Northwest Hwy., Park Ridge, Ill. 60068. Mo. Photojournalists may obtain sample on request. Also ask for guideline sheet. Prefers unposed b&w glossies and color trans. of human-interest activities related to members of Methodist Church. Pix with captions/text preferred in 8×10 b&w, 2¼×2¼ trans. Pays on acc. from $10–25 ea. Enclose S.A.S.E. with queries/submissions.

United Church Observer, The, 85 St. Clair Ave., E., Toronto 7, Ontario, Canada. Mo. Send Int'n Reply Coupon for 35¢ for sample copy. Edited to interests of members of United Church of Canada. Buys b&w glossies with captions/ms. Also color trans. from 35mm up, larger preferred. Rates vary. Queries/submissions should enclose Int'n Reply Coupon for postage, plus S.A.E.

Weekly Unity, (Unity School of Christianity), Lee's Summit, MO 64063. Wk. Sample copy on request. Nonsectarian. Wide range of subject matter with religious theme tie-ins. Buys b&w glossies only with captions/ms. Query. Enclose S.A.S.E.

22. Stock-Photo Agencies/Syndicates

The international sale of stock photographs is a multimillion dollar business. Many photographers devote full time to producing stock photos; it is not uncommon for them to have up to 100,000 or more photographs on hand in a stock-agency library to which they are constantly adding new material. A far greater number of photographers have fewer stock photos—the extras left over from assignments, or shot on impulse, or even fine pictures that for some reason were rejected on a job they covered on speculation. To these photographers, the income from pictures that would otherwise simply be gathering dust in a forgotton file is pure gravy.

Before you send photographs to any agency, read Section 7; *Stock Photos—A Prime Source of Income.* Then query the agencies that interest you as to subject matter, policies, and so on. Remember that subject interests described here are enormously condensed and do not necessarily reflect an agency's immediate or most current needs.

The following is by no means a definitive list. Moreover, being listed—or omitted—carries no recommendation or implication whatsoever. All it represents is information available to us at the time we go to press.

Until or unless an agency advises you differently, *all* submissions of material should be accompanied by an S.A.S.E. (self addressed, stamped envelope.)

Alpha Photo Associates, 110 West 32 St., New York, N.Y. 10001. Gen. stock photos from scenics through sports, human interest, travel, etc. B&w and color (trans. from 35mm up). Pay on publication according to how and where photos are used.

Animals Animals, 535 Madison Ave., New York, N.Y. 10022. All types of animals, insects, fish, birds, rodents, etc. Accepted *only* if subject is in natural habitat and involved in some form of action—feeding, fighting, etc. Query for details.

Audubon Library, 132 W. 31st St., New York, N.Y. 10022. Do not confuse the library division with the Aububon magazine; subjects suitable for one may not be acceptable to the other. Basic subject interests in 8×10 b&w and color trans. (35mm up) are natural history, flora, and fauna of all global areas. "If it flies, creeps, crawls, walks, or swims, we're interested." Also interested in environmental and ecological subjects. On b&w glossy pix, photographer receives 50% of sale price; on color, he receives 60%. On submissions, include S.A.S.E.

Authenticated News International, 170 5th Ave., New York. "We serve publications of all categories, including newspapers, Sunday supplements, house organs, trade journals, religious, medical, travel, and theatrical pub., textbooks and encyclopedias, etc." B&w, single and pix series, news pix, human interest, cheesecake, etc. How-to-do series. Color—4×5 min. size trans.—food and recipe pix, scenics, animals, babies, cheesecake, etc. Pay. on 50/50 royalty basis.

Bernsen's International Press Service Ltd., 15 E. 40th St., New York, N.Y. 10016. (London home office, but New York office seeks pix—both b&w and color trans. for selling through branch offices in many countries.) Requires full information on well-researched subjects of interest overseas. Human interest, oddities, gimmicky, popular mechanical, scientific, medical, etc. Willing to syndicate on 50%-net basis, but prefer to assign free lances on stories originated by BIP or photographer. On picture stories, buys outright and pays on acc. Always query first on picture story ideas.

Bettman Archive, Inc., 136 E. 57th St., New York, N.Y. 10022. A historical photo agency—does not sell on commission, but buys outright: negatives, trans., prints dealing with American

ways of life, 1880–1930. Street scenes, farming, West, industry, offices, historical sites. Also buys entire historical photo morgues, specialized collections. Query before submitting any material. Payment immediately upon acc.

Black Star, 450 Park Ave. South, New York, N.Y. 10016. B&w and color pic stories on American way of life. Strong single pix of storytelling nature. Human interest, animals, children, situation, nature. Sells on a commission basis both here and overseas. Query before sending samples.

Camera Clix, Inc., 19 W. 44th St., New York, N.Y. 10036. Color exclusively. Animals, art, human interest, scenics, etc. Sells on a commission basis here and overseas. Query before submitting samples.

Central Press Association, 1380 Dodge Court, Cleveland, Ohio 44114. Daily Syndicate. Editor: Courtland C. Smith. B&w pix of spot news, news features, human interest, cheesecake. Pay $5, on acc.

Culver Pictures, Inc., 660 First Ave., New York, N.Y. 10016. Buys collections, old glass negatives, anything of historical nature with news value. Culver's bids are a must for photographers closing out old files, or special collections of jazz, factories, old street scenes, schoolrooms, etc. Prices are negotiable. Query before submitting.

Devaney, A., Inc., 40 E. 49th St., New York, N.Y. 10017. B&w and color trans. Human interest, models, sports, seasonal, foreign, agriculture, industry, etc. $10 and up on b&w. Varies for color. Pay. on acc.; also handle royalty accounts. Query first.

De Wys, Inc., 124 E. 24th St., New York, N.Y. 10016. Sports, travel, human interest, foreign, models, animals. B&w and color trans. from 35mm. Commission basis of 50/50 on client acc. Prefer photographers to submit samples of about ten pix with S.A.S.E. "We quickly decide from samples whether or not we will handle additional material."

European Picture Service, (division of **Photoworld**), 110 W. 32nd St., New York, N.Y. 10001. B&w story-telling singles. Also handle color trans. Pay varies on acc. or on royalty basis.

FPG (Freelance Photographers Guild), 51 Park Ave. S., New York, N.Y. 10010. B&w and color trans.; singles and picture-story series. Wide range of subjects—babies, glamour, human interest, animals, farms, sports, nature, etc. B&w, $40–1000; color, $125–2,500. Commission paid on client's acc. Query first.

Gilloon Photo Agency, 155 E. 44th St., New York, N.Y. 10017. Picture Editor: Frank J. Gilloon. Seminews, feature layouts; sports,

candids of personalities. Color, 35mm and up. Rates vary.

Glanzer News Service, 223 Coldstream Ave., Toronto 12, Canada. Managing Editor: Phil Glanzer. B&w pix to illus. trade news articles and general features. Trade pix $3–5; pix for feature articles $5–10. Pay on acc.

Globe Photos, Inc., 67 W. 44th St., New York, N.Y. 10036. Photo features from 10 to 25 pix that tell a story in color or b&w. Also handle color pix for advertising, editorial or calendar use. Professionals only. Releases required. Pay royalty basis 50/50 for b&w, 60/40 for color. Pay 10th of mo. following sales.

Harris & Ewing Photo News Service, 155 E. 44th St., New York, N.Y. 10019. B&w and color feature stories; variety of subject interests. Sells both here and overseas. Min. size trans., 35mm. Query before submitting.

Keystone Press Agency, Inc., 170 Fifth Ave., New York, N.Y. 10010. News, human interest, personalities, pix for educational use. Clients billed $35 for b&w pix used editorially; $125 for editorial color. Photographers receive commission about 90 days after customer remits billing to clients.

Lambert, Harold M., Studios, Inc., 2801 Cheltenham Ave., Phila., Pa. 19150. B&w and color trans. Glamour, scenics, travel, hobbies, oddities, animals, sports, seasonal, human interest. Negatives only in b&w, min. $2^1/_4 \times 2^1/_4$. Trans. $2^1/_4 \times 2^1/_4$ and up. Pay on royalty basis or outright basis. Photographers agent.

Lewis, Fredrick, Inc., 35 E. 35th St. New York, N.Y. 10016. Color trans. and b&w. Encyclopedic range of subjects, USA and world over. People, places, things. Emphasis on people, studies, landscapes, current events, etc. Sell on commission basis only. Query before sending samples.

Monkmeyer Press Photo Service, 15 E. 48th Street, New York, N.Y. 10017. B&w and color (trans.) feature stories of wide interest—teenage activities, foreign countries, geographical subjects. Rates vary according to client. Commission sales only. Query for further details.

Moss Feature Syndicate, P.O. Box 20205, 808 Summit, Greensboro, N.C. 27420. B&w and color trans. of nudes, oddities of nature, etc. Pay $5 and up. Also buys from overseas. Pay on acc.

National Audubon Society, (photo and film dept.). Please see **Audubon Library** listed earlier.

Outdoor Photographers League, 4486 Point Loma Ave., San Diego, Calif. 92107. International organization of sportsmen whose photos and feature articles the League markets via ad agencies, encyclopedia, and other publishers. B&w and color trans. of hunting, fishing, travel,

wildlife, ecology, boating, photo kinks, how-to-build pix to illustrate outdoor or photo articles. Pays 60% of sales receipts to photographer for feature material. Payment made on day of firm sale. Free OPL Newsletter and membership application form to serious producers.

Photofind Agency, Pier 37 Embarcadero, San Francisco, Calif. 94133. An affiliate of Rapho-Guillumette Agency in New York. Welcomes newcomers of top professional status. Sells internationally. Wide range of b&w and color trans. needed. Query first.

Photo-Illustrators Service, 2110 N. 69th St., Milwaukee, Wis. Accent on human interest, seasonal holiday material, glamour and pin-ups, sports, dairy subjects. B&w, $5 and up. Color trans., $10 and up. Color trans. for covers, $60 and up. Query first.

Photo Library, Inc., 222 E. 44 St., New York, N.Y. 10017. Supplies wide range of b&w and color to buyers. Specialize in advertising photos. (Model releases must be had for recognizable people, private homes, etc.) Pressing need for ecological subjects, animals, birds, insects, etc. No zoo shots that are obviously such; element of natural action preferred. Also sells overseas. Regular commissions paid to photographers at end of month of billing. Query Librarian if desirable. All submissions of material must be accompanied by S.A.S.E.

Photoworld, 51 Park Ave. S., New York, N.Y. 10010. This is an affiliate of FPG Agency listed earlier. Emphasis is on general historical subjects from mid-1800's to present. Subjects include people and fashions on an era, street scenes, city streets and vehicles, sports, celebrities, rural, World Wars I and II, etc. Query before submitting, especially if glass negatives are involved. Rates vary with subject matter, quantity, etc. Pay on acc.

Pictorial Parade, Inc., 130 W. 42nd St., New York, N.Y. 10036. A general picture agency handling both b&w and color trans. 35mm trans. are stocked, but most calendar and greeting-card manufacturers want 4×5 sizes or larger. "We specialize in editorial b&w and color for ad agencies, magazines, newspapers, text books, encyclopedias, and many offbeat or little-known markets." All photos must be thoroughly captioned. Commission 50/50 on sales. Queries welcomed. Speculative submissions must be accompanied by a S.A.S.E.

Pix, Inc., 145 E. 52nd St., New York, N.Y. 10022. A general stock agency handling a wide range of subject matter in both b&w and color trans. In addition to well-captioned singles, series, etc., markets photo-illustrated stories accompanied by manuscripts. Details and commission rates available on request.

Press Illustration Service, 369 Lexington Ave., New York, N.Y. 10017. B&w singles;

glamour, scenics, pets, farm, travel, hobbies, oddities, religious, human interest, gardening, sports, nature. Rates vary.

Rapho-Guillumette Pictures, 59 E. 54th St., New York, N.Y. 10022. B&w and color human interest and scenic pix. Pay on royalty basis.

Religious News Service, 43 W. 57th St., New York, N.Y. 10019. A combination stock agency and a news agency, issuing daily releases. Interested in b&w pix of religious activity, spot news and features, social issue pix, scenics, art (sculpture), etc. B&w pix are paid for ($5 and up) at end of month following acc. "We also need correspondents in various localities."

Roberts, Harold Armstrong, 420 Lexington Ave., New York, N.Y. 10017. Very wide range of stock subjects. Query for details. Buys b&w negatives; color trans. are sold on a commission basis. Pay on pub.

Sekai Bunka Photo Library (American office), 501 Fifth Ave., New York, N.Y. 10017. Full information not available as we go to press. This appears to be a stock-photo library affiliated with a publisher in Tokyo having a wide distribution in Europe, Asia, the Orient, North America, etc. The range of subject matter needed also appears to be very wide. We suggest you query Sekai Bunka Photo Library Dept. at the above address.

Shostal Associates, Inc., 60 E. 42nd St., New York, N.Y. 10017. "We accept color transparencies only, size 4×5 preferred, or even larger. Smaller sizes welcomed only if superb quality." Wide subject range includes landscapes, human interest, industry, science, farm-agricultural activity, home exteriors and interiors, foreign scenes, places of interest. Agency commission is 50%, pay monthly.

Three Lions, Inc., 100 Fifth Ave., New York, N.Y. 10011. B&w pic stories pertaining to women interests; also with men appeal; i.e., sports, hobbies, educational, and handicraft. Also color pix for cover and inside use. Min. size color 4×5. B&w, $5–10. Inside color, $25–100. Color covers, $50–150. Pay on acc.

Underwood and Underwood News Photos Inc., 3 West 46th St., New York, N.Y. 10036. All subjects in 8×10 b&w and color trans., size 2¹/₄×2¹/₄ and up. Foreign subjects also welcomed. 50% commission to photographer on selling price. Query first, or include S.A.S.E. with test submission.

Underwood Reserve Illustrations, Inc., 42-15 Crescent St., Long Island City, N.Y. 11101. Human interest, scenics, industrials, models (releases required). Color only, min. size 2¹/₄×2¹/₄. Commission 50%, payment on pub.

United Press International Newspictures, 220 E. 42nd St., New York, N.Y. 10017. B&w and color singles and pic stories; spot news if dramatic, roto features, news features and human interest, personalities and celebrities. Color trans. in any size from 35mm up. Prefer negatives to prints in b&w. Full caption details required. Include S.A.S.E. with submissions.

Universal Trade Press Syndicate, 37-20 Ferry Heights, Fair Lawn, New Jersey 07410. News agency specializing in industrial and technical subjects. Queries proposing illustrated articles for trade publications welcomed. Commission to photographer, 65% of receipts upon payment by buyer.

Wide World Photos, 50 Rockefeller Plaza, New York, N.Y. 10020. "Our library contains 50,000,000 b&w and color news and feature pictures." Overseas sales handled from New York office. Rates vary according to use of pix by publishers, etc. Query first, or submit captioned samples with a S.A.S.E.

Overseas Agencies

The following overseas agencies have expressed interest in obtaining photographs of many different types from North American photographers. Their needs and policies, including payment arrangements, vary widely. They also specialize in selling to markets little known in North America—these in addition to the same types of markets we have.

We highly recommend that you *query* overseas agencies before submitting material. Explain the kinds of photographs you have to offer, quantity, etc.; in return, ask for details on their subject interests and policies. Address your queries to the Stock Photo Librarian.

Barnaby's Picture Library, Barnaby House, 19 Rathbone St. London, WIP 1AF, England. A general stock-photo house.

Camera Press Ltd., Russell Court, Coram St., London WC1, England. General stock-photo house.

Delfos Press Agencia, Foto-Reportajes Internacionales, Alcantara 8, Madrid-6, Spain. General stock-photo agency, especially interested in b&w and color feature story series.

Healy Agency, 29A Gunter Grove, London, SW 10, England. Specializes in serving travel and tourism clients.

International News Service Ltd., Tokyo Central, P.O. Box 1651.

Paul Popper Ltd., 24 Bride Lane, London, England. General stock-photo agency. Also syndicates special-interest feature stories.

Servizio Internazionale d'Illustrazioni per la Stampa, San Matco, 4836 Casella Postale 355, 30100-Venice, Italy.

23. Trade Publications

Several thousand trades and professions have one or more publications (often called *journals*) devoted exclusively to the interests and needs of their own group of trade/professional subscribers. Although often as large and attractive as general-consumer, newsstand publications, trade journals are available only by subscription. Many develop their own stable of contributors—photojournalists to whom they give specific assignments to produce photo/text package deals. In more than a few instances, these assignments pay very well indeed, with extra allowances to cover all the expenses incurred by the photojournalist, plus of course a negotiated price for the photo/text package.

The following represents a cross-section of trade publications, a minor fraction of the total number of publications that are in constant search of new, fresh, professional talent. In this era of highly specialized publications, the trade publications offer a constantly expanding field of opportunities to those who can successfully wed

a typewriter to their cameras.

Other trade publications appear in Parts 1, 2, 3, 4, 5A–5B, 12, 15, 16, 18, 19, 20. Stock-photo agencies (Part 22) are also suppliers to trade publications.

Advertising & Sales Promotion, Advertising Pub. Co., 740 Rush St., Chicago, IL 60611. Pix/text stories on sales promotion programs. Buys b&w glossies with captions/text. Pay varies with material. Query first. Enclose S.A.S.E.

Alaska Construction & Oil, 109 Mercer St., Seattle, WA 98119. Mo. Edited to interests of Alaskan management/administration of construction, timber, oil, mining, other resources. Buys pix with captions/text. B&w glossies, $10; color trans., $50. Query. Enclose S.A.S.E.

American Drycleaner, 500 N. Dearborn St., Chicago, IL 60610. Mo. Uses b&w glossies with captions/text on subjects related to the problems, solutions, management, etc. of the dry cleaning industry. Rates vary. Query, enclosing S.A.S.E.

American Paint & Wallpaper Dealer, (American Paint Journal Co.), 2911 Washington St., St. Louis, MO 63103. Buys b&w glossies with captions etc. on subjects related to the retailing of wallpaper and allied items. Also uses b&w photo feature articles. Rates vary. Query on important prospects. Enclose S.A.S.E.

American Roofer & Building Improvement Contractor, Shelter Pub., 221 Lake St., Oak Park, IL 60302. Mo. Action pix showing job progress in manufacture and application of asphalt, coal tar pitch, asbestos, tile, wood and metal roofing, siding and building improvement materials. B&w pic. stories. Pay on acc.

Architectural And Engineering News, Chestnut & 56th Sts., Philadelphia, PA 19139. Mo. Edited to professional interests or architects, consulting engineers, others in related fields of specialization. Buys 8×10 b&w glossies with full captions/text. Rates vary. Query. Enclose S.A.S.E.

Architectural Record, McGraw-Hill Bldg., 330 W. 42nd St., New York, N.Y. 10036. Mo. Edited to interests of architects, engineers, specialists in related fields. Pro-quality photos/captions/text only. High degree of technical knowledge a must. Rates vary with quality/contents. Best query, stating qualifications. Enclose S.A.S.E.

Architecture/Concept, 310 Ave. Victoria, Suite 201, Montreal, Que., Canada. Mo. Pix of subjects (with captions/ms) related to application of new products or construction methods and design. Uses some color, size 4×5 preferred. Rates vary. Pays on acc. Include Canadian stamps or Int'n Reply Coupons with all queries/submissions.

Area Development, 114 E. 32nd St., New York, N.Y. 10016. Mo. Edited to interests of company executives and others planning to locate, build, transfer to new plant sites. Study contents and style, then query. Uses factual b&w glossies with captions/text. Buys at prorated page rates. Enclose S.A.S.E.

Audio, 134 N. 13th St., Philadelphia, PA 19107. Mo. Pix and short illustrated articles in installations of hi-fi equip. in homes. Pic stories, $35 per page. Cover color trans (4×5 preferred) rates vary. Pays on acc. Query, enclosing S.A.S.E.

Automotive Rebuilder, 11 S. Forge St., Akron, OH 44304. Mo. Edited to interests of rebuilders of automotive parts, transmissions, engines, etc. Study first, then query. Buys b&w singles and photo-feature articles with captions/text. Rates vary with quality & contents. Enclose S.A.S.E.

Baker, The, 1602 Harold St., Houston, Tex., 77006. Mo. Emphasis on how-to of building sales volume, distribution methods, remodeling, equipment improvements, etc. Query on feature photo/text ideas. Pay varies with material, quality. Include S.A.S.E. with queries/submissions.

Bakery Production And Marketing, 3460 John Hancock Center, Chicago, Ill. 60611. Wk & mo. Buys b&w glossies with captions/text on a variety of bakery/marketing related subjects. Query first with S.A.S.E. Rates vary.

Banking, 90 Park Av., New York, N.Y. 10016. Mo. B&w pix of banking and business subjects; activities encouraged or sponsored by banks. Pay $5–6, on pub.

Beaver, The, (Hudson's Bay House), Winnipeg, Manitoba, Can. Quarterly. Buys b&w glossies and color trans. with captions/text. Study sample copies for range of coverage and style. Pays on pub. at varying rates according to quality and use. Enclose Canadian stamps or Int'n Reply Coupon with queries/submissions.

Bedding Magazine, 724 Ninth St., N.W., Washington, DC 20001. Buys b&w glossies with captions/text on bedding and upholstering factories and machinery in operation, handling procedures and equipment, maintenance, etc. Uses some singles, some feature-series b&w's with pay according to quality/use. Pays on pub. Enclose S.A.S.E.

Boutique Magazine, Suite 2290, Hotel McAlpin, 34th St., New York, N.Y. 10001. Edited to interests of manufacturers and retailers of avant-garde boutique merchandise. Study first, then query with S.A.S.E. Rates vary on acceptance.

Bowling Proprietor, The, West Higgins Rd., Hoffman Estates, Ill. 60172. Mo. Pix of unusual and effective promotion of bowling establishments, new ideas, improvements, better management, etc. Buys b&w glossies with captions/text. Rates vary. Pays on pub. Include S.A.S.E. with queries/submissions.

Builder, The, 3219 Executive Park Dr., Springfield, Ill. 62708. Mo. Buys b&w glossies only with captions/text on highway engineering and construction industry in Illinois. Study subject range and style first, then query with S.A.S.E. Rates vary.

Building Materials Merchandiser, 300 W. Adams St., Chicago, Ill. 60606. Mo. Edited to interests of building and hardware wholesalers and retailers. Study range and style first, then query. Pix bought with captions/text at approx $50 per printed page (including photos). Pays on acc.

Canadian Automotive Trade, 481 University Ave., Toronto, Ont., Canada. Uses only b&w glossies with captions/text. Automotive news pix and photo-feature series illustrating technical and semi-technical subjects. Rates vary on acc. Enclose Canadian stamps/Int'n Reply Coupon with queries/submissions.

Canadian Electronics Engineering and **Canadian Contractor And Maintenance Supervisor,** 481 University Ave., Toronto, Quebec, Canada. Subjects having direct bearing upon electronics and electronics industry. Buys b&w pro glossies only. Both pix and text must have a close tie-in with the Canadian electronics scene. No color. Rates vary with contents and quality. Best to study publications first, then make specific query(s). Enclose Canadian stamps or Int'n. Reply Coupon and S.A.S.E. with all queries/submissions.

Canadian Food Industries, National Business Pub., Ltd., Gardenvale, Que., Canada. Mo. Pix and photo series features with captions/text related to food growing, processing, consumption. Must be pertinent to interests of Canadian audiences. Rates vary with length, contents, quality, use. Min. size color trans. considered is 2¹/₄×2¹/₄. Uses 5×7 glossies but prefer 8×10 prints. Pays on acc. Enclose Canadian stamps or Int'n Reply Coupon with communications.

Canadian Mil-Mac Publications Group:
Canadian Power & Sail
Truck Transportation
Insurance Agent & Broker in Canada
Above publications are all located at 203 Adelaide Street, West, Toronto, Ontario, Canada. Bimonthlies. B&w glossies and color trans ($2^{1}/_{4}\times2^{1}/_{4}$) are purchased singly with captions, or in series with captions/text for each publication. Prices are negotiable and paid on acc. Study sample copies first, then query, enclosing Canadian stamps or Int'n Reply Coupons.

Candy And Snack Industry, 777 Third Ave., New York, N.Y. 10017. Mo. Edited to interests of manufacturers, packagers, retailers, advertisers, distributors of candy, cookie, other snack products. Buys b&w glossies only with factual captions/text. Uses color trans for covers. Rates vary with subject, length, quality. Enclose S.A.S.E. with all queries/submissions.

Candy Industry, Magazines for Industries, Inc., 777 3rd Ave., New York, N.Y. 10017. Biwk. B&w glossy photos with captions/text on subjects related to mass production machinery in plants, novel promotional programs and marketing displays, etc. Pays on pub. Include S.A.S.E.

Casual Living Magazine, Empire State Bldg., Suite 4719, 350 Fifth Ave., New York, N.Y. 10001. Mo. Edited to interests of department store and other retailers of casual furniture and accessories. Readership also includes manufacturers and those interested in advertising/promotion/distribution of casual summer furniture, etc. Buys 8×10 b&w glossies with captions/text. Rates vary. Enclose S.A.S.E. with queries/submissions.

Ceramic Industry, 5 S. Wabash Ave., Chicago, Ill. 60603. Mo. B&w and color pix of ceramics and glass processes. Want detailed, technical caps. Subject matter must be other than average production technique; i.e., a faster, better, less expensive way of doing it. Pay $5-50, on acc.

Commercial Fertilizer And Plant Food Industry, 75 3rd St., N.W., Atlanta, GA 30308. Mo. B&w glossy photos with captions/text of interior and exteriors of new or remodeled chemical fertilizer and plant food manufacturers/producers. Query first, enclosing S.A.S.E. Rates vary on pub.

Compressed Air Magazine, 942 Memorial Parkway, Phillipsburg, N.J. 08865. Mo. 50¢. B&w industrial or construction pix pertaining to uses of compressed air, i.e., a new air-operated device of any kind in action. Pay. $5-10; cover $15. Pay on acc.

Construction Digest, Box 1074, Indianapolis, Ind. 46206. Biwk. Edited to interests of those involved in heavy construction and public works programs in central midwest states; flood control, pipeline construction, major construction projects. Buys b&w glossy prints with factual captions, etc. Major equipment involved should be identifiable. Study, then query with S.A.S.E.

Construction Equipment, 205 E. 42nd St., New York, N.Y. 10017. Mo. Buys photos in b&w with captions/text on use of heavy equipment in construction work. Sample copy on request. Query first, enclosing S.A.S.E.

Constructioneer, 1 Bond St., Chatham, N.Y. 07928. Biwk. B&w pix with captions/text of construction equipment in use on projects in N.Y., Pa., N.J., Del. Rates vary on acc. Send S.A.S.E. with queries/submissions.

Cosmetics Fair, 65 E. 55th St., New York, N.Y. 10022. Mo. Sample copy on request to pro photojournalists. Edited to interests of controlled circulation of members of cosmetics industry—including retail cosmeticians, buyers, etc. Buys photos (b&w glossies) with captions/text. Study, then query on major feature ideas, enclosing S.A.S.E.

CQ, 14 Vanderventer Ave., Port Washington, N.Y. 11050. Mo. Buys b&w glossies and color trans. with captions/text of interest to amateur radio operators. Also related electronics equipment, maintenance, etc. Pays up to $10 for b&w, $25 and up for color cover trans. Enclose S.A.S.E.

Craft, Model And Hobby Industry, Hobby Pubs., 299 W. 28th St., New York, N.Y. 10001. Mo. Edited to interests of wholesalers, distributors, dealers in craft materials, models, kits, accessories, etc. Buys b&w photos with captions/text on merchandising methods, sales promotions, related subjects. Best study first, then query. Rates vary. Enclose S.A.S.E.

Craftsman, The Leathercraftsman, Inc., P.O. Box 1386, Fort Worth, Tex. 76101. Bimo. Pix of subjects related to leathercraft, leather art; people connected with it. B&w $5 and up.

Decorating Retailer, 2101 S. Brentwood Blvd., St. Louis, MO 63144. Mo. Edited to interests of decorating products industry, merchandising, promotions, sales, displays, etc. Buys b&w glossies with captions/text. Enclose S.A.S.E. with communications.

Dental Management, Ridgeway Cen. Bldg., Stamford, Conn. 06905. Mo. Edited to interests of practicing dentists with emphasis on patient relationships, business aspects of record keeping, collecting, personal finance/investment programs for dentists. Buys b&w glossies with captions/ms, $10. Pays on acc. Enclose S.A.S.E. with submissions.

Dispensing Optician, The, 1980 Mountain Bldv., Oakland, Calif. 94611. Buys b&w glossies with captions/text on technical aspects of optical dispensing industry. Study first, then query. Enclose S.A.S.E. with queries/submissions.

Domestic Engineering Magazine, Medalist Publications, Inc., 1801 S. Prairie Ave., Chicago, Ill. 60616. Mo. Pix of topical or human interest related to plumbing, heating and cooling. B&w $10-12.50; cover, $10-30; pic. stories $5-10. Pay on acc.

Driller, The, Box 527, Barrington, Ill. 60010. Buys b&w glossies with text/captions on modern well drilling (water) equipment in action, unusual wells, etc. Pays $10 per b&w on acc. Enclose S.A.S.E.

Drive-in Management, 757 3rd Ave., New York, N.Y. 10017. Mo. 50¢. Pix of all phases of drive-in restaurant operation stressing practical ideas. Also use color trans. for four-color cover. Query on color subjects. B&w $5-10; color rates vary.

Electrical Contractor & Maintenance Supervisor (EC & MS) Magazine, 481 University Ave., Toronto 101, Ont., Canada, Mo. Buys b&w glossies with captions/ms only. Electrical installations, preferably with Canadian tie-ins. Pays on acc. Enclose Canadian stamps or Int'n Reply Coupons with submissions.

Electrical South, 1760 Peachtree Rd. N.W., Atlanta, Ga. 30309. Mo. Directed circulation. Pix with text; activities of electrical contractors; pic. stories of electrical construction. B&w $5-10. Pay on acc.

Electricity in Building Magazine, Electrical Information Pub., Inc., 2132 Fordem Ave., Madison, Wis. 53701. Mo. Pix of home building activity. Emphasis on electrical built-in products preferred, including electric heating. B&w, rates vary; cover (b&w) rates vary, determined by quality. Pay on acc.

Farm And Power Equipment, 2340 Hampton Ave., St. Louis, MO 63139. Mo. Sample copy on request. Edited to interests of manufacturers, distributors, retailers of light farm, landscaping, garden equipment. Buys b&w glossies with captions/ms, will judge full, feature-length articles from b&w contact sheets. Also uses color trans., min. size $2^{1}/_{4}\times2^{1}/_{4}$. Rates vary on acc. Enclose S.A.S.E.

Farm Supplier, Mt. Morris, IL 61054. Mo. Buys photos only with captions/ms. Emphasis on merchandising, sales, related subjects centering around farm supplies. Rates vary. Query first, enclosing S.A.S.E.

Financial World, 17 Battery, New York, N.Y. 10004. Wk. Pix to illustrate ms dealing with more important corporations; all industries, including agriculture, mining, etc. See magazine for type pix used. B&w $20. Pay on pub.

Flooring, Harbrace Pubs., Inc., 757 Third Ave., New York, N.Y. 10017. Mo. Edited to interests of flooring contractors, dealers, installers, etc. Variety of materials and wide range of industry subjects. Buys 8×10 glossies with captions/text and rates according to

length, subject, use, etc. Pays up to $75 for large color trans. Pays on acc. Enclose S.A.S.E.

Food In Canada, 481 University Ave., Toronto 2, Ont., Canada. Mo. Buys captioned single pix and photos to illustrate text on Canadian food processing operations. Rates are negotiable. Study first, then query. Enclose Can. stamps or Int'n Reply Coupons with queries/submissions.

Freezer Provisioning And Portion Control, 25 S. Bemiston Ave., St. Louis, MO 63105. Mo. Buys b&w pix with captions/text pertaining to freezer locker plants, frozen foods, portion-control processors, related subjects. Pays on acc. Rates vary. Enclose S.A.S.E. with queries/submissions.

Glass Digest, 15 E. 40th St., New York N.Y. 10016. Mo. Pix pertaining to the field of flat glass and architectural metal; glass and metal used architecturally in buildings or homes; items of interest and value to distributors of glass and architectural metal contractors. Store fronts. B&w $5.00 and up. Pay on pub.

Heating, Piping & Air Conditioning, 1450 Don Mills Rd., Don Mills, Ont., Canada. Mo. Pix and photo-feature series with captions/text on technical subjects related to heating, ventilating, air conditioning, piping for all types of large buildings. Uses b&w inside; also buys color trans. for covers. Rates vary. Enclose Canadian stamps or Int'n Reply Coupons with all submissions.

Heavy Construction News, 481 University Ave., Toronto 2, Ont., Canada. Wk. Primary interest focuses upon Canadian construction projects. Uses single pix only if taken on assignment. Pix in feature articles must be accompanied by full details of job, equipment shown, contractors, and engineers. Rates on package deals vary on acc. No color used. Queries and submissions should include Can. stamps or Int'n Reply Coupons as well as S.A.E.

Hotel & Motel Management, 845 Chicago Ave., Evanston, IL 60202. Mo. Copy sent on request. Buys b&w glossies with captions/text on variety of subjects related to the management of hotels and motels. Pays on acc. Send S.A.S.E. with query/submissions.

Ideals Publishing Co., 11315 Watertown Plank Rd., Milwaukee, Wis. 53225. Qt. For Christmas issues: winter seasonals indoors and out, table-top and floral arrangements, religious scenes, rural festivities at Christmas time. For Easter: religious art, spring rural scenes, spring floral arrangements and other decorative table art. Others: vacation themes, outdoor scenics, etc., autumn season, back to school, Columbus Day, Thanksgiving, harvest, fall floral displays, etc. Suggest query. Work on assignment. B&w $10–15., color trans. $25–50., covers, 50% is added to rate.

Implement And Tractor, 1014 Wyandotte, Kansas City, MO 64105. Bimo. Buys b&w glossies, 8×10 size, with captions/text. Accent on use of farm and light industry machinery—dealer display and product promotional techniques, shop services, merchandising, etc. Pay varies considerably. Query first, enclosing S.A.S.E.

Industrial Finishing, Hitchcock Bldg., Wheaton, Ill. 60187. Mo. Copy sent on request. Buys b&w quality photos with captions/text as package deal. Pays up to $150 per feature. Accent is on technical aspects of finishing operations. Study, then query, enclosing S.A.S.E.

Kitchen Business, 1501 Broadway, New York, N.Y. 10036. Mo. Buys top-quality b&w glossies 8×10 with captions and/or text on variety of subjects dealing with kitchen planning (including plumbing, cabinet installations, etc.), kitchen shops and showrooms, displays, merchandising, appliances, etc. Study, then query with S.A.S.E. Page rates vary with length, quality, use. Pays on acc.

Knitter, The, Box 1225, Charlotte, NC 28201. Mo. Buys 8×10 glossies with captions/text. Edited to interests of executives in the knitting plant industry. Pays on pub. Enclose S.A.S.E. with queries/submissions.

Lawyers World, Suburban Station Bldg., Philadelphia, PA 19103. Bimo. Slanted to interests of practicing lawyers in both private and corporate offices. Office management, investments, leisure activities, etc. Best to study first, then query. Uses both b&w and color trans. Rates vary with subject, length, quality. Pays on pub. Enclose S.A.S.E.

Leather And Shoes, 10 High St., Boston, Mass. 02110. Wk. Buys b&w glossies with captions/text of interest to leather and shoe manufacturing industry. Rates vary. Essential to query, enclosing S.A.S.E., whether or not pub. is currently in need of additional material.

Living Color Financial Displays Inc., 296 N.E. 67th St., Miami, Fla. 33138. V.P. Color pix; human interest, with model release. Color (4×5) $175 max. Pay on acc.

Luggage & Leather Goods, Business Journals, Inc., Room 416, 1133 Broadway, New York, N.Y. 10010. B&w single 8×10 glossies, and b&w pix in series. All must be captioned or with factual text. Accent on retailing methods of luggage, personal leather goods, outstanding shop window and in-store displays, promotions, etc. All must be buyer-oriented. Rates vary. Query first with S.A.S.E.

Mart Magazine, Buttenheim Pub. Co., Berkshire Common, Pittsfield, Mass. 01201. Bimo. Buys b&w glossies with captions/text on promotional activities originated by radio, TV appliance, speciality dealers. Rates vary on acc. Enclose S.A.S.E. with queries/submissions.

Materials In Design Engineering, 600 Summer St., Stamford, Conn., 06904. Mo. Sample copy, 50¢. Industrial close-ups (8×10 b&w glossies) showing interesting applications of engineering materials (both metals and non-metals) and finishing. Rates vary on acc. Best to query first on specific photo/caption/text package ideas. Enclose S.A.S.E. for reply.

Maytag Merchandiser, Maytag Co., 403 W. 4th St. N., Newton, Iowa 50202. Uses b&w glossies with captions/prints of washers, dryers, appliances in promotions, window and point-of-sale displays, coin laundries, etc. Human interest wherever possible. Query first with specific ideas, enclosing S.A.S.E. Rates vary on package deals.

Metal Center News, (American Metal Market Co.), 576 Fifth Ave., New York, N.Y. 10036. Mo. Edited to interests of personnel engaged in metal industry—management, sales, production, warehouse distributors, etc. Metals include aluminum, copper, steel. B&w photos bought with factual captions/text. Study copy first, then query, enclosing S.A.S.E. Rates vary on acc.

Metal Finishing, 99 Kinderkamack Rd., Westwood, N.J. 07675. Mo. Buys b&w glossies with captions/copy on metal finishing with electroplating, lacquering, rust-proofing, etc. Pay varies with contents, length, quality; payment made on pub. Query first, enclosing S.A.S.E.

Modern Brewery Age, 80 Lincoln Ave., Stamford, Conn. 06902. Bimo. Edited to interests of personnel in the brewing industry—managers, executives, technicians, marketing, etc. Buys b&w photos (8×10 glossies) with factual captions only, or as part of photo/text features. Rates vary. Query first, enclosing S.A.S.E.

Modern Schools Magazine, Box 1648, 2132 Fordem Ave., Madison, Wis. 53701. Send for subject range details. Edited primarily to interests of members of school administration, school boards, architects and engineers involved in problems of providing heat, lighting, ventilation, electronic equipment in schools. B&w pix must be pro quality, factually captioned or with text. Rates negotiable; pays on acc. Query first, enclosing S.A.S.E. for return submissions.

Monetary Times, 1080 Beaver Hall Hill, Montreal, Que., Canada. Mo. Sample copy, $1. Important to study subject range and style, then query. Buys b&w pix—up to $15 ea. with captions pertaining to business and industry. Also uses 2¼×2¼ color trans., varying rates. Pays on pub. Enclose S.A.E. with Canadian stamps or Int'n Reply Coupon with submissions.

Motor West, Box 650, Orange, Calif. 92666. Mo. Edited to interests of automotive trade industry. Purchases b&w glossies with cap-

tions/copy only. Must be significant to automotive trade in far west. Study first, then query. Pays on pub. Rates vary. Enclose S.A.S.E. with queries/submissions.

NAHB Journal Of Homebuilding, 1625 L St., N.W., Washington, DC 20036. Mo. Edited to interests of members on NAHB engaged in successful projects in homebuilding, apartment building, etc. Buys b&w glossies with factual copy for interior, pays up to $100 depending upon importance, quality, etc. Buys color trans. for covers, $50 and up. Pays on pub. Query first, enclosing S.A.S.E. with all submissions.

National Wool Grower, The, 600 Crandall Bldg., Salt Lake City, Utah 84101. Mo. Edited to interests of sheep growers and sheep industry per se. Buys b&w glossies only with factual captions/ms. Study back issues first, then query. Rates vary on acc. Include S.A.S.E. with queries/submissions.

Nation's Restaurant News, 2 Park Ave., New York, N.Y. 10016. Biwk. Newspaper edited to interests of executives and owners of successful restaurants and chains, including major drive-ins. Buys b&w glossies only with captions/copy. Emphasis on news of mergers, openings, hot news items of wide interest with "inside" angles. Query on photo feature ideas. Rates vary with subject, length, quality. Sample copy available to pro photojournalists on request. Enclose S.A.S.E. with queries/submissions.

Nursery Business, 850 Elm Grove Rd., Elm Grove, Wis. 53122. Mo. Edited to interests of professional plant growers, retailers of garden and horticulture materials, operators of garden centers and suppliers. Buys b&w glossies with captions/copy. Rates vary; pays on acc. Query first with S.A.S.E.

Office Products, Hitchcock Bldg., Wheaton, Ill. 60187. Mo. Sample copy, 60¢. Edited to interests of dealers who sell all types of office products—sales promotion programs, expansions, news items of nationwide interest, business management aids, etc. Buys 8×10 glossies only with factual captions/text. Rates vary on acc. Enclose S.A.S.E.

Oil And Gas Journal, The, Petroleum Pub. Co., 211 S. Cheyenne, P. O. Box 1260, Tulsa, Okla. 74101. Wk. B&w glossies and color trans. with captions/copy related to oil and gas operations. Technical subjects. New equipment/methods, engineering ideas. Rates vary on acc. Enclose S.A.S.E. with queries/submissions.

Oilweek, 805 8th Ave., S.W., Calgary, Alberta, Canada. Wk. Edited to interests of industry personnel, emphasis on Canadian activities in the field. Buys b&w glossies (8×10) only with factual captions/copy. Rates vary on acc. Enclose Canadian stamps or Int'n Reply Coupon with submissions.

Outdoor Power Equipment, 3339 W. Freeway, Box 1570, Ft. Worth, Tex., 76101. Buys single b&w glossies in vertical format and with full captions/text, or story-telling photo feature series in b&w. Emphasis on power-equipment retail outlets for power snow blowers, mowers, snowmobiles, powered garden tillers, chain saws, etc. Study first, then query with specific photo/copy ideas. Rates vary. Enclose S.A.S.E. with submissions.

Petroleum Marketer, 636 First Ave., West Haven, Conn. 06516. Bimo. Edited to interests of independent oil jobbers, management and methods of major oil-company operations. Buys b&w photos to illustrate. Best to query first on specific ideas. Rates vary on page basis. Enclose S.A.S.E. with queries/submissions.

Petroleum Today, 1271 Avenue of the Americas, New York, N.Y. 10020. Qt. Use general interest articles on all phases of petroleum and related activities and b&w and/or color pix to illustrate oil products (no brand names visible), personalities (in conjunction with story), operations; autos, sports, unusual industries, etc. No highly technical material. B&w rates vary; color (min. size trans. 35mm) rates vary. Pay on acc.

Progressive Architecture, 600 Summer St., Stanford, Conn. 06904. Mo. Edited to interests of professional architects and designers. Highly technical in contents. Buys some captioned b&w glossies and large format color trans. Study, then query. Enclose S.A.S.E.

Progressive Grocer, 420 Lexington Ave., New York, N.Y. 10017. Mo. Pix showing seasonal displays in supermarkets—Christmas, Easter, Halloween, Thanksgiving, spring-cleaning themes, back-to-school, summer themes. B&w $7.50–$10. Color $20, and up. Enclose S.A.S.E.

Pulp & Paper Magazine of Canada, National Business Publications, Ltd., Gardenvale, P.Q., Canada. Bimo. Pix pertaining to Canadian pulp, paper and forestry subjects. B&w (5×7). Rates vary on acc. Enclose Int'n Reply Coupon with S.A.E.

Safeway News, (Safeway Stores, Inc.), P.O. Box 1168, Oakland, Calif. 94604. Mo. Buys b&w vertical format glossies for covers; uses b&w pix of general human interest with food tie-ins throughout interior of magazine. Captions/copy needed with pix. Rates vary on acc. Include S.A.S.E. with all submissions/queries.

Signalman's Journal, The, 2247 W. Lawrence Ave., Chicago, Ill. 60625. Edited to interests of railroad signalmen. Buys b&w single photos with factual captions, and photo-feature articles with captions/text. Rates vary on publication. Enclose S.A.S.E.

Southern Beverage Journal, 3671 N.W. 52nd St., Miami, Fla. 33142. Mo. Edited to interests

of retail liquor dealers. Buys b&w photos with captions/text dealing with successful management and merchandising methods developed by Southern retail liquor dealers. Pays on acc. Rates vary. Enclose S.A.S.E. with submissions.

Southern Motor Cargo, P.O. Box 4169, Memphis, Tenn. 38104. Buys b&w glossies with captions/copy pertaining to unusual trucks and trucking operations in South. Also human interest individuals and groups in trucking industry. Rates vary on pub. Enclose S.A.S.E. with queries/submissions.

Sporting Goods Dealer, The, (Sporting Goods Dealer Pub. Co.), 1212 N. Lindberg Blvd., St. Louis, MO 63166. Mo. Edited to interests of sportsmen and sporting goods retail outlets. Buys b&w glossies with captions/copy.; exciting sports action, hunting, fishing, boating, sailing, archery, camping, skiing, youth participation. Also interesting sporting goods store displays, merchandising ideas, etc. Rates vary on acc. Include S.A.S.E. with queries/submissions.

Super Service Station, 7300 N. Cicero Ave., Chicago, Ill. 60646. Mo. Buys b&w pix with captions/copy of outstanding gasoline service stations, successful merchandising displays and techniques, sales promotional activities, unusual but practical service station architecture. Pay varies on pub. Enclose S.A.S.E

Supermarket Management, 209 Dunn Ave., Stamford, Conn. 06905. Quarterly, $1. Sample copy on request to established photojournalists. State qualifications. Photo-illustrated articles bought as package deals on assignment only. Study first, then query with possible coverage details. Pays on pub up to $150 for package deals. Enclose S.A.S.E. with queries/submissions.

Teens' And Boys' Outfitter, 71 W. 35th St., New York, N.Y. 10001. Mo. Edited to interests of manufacturers and retail stores that feature apparel for boys and youths. Experienced photojournalists should study publication (sample free on request) and query first; photo features bought on assignment only. Rates vary on pub. Enclose S.A.S.E. with all communications.

Texas Fashions, 3641 Apparel Mart, 2300 N. Stemmons Freeway, Dallas, Tex. 75207. Edited to interests of management and buyers for retail stores featuring children and women's fashions/apparel. Study first, then query. Rates vary on acc. Enclose S.A.S.E. with all communications.

Tire Review, 11 S. Forge St., Akron, OH 44304. Mo. Edited to interests of tire dealers; merchandising displays, tire sales promotions (also accessories), success techniques. Buys b&w glossies with captions/copy. Rates vary

on acc. Enclose S.A.S.E. with queries/ submissions.

Toys, 757 Third Ave., New York, N.Y. 10017. Edited to interests of wholesale distributors, buyers, retailers of toys. Features articles on wholesale/retail merchandising operations illus. with b&w pix/text packages. Also uses some color trans. in larger formats. Rates vary. Enclose S.A.S.E. with queries/submissions.

Volume Feeding Management, 205 E. 42nd St., New York, N.Y. 10017. Mo. Color (trans.) "how-to" pix and illustrated merchandising ideas for owners of restaurants, cafeterias, schools, and colleges; employee feeding, caterers, hotels, etc. Rates depend on quality of pix submitted. Enclose S.A.S.E. with queries/submissions.

Wines And Vines, 703 Market St., San Fran-cisco, Calif. 94103. Edited to interests of grape-growers, winery management personnel, distributors, retailers and wine hobbyists. Seasonal issues devoted to various wines. Buys b&w glossy photos with captions/copy on a wide range of wine-related subjects. Also buys some large-format color trans. Best to study publication, then query. Rates vary. (Sample copy on request to photojournalists.) Enclose S.A.S.E. with all communications.

24. Women's Interest

Many familiar magazines such as Ladies Home Journal, Cosmopolitan, Redbook, and McCalls have been deleted from the following listings at the requests of their editors. The reason most commonly given is that they are not in the market for free-lance photography.

Other specialized publications devoted mainly or in part to female interests and professions are listed in Parts 7, 10, 11, 12, 15, 16, 17, 19, 20, and 21.

AAUW Journal, 2401 Virginia Ave., N.W., Washington DC 20037. Semiannual. Edited to interests of American Association of University Women readership. Buys b&w glossies, $15 ea.; pays on pub. Subjects cover education in schools, ecology, reform, community affairs, cultural trends, etc. Submit S.A.S.E. with queries/submissions.

Baby Talk Magazine, 149 Madison Ave., New York, N.Y. 10016. Mo. 35¢. B&w pix of babies, toddlers, and mothers with new babies engaged in daily routines. Also four-color trans. for cover. Pay $10 and up, on pub.

Bride's Magazine, The, 420 Lexington Ave., New York, N.Y. 10017. Edited primarily to interests of engaged girls. Study current issues for coverage, style. Query first. Rates vary. Enclose S.A.S.E. with queries/submissions.

Chatelaine, 481 University Ave., Toronto 2, Canada. Mo. (Also published in French at 1242 Peel St., Montreal, P.Q.) B&w pix, singles and in series. Subjects suitable for woman's service publication—children, food, homemaking. Rarely buy unsolicited photos. All items must be Canadian or suitable for Canadian use. B&w $10–75. Best to query first. Pay on acc. Enclose Int'n Reply Coupon with all submissions.

Family Circle Magazine, 488 Madison Ave., New York, N.Y. 10022. Mo. Sample copy, 35¢. Edited to women's interests in family life, social life, travel, free-time activities, physical and mental health, etc. Buys photos with captions/text. Pay varies on acc. Study, then query, enclosing S.A.S.E.

Femme Fatale, 3550 N. Lombard, Franklin Park, Ill. 60131. Mo. Edited to interests of young American career women. Wide range of subjects from self-improvement to celebrities and man-woman relationships. Study, then query with specific outlines. Buys pix with captions/text. Pays on acc. at varying rates. Include S.A.S.E. with queries/submissions.

Girl Talk, 380 Madison Ave., New York, N.Y. 10017. Mo. Edited to interests of patrons of beauty salons. Study for breezy subject matter and presentation style, then query, enclosing specific ideas. Enclose S.A.S.E.

Glamour, 420 Lexington Ave., New York, N.Y. 10017. Best to study current issues for photo coverage, subject presentation, etc. Query first, enclosing S.A.S.E. Good rates.

Hadassah Magazine, 65 E. 52nd St., New York, N.Y. 10022. Pub. ten mo. per year. Buys b&w glossies (8×10) on civil liberties, nonpartisan foreign political affairs, U.N. matters pertaining to Israeli/Jewish themes, etc. Pix bought only with captions/ms. Pays $100 and up for color transparencies used for covers—Israeli/Jewish themes. Pays on acc. Enclose S.A.S.E.

Hairdo & Beauty, 750 Third Ave., New York, N.Y. 10017. Mo. Copy, 50¢. Buys some color trans. but primarily b&w photos with captions/ms. Will judge b&w from contact print sheets. Rates vary. Study first, then query. Enclose S.A.S.E.

Intimate Story, Ideal Pub. Corp., 295 Madison Ave., New York, N.Y. 10017. Mo. Picture Editor: E. C. Rethorn. Girls—³/₄ figure or head shots in costumes varying with months. B&w rates vary; color (min. size trans. 2¹/₄×2¹/₄) $200 for covers. Pay on acc.

Lady's Circle Magazine, 21 W. 26th St., New York, N.Y. 10010. Mo. Copy, 35¢. Edited to interests of housewives of all ages. Family care, children, house and garden, hobbies, spare time money-making, crafts, etc. Buys b&w photos only with captions/ms. Query first with specific ideas. Enclose S.A.S.E. Rates vary. Pays on pub.

Mademoiselle, 420 Lexington Ave., New York, N.Y. 10017. Wide coverage of subjects include fashion, travel, careers, etc. Photos commissioned to established pro photographers by arrangement. Study first, then query with specific ideas, enclosing samples, outline, etc. Enclose S.A.S.E. with all submissions.

MD's Wife, 535 N. Dearborn St., Chicago, Ill. 60610. Pub. six times per year as official journal of Women's Auxiliary to the American Medical Assoc., Inc. Buys b&w glossies and color trans. with factual captions/text. Edited to interests of doctor's wives and families. Study first, then query. Enclose S.A.S.E.

Modern Screen Magazine, 750 3rd Ave., New York, N.Y. 10017. Mo. Copy, 50¢. Buys b&w photos and color trans. as singles, in photo series, covers. Pix must be factual and have captions or ms. Celebrities in TV movies, show business. Good rates on acc. Best to study, then query with details. Enclose S.A.S.E.

Motion Picture (Macfadden-Bartell Corp.), 205 E. 42nd St., New York, N.Y. 10017. Mo. Sample copy on request to photojournalists. Edited mainly to interests of women aged 20 and up. Buys pro-quality b&w and color pix with factual captions/text. Features celebrities, newsworthy events, exposés, show biz personalities and profiles. Also seasonal pix. Pays good rates on variable scale upon acc. Query first, enclosing S.A.S.E.

Movie Life, 295 Madison Ave., New York, N.Y. 10017. Mo. Buys b&w glossies and color trans.

with factual captions/ms as singles or story-telling pic features. Emphasis on TV and movie personalities, their home lives, etc. Study, then query. Rates vary on pub. Enclose S.A.S.E. with all submissions.

Movie Mirror, Sterling Group, Inc., 315 Park Ave., New York, N.Y. 10010 (Emphasis on events in lives of interesting show-biz people (TV, movie, stage) with single pix, series, etc. having strong factual captions/text. B&w pay $25 ea. and up. Color trans., $200 and up. Pays on acc. Important to study first, then query. Be specific on ideas/illus. offered. Enclose S.A.S.E.

Photoplay, 205 E. 42nd St., New York, N.Y. 10017. Mo. Buys b&w and color pix as single or in series on motion picture stars and up-coming talent. Pays on acc. from $25 up for b&w photos with captions/copy; color trans. (35mm and larger) vary. Query, enclosing S.A.S.E.

Progressive Woman, Box 510, Middlebury, IN 46540. Mo. Sample copy, 75¢. Edited to interests of working women, women in business, professions, new trends in women's participation in business, community, political affairs. Buys b&w glossies and color trans. with captions/ms. Study, then query. Rates vary on acc. Enclose S.A.S.E. with queries/submissions.

Today's Family, Box 31467, Dallas, Tex. 72531. Mo. Edited to interests of average American housewife and mother. Buys b&w glossies only with factual and/or detailed captions/ms on subjects pertaining to family and home care, health, leisure time, hobbies and crafts, etc. Study first, then query with specific ideas. Enclose S.A.S.E.

Woman Beautiful, Box 23505, Ft. Lauderdale, Fla. 33307. Edited to interests of beauty salon employees and patrons—hair-styling, beauty aids and methods, etc. Buys b&w pix only with captions/ms. Rates vary on acc. Enclose S.A.S.E.

Woman's Day, One Astor Place, New York, N.Y. 10036. Mo. Huge-circulation magazine paying top rates for top-quality material. Essential to study current issues for wide range of subject coverage and style of presentation. Query in detail on specific subject matter and proposed approach. Good idea to enclose published clippings or other proof of your ability. Uses b&w glossies with captions/text inside, covers from color trans. Pays on acc. Enclose S.A.S.E. with all queries/submissions.

Woman's World, 261 Fifth Ave., New York, N.Y. 10016. Mo. Buys b&w glossies as single shots or in series only with captions/copy. Uses color trans. on covers. All rates vary. Edited to interests of women—their immediate personal problems and solutions, families, homes, leisure activities, community involvements, etc. Also uses seasonal material submitted well ahead of pub. dates. Study contents, then query, enclosing S.A.S.E. with all submissions.

SECTION 12

Glossary: Common and Technical Terms

For the person just entering the free-lance picture-marketing field, some of the technical and colloquial terms that are commonly used may be confusing. The following definitions apply to some of the words and phrases most frequently encountered.

ABC. Abbreviation for *Audit Bureau of Circulation,* an organization that checks the circulation claims of its subscribing publications as to their nature—paid, free complimentary lists, etc. Of primary interest to potential advertisers. The circulation claims on non-ABC publications may or may not be reasonably accurate.

Acceptance (payment on). This phrase implies that a purchaser will pay for specific rights to publish a picture at the time he accepts it. Some buyers pay promptly. Others lag 30 to 90 days. A few abuse the phrase by delaying payment until the photograph is actually in the works for publication.

Accredited school. In the field of photography, a school that has officially been accredited or licensed as an institution of higher learning.

Animation (movie). A movie composed of single drawings or inanimate objects, which are photographed by stop-motion techniques that result in an illusion of continuous movement.

Anti-curl solution. Commercial product used in final stages of washing prints to inhibit the tendency of printing papers to curl towards their emulsion sides as they dry.

Aspect ratio. The ratio between the width and the height. In a normal projected picture the aspect ratio is usually 4:3.

Assignment. A definite go-ahead to produce picture(s) for a specific client with mutual understanding as to the provisions and terms involved. With rare exceptions, it is best to have the assignment and provisions written out, however briefly and informally, and signed by both client and photographer. A true assignment and an "assignment on speculation" are not the same. See *Speculation.*

Barn-doors (on lighting equipment). Hinged, opaque flaps mounted on the light source that can be opened or closed to control the amount of illumination that reaches specific areas of a subject being photographed.

Binding (magazines, brochures, books, etc.). The method used to hold the pages together. Saddle-stitched publications have staples that meet at the center-fold. This type of binding has no spine or flat back as does, for example, a hard-cover book. *Perfect-bind* has pages glued together and presents a spine that usually carries printed matter. Spiral-bind and ring-bind have pages perforated along the edges. Normally, only the ring-bind can offer the advantages of both perforated pages and a spine or flat-back.

Bleed page. A page in which one or more illustrations bleed off the margins at the top, bottom, side, or into the gutter, where the bleed page meets its opposite page.

Bounce light. Light reflected upon a subject by light colored walls, snow, sand, cardboard reflectors, white umbrellas, etc. Much softer by nature than original-source light from the sun, flash, floodlight, spotlight, etc.

Burning-in. Intentional darkening of specific areas of a print during the printing procedures.

Collage. A series of images that have been cut out and reassembled to form a single unit; i.e., a totally different visual effect created through the combination of different images.

Color prints. A number of different processes yield color prints (to be viewed by reflected light the same as you view a black-and-white print) from *color negative* film. Enlarged full-color prints are often used for exhibition or display purposes, less frequently for publication use.

Color transparencies. Pictures recorded on positive color film to be viewed by transmitted light, which passes through them as, for example, by projection on a screen.

Colored pictures. Hand-colored black-and-white photographs. Rarely used in publications, regardless of technique employed.

Commission. The fee (generally a percentage of the total price received for a picture) charged by the photo agency or personal agent for locating a buyer and attending to the details of billing, collecting, etc.

Contact proofs. Full negative-size positive prints are made by placing as many negatives on a sheet of 8″ × 10″ (or larger) enlarging paper as the size of the paper will accommodate. The negatives are held flat against the paper with heavy glass or in a contact-proofing frame. All work is conducted in a darkroom. A brief exposure is made by white light, and the sheet of enlarging paper is then developed in the usual way. A sheet of 8″ × 10″ enlarging paper will accept four 4″ × 5″ negatives, twelve 2¼″ × 2¼″ negatives, etc. Before being contact printed, each negative should be code-numbered (often with India ink in the clear margin) for future file reference.

Contract. A formal written agreement, signed by a photographer and his client, which spells out the terms under which a firm assignment will be fulfilled.

Custom labs. Professionally equipped and staffed labs that specialize in developing and processing both negatives and prints to order. Some custom labs handle only black-and-white materials; some specialize only in color; others produce professional work in both media. The photographer uses both notes and standardized symbols to indicate how he wants enlargements made (portions to be lightened, darkened, etc.). Some labs are equipped to completely alter the colors of images in transparencies or prints that are to be used in advertisements and editorial reproductions. Many top-income photographers have all their work processed by custom labs.

Depth of field. The range of distance (near to far) at which images will appear in sharp focus at a given lens setting.

Differential focus. Intentional settings of a camera's distance scale and lens diaphragm opening that will render part of a scene in sharp focus while other parts of the same scene are out-of-focus and indistinct.

Dissolve (movie technique). The gradual disappearance of one scene as it is being replaced by a new scene.

Dodging. A darkroom technique used to lighten or darken certain areas of a print while a negative is being projected through an enlarger.

Dolly (movie). Essentially a platform on wheels that supports a camera and tripod; some also provide room for the camera operator. The wheels on some dollys are flanged for use on tracks. In all cases, the main purpose of a dolly is to provide steadiness while the camera is being moved during a scene or "take."

Dub (movie). To add sound to a movie originally shot as a silent film. (Sometimes used to improve or replace segments of film by rerecording an existing soundtrack.)

Exclusive publication rights. The outright sale of all future publishing rights and resulting use of or income derived from a negative or color transparency. A modified form of selling exclusive rights may apply only to a specific type of market. A calendar publisher, for example, may buy exclusive rights only to the use of a picture in calendar form. Or a text-book publisher may buy exclusive rights to the use of a picture in book form. In some cases, exclusive rights may be purchased for only a limited period of time. If in the course of time ownership of a photograph reverts to the photographer, the price is generally less than if all and permanent rights to the picture are transferred to the buyer. The exact terms under which exclusive rights are relinquished by the photographer should be clearly defined in written, signed form.

Facing pages. Opposite pages in a publication, sometimes called a *spread.* A photograph reproduced across a spread, in total or in part, should command a better page-rate fee than if the entire photograph is reproduced on a single page.

Fade in (movie). A scene that begins in darkness and gradually brightens to distinct and normal viewing exposure.

Fade out (movie). The opposite of fade-in, often used to switch from one scene or locale to another, or to symbolize the passing of a period of time.

Fee-plus basis. An arrangement whereby a photographer is offered a certain fee for an assignment—*plus* reimbursement for travel costs, model fees, props, and other reasonable expenses incurred in filling the assignment.

Ferrotyped picture (same as glossy or glazed). A photograph printed on paper that yields a smooth, glossy finish when pressed and dried upon a polished metal surface, i.e., a ferrotyping tin, plate, or drum. Ferrotyped prints tend to emphasize detail and are favored by many types of publishers for reproduction purposes.

Fillers. One or more photographs with brief, factual captions that can be used to fill out empty column space in a magazine, newspaper, etc.

Film gate. The spring-mounted, polished metal plate that presses the film flatly against the open area where each frame will be exposed to light (via the lens in a camera, or the lamp in a projector).

Film speed. (1) The rated sensitivity of a film emulsion to light, expressed in numbers that relate to slow, medium, or fast. (2) The rate of speed, in movies, at which individual frames move past the film-gate aperture. For sound movies, the normal rate is 24 fps (frames per second.)

Film strip. A series of positive transparencies that are projected one at a time. Some filmstrip rolls move from the top or feeder roll to the bottom or take-up roll; shorter strips are sometimes spliced together at beginning and end to form an endless loop that repeats itself as long as the projector is in operation.

First-publication rights. The purchaser of first-publication rights in a photograph usually agrees to pay a premium for the privilege of being first to reproduce a photograph. Once he has exercised this right, ownership reverts to the photographer who can thereafter sell further one-time publication rights (never first-time rights again) to other buyers.

Flyers. Usually small printed sheets of advertising, sales promotion, or public relations material containing photos of products or services offered. Used in direct-mail campaigns, newspaper and magazine coupons, or stuffers that go into parcels purchased at retail stores.

Focal length. When a lens is focused at infinity, its focal length is the distance from the rear nodal point of the lens to the film plane.

Glazed prints. See *ferrotyped prints.*

Glossy prints. See *ferrotyped prints.*

Gutter. The center groove between two consecutive or facing pages of a magazine, book, etc.

Half-tone screen. Parallel rows of small dots that form an image when a photograph is reproduced in a magazine, newspaper, etc. Photos reproduced on soft, uncoated paper stock require coarse half-tone screens (about 60 to 85 dots to the inch) to avoid smudging. Coated paper accepts finer half-tone screens (120-line or finer). The finer the half-tone screen, the better the tone values and details in a photograph can be reproduced.

Home-study school. Formerly known as a correspondence school. Students and instructors communicate by mail rather than by classroom contact.

House organs. The same company or organization publications known as *house publications* or *house magazines.* If an *internal* house organ, the publication is circulated to company employees only. If an *internal-external* house organ, it is also mailed to stockholders and interested persons outside the parent company. House organs are not the same as trade magazines, and are never sold on newsstands.

Independent-study school. The same as a home-study school.

Key symbols. (1) More or less standardized symbols, such as a cross-hatch mark, that a photographer uses on a contact print which will be sent (together with the original negative) to a custom lab for an enlarged print. The symbols indicate where and how the enlargement is to be darkened, lightened, etc. (2) For clarity, a finished photograph may be overlayed with a sheet of tracing paper on which the photographer lightly draws dotted lines, numerals, or other symbols (such as "X" to mark the spot) that will be reproduced in the published print. This is highly preferable to drawing on the face of the print—a job properly left to the buyer's art department.

Keyed photographs. Photos with a number on the margin or back, which corresponds to their negative file numbers. These numbers, when repeated in a caption or text material, are the key to the picture being referred to.

Magnetic sound. A magnetic stripe along the edge of movie film on which sound is recorded, or tape-recorded sound, which may or may not be synchronized with the changing of screen images projected from slides.

Media. The vehicle used to reproduce photographs, i.e., printed material such as magazines, books, posters, billboards, flyers, annual reports, TV commercials, etc.

Montage. The printing of two or more negatives onto the same sheet of enlarging paper so that each image blends into the next to form a composite final result.

National Home Study Council. An officially recognized organization that periodically makes a thorough examination of the course of study, quality of instruction, etc., before an independent-study school is granted the right to display an emblem signifying that it has been

approved as an accredited institution for home-study education.

Letterpress. A type of printing that requires raised surfaces be made of photographs that are to be reproduced. (See *offset* as opposed to letterpress).

Offset. Printing from a flat plane surface, such as a cylinder.

Optical sound (movies). A method of recording sound on movie film by varying the density and/or areas of a black-and-white track. (See *magnetic sound* as opposed to optical sound).

Page rate. Many publishers pay for material at a standard rate per page. A page consists of both illustrations and text. At $80-per-page rate, for example, the photo(s) and text occupying a full page would *together* earn $80. If the photographer provided *only* the pictures (but not the text), he would be paid for the percentage of space his photographs occupied on the full page.

Pan or panning. The technique of moving a camera horizontally or vertically from a fixed position while an exposure (still camera) or a scene (movie) is being recorded.

Perfect bind. See *Binding.*

Perforations (film). The small holes at the edge of the film by means of which the film is advanced from one frame to the next.

Personal agent. A person who calls upon potential buyers to present and, if possible, sell existing work or obtain photographic assignments for his client. A personal agent rarely represents more than a few photographers who work in noncompetitive fields. Normally, a personal agent (representative) will take on only established and well-recognized photographers. On each sale he charges a commission upward of 25 per cent of the amount collected from the purchaser.

Photo agency. An organization that maintains a large collection of photographs classified by subject matter. Some agencies handle general subjects, others handle only specialized sub-jects such as religious, animals, sports, news, etc. The function of the agency is to sell as many pictures as possible from its archives, maintain records, handle the billing, and collect for the photographs that they've sold. As a rule, agencies retain 40 per cent to 60 per cent of what they collect, and remit the balance to the photographers whose pictures they sold.

Picture Editor. Any person with authority to buy photographs for commercial use. His official title may be Art Director, Editor, Publisher, Art Buyer, etc. When in doubt as to whom to ask an appointment with or mail a submission of pictures to, play it safe. The title of Picture Editor will always lead to the right person.

P. O. P. Abbreviation for Printing Out Paper. This is the familiar brown or tan colored paper on which studio portrait proofs are generally submitted to a customer. Usually made by pressing the original negative flat on a sheet of P.O.P. and exposing the sandwich to sunlight or other direct light. No developing is required. Over a period of time the image, which is clear in a freshly printed P.O.P. proof, will fade until it disappears. This is intentional, for some people would retain the P.O.P. proofs without ordering permanent prints. Although there are ways that P.O.P. proofs can be made more or less stable, the average customer doesn't know the formulas required.

Publication (payment on). Under these terms, a buyer does not pay for a photograph until it is actually reproduced. This is definitely not to the photographer's advantage, but payment on publication is being made the policy of more and more publications.

Publication rights. See *Exclusive Rights, First-Publication Rights, One-time Publication Rights.* The last are the rights most frequently sold by photographers.

Saddle stitch. See *Binding.*

S.A.S.E. Abbreviation for self-addressed, stamped envelope. Most buyers require an S.A.S.E. if a photographer wishes unused materials returned to him.

Slanted material. Photographs, captions, text materials specifically aimed (slanted) toward the interests and tastes of specialized audiences such as skiers, car enthusiasts, dentists, etc.

Sound stripe. See *magnetic sound* and *optical sound.*

Speculation. The taking of photographs on your own with no assurance that the buyer will either purchase the results or reimburse your costs in any way. The opposite of a firm assignment—particularly a written assignment.

Spotting. The covering of blemishes on the face of a print resulting from dust specks, hair, line scratches, etc. Usually performed with fine sable brushes charged with dyes or stains.

Stock photos. Photographs that can be sold over and over again with one-time publication rights. It is considered legitimate to submit the same stock photo to a number of *noncompetitive* potential purchasers at the same time.

Storyboard. A series of sketches of the main scenes to be taken to provide continuity and variety, usually connected with movie-making or the production of TV commercials.

Take (movie). A scene that has been photographed successfully and is ready to "wrap up" as being completed.

Trade journal. A publication devoted strictly to the interests of readers engaged in a specific trade, service, or profession. Example: trade journals published for doctors, writers, bakers, druggists, airlines, retail marine stores, cement manufacturers, etc. Trade journals do not reach the newsstands; they are available only by subscriptions.

Zoom lens. A lens of variable focal length that provides various degrees of magnification of an image. Terms frequently used in connection with the use of zoom lenses are abbreviated thus: LS, long distance shot; MS, medium distance shot; MCU, medium close-up; CL, close-up; XCL, extreme close-up or magnification.

Photographer's Credits

INDEX